NK
835
.P4
P53
1982

The Pennsylvania
Germans

094

$18.95

THIS EXHIBITION IS SUPPORTED BY GRANTS FROM
THE PEW MEMORIAL TRUST; THE DU PONT COMPANY; AND
THE NATIONAL ENDOWMENT FOR THE HUMANITIES AND THE
NATIONAL ENDOWMENT FOR THE ARTS, FEDERAL AGENCIES.
ADDITIONAL CONTRIBUTIONS HAVE BEEN MADE BY
THE PENNSYLVANIA HUMANITIES COUNCIL,
THE WOMEN'S COMMITTEE OF THE PHILADELPHIA MUSEUM OF ART,
CAMPBELL SOUP FUND, AND THE DELAWARE HUMANITIES FORUM.

PHILADELPHIA MUSEUM OF ART
October 17, 1982, to January 9, 1983

THE MUSEUM OF FINE ARTS, HOUSTON
March 5, 1983, to May 15, 1983

THE FINE ARTS MUSEUMS OF SAN FRANCISCO:
M. H. de YOUNG MEMORIAL MUSEUM
July 2, 1983, to September 3, 1983

THE ART INSTITUTE OF CHICAGO
December 10, 1983, to January 29, 1984

ORGANIZERS OF THE EXHIBITION

Beatrice B. Garvan, *Associate Curator of American Art*
Philadelphia Museum of Art

Charles F. Hummel, *Deputy Director for Collections*
The Henry Francis du Pont Winterthur Museum

CONTRIBUTING CURATORS

Phillip H. Curtis, *Associate Curator and in Charge of Ceramics and Glass*
The Henry Francis du Pont Winterthur Museum

Donald L. Fennimore, *Associate Curator and in Charge of Metals*
The Henry Francis du Pont Winterthur Museum

E. McSherry Fowble, *Associate Curator and in Charge of Graphics and Paintings*
The Henry Francis du Pont Winterthur Museum

Vernon S. Gunnion, *Guest Curator*

Patricia T. Herr, *Guest Curator*

Nancy E. Richards, *Curator*
The Henry Francis du Pont Winterthur Museum

Susan B. Swan, *Associate Curator and in Charge of Textiles*
The Henry Francis du Pont Winterthur Museum

THE PENNSYLVANIA GERMANS

A CELEBRATION OF THEIR ARTS

1683–1850

Beatrice B. Garvan & Charles F. Hummel

AN EXHIBITION ORGANIZED BY
THE PHILADELPHIA MUSEUM OF ART
AND
THE HENRY FRANCIS DU PONT WINTERTHUR MUSEUM

Philadelphia Museum of Art

Cover design after plate 24

Editorial supervision: Jane Iandola Watkins
Design: Joseph B. Del Valle
Composition: Deputy Crown, Inc.
Printing: Lebanon Valley Offset

Library of Congress Cataloging in Publication Data
Main entry under title:
The Pennsylvania Germans.
 "An exhibition organized by the Philadelphia
Museum of Art and the Henry Francis du Pont Winterthur
Museum."
 Bibliography: p.
 1. Art, Pennsylvania Dutch—Exhibitions. 2. Folk
art—Pennsylvania—Exhibitions. 3. Art industries
and trade—Pennsylvania—Exhibitions. 1. Garvan,
Beatrice B. 11. Hummel, Charles F. 111. Philadelphia
Museum of Art. 1v. Henry Francis du Pont Winterthur
Museum.
NK835.P4P53 1982 745'.089310748'074014811 82-61416
ISBN 0-87633-048-0

Foreword

THE SENSE OF close community, laced with imagination and a healthy spirit of give and take, which pervades the vigorous art of the Pennsylvania Germans, has happily characterized this joint adventure of two great museums in the Delaware Valley. Pennsylvania German objects have been central to the history and collections of both institutions. In 1887, the Philadelphia Museum of Art received the first gift of such material in the form of a fragment of blue resist-dyed linen woven in Bucks County between 1780 and 1800. Thanks to the generosity and perspicacity of collectors such as Titus C. Geesey and J. Stogdell Stokes, the Museum assembled a distinguished body of objects, which are among the principal treasures of its American Wing. Henry Francis du Pont began collecting Pennsylvania German objects in the mid-1920s for Chestertown, his home at Southampton, Long Island. After inheriting the Winterthur estate in 1926, and enlarging the house in 1929–31, he shifted his Pennsylvania German collection to Winterthur. His most prolific period of collecting in this field was through the late 1930s, but several important architectural interiors were added in the 1950s, and choice items through the years to his death in 1969. His collection is today among the largest and most diverse holdings of Pennsylvania German art in a public institution.

The lengthy preparation of the exhibition began nearly four years ago, growing out of scholarly research at the Winterthur Museum and the Philadelphia Museum of Art. In 1978, Beatrice Garvan, Associate Curator of American Art, was working on a catalogue of the Pennsylvania German collections at the Philadelphia Museum, and Scott Swank, Deputy Director for Interpretation, was coordinating research for a catalogue of the Pennsylvania German collections at the Winterthur Museum. Beatrice Garvan met with Charles Hummel, now Deputy Director for Collections at Winterthur, to discuss a jointly sponsored exhibition to celebrate Pennsylvania German art. "The Pennsylvania Germans: A Celebration of Their Arts, 1683–1850" is the result of the high standards, broad knowledge, and perseverance of Beatrice Garvan and Charles Hummel, who conceived and co-directed the exhibition, and of the cooperative efforts of impressive numbers of the staffs at the Winterthur Museum and the Philadelphia Museum of Art.

This complex project explores new scholarly ground and brings together for the first time the full visual range of Pennsylvania German culture be-

tween 1683 and 1850, from plow to fraktur poem. The study of traditions transmitted from the Old World to the New was broadened by research in Europe. In the summer of 1980, Winterthur staff members Charles Hummel, Nancy Richards, E. McSherry Fowble, Susan Swan, Donald Fennimore, Scott Swank, and the late Benno Forman explored visual and archival sources in Germany, Austria, and Switzerland, on a trip funded in part with a grant from the Friends of Winterthur. On a similar quest for comparative material, Beatrice Garvan traveled to Germany, France, and the British Isles in 1977 and to Switzerland in 1980.

This publication and the exhibition itself are two elements in the manifold approach to the subject of Pennsylvania German art by the two sponsoring museums. An expanded microfiche catalogue of this exhibition will be issued by the University of Chicago Press in 1983 under the title *Pennsylvania German Art, 1683–1850*. Each museum is publishing a handbook of its Pennsylvania German collections. This is the most comprehensive exhibition of Pennsylvania German art ever mounted, and these artistic and historic objects have never been seen by the American public except on the East Coast— indeed, many of the objects from private collections have never been exhibited before—therefore, both sponsoring museums wanted the exhibition to travel to other parts of the United States during 1983–84. We are pleased that it will be shown at the Houston Museum of Fine Arts, the M. H. de Young Memorial Museum of the Fine Arts Museums of San Francisco, and the Art Institute of Chicago. The concluding event in this cooperative approach to Pennsylvania German art and culture will be the 25th Biennial Winterthur Conference, scheduled for October 3–4, 1983. The program at Winterthur will be part of the "Tricentennial Conference of American-German History, Politics, and Culture," jointly sponsored by the Winterthur Museum and the University of Pennsylvania.

Production of this catalogue and the design of the exhibition installation were primary responsibilities of the Philadelphia Museum of Art, and Winterthur undertook major responsibility for the funding of the planning and travel of the exhibition. Jean Sutherland Boggs, Director of the Philadelphia Museum of Art from 1979 through June 1982, gave enthusiastic support to the development of this project during her tenure. We are extremely grateful for the generosity of those who, during a difficult time of economic recession, made the exhibition possible. Crucial grants were received from the Pew Memorial Trust, the Du Pont Company, and the National Endowment for the Humanities and the National Endowment for the Arts, Federal agencies. Additional, most welcome contributions were made by the Pennsylvania Humanities Council, the Women's Committee of the Philadelphia Museum of Art, the Campbell Soup Fund, and the Delaware Humanities Forum.

The lenders, who parted with delicate and beloved objects for an extended period of time, deserve our warmest thanks. Above all, we salute the grace and sturdy vigor with which the Pennsylvania Germans, the first of whom settled in this country three hundred years ago, gave the necessities of life a bold shape, delicate design, or pithy message: "From the earth with sense the potter makes everything."

James Morton Smith, *Director*
Winterthur Museum and Gardens

Anne d'Harnoncourt, *Director*
Philadelphia Museum of Art

Lenders to the Exhibition

Abby Aldrich Rockefeller Folk Art Center,
Williamsburg, Virginia
Allentown Art Museum, Pennsylvania
American Antiquarian Society,
Worcester, Massachusetts
American Philosophical Society, Philadelphia
Annie S. Kemerer Museum, Bethlehem, Pennsylvania
The Art Institute of Chicago
The Baltimore Museum of Art
Mr. and Mrs. Charles Frederick Beck
Bindnagle Lutheran Church, Palmyra, Pennsylvania
Mr. and Mrs. Lester P. Breininger
Mr. and Mrs. Brodnax Cameron, Jr.
Central Moravian Church, Bethlehem, Pennsylvania
Mr. and Mrs. Eugene A. Charles
Chester County Historical Society,
West Chester, Pennsylvania
Francis G. and William D. Coleman
The Corning Museum of Glass, Corning, New York
David P. and Susan M. Cunningham
David Currie
The Dietrich Brothers Americana Corporation,
Philadelphia
Mr. and Mrs. James A. Drain
Dorothy and Eugene Elgin
Mr. and Mrs. Paul R. Flack
Franklin and Marshall College, Lancaster,
Pennsylvania
The Free Library of Philadelphia
Ellen J. Gehret
Germantown Historical Society, Philadelphia
Greenfield Village and Henry Ford Museum,
The Edison Institute, Dearborn, Michigan
David S. Hansen
S. Alexander Haverstick and John M. Haverstick
The Henry Francis du Pont Winterthur Museum,
Winterthur, Delaware

Heritage Center of Lancaster County, Inc.,
Lancaster, Pennsylvania
Dr. and Mrs. Donald M. Herr
Hershey Museum of American Life,
Hershey, Pennsylvania
Hill Evangelical Lutheran Church,
Cleona, Pennsylvania
The Historical Society of Berks County,
Reading, Pennsylvania
The Historical Society of Montgomery County,
Norristown, Pennsylvania
The Historical Society of Pennsylvania, Philadelphia
The Historical Society of Western Pennsylvania,
Pittsburgh
The Historical Society of York County,
York, Pennsylvania
Mr. and Mrs. Carroll Hopf
Mr. and Mrs. Victor L. Johnson
Juniata College, Huntingdon, Pennsylvania
William H. Kain III and Carol Kain Woodbury
Hilda Smith Kline
Gretchen Holderbaum Knothe
Lancaster County Historical Society,
Lancaster, Pennsylvania
Jeannette Lasansky
The Lehigh County Historical Society,
Allentown, Pennsylvania
Ms. Dotty Lewis
Mr. and Mrs. Roland C. Luther and
Ann Luther Dexter
Richard S. and Rosemarie B. Machmer
Mary Ann McIlnay
The Metropolitan Museum of Art, New York
The Moravian Archives, Bethlehem, Pennsylvania
Moravian Historical Society, Nazareth, Pennsylvania
Moravian Museums of Bethlehem, Pennsylvania
John and Rosamond Moxon

Museum of Art, Carnegie Institute, Pittsburgh
Museum of Fine Arts, Boston
National Gallery of Art, Washington, D.C.
National Museum of American History,
 Smithsonian Institution, Washington, D.C.
Oglebay Institute—Mansion Museum,
 Wheeling, West Virginia
The Pennsylvania Academy of the Fine Arts,
 Philadelphia
Pennsylvania Historical and Museum Commission
Peto Collection
Philadelphia Museum of Art
Private Collections (14)
Mr. and Mrs. Robert L. Raley
The Reading Public Museum and Art Gallery,
 Pennsylvania

Rockford-Kauffman Museum,
 Lancaster, Pennsylvania
Harold H. Royer
Schwenkfelder Library, Pennsburg, Pennsylvania
Mr. and Mrs. Richard Flanders Smith
C. Keyser Stahl
Charles V. Swain
Wadsworth Atheneum, Hartford
Mr. and Mrs. Paul N. Wagner
Waynesburg College Museum,
 Waynesburg, Pennsylvania
The Westmoreland County Museum of Art,
 Greensburg, Pennsylvania
Wyck Charitable Trust, Philadelphia
Yale University Art Gallery, New Haven
Don Yoder Collection

Preface

THE SEMINAL IDEA for this exhibition grew out of a desire to reestablish for a national audience the vitality inherent in the original arts of the Pennsylvania Germans and to explore in depth the particular contributions that they made to American arts and crafts. The material amassed for this exhibition, both the objects and the primary sources that document the objects, produced two complementary units, reflected in the title, "The Pennsylvania Germans," and the subtitle, "A Celebration of Their Arts, 1683–1850." The exhibition first provides an overview of the group, the diverse national origins of the settlers, the stability and the productivity of their regional settlements, and their importance in the establishment of the wealth and the international prestige of the colony of Pennsylvania before 1776. Over three hundred objects were selected out of some three thousand examined, which were made and owned by Pennsylvania Germans. In their decoration, inscriptions, and workmanship, these works reveal the traditions, beliefs, and achievements that this important early settlement group has contributed to American life.

"Dutch" was the general, all-inclusive term used in Pennsylvania to describe these central Europeans, no matter what their national origin. The term provided a quick, if oversimplified, identification, originally without prejudicial connotation, and was accepted by the Germanic settlers themselves. The first use of "Pennsylvania German" was probably in the nineteenth century, possibly as the result of academic studies that were beginning to sort out the historical relationships among the early migrant groups. Both terms are still used in the Pennsylvania countryside, although "Pennsylvania Dutch" has been commercialized and exploited and now more often than not is identified with the ubiquitous flat flowers and red hearts.

This is the first exhibition on this subject of this scope. Others have been devoted to specific artists or mediums, and some have emphasized regional settlements. But with the three hundredth anniversary of the founding of Pennsylvania, which in 1682 also included the three lower counties now organized as the state of Delaware, it seemed appropriate that the Philadelphia Museum of Art and the Henry Francis du Pont Winterthur Museum join staffs, collections, and resources to present a major exhibition of the arts of the Pennsylvania Germans and to publish the results of the research done over three years of planning. Nine curators, each a specialist in his or her area, worked on the project. Some one hundred and fifty collections, private and institutional, were explored as a result of the enthusiasm for the subject and the project of directors, curators, historians, and collectors. Wonderful

Pennsylvania German objects exist; we have drawn from the permanent collections of both the Philadelphia Museum of Art and Winterthur, but many more objects have been lent generously from regional institutions and private collections.

The material and the first round of research on objects selected suggested the organization of the exhibition into thematic units. Succeeding selections added to the development of these themes. Each curator concentrated his or her efforts on a category that broadened and strengthened the thematic content. Their essays and statements about each object in the exhibition will be published by the University of Chicago Press in a microfiche catalogue under the title *Pennsylvania German Art, 1683–1850*. The contributing curators and their categories are as follows: Phillip H. Curtis, ceramics and glass; Beatrice B. Garvan and Charles F. Hummel, furniture; Donald L. Fennimore and Vernon S. Gunnion, metalwork; E. McSherry Fowble, paintings, fraktur, drawings, and imprints; Susan B. Swan and Patricia T. Herr, needlework and woven textiles; and Nancy E. Richards, musical instruments, basketry, and small tools.

We have attempted to select objects that serve as splendid examples of the artistry that the Pennsylvania Germans exhibited in all aspects of their daily life, decorating even practical objects, and also that provide evidence about the themes: "From Diversity," "Pockets of Settlement," "The Marketplace," "Good Neighbors," "Liberty and Freedom," "For the Home," and "Religion and Education." Obviously there are many objects that could have been included in more than one thematic context; for example, most could sit in "The Marketplace," most were made "For the Home," many reflect "Religion and Education." We have drawn heavily on our colleagues and on each other to create this exhibition and catalogue. The essays and entries for the first three themes, "From Diversity," "Pockets of Settlement," and "The Marketplace," were written by Beatrice B. Garvan. "Good Neighbors," "Liberty and Freedom," "For the Home," and "Religion and Education" were written by Charles F. Hummel.

A question naturally arises: Why limit the exhibition to the Germans in Pennsylvania before 1850? There were many other German settlements in North America—in Georgia, New York, New Jersey, Maryland, North and South Carolina, Texas, and Canada. It was a problem of logistics. For example, we reluctantly left out Caspar Wistar, one of Philadelphia's most prominent Pennsylvania Germans, because we could not find a product from his Pennsylvania brass-button manufacturing operation and because his better-known glasshouse was located in New Jersey. We hope, however, that our concentration on a definable region has yielded enough depth to provide a sound basis for similar studies with other geographical boundaries. The cutoff date 1850 is more difficult to explain. To most scholars working in the field of Pennsylvania German folk life, a more appropriate terminal date would have been 1815, for after that, emigration motivation and patterns shifted away

from the movement of Lutheran and Reformed groups out of the Palatinate regions to other areas, especially Catholic Bavaria. The date 1850, which permits inclusion of later migrants like Anthony Baecher, a potter from Bavaria, and Martin Hoke, a coverlet weaver from Baden, was chosen to enable the exhibition to encompass the Germanic settlement of all of Pennsylvania to its western boundaries. In the section entitled "Pockets of Settlement," a numerical count combined with regional identification of objects makes clear, as we too recognize, that the patterns of migration and settlement indeed were different after 1820, with activity in the earlier period heavily concentrated in southeastern Pennsylvania.

The sheer number of surviving objects that can be identified as Pennsylvania German through manufacture or ownership is an indication of the size and the stability of Germanic settlement in Pennsylvania. These works are also an indication of the quality of workmanship, which has withstood the ravages of time. The objects have been a vast resource in themselves as documents, the equivalent of the written word, demanding equal attention or even translation as the personal language of the maker and/or user.

The themes of the exhibition grew out of the works, with the first unit organized as "From Diversity" because research revealed relationships of objects to settlers whose roots can be traced to France, Germany, Czechoslovakia, Austria, Poland, Switzerland, the northern Tirol of Italy, Denmark, and Sweden. Designs and inscriptions provide evidence of the travels of settlers from regions of Europe to locations in Pennsylvania. Genealogical and technical data revealed by the objects became documents recording the movement of people, ideas, and skills between the various "Pockets of Settlement" within Pennsylvania: from Germantown into the northern and eastern counties, from Philadelphia directly west to Lancaster and York, over the Blue Mountains, across the Susquehanna River, and finally to the western borders of Pennsylvania and beyond into Ohio. Although agriculture dominated daily life, "The Marketplace" encouraged production of a wide range of crafts and was one place where the language of buying and selling was shared by English, Scots, and Germans. The dexterity and technological skills of the Pennsylvania Germans contributed to the prosperity of the whole colony, which in turn promoted the section titled "Good Neighbors." The Pennsylvania rifle, used by both German and English colonists to great advantage in the Revolutionary War, makes this point; invented by the Germans in Pennsylvania, it combined features of the German jaeger gun and the English fowling piece. The rifle played an important part in "Liberty and Freedom," as did the eagle in all its variations, the celebration of American heroes, and the expression of personal liberties exhibited on fraktur, plates, and chests. The home was the center of Pennsylvania German life and community, and those objects made "For the Home" were traditional and usually colorful. They often were inscribed with marriage or birth dates. Some were especially created as wishes for the New Year or as valentines; family rela-

tionships were expressed through inscriptions with tender or biting phrases. The human qualities of the Pennsylvania Germans thus are given voice and character in these objects in a way not possible through written documents. From the home sprang the deep commitment to "Religion and Education." The rich Germanic heritage was preserved by continued attention to traditional religious and educational beliefs, and the great strengths of the Germanic settlements in Pennsylvania probably were due to their identification with their language and their church membership. Holidays, both religious, such as Easter and Christmas, and secular, such as Battalion Day and the county fair, were celebrated with music for worship services and for parades and dances—with the rest of Pennsylvania citizenry benefiting from the prodigy of the Pennsylvania German musical instrument makers.

The arts of the Pennsylvania Germans reflect how these hard-working, fun-loving, God-fearing, God-loving people confronted and came to terms with their lives before 1850. Many of the objects included here are themselves celebrations of various aspects of personal rites of passage, and it seemed fitting to celebrate the emergence of Pennsylvania into its fourth century with what fraktur artist Susanna Huebner might have termed "many a noble gift."

B.B.G. and C.F.H.

From Diversity

THE FIRST GENERATION of settlers who came to be known as Pennsylvania Dutch immigrated to Pennsylvania in the seventeenth century from all over what was known then as the Holy Roman Empire. Although many of their ancestral roots can be traced to specific locations in Europe, most of the families who came under William Penn's umbrella between 1683 and 1715 had moved about within various districts on the Continent before they left for America.

Migration was a popular, if hazardous, option for the inhabitants of central European towns, villages, and farms. The Thirty Years' War (1618–48), the Palatine war of succession, the long skirmishes among France, Germany, Holland, and Sweden (1672–1714), with England joining the fray upon the accession of William III of Orange in 1689, led warring armies and factions back and forth over the same ground. The richly productive agricultural valleys watered by the Neckar and Rhine rivers, nurtured by generations of meticulous farming practices, were laid waste by these conflicts. Louis XIV's final devastation of the Palatinate in 1688–89 forced realignments among the large landowners, resulting in wholesale redistribution of land. Some historians believe this dealt the fatal blow to the old feudal system within which the small landowners and tenant farmers had been working.[1] Personal religious practices were threatened by the tides of battles in which the faiths of kings, Catholic versus Protestant, were carried like banners into the national wars. Families and sometimes whole villages were forced to move out of an area or to conceal their religious beliefs if they suddenly became unacceptable to a new regime. Politically insecure, economically deprived, caught in religious controversies promulgated by inspired thinkers and vociferous intellectuals who were constantly debating and sometimes gathering and directing followers about them, many people gave up their geographical heritage in a desperate search for peace, reasonable prosperity, and a climate of religious tolerance.

Immigrants do not usually travel with much baggage; pieces of pottery and large household furnishings beyond the multipurpose trunk or chest most often are left behind. Only the basics are transported, such as clothing (the production of linen, for example, took at least a year from planting to sewing) and iron tools and implements (the result of a manufacturing process and not immediately available). There is evidence that iron tools, guns, and cloth—more valuable in Pennsylvania than in Europe—were carried along, especially from Germany, as capital to pay for the passage or for the first months of relocation. In 1736 one group, probably alerted to bring capital equipment, shipped with them, among other things: "Thirty Stoves [chimney backs in

this case], . . . five hundred and ninety-six Syths (sic), One hundred and three large Iron Instruments called Strawknives, . . . Twenty-seven Iron stew pans, . . . Five dozen and three Iron Shovels, . . . One cask of nails . . . , Fourteen copper kettles, Five copper stills, Two dozen scissors, four Umbrellas, Four dozen and one-half of Worsted Caps, . . . etc."[2] This load was confiscated and sold by customs officials in Philadelphia because the objects were not of English manufacture and import taxes had not been paid, but many other items escaped notice and trickled in. Thus were German-made objects scattered, providing models for Pennsylvania craftsmen of all nationalities. Germanic design and technology from the first were absorbed into the mainstream of Pennsylvania crafts. In fact, an analysis of pottery shards collected from several sites in Philadelphia, where records reveal German locksmiths, potters, weavers, and woodworkers at work, has failed to prove by either form or decoration whether the objects were made by potters relocated from Staffordshire or Strasbourg, for example. Basic raw materials and common patronage probably contributed to this early homogeneity in the crafts. Germanic arts applied to furnishings and official and personal records flourished primarily in the counties and townships where several generations of producers and consumers were of Germanic heritage. Excellent Germanic tools of special design, such as the light, razor-sharp scythe or the goosewing ax, did not change in their appearance in the New World.

Some of the domestic architecture, furniture forms, decorative designs, and customs of these immigrants were already hybrids before appearing in the New World. Furthermore, Old World artists and craftsmen brought with them skills that they had learned through rigorous apprenticeships in the guild system. Certain arts like fraktur work and sgraffito-decorated pottery were traditional to several national groups. In their new home, craftsmen imbued these skills with a fresh energy inspired by their optimism about settlement in Pennsylvania, where the arts were renewed again and again with the succeeding migrations.

The printed book was probably the most influential early source for design. Inventories reveal that Pennsylvania Germans of all sorts—farmers and craftsmen, rural and urban folk—owned books. Family Bibles provided an especially rich design field. Editions of the monumental Froschauer Bible came with the Swiss Mennonites; Isaac Lefevre brought a French Bible in 1712; Dutch Bibles were sent from Holland to support missionary activities. Jacob Kolb, a first-settlement weaver in Germantown, owned a copy of Erasmus's edition of the New Testament in Latin. Craftsmen's manuals, particularly those brought by weavers, were also important design sources in Pennsylvania. The illustrations in books were copied, for instance, by wood-carvers making molds for cast-iron stove plates, such as the "dance of death" panel produced at the Durham Furnace, in Bucks County (checklist 122).

Letters sent to relatives in Europe were full of dramatic descriptions of the risks of travel, such as the arbitrary taxes collected on the trip down the Rhine

and at the border of Holland, but it was the piracy of chests jammed with the minimal possessions needed for survival that caused travelers the most distress. There was enough optimism included in these letters, however, to encourage others to set out. Peter Roth of Hesse in Germany wrote on May 12, 1726, to his brother Johannes "on the Schuylkill": "How I wish to be with you besides my wife and children. We would have come to you if we only had the traveling money. We are burdened very heavy. We must pay militia tax, palace tax, building tax and monthly tax and an order has also been issued by the civil authorities to sequester the property of all Menonists for their earnest money."[3]

Amid the troubles throughout the Holy Roman Empire, trading companies and individual entrepreneurs were vigorously promoting for settlement regions like southern Africa, Brazil, Ireland, and parts of America. Francis Daniel Pastorius noted on March 7, 1684, that Europeans had made their homes in the Philadelphia area before Penn's settlement: "Concerning these first cultivated foreigners I will say no more now than that among them are found some Germans who have already been in this country twenty years and so have become, as it were, naturalized, namely people from Schleswig, Brandenburg, Holstein, Switzerland, etc., also, one from Nüremberg, Jan Jacquet by name"[4] Most of the families who came to Pennsylvania in the first large migrations prior to 1750 had not been out of central Europe before, although they often had been forced to move within the region one or more times, sometimes into neighboring Holland, where there were those who promoted and financed the religious migrations of some Protestant groups.

After the repeal of the Edict of Nantes in 1685, many Huguenots were forced to flee France and take refuge in Germany, Switzerland, England, or Holland. The Ferree family, for example, left their home in Alsace and went first to Landau in the Palatinate, then to Steinweiler, before coming finally to the Pequea Valley in Lancaster County, where they made a strong settlement adhering to the Calvinistic beliefs of the German Reformed Church. The Reformed pastor Charles Lewis Boehme occasionally preached to the Huguenots in French, but they felt little patriotism for the language of Catholic France; in Pennsylvania they chose to speak German or English.[5] Although Daniel Ferree had been a silk weaver in France, his family became gunsmiths in Pennsylvania in response to the demand. The prominence of Joel Ferree as an early rifle maker and as the first of several Ferrees to follow this trade is but one example of Huguenots who as individuals and as a group contributed to their Pennsylvania communities and maintained the same family pride in professional continuity they had had in Europe. The Huguenots were especially creative metalworkers, a fact recognized in seventeenth-century Boston and New York as well as in Pennsylvania; Joel Ferree, active as a gunsmith in Lancaster County by 1758, may have contributed to the development of the Pennsylvania, or Kentucky, rifle (pl. 9), the dreadnought of the Revolutionary War, which was a cross between the German jaeger gun and the English fowling piece. The DeTurks, another prominent early Huguenot family, fled

from France to Frankenthal in the Palatinate; in 1704 they joined the Hugue-
not settlement at Esopus, New York; by 1712 the DeTurks had moved to the
Oley Valley in Berks County, the second largest Huguenot settlement in
Pennsylvania. The checked bed linens woven from linen or wool spun by the
DeTurk family (pl. 111) are evidence that throughout their migrations this
group maintained the French-German custom of making up a colorful bed.

Various branches of the Huber family exemplify the Swiss dilemma. The
name Huber does not appear in Palatinate town or tax records until the seven-
teenth century; in Switzerland they had been prominent landowners entitled
to a coat of arms. They had been forced out of the regions around Zurich and
Bern in the 1650s by famine and economic losses from a series of bad harvests,
moving to Alsace, Swabia, and Württemberg, where they were caught in the
Palatinate turmoil. Hubers entered Pennsylvania throughout the eighteenth
century and settled in Berks, Northampton, and Lancaster counties, where
they belonged variously to the Reformed, Catholic, Moravian, and Mennonite
churches.[6] Mennonite Hubers who had been the victims of religious persecu-
tion in Switzerland since the sixteenth century had moved into the Palatinate
in groups, and after a generation or more often tried to return to Switzerland.
Gregor Jonas Huber (died 1741), the grandfather of George Huber, who
owned the sulphur-inlaid wardrobe (pl. 1) in 1779, was a linen weaver and
later a miller. His story illustrates well the tenacious effort the Swiss made to
retain their identity. He was forced to move from his ancestral family seat at
Oberkulm in the Swiss canton of Aargau to Ellerstadt in the Palatinate, where
he purchased a farm. His sons Johannes (1704–1784), who was George's
father, Christian, and Andreas tried to return to Oberkulm but were forced
to remain at Ellerstadt; the three eventually migrated to Pennsylvania. In a
pattern typical of many families, other Hubers stayed in Europe. Thus were
some Old World ties maintained.

While religious wars raged in territories to the north, in Switzerland the
Lutheran, Catholic, and Reformed church members and the state officials
thought that Swiss national defense was being threatened because of the grow-
ing number of Mennonites who were conspicuous and vocal in their refusal to
bear arms. In the early eighteenth century several schemes were proposed to
remove Mennonites from Switzerland permanently: one plan included estab-
lishing a colony in Georgia; another proposed free passage down the Rhine.
The free trip, William Penn's promises, and the encouragement and suste-
nance offered by sympathetic Quakers in Holland, may have been the decid-
ing factors in the decision to emigrate made by a distinguished group of Swiss
Mennonites from the Horgen and Schaffhausen regions of northern Switzer-
land who settled in Lancaster County in 1710–11. In 1709 William Penn
wrote to his secretary James Logan in Philadelphia: "Herewith comes the
Palatines, whom use with tenderness and love, and fix them so that they may
send over an agreeable character; for they are sober people, divers Mennonists,
and will neither swear nor fight."[7]

Switzerland, along with other European countries, came to regret the exodus of master craftsmen like Peter Holl I (died 1775), whose grandson Peter III (died 1825) probably was one of the joiners who made the wardrobe for George Huber in 1779. Leaving Switzerland about 1740, Peter Holl I settled in Virginia by 1752, traveled to Bucks and Montgomery counties in Pennsylvania in 1754, and finally moved his family into the prosperous and congenial Mennonite community in Manor Township, Lancaster County. Four generations of Peter Holls were mechanics, pump makers, turners, and joiners who made traditional house furnishings for their Mennonite neighbors.

The Holls, the Hubers, and the Ferrees were exactly the type of settlers that William Penn had sought for Pennsylvania. Penn's mother was Low German; he understood the skills and motivations of the central Europeans, and he wanted their industry and character to work for him. He had traveled up the Rhine into the Palatinate in 1677 and knew firsthand about the excellent farming practices there. He saw war-ruined farms and discontented farmers and craftsmen, and he made inviting offers of personal freedoms and land use to stimulate their removal to Pennsylvania. With the help of the Holland Friends, Penn spread his printed promotional materials into the Low Countries where many of the Rhinelanders previously had fled, and into the Rhineland itself. After the first settlements, word of mouth and other personal communication encouraged the influx of Germans to Pennsylvania long after Penn's time. Penn intended that everyone prosper from his plan, and many did indeed. One settler established in Philadelphia, Cornelius Bom, wrote in 1684: "The increase here is so great that, I believe, nowhere in history can be found such an instance of growth in a new country. It is as if the doors had been opened for its progress. Many men are coming here from many parts of the world, so that it will be overflowed with the nations."[8]

As knowledge about Penn's tolerant settlement in Pennsylvania was promulgated throughout Europe, other religious groups formed by schisms within the Lutheran, Reformed, Anabaptist, and Mennonite groups began to turn toward the New World and, specifically, toward Pennsylvania. The Dunkards from the region around Westphalia were a branch of the Mennonites who believed in baptism by immersion. They settled at Ephrata in Lancaster County. The Schwenkfelders were Silesian subjects of the Austrian Hapsburgs and like others occupied in the rural economy were impoverished by the Hapsburgs' wars. They were persecuted almost continuously into the eighteenth century for deviation from the Lutheran tenets and for their success at converting many Lutherans to their sect. In the 1720s, a small group of Schwenkfelders went to Saxony, where they were sheltered at the Moravian community at Herrnhut.[9] In 1734 the Schwenkfelders moved again, this time to Berks and Montgomery counties in Pennsylvania. Hans Huebner from Laubgrund, Silesia, was one of this group; he settled in Montgomery County, where his grandson George Huebner (pl. 2) was active as a potter.

The Moravians, the Unitas Fratrum, are identified with the militarist spirit-

ualist movement that began in Saxony. Their aggressive proselytizing was repugnant to most other sects and churches, and their ideology of the community of goods, which appealed to the masses who had been serfs throughout the feudal period, was threatening to church authority, for it forced economics into the tenets of Protestantism. The Moravians converted hundreds, and their missionary zeal was given great impetus by the challenges in America and the West Indies. Some of their converts, like John Jacob Schmick from Königsberg, Prussia, and Johanna Ingerheidt from Larvik, Norway (pls. 3, 4), were sent to Bethlehem, Pennsylvania, to do missionary work with the Indians. They met and were married there in 1752. Clockmaker Augustin Neisser, Jr. (checklist 107), migrated with his family from Sehlen in Moravia to the settlement at Herrnhut, and finally to Germantown and Bethlehem. Typical of the educated early immigrant tradesmen, Neisser was well read in the classics and multilingual.

Migration to Pennsylvania continued throughout the eighteenth century. By far the most numerous immigrants were Lutheran and Reformed, who came and settled solidly in southeastern Pennsylvania, where they gathered in communities loosely organized around their religious centers, sharing the church and school buildings. Pragmatic Protestant individualists, the Reformed and Lutheran settlers were the mortar between the sect settlements, bridging the gaps in commerce and communication between village and town and playing a major role in local if not national affairs until the Revolution. Jacob Stoudt, potter from Gimbweiler in the Saar Valley, was typical of the resourceful, economically motivated craftsmen who came to Pennsylvania throughout the mid-1700s. His redware pottery, decorated with slip and sgraffito (pl. 7), amply demonstrates the skills that these mid-eighteenth-century craftsmen brought, and by which they flourished. They moved into already established communities and refreshed old markets, where they reestablished traditional designs and craft techniques. Stoudt married the daughter of a German doctor in Bucks County and their children were bilingual. The Stoudts grew in numbers and prominence into the twentieth century.

The Revolutionary War halted immigration, except for the Hessians, those "dread invincibles" who were hired by the British to fight against the Americans. Although unpopular, they were enticed by Pennsylvania Germans to desert to the American cause. Many did remain after the war to settle in Pennsylvania communities—usually German-speaking—where they became craftsmen. John Christian Strenge (pl. 10) was one who stayed. Born in Altenhasungen, Hesse-Cassel, he fought with the Fifth Royal Grenadier Regiment throughout the war.

The years after the Revolution brought changes. Although George Rapp led the Pietist Harmonist Society from Württemberg to settlement on five-hundred acres in Butler County in 1805, in the early eighteenth-century manner,[10] other groups like the Seventh-Day German Baptists at Ephrata Cloister abandoned their semimonastic contemplative existence. The Germans migrat-

ing individually joined a society in flux that was stumbling toward a national identity. Much the same was happening in Europe after the Napoleonic Wars and the final fragmentation of the Holy Roman Empire. The reasons for and patterns of European immigration to Pennsylvania after 1800 became overlaid with economics, trade, and tariffs that were affecting world markets. Concern for the spiritual life continued, but one's beliefs were no longer a public matter; politics and property, production and markets, took the stage. Landholdings in Europe were being fragmented by the custom—followed also in Pennsylvania—that each child inherit equally. While this practice encouraged individualism in Pennsylvania, in Europe those unable to be occupied on the family landholdings turned to home handicrafts in a village setting to support themselves. There they met with economic competition from abroad, especially from the English, who dumped inexpensive, factory-produced textiles on European markets. Weavers like Martin Hoke, from Baden, Germany, were caught in the resulting depression affecting the German textile workers.[11] He was but one of many weavers who came to Pennsylvania at this time to produce for an American market which was known to be expanding into newly opened western territories. Arriving in Pennsylvania, possibly via Baltimore, Hoke set up in York County by 1832, when he advertised that he wove all kinds of tapestry and damask. The coverlet Hoke wove for E. Laucks (pl. 8) has the small geometric border patterns used by European weavers combined with the large-scale field patterns in the American style. Hoke represents the later migrations that were spurred on as much by the economic opportunities in Pennsylvania, which were widely publicized abroad, as by the less demonstrable impressions that Europeans must have formed about the freedoms which their relocated forebears had sought and for which they had fought in America.

The first-generation settlers in Pennsylvania had deep European roots, which had been strengthened through their several transplantings. Years of social and religious insecurity had made them hold to the soil with increasing tenacity. As one of the results of the climate of individualism that had developed out of the Reformation, the common man began to hold to his own intensely personal convictions, feeling he had the right to defend them. *Geht mit Gott* was a blessing bestowed on travelers and at the end of religious services, and this phrase—"Go with God"—became a social force also. With a will to survive and the self-confidence to face the unknown—the sea voyage and the untamed, untested American wilderness—Pennsylvania German settlers arrived in an adventuresome quest for new ground in which to set their roots.

1. *See*, for example, Richard S. Dunn, *The Age of Religious Wars 1559–1689* (New York, 1970).

2. Quoted in Preston A. Barba, ed., " 'S Pennsylvaanisch Deitsch Eck," *The Morning Call* (Allentown, Pa.), January 13, 1962.

3. Quoted in William Brower, "Johannes Roth (Rhodes) or Gleanings from the Life of a Pioneer Settler on the Schuylkill," *The Pennsylvania-German*, vol. 10, no. 3 (March 1909), pp. 121–22.

4. Quoted in Samuel Whitaker Pennypacker, *The Settlement of Germantown, Pennsylvania and the Beginning of German Emigration to North America* (Philadelphia, 1899), p. 89.

5. *See* George G. Struble, "The French Element Among the Pennsylvania Germans," *Pennsylvania History*, vol. 22, no. 3 (July 1955), pp. 267–76; and C. I. Landis, "Madame Mary Ferree and the Huguenots of Lancaster County," *Historical Papers and Addresses of the Lancaster County Historical Society*, vol. 21, no. 6 (1917), p. 101.

6. *See* Ricardo W. Staudt, "The Huber-Hoover Family of Aesch, Switzerland and Trippstadt, Palatinate. With Some Accent on Migrations to Pennsylvania," *Publications of the Genealogical Society of Pennsylvania*, vol. 12, no. 3 (March 1935), pp. 223–43; "Huber Family Notes," Bausman Collection, Genea-logical Society of Pennsylvania Collections, Historical Society of Pennsylvania, Philadelphia (hereinafter cited as Genealogical Society Collections, HSP); Don Yoder, ed., *Pennsylvania German Immigrants, 1709–1786: Lists Consolidated from Yearbooks of the Pennsylvania German Folklore Society* (Baltimore, 1980), p. 70; and the following records in the Genealogical Society Collections, HSP: Records, Moravian Church, Lititz, Pa.; Records, vol. 1, 1748–1864, Trinity Tulpehocken Reformed Church, Tulpehocken, Pa.; Records and Gravestone Inscriptions, Saint Mary's Church, Lancaster, Pa.; and Burial Book, 1744–1821, Moravian Church, Lancaster, Pa.

7. Quoted in Pennypacker, *Settlement of Germantown*, p. 14.

8. Quoted in *ibid.*, p. 104.

9. *See* J. Taylor Hamilton and Kenneth G. Hamilton, *History of the Moravian Church: The Renewed Unitas Fratrum 1722–1957* (Bethlehem, Pa., 1967), p. 82.

10. Homer T. Rosenberger, "Migrations of the Pennsylvania Germans to Western Pennsylvania," *The Western Pennsylvania Historical Magazine*, pt. 2, vol. 54, no. 1 (January 1971), pp. 64–65.

11. For a discussion of this depression, *see* Mack Walker, *Germany and the Emigration 1816–1885* (Cambridge, Mass., 1964), pp. 49–50.

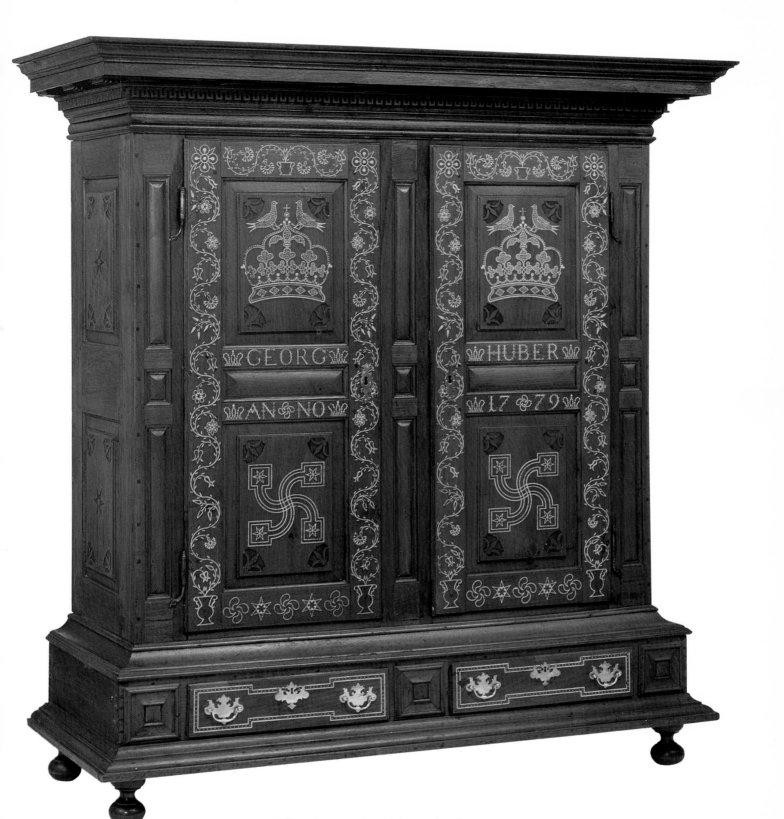

1 William Penn's colony in Pennsylvania
attracted settlers from diverse regions of
Europe. George Huber, owner of this ward-
robe, and its makers were of Swiss descent
(Philadelphia Museum of Art)

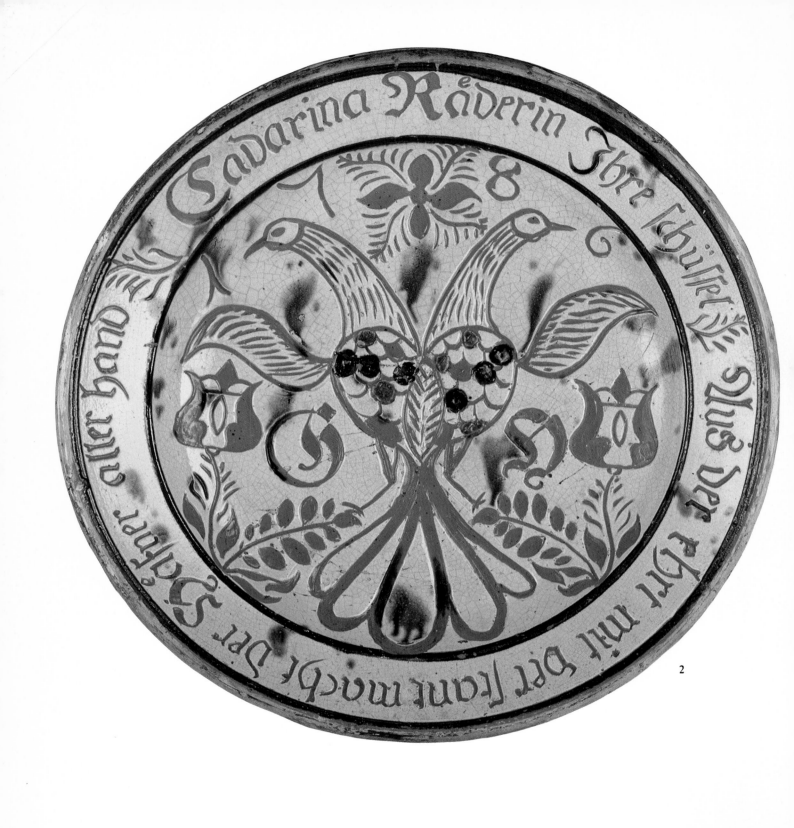

2

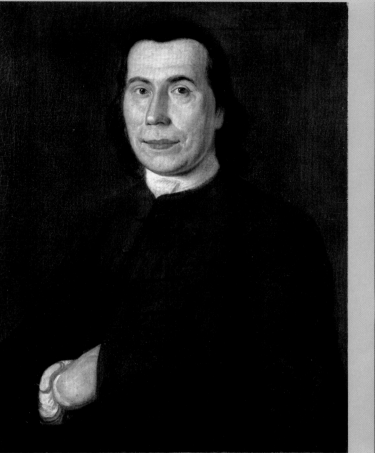

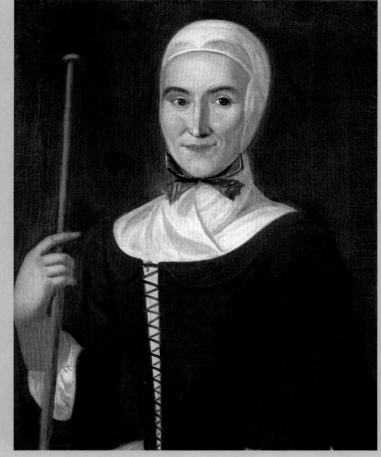

3

4

2 George Huebner, whose family emigrated
from Silesia in 1734, made this sgraffito-
decorated dish (Philadelphia Museum of Art)

3, 4 The Prussian-born John Jacob Schmick
and his Norwegian wife Johanna were
Moravian missionaries to the Indians
(Moravian Historical Society, Nazareth,
Pennsylvania)

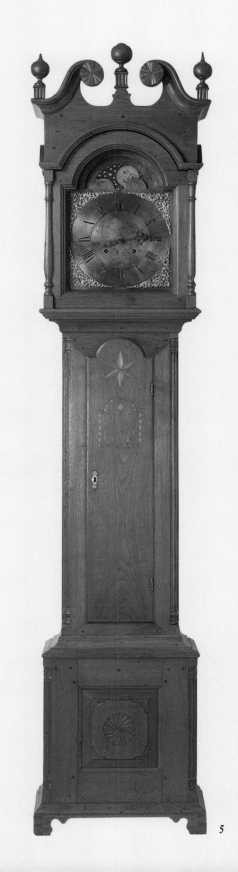

5 The ancestors of the clockmaker Jacob Godshalk have been traced to the district of Cleves in Germany (Pennsylvania Historical and Museum Commission)

6 The Germanic origin of the owner of this wardrobe, David Hottenstein, is reflected in its construction methods, form, and decoration (Winterthur Museum)

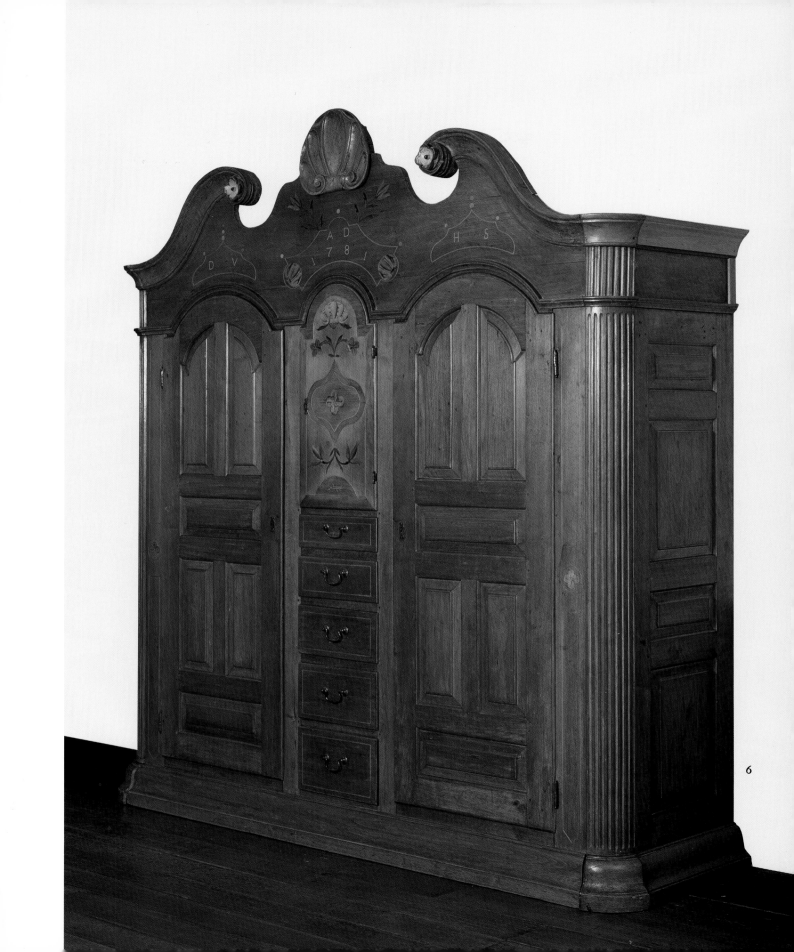

6

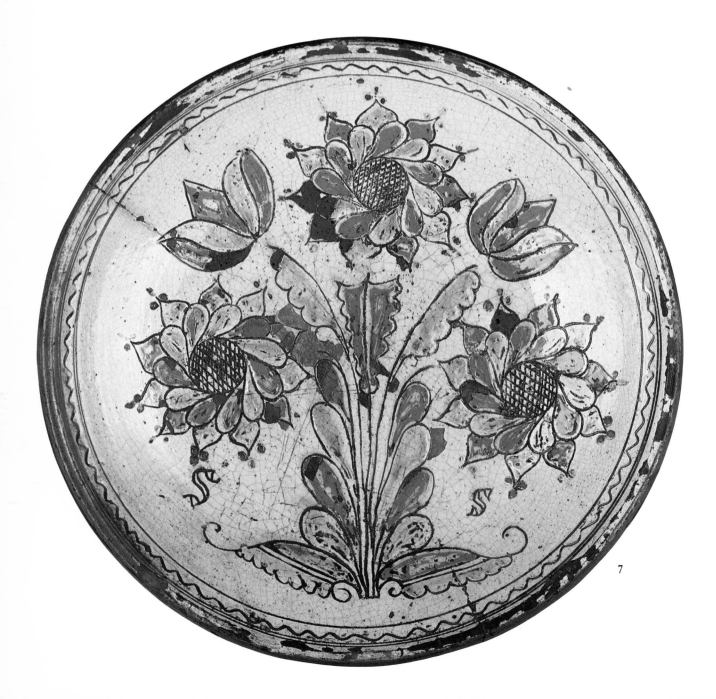

7

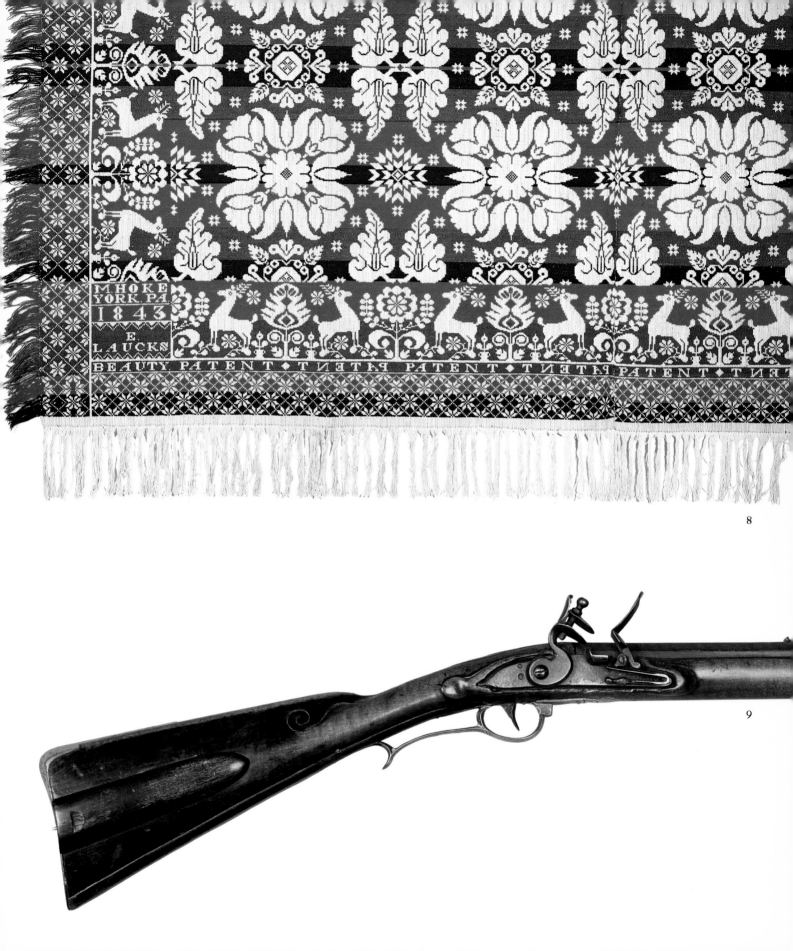

8

9

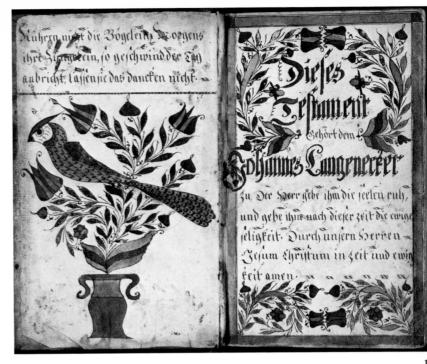

10 The Hessian soldier John Christian Strenge fought the colonials in 1776, but became a schoolteacher in Lancaster County, where he painted this bookplate (American Antiquarian Society, Worcester, Massachusetts)

11 The name of Henrich Faust, grandson of an emigrant from Hesse in Germany, is inscribed on this unicorn chest (The Reading Public Museum and Art Gallery)

10

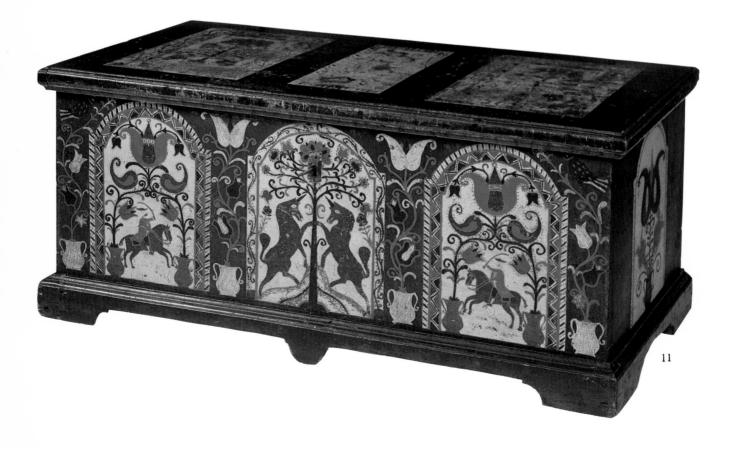

11

Plate 1

WARDROBE, 1779
Attributed to Peter Holl III (d. 1825) and Christian Huber
 (1758–1820)
Manheim and Warwick townships, Lancaster County
Inscribed: GEORG HUBER ANNO 1779
Black walnut, sulphur inlay, poplar, pine, oak, iron; height
 88″ (223.5 cm)
Philadelphia Museum of Art. Purchased. 57-30-1
Checklist 118

The makers and the owner of this wardrobe were of Swiss origin. George Huber* and his brother Christian were the great-grandsons of Johann Heinrich Huber, a Mennonite linen weaver from Oberkulm in the Swiss canton of Aargau, whose son Gregor Jonas (died 1741) moved to Ellerstadt in the Palatinate. Gregor's son Johannes, who was born at Ellerstadt in 1704, had become a prosperous miller in Manheim and Hempfield townships, Lancaster County, by 1745. His sons Jonas (died 1792) and Christian were joiners. This wardrobe, attributed to Christian Huber with Peter Holl III as an important end-of-apprenticeship piece for Christian's brother George, is similar in joinery but different in scale and design from examples probably by Peter Holl II (died 1784), with whom Peter III had worked in Manor Township, Lancaster County. Peter Holl III, joiner and pump maker, was the nephew of Peter Holl II and the grandson of Peter Holl I (died 1775), who left Switzerland about 1740 and moved to Manor Township about 1765.

Sulphur was often used to repair metals, thus, as a pump maker, Holl would have been familiar with its unusual feature of expanding as it hardened. Analysis of the wardrobe's designs inlaid with sulphur suggests that they were derived from textiles, handkerchief borders, and, especially, ecclesiastical linens. The designs were probably drawn on this wardrobe by a person trained at nearby Ephrata—a Jacob Huber family were nonresident members—as the designs most resemble those in the Christian alphabet, a manuscript illuminated at Ephrata in 1751 by Sister Margaretha Thomm (Ephrata Cloister).

*See Beatrice B. Garvan, *The Pennsylvania German Collection: Philadelphia Museum of Art*, Handbooks in American Art, No. 2 (Philadelphia, 1982), Biographical Index, s.v. "Huber, George."

Plate 2

DISH, 1786
George Huebner (1757–1828)
Upper Hanover Township, Montgomery County
Inscribed: 1786 G H Cadarina Raederin Ihre Schüssel Aus
 der ehrt mit verstant Macht der Haefner aller Hand
Earthenware with slip coating, clear lead glaze; dia. 12½″
 (31.8 cm)
Philadelphia Museum of Art. Gift of John T. Morris. 00-21
Checklist 9

George Huebner* was the grandson of Hans (1684–1754) and Maria Scholtz Huebner who migrated with the Schwenkfelders from Ober Harpersdorf, Silesia, in 1734. His father, John George (1720–1792), inherited the 200-acre farm in Frederick Township, Montgomery County, adding 152 adjoining acres in 1771. George may have apprenticed with John George Sissholtz (died 1788) or with John Ludwig Huebner (checklist 10), a Moravian potter who had come to Pennsylvania with the group's leader Count Nikolaus von Zinzendorf, and who lived in the Moravian colony in Oley Township, Berks County. In 1787–88 George Huebner was listed as a potter in Upper Hanover Township tax records. Huebner married Catharine Hartzel in 1785, bought property in Limerick Township, Montgomery County, in 1790, which he sold in 1792, and relocated to Vincent Township, Chester County. He purchased a farm from Charles Albrecht (checklist 331), the instrument maker, selling it in 1815 and moving to Manheim Township, Schuylkill County. This bold and colorful plate, made for one of the Raeder family, Huebner's neighbors in Upper Hanover Township, is inscribed with the potter's initials and the phrase "out of earth with understanding the potter makes everything."

*See Beatrice B. Garvan, *The Pennsylvania German Collection: Philadelphia Museum of Art*, Handbooks in American Art, No. 2 (Philadelphia, 1982), Biographical Index, s.v. "Hubener, George."

Plates 3, 4

PORTRAIT OF JOHN JACOB SCHMICK, SR., c. 1754
PORTRAIT OF JOHANNA INGERHEIDT SCHMICK,
 c. 1754
John Valentine Haidt (1700–1780)
Bethlehem
Oil on canvas; John, 26⅜ x 20½″ (67 x 52.1 cm); Johanna,
 26 9/16 x 20½″ (66.5 x 52.1 cm)
Moravian Historical Society, Nazareth, Pennsylvania
Checklist 174, 175

John Jacob Schmick (1713–1778), born in Königsberg, Prussia, was ordained into the Lutheran ministry after which he went to serve in Livonia, Russia. While there Schmick was converted by the Moravians, whose movement was gaining attention through the prominence and contacts of their leader Count von Zinzendorf, their developing community at Herrnhut in Saxony, and their far-reaching evangelical missions extending into the Caribbean, Canada, and the unknown lands in western Pennsylvania. In 1751 the Moravians sent Schmick to Bethlehem, Pennsylvania, to be a missionary to the Indians.* His future wife Johanna Ingerheidt (1721–1795), born in Larvik, Norway, arrived in Pennsylvania in 1752 on the ship *Irene*, which was owned by the Moravian church; they were married that year in Bethlehem.

John Valentine Haidt,† born in Danzig, was also a Moravian convert. Working as a goldsmith, he traveled to Augsburg, Dresden, Rome, Paris, and London before sailing for Pennsylvania on the *Irene* in 1754. When he painted these portraits of the Schmicks, the couple was about to set out as missionaries deep into Indian country, beyond the Blue Mountains.

*See Don Yoder, ed. and trans., "Into the Indian Country with Brother Schmick: A Moravian Diary of 1797," *The Pennsylvania Dutchman*, vol. 5, no. 2 (June 1953), pp. 2–3, 10.

†See Vernon Nelson, *John Valentine Haidt* (Williamsburg, Va., 1966).

Plate 5

TALL CASE CLOCK, 1775
Jacob Godshalk (c. 1735–1781)
Philadelphia
Inscribed: Jacob Godshalk Philadelphia P B 1775
Walnut, maple inlay, brass, pewter, iron; height 90″ (228.6 cm)
Hope Lodge, Whitemarsh: Pennsylvania Historical and Museum Commission. HL76.2.2
Checklist 109

The Godshalk family* had its origins in a village in the district of Cleves in Germany. Some members had moved to Frankfurt, whence the Reverend Jacob, a Mennonite minister and grandfather of this clockmaker, migrated to Germantown about 1699. By 1714 he had moved to a settlement promoted as an extension of Germantown, in Towamencin Township, Montgomery County. There his grandson Jacob made clocks from about 1755 to 1765, when he sold his land and moved into a small shop on Arch Street in Philadelphia. He had been made a member of the convivial social club the Fishing Company of Fort Saint Davids in 1763, and along with David Rittenhouse (pl. 77) and others was given responsibility for the care of the clock in the Pennsylvania Statehouse (now Independence Hall). Godshalk may have made these social and business contacts during an apprenticeship in Germantown, as is partly suggested by his use of pinions in the English-French style. In 1770 he married Elizabeth Owen in the Second Presbyterian Church in Philadelphia. He took his wife's younger brother Griffith Owen as his apprentice in 1773; Griffith served out Godshalk's time in the Revolutionary army.

*See Albert B. Root, III, "Will the Real Jacob Godshalk Please Stand Up?" *Bulletin of the National Association of Watch and Clock Collectors, Inc.*, vol. 19 (October 1977), pp. 451–56.

Plate 6

WARDROBE, 1781
Maxatawny Township, Berks County
Inscribed: DV AD 1781 HS
Black walnut, white pine, wood inlay, inlaid filler (probably sawdust with lead paint binder); height 101″ (256.5 cm)
Winterthur Museum. 58.17.6
Checklist 117

Jacob Hottenstein (1697–1753) left Esslingen in Germany before 1722 and was settled in Oley Township, Berks County, in 1727. His son David (1734–1802) and wife Catherine built a large stone house in 1783 in Maxatawny Township, where this wardrobe was inventoried in 1802 with the comparatively high valuation of five pounds, five shillings.* The wardrobe was built using Germanic construction: wedged dovetails, pegged mortise and tenons, and an interior locking device for the drawers. The scrolled pediment, flaring rounded moldings at the base, rounded fluted corners, and inlay motifs of shells, flowers, and insects, as well as the form of the piece—double cupboards flanking a central bank of drawers—

reflect the late Baroque (1700–1720) style in Germany, where large cabinets like this often were built into the woodwork.

*Inventory of David Hottenstein, 1802, Register of Wills, Berks County Courthouse, Reading, Pa.

Plate 7

DISH, 1765–74
John Jacob Stoudt (1710–1779)
Rockhill Township, Bucks County
Inscribed: S S
Earthenware with slip coating, clear lead glaze; dia. 12 5/16″ (31.3 cm)
Philadelphia Museum of Art. Purchased: Baugh-Barber Fund. 1980-91-1
Checklist 26

Jacob Stoudt,* the fifth child of Johannes Abraham Stoudt of Gimbweiler in the valley of the Saar, was baptized in the Reformed church at Wolfersweiler in the French-occupied Rhineland. Jacob was a trained potter of means when he arrived at Philadelphia with his brother John on the *Samuel* on August 30, 1737. He married Anna Miller Leisse (spelled variously as Le Cene and Lacey), the daughter of a German doctor and the widow of a Huguenot who had come to Pennsylvania in 1732. This plate was made for their daughter Salome (1743–1827), who married Gabriel Swartzlander in 1774. Stoudt's distinctive designs and his use of copper and iron oxides in the slip mixture to color his designs outlined in sgraffito are typical of the decorated pottery of the middle Rhineland regions of Alsace and Westphalia.

*See Beatrice B. Garvan, *The Pennsylvania German Collection: Philadelphia Museum of Art*, Handbooks in American Art, No. 2 (Philadelphia, 1982), Biographical Index, s.v. "Stout, Jacob."

Plate 8

COVERLET, 1843
Martin Hoke (c. 1803–1881)
York, York County
Inscribed: M. HOKE YORK, PA. 1843 E. LAUCKS BEAUTY PATENT
Wool, cotton; width 87″ (221 cm)
Dr. and Mrs. Donald M. Herr
Checklist 282

Martin Hoke of Baden, Germany, was one of many skilled weavers who left Germanic Europe in the early nineteenth century because imported, factory-made textiles were flooding the markets. This

bedcover, probably commissioned by E. Laucks, was made on a Jacquard loom using typical Pennsylvania German construction—two three-ply natural cotton warps and one single-ply blue warp interwoven with red and blue wool wefts.* The materials and the symmetrical organization of the prancing deer and stylized floral forms reflect eighteenth-century Germanic *beiderwand* weaving traditions.

*See Janet Gray Crosson, *Let's Get Technical—An Overview of Handwoven Pennsylvania Jacquard Coverlets: 1830–1860* (Lancaster, Pa., 1978).

Plate 9
FLINTLOCK RIFLE, 1770–90
Joel Ferree (1731–1801) or Jacob Ferree (1750–1807)
Leacock or Strasburg Township, Lancaster County
Inscribed: J Ferree
Maple, iron, brass; length 55″ (139.7 cm)
Rockford-Kauffman Museum, Lancaster, Pennsylvania
Checklist 161

The Ferrees were Huguenots. Joel Ferree was descended from Daniel, a silk weaver, and Mary Ferree, who fled from Alsace in 1685 after the repeal of the Edict of Nantes to Landau on the Queich River in the Rhenish Palatinate and later to Steinweiler, where Daniel died. Mary Ferree left for England with her children in 1708, went on to America in 1709, and settled on acreage she purchased in Lancaster County in 1710. Of French noble birth, Mary was known as Madam Ferree in America. Joel Ferree was the first of seven Ferree family gunsmiths. In 1775 a committee of the Provincial Council resolved that "a messenger be sent to Joel Ferree of Lancaster County . . . requesting him immediately to complete the Guns wrote for as patterns, and to know how many he can furnish of the same kind and at what price."* This .60-caliber smoothbore rifle has its original flint firing mechanism and the early features of a flat butt, wood patch-box lid, and incised carving.

*Quoted in Henry J. Kauffman, *Early American Gunsmiths 1650–1860* (New York, 1952), p. 29.

Plate 10
BOOKPLATE, c. 1800
John Christian Strenge (1758–1828)
Lancaster County
Ink and watercolor on paper; 6¾ x 4⁵⁄₁₆″ (17.1 x 11 cm)
American Antiquarian Society, Worcester, Massachusetts
Checklist 235

John Christian Strenge* was born in Altenhasungen, Hesse-Cassel, in northern Germany. He fought with the Fifth Royal Grenadier Regiment in America against the colonials throughout the Revolution. One of the many Hessians who remained in Pennsylvania, Strenge became a teacher in a Lancaster County union school, so named because it served Mennonite, Lutheran, and Reformed communities. His careful manuscript hand reflects his Old World education, while his distinctive fraktur style, with its bright yellows, orange reds, and ultramarine blues, suggests his familiarity with regional Lancaster styles, especially those of the Mennonites. This bookplate is bound in a New Testament, published by Michael Billmeyer in 1795 in Germantown.

*See David R. Johnson, "Christian Strenge, Fraktur Artist," *Der Reggeboge: The Rainbow. Quarterly of the Pennsylvania German Society*, vol. 13, no. 3 (July 1979), pp. 1–24.

Plate 11
CHEST, 1784
Bern Township, Berks County
Inscribed: Henrich Faust 1784
Pine, painted; height 21⅝″ (54.9 cm)
The Reading Public Museum and Art Gallery, Pennsylvania. 44-132-1
Checklist 75

Henrich (Henry) Faust (1766–1825) was the grandson of emigrant Philip (died 1786) from Hesse in Germany. Born in Bern Township, Berks County, Henrich moved to Northumberland County in 1794; by the time of his death in 1825, Northumberland County had been divided and Faust's lands were in Union County. Included in his extensive inventory were two chests valued at one dollar, slightly less than his silver shoe and knee buckles (a dollar and a half), and the same as a wool wheel.*

A series of chests† and boxes by the unicorn school of joiner-painters—the name derived from the dominant element in their designs—are inscribed with Bern Township family names and date from 1776 to 1803 (*see* pl. 38). Analysis of construction and design divides them among three craftsmen's hands, the first two closely related, possibly from the shop of the Eulors, Adam I (died 1755), Adam II (died 1784), and his son Michael, joiners in Bern Township.

The distinctive designs on these chests may have come into Berks County on fraktur, woven textiles, or printed materials. For example, engravings abounded of the arms of the Bakers' Guild with its paired prancing lions, of the British coat of arms with the famous lion and the unicorn, and of the arms of Pennsylvania with a rampant pair of unharnessed horses. The most strikingly similar treatment can be found on a chest dated 1753 at the Schweizerisches Landesmuseum of Zurich, which was a type commonly made in Val Mustair-Münstertal, Switzerland.‡ It has almost all the motifs found in various combinations on the Berks County group.

*Inventory of Henrich Faust, No. 14, 1825, Union County Courthouse, Lewisburg, Pa.
†See Monroe H. Fabian, *The Pennsylvania-German Decorated Chest* (New York, 1978), pp. 128–35, figs. 84–96.
‡René Creux et al., *Volkskunst in der Schweiz* (Paudex, Switz., 1976), p. 91, fig. 6. The author is indebted to Walter Trachsler, curator, Furniture Department, Schweizerisches Landesmuseum, Zurich, for information on this subject.

Pockets of Settlement

HEIDELBERG, Strasburg, Manheim, and Colmar are names of Pennsylvania towns; so are Goschenhoppen, Conshohocken, and Tulpehocken, as well as Chester, York, and North Wales. Three hundred years after William Penn established his colony, there is clear evidence of the international mix among the people who began his "holy experiment" in 1682. Resettlement for all the colonists and for the Indians was not simple. Documents record the difficulties; objects—architecture, artifacts, and writings—illustrate the solutions.

The continental European settlers had the farthest to travel to Penn's land. Many of their accounts, letters, and journals describe the distressing conditions which had provoked their emigration and the hardships which they had endured on the trip—the journey on the Rhine, the waiting in Holland, and the long, unforeseen stopovers in England, where small reserves often were depleted before final embarkation. If the immigrants survived the trip—and many did not—they still faced the unknown at Philadelphia. The fortunate ones were met by relatives at the dock, their sustenance and shelter thereby assured for the first season; this usually meant that the family could stay together. Others whose money was gone or who had indentured themselves in Europe to pay for their passage entered into service for a number of years. Families thus could become separated, for younger members might be apprenticed or indentured apart from the rest of the family until the age twenty-one. Newspapers throughout the eighteenth century carried advertisements placed by relatives trying to locate kin thus separated. Despite such hardships for individual settlers, the colony of Pennsylvania benefited greatly from the indentured and apprentice labor system, which provided Philadelphia and the countryside with the services and skills of well-trained European craftsmen. And to the Germans' advantage, such economic arrangements must have accelerated the process of acquiring at least a working knowledge of English. The following advertisement from the *Wochentlicher Pennsylvanischer Staatsbote* of April 7, 1772, is not one of the heartrending examples of parents trying to find children. It does demonstrate, though, how the conditions at first settlement spread a wide range of craft skills across Pennsylvania, thus helping to establish very early a productive economy encouraging the development of individual skills, which later would contribute to the climate of American independence: "Henrich Hebener, born in Hanover and now working with Johann Andreas Rohr, locksmith, Second Street, Philadelphia, came to America many years ago with his brothers Georg and Caspar. Georg now lives in Carolina. Information is sought about Caspar, who formerly worked in Richard Wister's glass house in New Jersey (Salem)."[1]

As early as 1663 German Mennonites in numbers had settled in what would become Pennsylvania. However, it was the arrival of Francis Daniel Pastorius, a Frankfurt lawyer, in 1683, which marked the beginning of the first major Germanic migration to America, a movement centered on Pennsylvania. Pastorius landed in August; in October the first group of merchants and weavers, many of whom were Quakers from Krefeld, arrived to begin building the settlement at Germantown. Pastorius's own household was a microcosm of the Germantown to come; it included ten people, among whom were "adherents of the Romish, the Lutheran, the Calvanist (Reformed), the Anabaptist, and the English Churches, and only one Quaker."[2]

The Pennsylvania experiment in general and the Germantown settlement in particular attracted attention in Europe among intellectual, civic, and religious leaders. In 1696 John Kelpius, a member of a Siebenbürgen noble family who was educated at the University of Altdorf, brought with him to Germantown the *horologium achaz*, an astronomical-astrological instrument made in Augsburg in 1578.[3] Adventuresome educated professionals who had been judges, mayors, ministers, and ducal employees came individually. In 1717 the ducal government of Württemberg complained that "even the propertied class, have made the ill-considered and dangerous decision, to leave our Duchy and lands and go to Pennsylvania and Carolina in America."[4] Early Dutch settlers of Germantown like Hendrick Pannebecker and Matthias Van Bebber were educated, multilingual men who owned libraries and who had much in common with their Philadelphia Quaker counterparts like Israel Pemberton, James Logan, and Isaac Norris, and they communicated with one another in German, English, and Latin.[5]

Germantown became the religious, intellectual, and commercial center for the earliest German settlers to Pennsylvania, and the eye of the needle through which many later arrivals passed. Its religious diversity attracted sect leaders; the community had churches or meetinghouses for Mennonites, Presbyterians, Lutherans, Methodists, Reformed, Episcopalians, and Quakers, with Pietist hermits in the surrounding terrain. The first Swiss Mennonites met with other religious leaders at Germantown before returning to Europe to lead one of the largest groups to settlement in Lancaster County. Conrad Beissel left Germantown to meditate in Lancaster County, where he founded the Ephrata Cloister in 1732; residents of Ephrata and Germantown remained in close communication. Moravian leaders, removed from their first American mission in Georgia, stopped off in Germantown in 1736 on their way to establishing what would become Bethlehem and Nazareth. Early Schwenkfelders in Montgomery County like Christopher Wagner, whose daughter owned the 1776 walnut wardrobe (*see* checklist 116), were also closely associated with the Moravians and Lutherans of Germantown.[6]

The early groups and individuals settling in Pennsylvania—German, Dutch, and English alike—retained their contacts with Europe through family ties and business partnerships. These contacts flourished within the worldwide

Quaker network of trade, at the center of which in Holland was Penn's close associate Benjamin Furly. Through Furly and others word of the economic success of Penn's colony and the intellectual vitality and the spirit of accord that blossomed in Germantown sped across Holland and into the rest of Europe. Letters like this of March 1684 from the Swiss immigrant Joris Wertmuller were passed around, adding color to the descriptions in promotional tracts such as those published and distributed by the Frankfort Land Company, whose settlement objectives were handled in Pennsylvania by Pastorius: "The city of Philadelphia covers a great stretch of country, and is growing larger and larger. The houses in the country are better built than those within the city. The land is very productive, and raises all kinds of fruits. All kinds of corn are sown. From a bushel of wheat, it is said, you can get sixty or seventy, so good is the land."[7]

With Pastorius the Pennsylvania agent for the Frankfort Land Company, settlement in the regions north of Germantown was encouraged from the outset; however, many of the settlers became isolated from Germantown and their descendants would become identified with the development of rural Pennsylvania. Pannebecker and Van Bebber are examples of well-to-do settlers who built first in Germantown before moving on to large tracts of land to the north in what would become Montgomery County. Van Bebber's piece had been purchased by his father from Penn in Europe; Pannebecker bought his land directly. In accordance with Penn's requirements, both men promoted settlements and sold off their land to immigrant groups and individuals. Because so many settlers had emigrated as congregations, the tracts purchased by families for homesteads, even if far apart, had a focal center—the church and school.

As well as investors, many of the descendants of early Germantown settlers moved north and west into the agricultural townships. For example, Aarents Klincken was a wealthy burger and friend of Penn who came from Holland and settled in Germantown. His descendant Christian Klinker (checklist 12), a potter-farmer in the mid-eighteenth century, was settled on a Bucks County tract that had been held within the family. Another example is the potter Johannes Neesz (checklist 16), who was the namesake of John Naas (died 1743), an early Germantown resident who purchased and moved to a large tract of land in Frederick Township, Montgomery County, on which he established the family homestead which was held through the nineteenth century. Catharina Rex, owner of a colorfully painted chest (pl. 35), was the daughter of blacksmith and farmer George Rex, a prominent Germantown-born Lutheran who moved to Heidelberg Township, Northampton County, before 1749.

It was generally the rich natural resources of Pennsylvania which determined the settlement and success of the Pennsylvania German communities and were celebrated in early settlers' letters and accounts. The enormous virgin forests must have been amazing to the immigrants who came from the tree-

less valleys and lowlands of the Palatinate and Holland. In a 1684 letter to his parents, Pastorius commented on encountering such woods in his newly laid out Germantown: "I heartily wish for a dozen sturdy Tyrolese to fell the mighty oaks, for whichever way one turns it is *Itur in antiquam sylvam,* everything is forest."[8]

Walnut was the preferred wood for furniture in the late Renaissance style of England and continental Europe at the time of the first migrations, and there was plenty of black walnut in Pennsylvania when settlement began. The abundance of this raw material probably encouraged the continuation of Old World styles and may account for some of the similarities among the furnishings produced in the various early settlements. The varied migratory paths of the different religious groups probably preclude any style attribution to particular national or regional European origins, but the furniture of Philadelphia, Germantown, and Montgomery and Lancaster counties is distinguished for its use of solid walnut which was sometimes inlaid, occasionally carved, and usually fashioned with bold cornice and base moldings. The wardrobes belonging to Lancaster County Mennonites (pls. 1, 103), the tables made at Ephrata and Bethlehem-Nazareth (checklist 103, pl. 19), the wardrobe made in Montgomery County for a Schwenkfelder (checklist 116), the gateleg table (checklist 102) and panel-back side chair (pl. 16) associated with Germantown, and Caspar Wistar's Philadelphia furnishings[9] all are examples of the handsome forms and styles which, although far from their Renaissance origins, bear close resemblance to their contemporary European urban middle-class counterparts. Much of the furniture produced by later migrants, however, lacks even an awareness of these urban continental forms. For example, furniture made in Lancaster after 1770, like the dressing table (pl. 65) and desk and bookcase (pl. 78), reflects the earlier tradition of solid walnut casework but reveals that Philadelphia rather than Europe had become the design source.

Although the earliest objects that can be attributed to Pennsylvania Germans in Germantown were made by or for the second generation, they nevertheless reflect clearly the urbane character of this settlement located in the wilds a brisk two-hour walk from Philadelphia. By 1760, life and the arts in Germantown were indistinguishable from those in Philadelphia, and Germantown continued to develop rapidly until the Revolutionary War. Germantown's influence waned after 1777, however, when Christopher Sauer's Tory sympathies caused his printing press to be confiscated; Lancaster and York became the focal centers for Pennsylvania Germans.

Until the Revolution, the county seats of Lancaster, York, and Reading did not rival the Germantown-Philadelphia area in trade or influence, although these towns became regional centers where markets were held and courts sat. The town of Lancaster flourished, located almost due west of Philadelphia, to which it was connected by a toll road over which wagon traffic rolled. The furnishings produced there reflect the influence of the town's English-Welsh

settlers, with their close Philadelphia connections, and the strong Germanic settlements in the area. Founded and developed by Edward Shippen, a member of a prominent merchant family of Philadelphia, Lancaster enjoyed a prosperous economy due largely to the meticulous farming practiced by the Swiss Mennonites who settled in surrounding townships in 1710 and thereafter. In 1754 Governor Pownall described the land of one such "Switzer" as "the finest farm one can possibly conceive, in the highest culture."[10] Although most Lancaster County settlers were farmers by occupation and therefore somewhat physically removed from urban life, they in fact were not isolated but instead remained deeply concerned with the commercial and religious life that was at the heart of the development of the town of Lancaster. Many Lancaster merchants and most of the neighboring Mennonite farmers grew rich, a fact demonstrated by the large scale of the desks, wardrobes, and cupboards built for the farmers' great stone houses. The Herrs (pl. 103), the Hubers (pl. 1), the Millers (*see* checklist 74), the Witherses (pl. 78), and the Levys (pl. 23) are but a few of those who commissioned local craftsmen to make grand furnishings to commemorate marriages, births, and housebuildings. The wardrobe by John Baughman (pl. 28) with classical details like fluted pilasters suggests this Lancaster County furniture maker's familiarity with architectural traditions possibly learned from a design book, several of which were available in the Juliana Library Company in Lancaster by 1760.

The rural Pennsylvania German communities developed their own style characteristics, and regional attributions of furnishings are often based on inlaid or painted decoration, idiosyncratic construction methods, or a combination of both. Pockets of style and techniques that have emerged include the sulphur inlay of Lancaster County (pls. 1, 103); the unicorn paintings on chests and boxes of Berks County (pls. 11, 38); the frakturlike decoration on boxes and tape looms by John Drissell of Bucks County (pl. 33); the symmetrically designed, flowered chest panels by Christian Seltzer (checklist 81) and John Ranck (pl. 66) of Lebanon County; and the stencillike, spriggy decoration of the Schwaben Creek Valley in Northumberland County (pl. 36).

Painted decoration on furniture had been used in Gothic Europe, probably as a substitute for intricate metal- and leatherwork. By the late eighteenth and early nineteenth centuries elaborately painted surfaces had become a standard feature of rural European furnishings, which was part of the crafts heritage brought to Pennsylvania. Such furniture in both Europe and Pennsylvania usually was made of a softwood, in Pennsylvania chiefly pine or poplar. The related decorative technique of sponging and feathering a dark color over a lighter ground to produce a grained effect was used especially on eighteenth-century Alsatian furniture;[11] similar colors and techniques can be seen on furniture made in some regions of Berks, Lehigh, and Northampton counties, which were settled by French Huguenots, and in areas of Bucks County where Dutch Huguenots from Esopus, New York, had moved. The Bladt chest (pl. 38), the Bieber wardrobe (pl. 27), and the Kern chest (*see* check-

list 77) all show examples of this painting technique.

Precedents for regional Pennsylvania designs such as the prancing beasts seen on Berks County chests (pls. 11, 38) and many of the motifs on sgraffito-decorated pottery by David Spinner (pl. 85) are found easily on European woven textiles, but there are also close prototypes in furniture and pottery from areas of Switzerland from which the families of the makers of such objects originated. Attributions to specific shops or craftsmen sometimes may be worked out by combining genealogical data and evidence of design origins with regional characteristics. Joiners like John Bieber (pl. 27) or Peter Holl III (pl. 1) are the most difficult craftsmen to trace. They built everything from great barns to coffins and cradles. The more specialized craftsmen like Lebanon gunsmith John Philip Beck (pl. 22) worked in a single location where he extended his influence through his apprentices like Nicholas Beyer (checklist 164), thus creating a regional gun style. On the other hand, woodworkers moved about, shared their skills, and worked in teams. And whereas English objects often were labeled for their maker, Pennsylvania German products usually were marked for the owner, further adding to the difficulty of attribution. The vitality and characteristics of a region and its social and economic stability probably were determined as much by the quality and quantity of the natural resources as by the characteristics of church membership—the initial center of group dynamics. Decorative pottery making throve particularly in the Bucks County townships of Haycock, Rockhill, and Hilltown, where rich clay deposits abounded. Style and design similarities and differences can be explained by analyzing the products and organization of regional potteries. Overlapping apprenticeships, outright copying of designs, traveling journeymen, and local popularity of a certain design or shape all contributed to the personality of the wares of a pottery. Imported pewter and ceramics probably inspired form and decoration. European-trained journeymen may have both added forms and designs and blurred the edges of local style definitions by moving to and working at several potteries. But the Pennsylvania Germans added their own imaginative fillips which are now called a "style" or regional characteristic.

The papers and diaries of important early Pennsylvania German Philadelphians like Stephen Benezet from Abbeville, France, and Jacob Hiltzheimer from Mannheim in Germany, and of European travelers in Pennsylvania confirm that there was a great deal of communication between rural and urban Pennsylvania Germans. This was accomplished through traveling and visiting, family ties, and letters and newspapers. Benezet's daughters married Moravians and one lived at Bethlehem; entries in the Hiltzheimer diary show a horse trader moving easily from his Philadelphia obligations—"in forenoon went with Stoffel Reigart on board a dutch Ship, to see my Kindsman Christian Nerber"[12]—to sociable sporting events with his English friends in Allentown. Rural settlers also maintained their contacts among other country dwellers, for although settlers were spread throughout the countryside on

their homesteads, they visited, read newspapers, and attended public meetings. La Rochefoucauld-Liancourt commented on this while traveling in Pennsylvania in 1795: "There is a printer in Reading who publishes a German Gazette weekly; the price is a dollar a year. The sale extends as far as Pittsburg, . . . Every one here . . . takes an interest in state affairs, is extremely eager to learn the news of the day, and discusses politics as well as he is able."[13]

Another instrument promoting such communication between Pennsylvania Germans was Christopher Saur's German-language press and newspaper (pls. 14, 15, checklist 236), which was well located in Germantown for the collecting of travelers' accounts, foreign news, and notices of ships' arrivals and departures. He also printed notices of lost family members and land sales. Printers were active also in most other towns publishing newspapers and almanacs (pls. 63, 99).

Roads were other important links between pockets of settlement, and those who traveled them frequently carrying the latest news, like itinerant ministers and business travelers, strengthened the ties between communities as they spread their interpretations of scriptures or news across the territory. Pennsylvania Germans like John Drissell (see pl. 33) signed petitions for roads to promote and facilitate travel and communication; such passageways became a vital network for Germans and English alike. The Great Road, the Lancaster Turnpike, went west from Market Street in Philadelphia, and became the artery over which the commodious Conestoga wagons rumbled night and day, carrying the rich grain exports that supported Philadelphia's leg of the triangle trade between the West Indies and England. News, produce, people, and ideas all traveled these routes. This intercourse, especially between the urban centers, fostered a homogeneity that is reflected in the arts of the English and German settlers. The bold turnings on the legs and stretchers of Germantown furniture such as the gateleg table (checklist 102) and the panelback side chair (pl. 16) are similar to the English and Welsh settlers' interpretations of continental, especially Dutch, prototypes. The walnut case that houses Augustin Neisser, Jr.'s tall case clock (checklist 107), probably made in Germantown, lies distinctly within an English tradition. John Meng's self-portrait (checklist 178) exactly follows the style of contemporary provincial English portraits in showing a prosperous young man, here the son of a Germantown first settler from Mannheim, Germany, in a stiffly formal pose against the ubiquitous romantic landscape.

Social and economic contacts between regional Pennsylvania German groups and settlements prospered within the mercantile system of the colony as a whole, which absorbed the cadences of dialects, earnest pragmatism, superb production, and intellectual capacities of the earliest Germanic immigrants. A similar yet somewhat different sort of blending took place for the thousands who migrated from eastern to western counties after the Revolutionary War and for many of the central Europeans who came to Pennsylvania after 1812.[14] They had in common with earlier settlers the goal of farm-

ing unsettled lands and establishing themselves in communities with church at their center. However, certain factors combined to dilute the eastern form of Pennsylvania German identity in the western settlements. Southeastern Pennsylvania communities were often bypassed or simply passed through on the way to western lands. The Erie Canal opened up western Pennsylvania to emigrants from New England and New York. Weaver Adam Hoerr (pl. 30) from New York, for example, carried Old World tradition, design, and techniques into the western counties. Hoerr worked on a wide loom, a type that had been used in New York State for ten years before appearing in eastern Pennsylvania—an instance of new technology moving into western Pennsylvania via the Erie Canal, thus bypassing eastern Pennsylvania. The Cumberland National Road stretched across Pennsylvania from Maryland to Ohio by 1818, opening up the west to Virginia and Maryland settlers, German and English. Albert Gallatin's (pl. 42) glassworkers probably traveled this road on their way to Fayette County.[15] The Harmonist group from Württemberg, Germany, led by George Rapp to Butler County in 1805, moved directly west after arrival in Pennsylvania and concentrated their creative energies on large-scale manufacturing enterprises (pl. 41, checklist 315–17) rather than on traditional crafts. Individuals who moved west, specialists and schoolmasters like Carl Scheibeler (pl. 40) who traveled about and painted fraktur, did continue that important traditional form of record keeping. But the colorful skills which had flourished in the eastern communities were not strengthened through successive infusions of Germanic migrations to the west, where the Pennsylvania German settlements were spread out and interspersed with those of the English and Scotch-Irish, thus isolating the Germans even more from the traditional forms of community organization.

Developing industrialism, including mass production, and the vast distances between western villages and even homesteads because of soil conditions further caused the realignment of communities as they became political constituencies within the new United States. That vital impetus of adventurous, pragmatic individualism which had been the spine and strength of the spirit in the pockets of settlement in eastern Pennsylvania was spent after the Revolutionary War; in the westward migration, the particularly Germanic individualism evident in the seventeenth- and eighteenth-century eastern settlements was dissipated and dispersed as a result of the breaking of home ties and the resulting regrouping. Henry Shellenberger, who made the desk and bookcase (pl. 39) in Fayette County, used methods outside the traditions of Germanic joinery; the blanket attributed to Regina Whitner Rarig of Roaring Creek in Columbia County (checklist 270) was woven in a pattern closer to a Scotch-Irish plaid than to a Pennsylvania German check or coverlet design. Both objects demonstrate the increasing remoteness of Old World origins. The distinctly Germanic forms, designs, and methods of manufacture which had reflected so colorfully that Pennsylvania Germans had valued their Euro-

pean roots in the early eastern settlements were blended into the mix of the greater, more heterogeneous community of post-Revolutionary America. Significantly, the new settlements in western Pennsylvania were not named Heidelberg, Manheim, or Colmar, but rather Franklin, Washington, and Uniontown.

1. Quoted in Edward W. Hocker, *Genealogical Data Relating to the German Settlers of Pennsylvania and Adjacent Territory. From Advertisements in German Newspapers Published in Philadelphia and Germantown, 1743–1800* (Baltimore, 1980), p. 113.

2. Quoted in Henry S. Dotterer, "The Church at Market Square," *Historical Notes Relating to the Pennsylvania Reformed Church*, vol. 1, no. 2 (June 10, 1899), p. 23.

3. *See* Louis Winkler, "Pennsylvania German Astronomy and Astrology x: Christopher Witt's Device," *Pennsylvania Folklife*, vol. 24, no. 2 (Winter 1974–75), pp. 36–39. The *horologium achaz* is in the American Philosophical Society, Philadelphia.

4. Quoted in Don Yoder, ed., *Pennsylvania German Immigrants, 1709–1786: Lists Consolidated from Yearbooks of the Pennsylvania German Folklore Society* (Baltimore, 1980), p. 8.

5. *See* Samuel Whitaker Pennypacker, "Bebber's Township and the Dutch Patroons of Pennsylvania," *The Pennsylvania Magazine of History and Biography*, vol. 31, no. 1 (1907), pp. 1–18.

6. *See* John W. Jordan, "John Bechtel: His Contributions to Literature, and His Descendants," *The Pennsylvania Magazine of History and Biography*, vol. 19, no. 2 (1895), pp. 137–48.

7. Quoted in Samuel Whitaker Pennypacker, *The Settlement of Germantown, Pennsylvania and the Beginning of German Emigration to North America* (Philadelphia, 1899), p. 100.

8. Quoted in Dotterer, "The Church at Market Square," p. 23.

9. *See* Philadelphia, Philadelphia Museum of Art, *Philadelphia: Three Centuries of American Art* (April 11–October 10, 1976), pp. 25–27, no. 22.

10. Quoted in P. H. Gibbons, *"Pennsylvania Dutch," and Other Essays* (Philadelphia, 1872), p. 102.

11. *See* Georges Klein, *Arts et traditions populaires d'Alsace: La Maison rurale et l'artisanat d'autrefois* (Colmar, 1973), pp. 85–109.

12. Quoted in Henry S. Dotterer, "Jacob Hiltzheimer's Diary," *Historical Notes Relating to the Pennsylvania Reformed Church*, vol. 1, no. 2 (June 10, 1899), p. 22.

13. Quoted in J. Bennett Nolan, *Early Narratives of Berks County* (Reading, 1927), p. 144.

14. *See* Homer T. Rosenberger, "Migrations of the Pennsylvania Germans to Western Pennsylvania," *The Western Pennsylvania Historical Magazine*, pt. 1, vol. 53, no. 4 (October 1970), pp. 319–35; pt. 2, vol. 54, no. 1 (January 1971), pp. 58–76.

15. *See* James Veech, *The Monongahela of Old: Or, Historical Sketches of South-Western Pennsylvania to the Year 1800* (Pittsburgh, 1858–92), pp. 166–77.

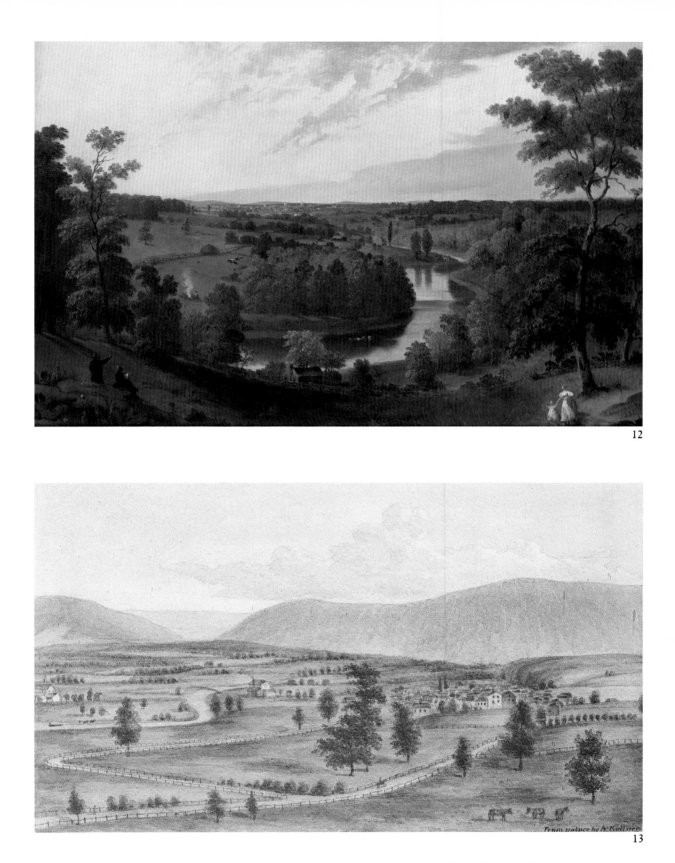

12

13

12 Germanic settlers spread across the
Pennsylvania countryside from Germantown
to Allegheny County in the west. Lancaster
County's rich farmland, watered by the
Conestoga Creek, was depicted by Jacob
Eichholtz in 1833 (Pennsylvania Academy
of the Fine Arts, Philadelphia)

13 The village of Hamburg, at the base of
the Blue Mountains, was represented by
Augustus Koellner in 1840 (Collection
Richard S. and Rosemarie B. Machmer)

14, 15 On his Germantown printing press, Christopher Saur printed a hymnal for the choir at Ephrata Cloister in 1739 (Collection Don Yoder) and the German-language Bible in 1743 (Juniata College, Huntingdon, Pennsylvania)

16, 17 Provenance traces this turned side chair of 1730–40 to Germantown (Winterthur Museum) and the plank-seat chair of 1750–80 to Bethlehem (Private Collection)

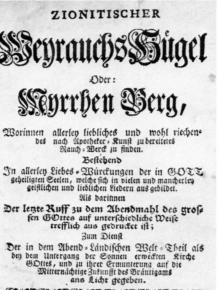

14

15

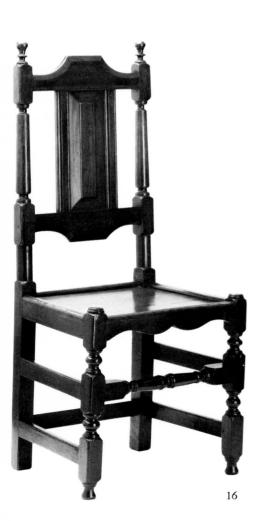

16

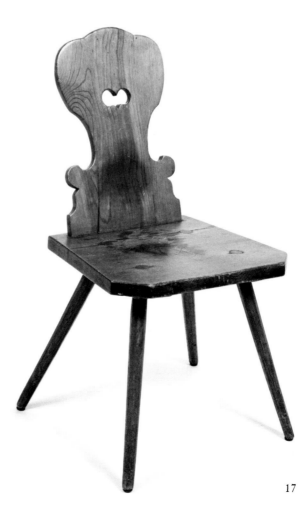

17

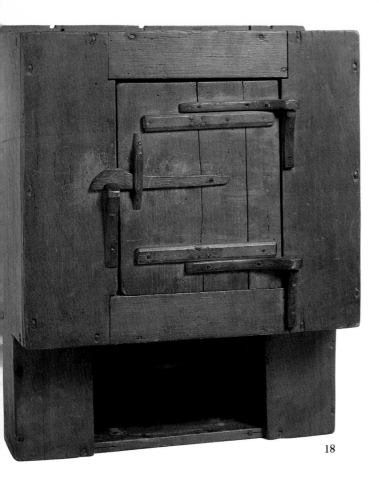

18

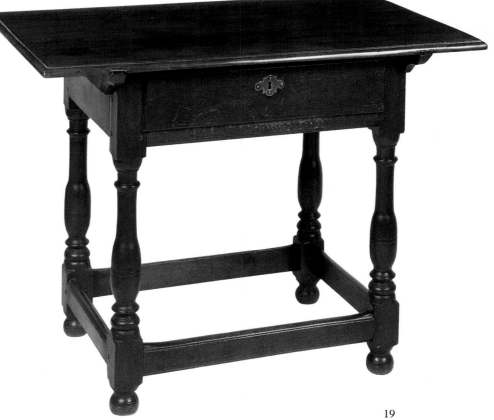

18 The religious community of Ephrata in
Lancaster County furnished its monastic
rooms with such plain objects as this wall
cupboard of 1750–60 (Philadelphia Museum
of Art)

19 Moravian communities used small, neatly
made tables with turned legs like this one of
1740–60 (The Moravian Archives, Bethlehem,
Pennsylvania)

19

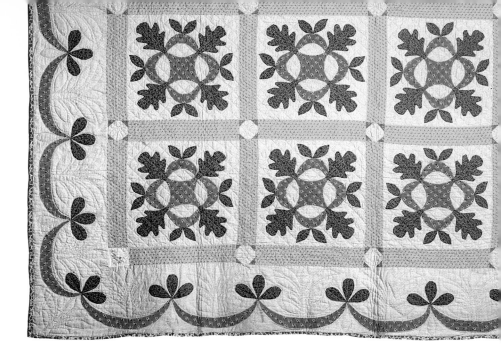

20 Frances Wenger of Lancaster County appliquéd this colorful quilt, which she signed and dated August 26, 1848 (Private Collection)

21 The Sussel-Washington Artist of Berks County painted this baptismal wish for Stovel Emrich, who was born in 1771 (Winterthur Museum)

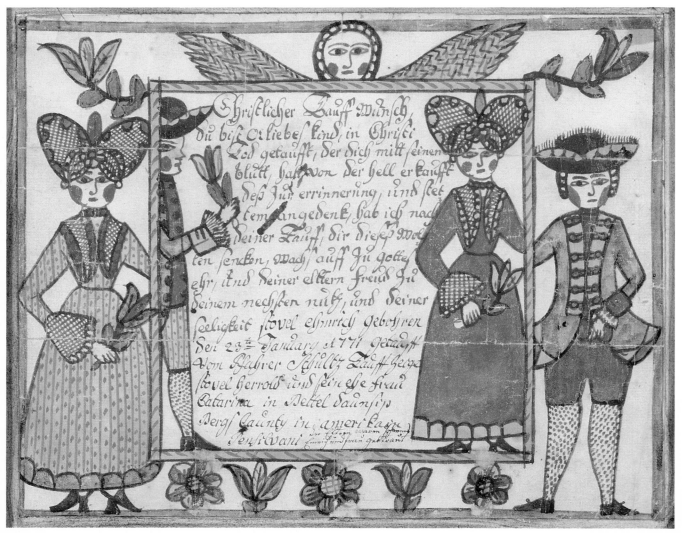

21

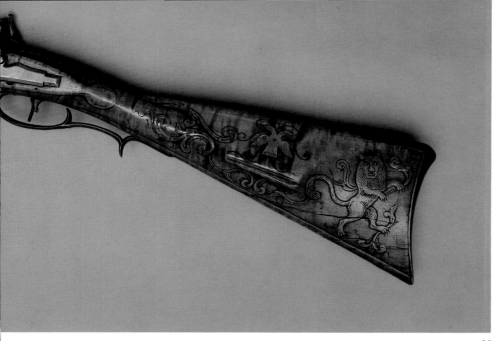

22 Lebanon's renown as a riflemaking center was due in great part to the expertise of John Philip Beck (1752–1811), the maker of this .52-caliber rifle (Private Collection)

23 Peter Getz, prominent German silversmith of Lancaster, made this tureen with chased, cast, and engraved ornamentation about 1790 (Wadsworth Atheneum, Hartford, Connecticut)

22

23

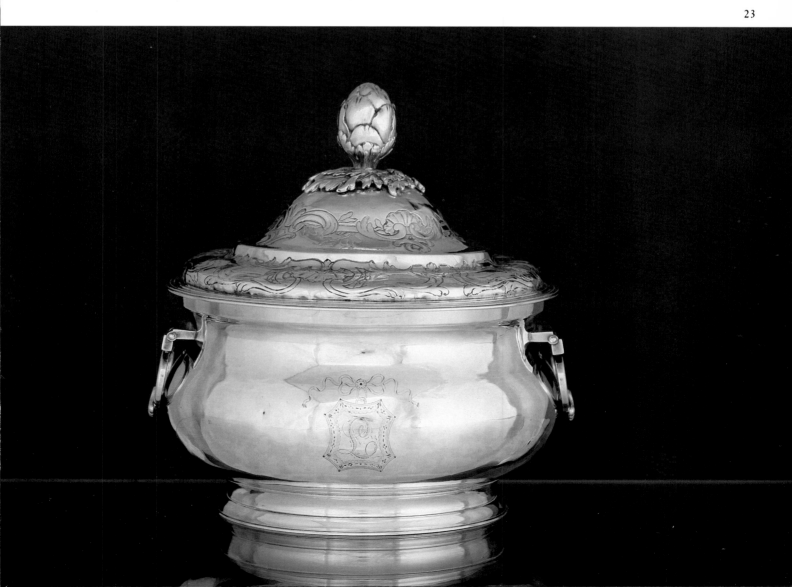

Elisa Adam,
[Tochter von Friderich Adam und seiner Ehefrau Elisa eine geborne Weber] wurde geboren in Warwick Taunschip Lancaster County im Staat Pennsylvanien, den 11ten tag July 1832, und getauft worden den 29ten tag September 1833, von Wm. Bätis. Taufzeugen die Eltern.

24 The Lancaster County illuminator known
as the Mount Pleasant Artist recorded the
birth on July 11, 1832, and the baptism on
September 29, 1833, of Elisa Adam of
Warwick Township (Franklin and Marshall
College, Lancaster)

25 The Lebanon clockmaker Jacob Graff
made this eight-day tall clock about 1735–50
(Winterthur Museum)

26 The York clockmaker John Fisher made
this clock with a 35-day movement, astro-
nomical dial, and planispheric map, in 1790
(Yale University Art Gallery, New Haven)

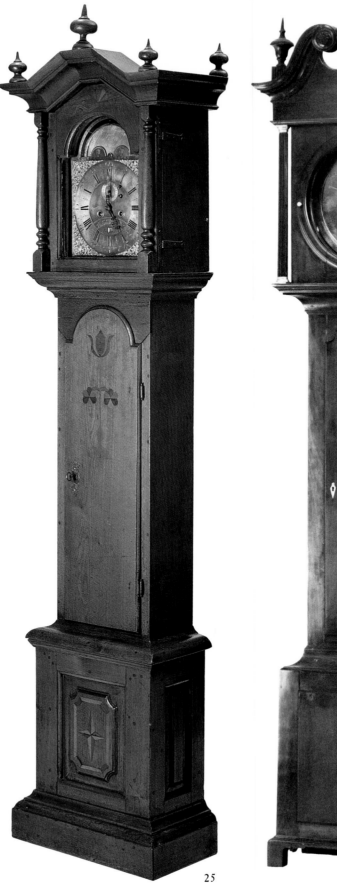

25

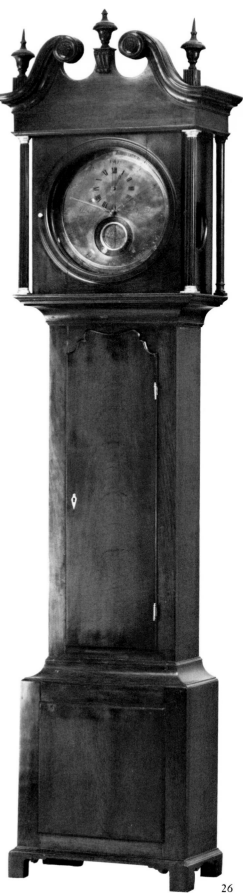

26

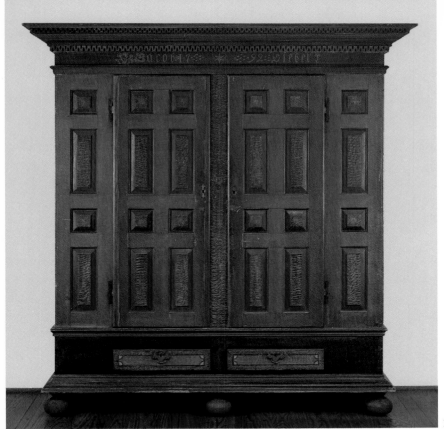

27 John Bieber probably built this sponge-painted wardrobe for his brother Jacob, of Berks County, in 1792 (Private Collection)

28 In his Conestoga Township joinery shop about 1790–1800, John Baughman produced this wardrobe featuring architectural design elements (Collection Dr. and Mrs. Donald M. Herr)

29 A Bucks County weaver wove this rare example of a child's coverlet in 1839 (Collection Mr. and Mrs. Paul R. Flack)

30 Adam Hoerr, working in western Pennsylvania, used a wide-width Jacquard loom to weave this unseamed coverlet in 1848 (Pennsylvania Historical and Museum Commission)

31 In northern Lancaster County, Meri Weinholt embroidered this hand towel with bold cross stitches in 1839 (Collection Dr. and Mrs. Donald M. Herr)

27

28

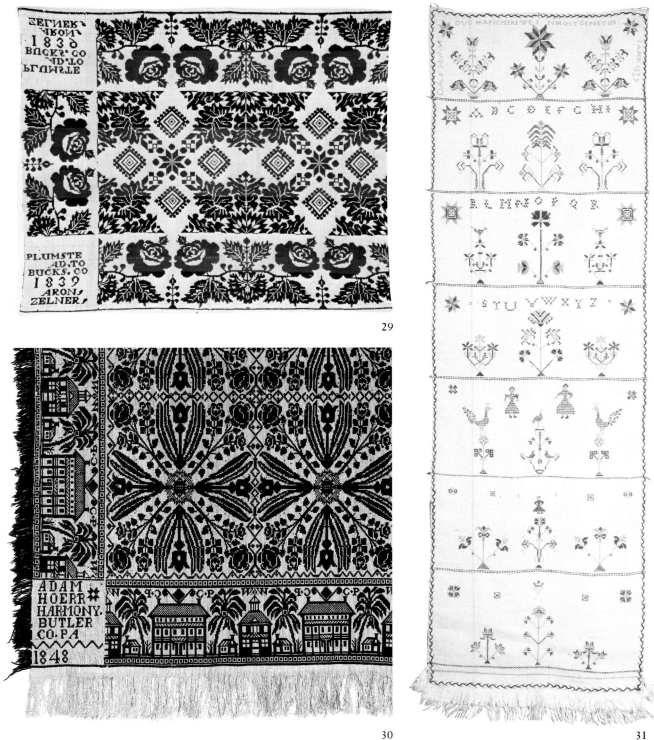

29

30

31

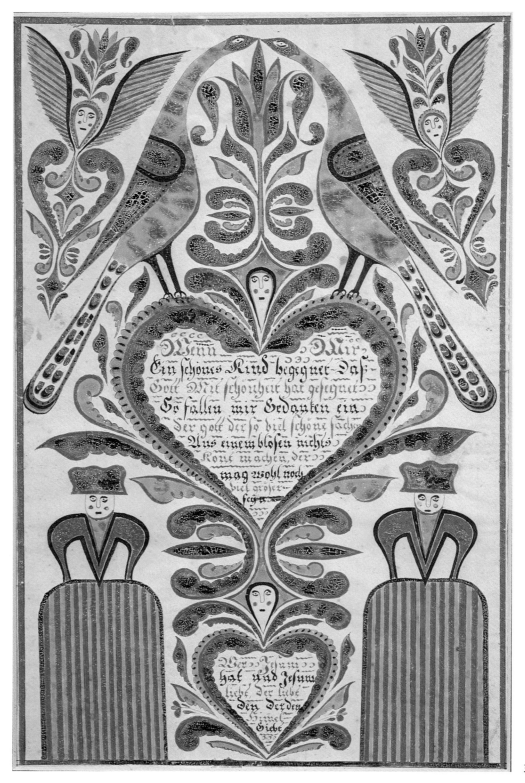

32

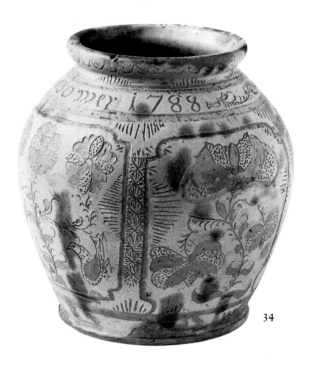

34

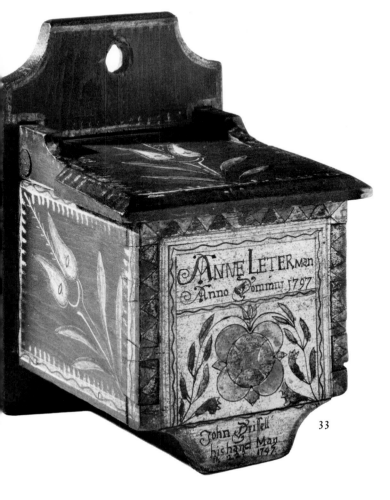

33

32 This religious text with its brilliant colors and stylized figures was probably illuminated by Martin Gottshall of Montgomery County about 1835–45 (Private Collection)

33 John Drissell of Bucks County painted this salt box, dated 1797, with multicolored designs and hand lettering that resemble local fraktur work (Winterthur Museum)

34 The Berks County potter Philip Sussholtz decorated his earthenware jar with sgraffito designs in 1788 (Winterthur Museum)

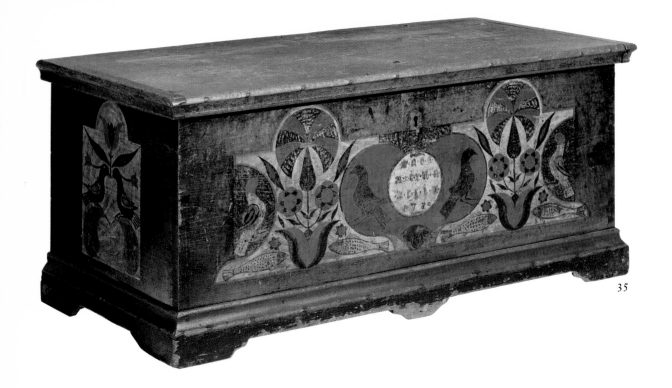

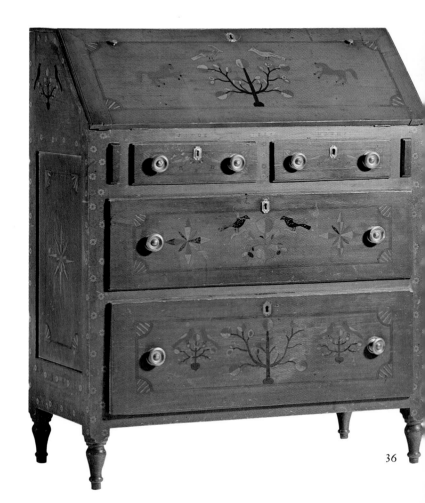

35 The name of Cadarina Rexin (Catharina Rex) of Northampton (Lehigh) County and the date 1780 are inscribed on this painted chest (Collection Richard S. and Rosemarie B. Machmer)

36 The small Pennsylvania German community nestled in the Schwaben Creek Valley of Northumberland County is associated with furniture decorated with the brilliantly colored designs seen on this pine desk dated 1834 (Winterthur Museum)

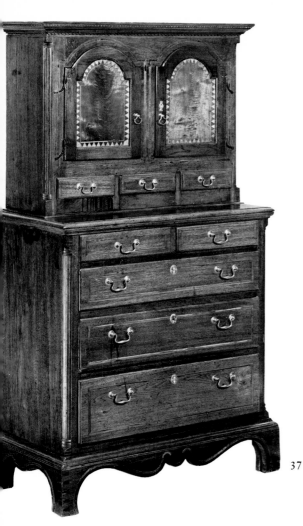

37

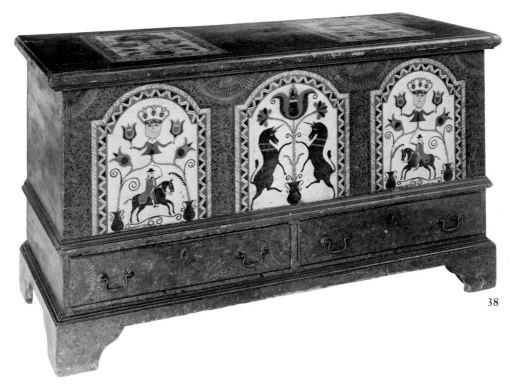

38

37 The cupboard over drawers, such as this wood-inlaid Berks County example of 1780–1800, is an unusual Pennsylvania German form (Collection Mr. and Mrs. Robert L. Raley)

38 Typical Berks County finesse and detailed joinery methods are demonstrated in this traditional painted chest of 1803 (Philadelphia Museum of Art)

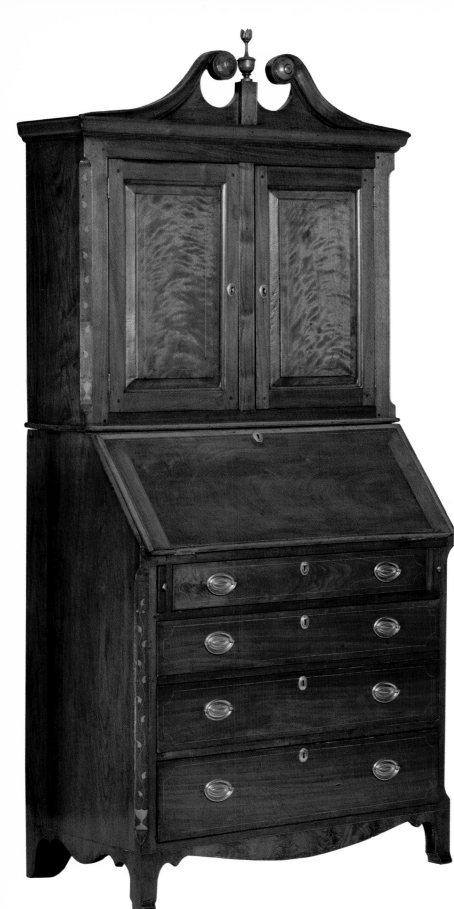

39 This Fayette County desk of 1826, held together by nails, not wedged dovetails, is the work of a western Pennsylvania joiner relinquishing Germanic construction techniques (Museum of Art, Carnegie Institute, Pittsburgh)

40 Carl Scheibeler, schoolmaster in Westmoreland County, embellished the Gothic script of this birth and baptismal certificate with calligraphic flourishes in 1789 (The Westmoreland County Museum of Art, Greensburg, Pennsylvania)

41 The Economy Hotel, seen here in an architectural drawing of 1834, stood at the center of the Harmonists' town established in Beaver County (Pennsylvania Historical and Museum Commission)

39

40

41

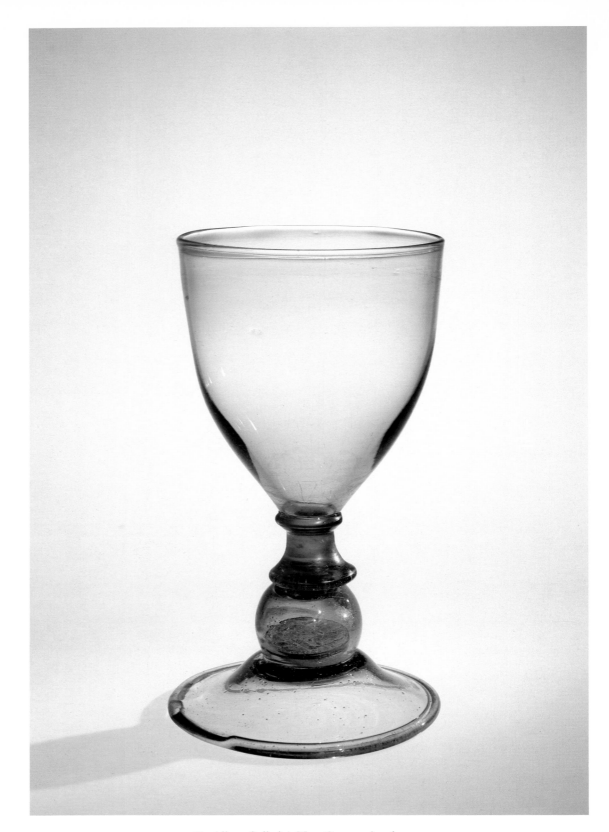

42 Albert Gallatin's New Geneva glass factory in Fayette County, founded in 1797, produced this presentation goblet, enclosing his silver medal from the University of Geneva in its stem (The Corning Museum of Glass, Corning, New York)

Plate 12

CONESTOGA CREEK AND LANCASTER, 1833
Jacob Eichholtz (1776–1842)
Lancaster, Lancaster County
Inscribed: J. Eichholtz 1833
Oil on canvas; 18 x 30″ (45.7 x 76.2 cm)
The Pennsylvania Academy of the Fine Arts, Philadelphia.
 Presented by Mrs. James H. Beal. 1961.8.10
Checklist 183

Lancaster County is well watered, and the Conestoga Creek, which winds tortuously across the county from the river of the same name through Earl Township, through the borough of Lancaster, and into Pequea, Manor, and Conestoga townships on its way to the Susquehanna River, is one of the most important water sources. This view of the creek's valley with the town of Lancaster in the distance was done from the south or east in afternoon light. Worked fields alternate with wooded lots, and the grazing lands bordering the creek are fenced with posts with four rails. The most desirable grazing land included such waterways, for they made water available, thus eliminating the need to carry water from a well; served as passageways for small boats traveling to distant markets; and often refreshed the deep topsoil of the valley with new soil in spring floods.

Jacob Eichholtz painted the Conestoga Creek and the surrounding countryside dotted with one-story yeomen's houses with no outbuildings, chimneyed stone houses with windowless gables in the central European manner, and an indeterminate cluster of buildings in the distance—Lancaster. There is some nostalgia in Eichholtz's treatment, but the general character and the bigness of the Lancaster County landscape are accurately caught.

Plate 13

VIEW OF HAMBURG, PENNSYLVANIA, c. 1840
Augustus Koellner (1813–1906)
Hamburg, Windsor Township, Berks County
Inscribed: From nature by A. Kollner.
Watercolor on paper; 6⅝ x 11″ (16.8 x 27.9 cm)
Richard S. and Rosemarie B. Machmer
Checklist 188

"Hamburg is a considerable village on the east bank of the Schuylkill river. It contains between ninety and one hundred dwellings: several stores, taverns, and one church: population nearly six hundred. There is a bridge over the Schuylkill here. Considerable improvement has lately been made on the country around this town. Some of the land has been rendered highly productive. This shows what can be done by proper culture."*

Augustus Koellner's view of Hamburg, painted about the same time as the above description was written, shows the town from the east set against the Blue Mountains. Originally one tract of land owned by Martin Kaercher, Sr., it was settled by Martin, Jr., who laid out the town in 1779. As in other inland Pennsylvania towns, the canal system and later the railroads spurred Hamburg's development over the rolling fields seen in this painting.

Koellner was born in Düsseldorf, Germany.† Trained in lithography in Europe, he immigrated to the United States in 1839 and later went to work for the Philadelphia printing house of Huddy

and Duval. Some of his American views were printed by Goupil, Vibert and Company of New York and Paris between 1848 and 1851.

*I. Daniel Rupp, *History of the Counties of Berks and Lebanon* (Lancaster, Pa., 1844), p. 252.
†*See* Nicholas B. Wainwright, "Augustus Kollner, Artist," *The Pennsylvania Magazine of History and Biography*, vol. 84, no. 3 (July 1960), pp. 325–51.

Plate 14

TITLE PAGE OF "ZIONITISCHER WEYRAUCHS-
 HUGEL," 1739
Christopher Saur (1694–1758), publisher
Germantown
Letterpress; 6½ x 4¼″ (16.5 x 10.8 cm) (book)
Don Yoder Collection
Checklist 237

Plate 15

TITLE PAGE OF "BIBLIA, DAS IST: DIE HEILIGE
 SCHRIFT ALTES UND NEUES TESTAMENTS,"
 1743
Christopher Saur (1694–1758), publisher
Germantown
Letterpress; 9¹⁵⁄₁₆ x 8″ (25.2 x 20.3 cm) (book)
Juniata College, Huntingdon, Pennsylvania
Checklist 238

There were close social and economic ties between Germantown and Ephrata in the first and second generations of settlement. Conrad Beissel, a baker from Germany, reapprenticed as a weaver in Germantown, then set out for a life of contemplation in Lancaster County, where he founded the Ephrata community in 1732. Beissel's friend and fellow immigrant Christopher Saur,* a journeyman tailor in Germany, settled first in Lancaster County. After his wife left his household to join Ephrata, he moved to Germantown where he worked as a wheelwright, carpenter, clockmaker, and general mechanic.

Beissel's desire for a German printer in Pennsylvania to publish his writings intensified Saur's efforts in the 1730s to begin such an enterprise. Lacking the capital to bring complete printing materials from Europe, he was able to import type, and may have made the press himself. Benjamin Franklin, however, controlled the paper supply and refused to give "credit to the Dutch."† Conrad Weiser came to Saur's aid, and in 1739 Saur published this hymnal and a separate volume of choir tunes for Ephrata in an edition of fifteen hundred. The Bible, the first printed in America, was a major achievement for Saur and for the Ephrata mill that produced the quarto-sized paper for an edition of twelve hundred.

See Julius Friedrich Sachse, *The German Sectarians of Pennsylvania 1708–1742: A Critical and Legendary History of the Ephrata Cloister and the Dunkers* (Philadelphia, 1899), pp. 312–49.
†Quoted in *ibid.*, p. 320.

Plate 16
SIDE CHAIR, 1730–40
Germantown
Walnut; height 43¾" (111.1 cm)
Winterthur Museum. 66.698
Checklist 65

Plate 17
PLANK-SEAT CHAIR, 1750–80
Bethlehem
Inscribed: SBD
Pine, chestnut, oak; height 33" (83.8 cm)
Private Collection
Checklist 67

There was a lot of traffic between Germantown and Bethlehem. For example, Moravians like Augustin Neisser, Jr. (checklist 107), lived in Germantown and worked in both places. Another craftsman with ties to both communities was the turner John Bechtel (1690–1777),* who might well have made this panel-back side chair, with its crisp, symmetrically turned members, for his Germantown neighbor, the prosperous tanner Bernard Reser (died 1761). Bechtel, who had apprenticed in Heidelberg, Germany, settled in Germantown in 1726, where he became a preacher in the Reformed church. Daily services and meetings were held in his house. Along with other prominent religious leaders, Bechtel was deeply concerned about the lack of an organized ministry in Pennsylvania, and traveled about meeting with different sects to try to join them together "for the purpose of promoting mutual love and forebearance."† In 1742 he was ordained Moravian; in 1749 he gave his Germantown property to the Moravians to set up a school and moved to Bethlehem. Thus could occur the movement of style from one center to another.

The plank-seat chair, a simpler type of seating, was a traditional, pragmatic form made in Slavic regions like Moravia and all over Germany, Switzerland, and Alsace. In southeastern Pennsylvania, where provenance places most American examples, the form was known as a *Brettstuhl,* or "board stool,"‡ and was differentiated from other seating furniture on an inventory list as "a Stool with a Back."§

*See John W. Jordan, "John Bechtel: His Contributions to Literature, and His Descendants," *The Pennsylvania Magazine of History and Biography,* vol. 19, no. 2 (1895), pp. 137–51.
†Quoted in *ibid.,* p. 138.
‡Benno M. Forman, "German Influences in Pennsylvania Furniture," in Scott T. Swank et al., *Arts of the Pennsylvania Germans at Winterthur,* forthcoming.
§"Last Will and Testament of David Longacre," *The Perkiomen Region,* vol. 13, no. 1 (January 1935), p. 43.

Plate 18
HANGING WALL CUPBOARD, 1750–60
Ephrata, Lancaster County
Poplar, pine, walnut; height 25³⁄₁₆" (64 cm)

Philadelphia Museum of Art. Gift of J. Stogdell Stokes. 28-10-97
Checklist 87

Ephrata was a Pietist community of celibate "brothers" and "sisters." Each room, or cell, at the cloister had a bed, table, chair or bench, and a small wall cupboard such as this. Made of poplar and pine with carved walnut pintle hinges and lift latch, and wrought iron nails, this cupboard clearly manifests the pietistic emphasis on creating ascetic surroundings. The community's motto, *Arbeite und Hoffe* ("work and hope"), expresses the energy generated by the Germanic work ethic combined with the religious fervor that made Ephrata a productive early settlement.

The Ephrata woodworkers were atypical in using wrought nails instead of wedged dovetails for joinery. Making nails was a tedious task, usually a smith's sideline, but Ephrata had a complete nailery supplying their community and the surrounding area, an unusual degree of specialization within their communal philosophy. Ephrata's skills in papermaking and book printing and binding also kept the community in close touch with other Germans, such as the Saur family of printers in Germantown.

Ephrata ran a school for the local community, and as an educational center dispersed elegant illuminations throughout the countryside, which seem to have served as models for several decorative mediums.* The designs on the Huber wardrobe (pl. 1) and on chests attributed to John Ranck (pl. 66) and Christian Seltzer (checklist 81) exhibit this influence.†

*See Julius Friedrich Sachse, *The German Sectarians of Pennsylvania 1708–1742: A Critical and Legendary History of the Ephrata Cloister and the Dunkers* (Philadelphia, 1899), frontispiece, repro. opp. p. 71, repro. pp. 74, 350.
†See also Jean Lipman and Eve Meulendyke, *American Folk Decoration* (New York, 1951), p. 30, figs. 10–11.

Plate 19
SIDE TABLE, 1740–60
Nazareth or Bethlehem, Northampton County
Walnut, tulip, ash or oak; height 28½" (72.4 cm)
The Moravian Archives, Bethlehem, Pennsylvania
Checklist 101

The Moravian crafts community at Bethlehem was highly organized, with furniture craftsmen like John Bechtel (*see* pl. 16) and the probable owner of this table, David Zeisberger, working more independently in their own woodworking shops. Small, neatly made tables like this, with a distinctive leg turning pattern—an elongated vase shape with a rounded ring near the top—have been found in Moravian communities at Nazareth, Bethlehem, and Lititz, Pennsylvania, and at Winston-Salem, North Carolina. These tables have certain common construction details: tops pegged to frames through two keyed, dovetailed battens; frames molded on the four bottom sides; and drawers constructed with wedged dovetails. This similarity of joinery can probably be explained by the constant interchange of people among the various Moravian communities.* If these tables were not so closely identified with the Moravians, they are enough alike to be attributed to a single shop. Their design may have to do with a specific use not yet known.

*See John Bivins, Jr., *The Moravian Potters in North Carolina* (Chapel Hill, N.C., 1972), pp. 15–72; Kenneth G. Hamilton, ed.

and trans., *The Bethlehem Diary*, vol. 1, *1742–1744* (Bethlehem, Pa., 1971); and J. Taylor Hamilton and Kenneth G. Hamilton, *History of the Moravian Church: The Renewed Unitas Fratrum 1722–1957* (Bethlehem, Pa., 1967), pp. 82–93, 132–45.

Plate 20

QUILT, 1848
Frances Wenger
Lancaster County
Inscribed: Frances Wenger August TH 26 1848
Cotton; width 89" (226.1 cm)
Private Collection
Checklist 295

This colorful, precisely patterned, appliquéd quilt signed and dated by its maker, Frances Wenger, is a rare document of the quilting art before 1850; dated Pennsylvania German quilts suggest that woven coverlets were the most popular bedcoverings until 1845. This quilt is made of pieces of printed plain-weave cotton appliquéd in the "oak leaf" and "orange slices," or "reel," patterns.* The latter was used alone in a late eighteenth-century quilt that has descended in a New York Dutch family;† the "oak leaf" is thought to be of New England origin.‡ These two patterns were used together with variations in several eastern regions of the United States.§ The Wengers were early settlers of eastern Lancaster County.

*For another example, *see* Lilian Baker Carlisle, *Pieced Work and Applique Quilts at Shelburne Museum*, Museum Pamphlet Series, no. 2 (Shelburne, Vt., 1957), repro. p. 70.

†*Ibid.*, repro. p. 15; *see also* repro. p. 35.

‡*See* Carrie A. Hall and Rose G. Kretsinger, *The Romance of the Patchwork Quilt in America* (Caldwell, Idaho, 1947), p. 119, pl. XXXIII, no. 16; p. 155, pl. XXIII.

§*See* Editors of McCall's, *Heirloom Quilts* (New York, 1974), repro. p. 32.

Plate 21

BAPTISMAL WISH FOR STOVEL EMRICH, 1771–80
The Sussel-Washington Artist
Bethel Township, Berks County
Ink and watercolor on paper; 10⅝ x 12¹⁄₁₆" (27 x 30.6 cm) (sight)
Winterthur Museum. 58.120.15
Checklist 207

The Sussel-Washington Artist may have been Swiss. The design organization of several fraktur clearly in his style is unmistakably related to engraved-glass house blessings made in Switzerland to hang in a front window.* The size, shape, and even folding patterns also resemble Swiss prototypes,† and the costumes depicted are similar to festival costumes from Saint Gall.‡ This baptismal wish and others were folded to enclose a coin, presumably a baptismal present from the sponsors to the child. A number of the

fraktur made by the Sussel-Washington Artist illustrate notable personages like George and Martha Washington and "Malley Queen of Sedburg."

See René Creux et al., *Volkskunst in der Schweiz* (Paudex, Switz., 1970), repro. opp. p. 151.

†*See ibid.*, p. 244, figs. 2–4; and Christian Rubi, *Taufe und Taufzettel im Bernerland* (Wabern-Bern, 1968), figs. 13–21.

‡*See* Creux et al., *Volkskunst*, repro. p. 201.

Plate 22

FLINTLOCK RIFLE, 1780–1811
John Philip Beck (1752–1811)
Lebanon, Lebanon County
Inscribed: J. P. Beck J.B. PW
Maple, iron, brass, silver; length 60½" (153.7 cm)
Private Collection
Checklist 163

John Philip Beck came to Pennsylvania from Rotterdam at the age of two.* He worked as a gunsmith in Lebanon all his life, producing guns similar to the flintlock rifles being made in Germany about the time his family migrated. This .52-caliber smoothbore rifle reflects what is known as the Lebanon style with its elaborate brass patch box, long wrist, high comb, and high-relief carving on the wood stock. Beck's long residency in the town and his training of apprentices like Nicholas Beyer (checklist 164) probably established the distinctive characteristics of Lebanon rifles and secured their solid reputation for excellence.†

See Samuel E. Dyke, "The Beck Family of Gunsmiths, Lancaster County, Pennsylvania," *Journal of the Lancaster County Historical Society*, vol. 72 (1968), pp. 28–41.

†*See* Merrill Lindsay, *The Kentucky Rifle* (New York, 1972), nos. 19–20.

Plate 23

TUREEN, c. 1790
Peter Getz (1764–1809)
Lancaster, Lancaster County
Inscribed: P. GETZ L
Silver; height 8⅜" (21.3 cm)
Wadsworth Atheneum, Hartford. The Philip H. Hammerslough Collection
Checklist 149

This silver tureen made by the Pennsylvania German Peter Getz for Aaron Levy, a prominent and urbane Jewish merchant-landowner, attests to the range of skills available beyond Philadelphia. Getz and Levy both were important citizens of Lancaster. Getz, a Mason, crafted swords for the tiler of the Lancaster Masonic lodge in 1794 and 1807. A charter member of the Active Fire Company in Lancaster, he also repaired fire engines.* In 1800 Getz was appointed arms inspector by Governor Thomas McKean. His death notice credited him as "the original improver of the new

printing press, constructed with rollers in lieu of a screw."† This tureen with the chased and cast ornament on the lid and the bright-cut engraving of the framed initial demonstrates Getz's grasp of the techniques of decorating silver while admitting a provincial combination of period styles.

*See Vivian S. Gerstell, *Silversmiths of Lancaster, Pennsylvania 1730–1850* (Lancaster, Pa., 1972), pp. 26–35.
†Quoted in *ibid.*, p. 29.

Plate 24
 *BIRTH AND BAPTISMAL RECORD FOR ELISA
 ADAM*, 1833
 The Mount Pleasant Artist (active 1813–35)
 Lancaster County
 Ink and watercolor on paper; 9¼ x 7¼″ (23.5 x 18.4 cm)
 Franklin and Marshall College Collections, Lancaster, Pennsylvania
 Checklist 215

Bookplates and birth, baptismal, and confirmation records are attributed to the distinctive hand of the Mount Pleasant Artist, so called because one example of his work is inscribed in English on the reverse: "For 50 Cents a piece you can have as much as you please Mount Pleasant Printing Office South Cocalico Township Lancaster County Pennsylvania."* The Mount Pleasant Artist probably was a schoolteacher serving several communities. From 1813 to 1818 he made fraktur records for families in northeastern Lancaster County and in Wernersville, Berks County. In the 1830s he was located in Mount Joy and Rapho townships in northwestern Lancaster County and in Hellam Township, York County. He used gold leaf or powder on some of his designs, and often painted a clock to record the time of birth, which, like the signs of the zodiac, symbolized the Pennsylvania Germans' wishes for good health and fortune.

*Donald A. Shelley, *The Fraktur-Writings or Illuminated Manuscripts of the Pennsylvania Germans*, The Pennsylvania German Folklore Society, vol. 23 (Allentown, Pa., 1961), fig. 222.

Plate 25
 TALL CASE CLOCK, c. 1735–50
 Jacob Graff (d. 1778)
 Lebanon, Lebanon County
 Inscribed: JACOB GRAFF MACHET DIESE
 Walnut, brass, iron, pewter; height 98″ (248.9 cm)
 Winterthur Museum. G65.2261
 Checklist 170

Jacob Graff, identified as the maker of this clock by its German inscription, was taxed as a clockmaker in Lebanon in 1750. He may have made this piece for the Illig family of Millbach Township, Lebanon County, who had settled there by 1732.

 The case of this clock is distinctive for the German-Dutch personality of the bonnet molding and the smoothly inlaid tulip and star on the front. Its eight-day works, day-of-the-month and -week dials, anchor recoil escapement, and rack-and-snail mechanism are typical of the best Pennsylvania clocks. This example is unusual in its lack of the Germanic feature of lantern pinions.

Plate 26
 TALL CASE CLOCK, 1790
 John Fisher (1736–1808)
 York, York County
 Inscribed: John Fisher York Town
 Black walnut, tulip, brass, blued steel; height 100¾″ (255.9 cm)
 Yale University Art Gallery, New Haven. The Mabel Brady Garvan Collection. 1936.307
 Checklist 112

John Fisher migrated to Pennsylvania with his parents from Swabia in Germany in 1749. He, like many German settlers in York and Adams counties, had social and business connections in Maryland throughout his life. Boundary disputes between Pennsylvania and Maryland did not inhibit the traffic between the extended families of Germans in the region. In 1766 Fisher married Barbara Lightner in Baltimore, and they settled in York. Where and with whom Fisher apprenticed is not known, but probably it was in a German shop, for the dial motions in this clock are driven with lantern pinions in the German style. *The Maryland Gazette* (Baltimore) of September 10, 1790, described this complex clock as a notable invention: "It has a thirty-five-day movement and displays seconds, hours, months, and days, as well as the signs of the zodiac and the seven planets of the pre-Copernican system; its astronomical dial has a moon face and stars and a planispheric map of the northern hemisphere with sunrises and sunsets indicated."*

*Quoted in Edwin A. Battison and Patricia E. Kane, *The American Clock, 1725–1865. The Mabel Brady Garvan and Other Collections at Yale University* (Greenwich, Conn., 1973), p. 134, repro. pp. 135–37.

Plate 27
 WARDROBE, 1792
 Attributed to John Bieber (1768–1825)
 Northampton (Lehigh) or Berks County
 Inscribed: Jacob 17 92 Bieber
 Tulip, painted, white pine; height 87½″ (222.3 cm)
 Private Collection
 Checklist 120

Plate 28
 WARDROBE, 1790–1800
 John Baughman (1746–1829)
 Conestoga Township, Lancaster County
 Inscribed: John Baughman
 Walnut, poplar; height 82″ (208.3 cm)
 Dr. and Mrs. Donald M. Herr
 Checklist 119

These two wardrobes exhibit the varying designs and construction techniques practiced by Germanic craftsmen in two pockets of settlement in southeastern Pennsylvania. Although the diverse national origins of settlers in these areas may account for some of these style and technique differences, the traditional wardrobe

form persisted in most Germanic communities within local design vocabularies. This piece of furniture could be disassembled by lifting off the cornice unit and removing the pegs and wedges from the framework of the paneled sides.

John Bieber's wardrobe with its panel-and-frame construction is painted white with blue and red overpainting and graining. Comparisons with other pieces attributed to Bieber and with other Berks County furniture (pls. 6, 38) suggest that Bieber had developed his own shop techniques. He used thick boards, large wedged dovetails, and an idiosyncratic drawer construction, which required that the back and bottom be assembled with the front and side in one fitting. His painting technique is also distinctive, for he used the same wood block or shaped sponge to apply the blue over white on this piece and a wardrobe he made in 1794.*

John Baughman of Lancaster County called himself a house-carpenter, but his account book indicates that he had a joinery shop as well.† The sheer bulk of Baughman's wardrobe and others made in Lancaster shops (pls. 1, 103) implies use in large houses. This wardrobe's Doric pilasters (probably taken from an architectural design book) on swelled brackets, plain unwedged dovetails, pegged door frame, and drawer bottoms nailed at the backs, suggest that Baughman's was an English-German shop serving the mixed region around the urban center of Lancaster.

A third wardrobe (checklist 116), by an unknown Montgomery County cabinetmaker, is constructed with wide, walnut planks, which were cut and placed so that their colorful grain accentuates the diagonals of the mitered front boards and the crotch-grained units of the deeply fielded door panels. Inlaid with the initials of Sarah Wagner and the date of her marriage to Abraham Yeakle, 1776, this is a handsome and early documented example of the traditional wardrobe form as made in communities north of and closely associated with Germantown.

*See Beatrice B. Garvan, *The Pennsylvania German Collection: Philadelphia Museum of Art*, Handbooks in American Art, No. 2 (Philadelphia, 1982), p. 34, no. 5. *See also* Jonathan Cox, "The Woodworking Community in Allentown, Salisbury Township, Whitehall Township, 1753–1805" (M.A. thesis, University of Delaware, 1982).

†See John J. Snyder, Jr., "Chippendale Furniture of Lancaster County, Pennsylvania, 1760–1810" (M.A. thesis, University of Delaware, 1976), pp. 11–12.

Plate 29
CHILD'S COVERLET, 1839
Aaron Zelner (1812–1893)
Plumstead Township, Bucks County
Inscribed: PLUMSTE AD. TO BUCKS. CO 1839 ARON, ZELNER,
Wool, cotton; width 34″ (86.4 cm)
Mr. and Mrs. Paul R. Flack
Checklist 280

Plate 30
COVERLET, 1848
Adam Hoerr (b. c. 1812)
Harmony, Butler County
Inscribed: ADAM HOERR HARMONY. BUTLER CO. PA 1848 CP WW [repeated]
Wool, cotton; width 76″ (193 cm)

Old Economy Village: Pennsylvania Historical and Museum Commission. OE65.6.1
Checklist 285

Coverlets of colored wool wefts interwoven on cotton warps were available in most regions of nineteenth-century Pennsylvania. This child's coverlet is a rare surviving example; the full size was standard, although before the introduction of the wide looms into western Pennsylvania from New York State in the mid-1830s, such coverlets had to be woven on narrow looms (38″ wide) and seamed.* These coverlets were woven on Jacquard looms in compound weaves with supplementary weft tie-down proportions of 2:1 and 4:1, respectively.

Aaron Zelner, a descendant of the early Bucks County Zöllners, worked in Bucks County before migrating with other local families to Canada about 1845. He was the first Jacquard weaver in Waterloo County, Ontario, by 1855.† Adam Hoerr was one of the weavers who worked in western Pennsylvania on the wide loom after 1835.

*See Patricia T. Herr, "Handwoven Masterpieces: Southeastern Pennsylvania Coverlets," *Early American Life*, vol. 13, no. 1 (February 1982), pp. 15–19, 60.

†Harold B. Burnham and Dorothy K. Burnham, '*Keep Me Warm One Night*': *Early Handweaving in Eastern Canada* (Toronto, 1972), pp. 319, 325.

Plate 31
HAND TOWEL, 1839
Meri Weinholt (1804–1880)
Northern Lancaster County
Inscribed: DAS HAN DVC HAPICMERIWEINHOLTGENETIM IAHR 1839 [alphabet minus j]
Linen, cotton embroidery; length 60″ (152.4 cm)
Dr. and Mrs. Donald M. Herr
Checklist 306

Embroidered in a bold cross-stitch with red and blue cotton threads on plain-weave linen, this hand towel decorated with standing female figures, birds, and vases of flowers organized between horizontal bandings is typical of northern Lancaster County work done near the Lebanon County line. The inscription—"this hand towel I, Meri Weinholt, have sewn in the year 1839"—is in Pennsylvania German dialect, evidence that German probably was the spoken language in the Weinholt household. The maker of this towel, Meri (Mary) Sollenberger Weinholt, daughter of John and Mary Martin Sollenberger, married the farmer George Weinholt in 1830. They had six children; their son Michael was born the year this towel was made.

Plate 32
RELIGIOUS TEXT, 1835–45
Attributed to Martin Gottshall (d. 1857)
Franconia or Salford Township, Montgomery County
Ink and watercolor on paper; 12 x 7¾″ (30.5 x 19.7 cm)
Private Collection
Checklist 233

Martin Gottshall was one of eleven children of the Mennonite schoolmaster Reverend Jacob Godshall (1763–1845) and his wife

Barbara Kindig Godshall; he was a cousin of the clockmaker Jacob Godshalk (pl. 5). Martin and his brother Samuel ran a successful mill on the Perkiomen Creek at Salford. They followed their father as dedicated local schoolteachers and were active until the state law establishing compulsory public education went into effect in 1849. Their commitment extended to the point of giving two pieces of their land for schools, one on the edge of the family homestead, the other on their mill property.

The Reverend Jacob and his bachelor sons Martin and Samuel were known for their illuminated drawings. The brilliant colors in a thick gum medium and stylized symmetrical figures, birds, and flowers seen on this fraktur may be Martin's particular style. One extant example by Samuel—an alphabet with bird—is less formally organized.*

*Copy in Notebook of John D. Souder, begun 1938, Private Collection.

Plate 33

SALT BOX, 1797
John Drissell (active 1790–1817)
Milford Township, Bucks County
Inscribed: ANNE LETERMAN Anno Dommni 1797 John
 Drissell his hand May th 22d 1797
White pine, painted; height 11" (27.9 cm)
Winterthur Museum. 58.17.1
Checklist 59

The Drissells were Mennonites who had settled in Milford Township, Bucks County, by 1749, for in that year a John Drissell signed the township's petition for a road.* The John Drissell who made this salt box was the son of a carpenter who had worked in Allen Township in 1775 and had located in Milford Township by 1787.† John inherited his father's plantation in Lower Milford Township in 1817.

Drissell probably made and decorated small boxes with sliding lids (checklist 58) and tape looms (checklist 64) for young women, most of whom went to one of three schools run by the Lutheran schoolteacher John Adam Eÿer. This salt box is inscribed for Anne Leterman; an Ann Ladterman, daughter of Abraham, was enrolled in Eÿer's schools in Bedminster Township and Hilltown, Bucks County, at various times from 1782 to 1785.‡ The multicolored designs and carefully hand-lettered inscriptions on much of Drissell's woodwork suggest that the decorative fraktur work of Eÿer (checklist 195, 212, 220) influenced craftsmen in the area working in various mediums.

*See William W. H. Davis, History of Bucks County, Pennsylvania, from the Discovery of the Delaware to the Present Time (New York, 1905), vol. 1, p. 430.
†Tax List, 1787, Milford Township, Bucks County, Historical Society of Pennsylvania, Philadelphia.
‡See Frederick S. Weiser, "IAE SD: The Story of Johann Adam Eyer (1755–1837), Schoolmaster and Fraktur Artist, with a Translation of His Roster Book, 1779–1797," in Albert F. Buffington et al., Ebbes fer Alle-Ebber—Ebbes fer Dich: Something for Everyone—Something for You. Essays in Memoriam—Albert Franklin Buffington, Publications of the Pennsylvania German Society, vol. 14 (Breinigsville, Pa., 1980), pp. 435–506.

Plate 34

JAR, 1788
Philip Sussholtz (d. c. 1826)
Berks County
Inscribed: philib sussholtz den 5 ockdomer 1788
Earthenware with slip coating, clear lead glaze; dia. 6⅞"
 (17.5 cm)
Winterthur Museum. 65.2706
Checklist 27

Philip Sussholtz was one of a family of potters who first settled in Upper Hanover Township, Montgomery County, later moving to Berks and then Northumberland County between 1785 and 1800.* Jars like this one, robustly shaped and colorfully decorated with sgraffito designs, German inscriptions, and daubs of copper oxide (green), were special presentation pieces.

Johannes Neesz (checklist 16), Jacob Scholl (checklist 19), and Samuel Troxel (checklist 28–30) belonged to other prosperous families of Montgomery County potters who dug their clay from ground, usually their own, along the network of streams that watered their swamps and fields. In such places the clay stratum was deep—a foot or more—enough to support a pottery for three or four generations. Montgomery and Bucks counties each had a pottery in almost every township; tax records usually reveal such an enterprise to have been a single-man operation with a journeyman and local boys as seasonal helpers.

*See William J. Hinke, copier, Schwartzwald Reformed Church Records, Exeter Township, Berks County, Philip Schaff Library, Lancaster Theological Seminary, Lancaster, Pa.; and Beatrice B. Garvan, The Pennsylvania German Collection: Philadelphia Museum of Art, Handbooks in American Art, No. 2 (Philadelphia, 1982), Biographical Index, s.v. "Hubener, George."

Plate 35

CHEST, 1780
Heidelberg Township, Northampton (Lehigh) County
Inscribed: CADA RINA REXIN 1780
Pine, painted; height 21¾" (55.2 cm)
Richard S. and Rosemarie B. Machmer
Checklist 73

Woodworkers were to be found in every Pennsylvania German community, for they provided the essential services of housebuilding and furniture making. This chest was made and inscribed for Catharina Rex, daughter of George, a farmer and blacksmith in Heidelberg Township.* Other chests, although made with different joinery methods, were decorated by the same hand that ornamented this chest for members of Schlosser's Church in nearby Whitehall Township in 1781, which suggests that a relatively remote area could support more than one joiner and possibly even more than one shop. It is probable that such a community could satisfy the needs of its members with its local production.

*See Helen Cain and Charles Hummel, "The Carnation Chests: New Discoveries in Pennsylvania German Art," Antiques (in press).

Plate 36

DESK, 1834
Schwaben Creek Valley, Northumberland County
Inscribed: Jacob 1834 Maser
Poplar, painted, pine; height 49⅛″ (124.8 cm)
Winterthur Museum. 64.1518
Checklist 97

Brilliant colors—greens, reds, and yellows—applied to furniture made chiefly of softwoods identify a closely knit community of craftsmen and consumers tucked in the Schwaben Creek Valley between the Line and Hooflander mountains. Settled by 1776 with Lutheran and German Reformed church members, the community was infused with subsequent Germanic migrations, but remained physically isolated. The furniture produced there frequently was inscribed with a date and sometimes a name, although it is not clear whether these were makers or owners.

The date on this desk, 1834, places it within a group of furniture forms that were painted by different hands.* The desk was inscribed for Jacob Maser in the year of his marriage to Catherine Christ, but it is not known that he built or painted the piece. His inventory does list a quantity of carpentry tools,† but it is not certain that he was a carpenter by trade, for the character and closeness of the Schwaben Creek settlement may have made any such specialization of craft impractical.

†*See* Frederick S. Weiser and Mary Hammond Sullivan, "Decorated Furniture of the Schwaben Creek Valley," in Albert F. Buffington et al., *Ebbes fer Alle-Ebber—Ebbes fer Dich: Something for Everyone—Something for You. Essays in Memoriam—Albert Franklin Buffington*, Publications of the Pennsylvania German Society, vol. 14 (Breinigsville, Pa., 1980), pp. 331–94.
†*See* Frederick S. Weiser and Mary Hammond Sullivan, "Decorated Furniture of the Mahantango Valley," *Antiques*, vol. 103, no. 5 (May 1973), p. 939 n. 3.

Plate 37

CUPBOARD OVER DRAWERS, 1780–1800
Berks County
Walnut, white and yellow pine, tulip; height 65⅜″ (166.1 cm)
Mr. and Mrs. Robert L. Raley
Checklist 93

Plate 38

CHEST, 1803
Upper Bern Township, Berks County
Inscribed: MARGRETH BLADTEN 1803
Tulip, painted, pine; height 31″ (78.7 cm)
Philadelphia Museum of Art. Gift of Arthur Sussel. 45-12-1
Checklist 85

The chest was a traditional Germanic furniture form; the cupboard over drawers belongs within Alsatian and Welsh traditions. These two pieces are related to one another and to other Berks County furniture in construction and design. Both are joined with fine, tight dovetails with sliverlike wedges, the work of a skilled cabinetmaker or joiner. They also have in common the prominent Berks County decorative feature of sawtooth borders—one painted, the other inlaid—around arched panels. In addition the cupboard has a wide string inlay on undulating skirting similar to that on a tall chest made in 1790 for a member of the Sharadin family of Maxatawny Township, Berks County.*

The sawtooth decoration enframing inset panels with prancing beasts displayed on this chest was used in the Münstertal area of Switzerland.† It is possible that the unicorn design could be attributed to the Eulor family of Bern Township cabinetmakers, whose ancestry may be Swiss. The ground of the chest, sponge painted rather than feathered or grained, and the form of the cupboard with drawers follow French Alsatian traditions. Thus these two examples of Berks County craftsmanship represent well the creative adaptations of European decorative arts made by Pennsylvania Germans in regional settlements.

*Berks County Historical Society, Reading, Pa.
†*See* Georges Klein, *Arts et traditions populaires d'Alsace* (Colmar, 1976), pp. 85–97.

Plate 39

DESK AND BOOKCASE, 1826
Henry Shellenberger (active 1814–35)
Bullskin Township, Fayette County
Inscribed: H. Shellenberger
Walnut, cherry, butternut, maple, poplar, pine; height 86½″ (219.7 cm)
Museum of Art, Carnegie Institute, Pittsburgh. Promised gift of Mr. and Mrs. James A. Drain, 1981
Checklist 96

Henry Shellenberger was born in western Pennsylvania, although his family roots were in Lancaster County and before that in Switzerland; his wife Helena Updegraff's family, also from Lancaster County, was originally from Holland. Several Shellenbergers, along with many English and Scotch-Irish families, migrated west in 1784 after the post-Revolutionary peace finally had been established in the region. As they had in the east, the churches again provided the spiritual and physical centers for these Germanic communities, although the western congregations were more spread out and interspersed with extensive non-Germanic settlements.*

This desk by Shellenberger, who was working as a joiner by 1814, has none of the Germanic joinery techniques usually found in Lancaster County furniture: for example, the dovetails are not wedged and nails secure joints. Furthermore, the linear maple inlay is more typical of the English-Welsh line-and-berry designs recognized as Chester County work,† demonstrating that Germanic communities in western Pennsylvania were losing some of their Old World identity, if not their pioneering spirit.

See Homer T. Rosenberger, "Migrations of the Pennsylvania Germans to Western Pennsylvania," *The Western Pennsylvania Historical Magazine*, pt. 1, vol. 53, no. 4 (October 1970), pp. 319–35; pt. 2, vol. 54, no. 1 (January 1971), pp. 58–76.
†*See* Robert W. McDermott, "Early Furniture of Western Pennsylvania," *Antiques*, vol. 102, no. 2 (August 1972), pp. 244–50.

Plate 40

*BIRTH AND BAPTISMAL CERTIFICATE FOR
JACOB KUNTZ,* 1789
Carl Scheibeler (active 1789–1846)
Hempfield Township, Westmoreland County
Inscribed: Bonscrift von Carl Sheibeler. April–Mai . . . in
 Hempfield Township, Westmoreland County. 1789.
Ink and watercolor on paper; 16⅜₁₆ x 12¾″ (41.1 x 32.4 cm)
The Westmoreland County Museum of Art, Greensburg,
 Pennsylvania. Gift of the Woods-Marchand Collection.
 60.533
Checklist 210

Jacob Kuntz, son of the tanner Johannes Kuntz and his wife Elisa-
betha Marchand Kuntz, was born and baptized in 1788 in Greens-
burg, Westmoreland County. Carl Scheibeler, who executed this
commemorative certificate for Kuntz in 1789, was a teacher at the
Harrold Settlement in Greensburg and in Hempfield Township.
The fraktur exhibits the usual combination of calligraphic flour-
ishes with a text in Gothic lettering. Its vertically organized,
highly abstracted flower designs resemble a simplified Ephrata or
Snow Hill style (*see* checklist 256). The semicircular border de-
sign probably was adapted from instructions for cross-stitch or
satin stitch taken from an embroidery pattern book.
 Scheibeler's later, freer, and very colorful style is seen on a
fraktur made in 1846 for Elisabeth Burger of Franklin Township,
Westmoreland County,* and is similar to work by Charles Edward
Münch (checklist 213), whom Scheibeler may have known earlier
in the Lykens Valley of Dauphin County. Scheibeler moved
around throughout his more than fifty-year work span, often
serving more than one school, as was the custom in rural Penn-
sylvania.

*The Westmoreland County Museum of Art, Greensburg, Pa.

Plate 41

ECONOMY HOTEL, 1834
Attributed to Frederick Reichert
Old Economy, Beaver County
Ink and watercolor wash on paper; 16¾ x 22¼″ (42.5 x
 56.5 cm)
Old Economy Village: Pennsylvania Historical and Mu-
 seum Commission. OE72.17.83
Checklist 218

George Rapp led the pietistic Harmonists from Württemberg,
Germany, to Harmony, Butler County, in western Pennsylvania
in 1805; they settled at Economy in Beaver County in 1825. This
architectural drawing attributed to Rapp's adopted son Frederick
Reichert shows the direct transfer of a European architectural
element—the hipped-over-bell cast roof—to an American struc-
ture, here the hotel in the center of Economy. This roofing style
in time disappeared in favor of the simpler gable-and-hipped con-
struction. Except for a few surviving houses and drawings of the
early Moravian communities at Lititz and Bethlehem, very little is
known about the adaptation of exterior features from European
vernacular architecture to Pennsylvania structures.
 As an emblem of nineteenth-century religious migration from
Europe, the architecture of Economy, ambitious in style and
engineering, was as curious to those outside the community in the

Pennsylvania of its day as that of Bethlehem and Ephrata had
been earlier. The Harmonists' self-contained religious communi-
ties with expansive economic goals might better be compared to
the nineteenth-century Shaker phenomenon in New England than
to the earlier Germanic migrations in eastern Pennsylvania. George
Rapp's daughter Gertrude, probably responding to a market de-
mand for fine dress textiles, began the society's silk-producing and
manufacturing business, which throve until 1846. The Harmonists
produced cut and voided velvets, compound silk weaves, and fine
ribbons (checklist 315–17).

Plate 42

GOBLET, 1798–1800
New Geneva Glass Works
New Geneva, Fayette County
Free-blown glass; height 9⅛″ (23.2 cm)
The Corning Museum of Glass, Corning, New York.
 79.4.329
Checklist 45

Early German settlers such as Caspar Wistar and Henry William
Stiegel had introduced glass manufacturing to eastern Pennsyl-
vania. Albert Gallatin, born in 1761 in Geneva, Switzerland, mi-
grated first to New England, but settled in Fayette County, Penn-
sylvania. In 1797, after corresponding with friends in Greensboro,
North Carolina—John Badollet, Louis Boudillon, and Charles
Cazenove—about the availability of German glassblowers to begin
a new enterprise, Gallatin and his brother-in-law James Nicholson
joined the others to found the New Geneva Glass Works, the first
glasshouse west of the Allegheny Mountains.* Although the ven-
ture was successful, Gallatin sold out and later became an impor-
tant investor in western Pennsylvania lands. A scholar and a dip-
lomat, he was a member of the House of Representatives from
1795 to 1801, and served as secretary of the treasury from 1801 to
1815. This special presentation goblet has Gallatin's silver Prix de
Diligence medal, awarded by the University of Geneva in 1779,
enclosed in the stem.

*See Lowell Innes, *Pittsburgh Glass 1797–1891: A History and
Guide for Collectors* (Boston, 1976), pp. 10–11, 13–15.

The Marketplace

MOST TRAVELERS' descriptions of the Pennsylvania German countryside failed to portray the bustle and vitality of the business of daily life. The dawn-to-dusk activities of aggressive settlers who combined specialized craft skills with at least subsistence farming were not visible to the outsiders who depicted the Pennsylvania Germans. A strong work ethic, shared by most early immigrants to America, was a consuming drive among the central Europeans who came to Pennsylvania. Benjamin Franklin, who had had extensive dealings with these settlers, wrote in 1753: "When any of them (the English) happen to come here, where labor is much better paid than in England, their industry seems to diminish in equal proportion. But it is not so with the German laborer; they retain their habitual industry and frugality they bring with them, and, receiving higher wages, an accumulation arises that makes them all rich."[1] This particular characteristic of the Pennsylvania Germans was conspicuous from first settlement. In 1730, the Philadelphia Presbyterian minister Jedidiah Andrews described his German neighbors: "Those yt live in town, are mostly a kind of Gibeonites, hewers of wood, &c. They are diligent, sober, frugal people, rarely charged with any misdemenour. Many of 'em, yt live in the country and have farms, by their industry and frugal way of living, grow rich, for they can underlive the Britons, &c."[2]

Over the years, however, it was not those like Franklin or Andrews, who lived and worked with and for the mixed nationalities of the early immigrant society, but rather travelers like historian Francis Parkman who began the nostalgic oversimplification of Pennsylvania German agricultural life. Parkman, riding through Lancaster County in 1845, wrote in his *Journal*: "The people chiefly Dutch—among them a number of Mennonists, with long hair and beard. All the people here are as strong and hardy as any men I ever saw —seem to take life easily—have open and hearty manners. . . . At Paradise stopped at the fine, old, whitewashed stone house of Mr. Whitmer, who came out, dressed like an ordinary laborer, and gave us a hearty Dutch welcome"[3] By 1910, Rudyard Kipling could observe: "It's a kindly, softly country there, back of Philadelphia among the German towns, Lancaster way. Little houses and bursting big barns, fat cattle, fat women, and all as peaceful as Heaven might be if they farmed there"[4]

This idealized image of these rural, satisfied people of plenty became locked into the American vision of the "good old days." The existence of such an image does, however, attest to the fact that some of William Penn's plan for his colony worked—as seen clearly in the economic prosperity of the Pennsylvania German farm. The success of his land allocation system depended

upon his great tract being settled all over as evenly and as quickly as possible. He did not want large grants held for speculation, but rather divided into individual farms, which would produce for the market soon after he granted the purchase by patent. Penn based his economic plan upon his firsthand evaluation of the national character of the groups among whom he promoted settlement: the Germans were to immigrate to work the land, the English to trade and invest. His object was to set a pattern of business that would turn competition between the two groups into productivity, with the base of the power structure remaining in Philadelphia, preferably in the hands of the Quaker grandees who served his interests.

Land was the first commodity sought by both the Germans and the English, each group for its different purposes, and there were sharp dealings between these two groups at first settlement.[5] Penn delayed closing an agreement with the members of the Frankfort Land Company for fifteen thousand acres (three townships) until they could guarantee that within a year they would have thirty households settled on the land, ten in each township. He also turned down the Company's request to have its tract border the Delaware River, for Penn had reserved that area for shipping interests; he wanted the Germans established inland on farm tracts interspersed with English settlements. Francis Daniel Pastorius, who had led the first groups to Germantown, was the Company's agent. He and Penn were at odds during this land negotiation, although both men had similar investment goals. However, to Pastorius, unlike Penn, economic interaction between the English and the Germans was of secondary consideration to what he considered the intellectual and spiritual needs of the German settlers. The frustrations he felt during the dealings for the land grant surfaced in a letter he wrote March 7, 1684: "I for my part would well wish that we might have a separate little province, and be so much the more free from all oppression."[6]

In the end, Penn, to achieve his goal of settlement by German craftsmen and farmers who would supply local, regional, and international markets, gave in to the Frankfort Land Company's demands for single large tracts while securing settlement deadlines for his own purposes. The ultimate agreement worked for both interests. The Company received land extending across what became Montgomery and Bucks counties, an arrangement allowing the original Germantown settlement to expand into new communities, which could maintain close contacts with and access to the Germantown market, established by Pastorius in 1684 as a cooperative to sell linen and vegetables, both in demand in Philadelphia. In 1685 Philadelphia merchant Robert Turner wrote to Willam Penn about the success of this early economic relationship: "The manufacture of Linnen by the Germans goes on finely, and they make fine Linnen: Samuel Carpenter having been lately there declares they had gathered one Crop of Flax and had sowed for the Second and saw it come up well."[7] Thus Pastorius's initial concern that the Germans would have difficulty settling Pennsylvania because they were "mostly linen-

weavers and not any too skilled in agriculture" was soon allayed. As one settler, William Streypers, reported on October 22, 1684: "I have been busy and made a brave dwelling house, and under it a cellar fit to live in, and have so much grain, such Indian Corn and Buckwheat that this winter I shall be better off than I was last year."[8] This economic success would continue and amplify over the years as the results of the Pennsylvania Germans' energetic land development and their contributions to crafts and industries brought financial reward to themselves and the colony.

The Pennsylvania Germans held their land through several generations, protecting it with legal strictures in wills, while practicing excellent conservation methods in the daily routine to guarantee productivity for the next generation.[9] They adhered to the European custom of dividing property and estates equally among issue, male and female, a tradition that encouraged individualism and self-reliance as the homestead became the basic economic unit. The nineteenth-century interpretation of the Pennsylvania Germans saw this individualism as stubborn determination to retain old values. The Pennsylvania German farmer, who once had been highly regarded as the source of the plenty within the cornucopia, came to be caricatured as vainly attempting to retain a regressive self-sufficiency in the face of the nineteenth-century technology that invaded the rural landscape with canals, trains, and mechanized farm implements, all of which depended upon large groups of organized labor.

In reality, the Pennsylvania Germans had little desire to be economically self-sufficient. Their entire economy—based on barter, buying, and selling—was highlighted by the market. An economic necessity as well as a major social event, the market was an arena in which the Germans, French, Dutch, Scots, Irish, and English spoke the same language—the language of commerce in which words were not always necessary. Whatever dialects may have been spoken or understood in the home, church, or tavern, the first new language most settlers learned was that of the marketplace.

The proficiency of the Pennsylvania German farmers has been celebrated in many descriptions of their homesteads. The importance of the farm activity and the pride and interest in careful, thoughtful manual labor can best be seen in the Germans' application of their arts as flourishes on even the most commonplace tools and implements. For example, it was helpful to identify a bag in which grain was taken to the mill, but stamped decorations like the date within a heart, horse, flower motif, and frakturlike lettering seen on one grain bag (checklist 267) went beyond the needs of mere pragmatic identification. Of equal but not so obvious importance within these craft traditions was quality, for it was the combination of imaginative artistry with high quality that gave the Pennsylvania German goods their broad market appeal; their value was built in. Objects like the butter print, the broadax, and the coverlet advertised the products or purpose and sometimes also their makers. The butter prints not only decorated the butter—or, as some hoped, protected its sweetness from the evil spirits that could turn it sour—but in the case of the

example exhibited (pl. 54), advertised the producer as well as the quality of the product by its inscription: "Eliza beth Good Fresh Butter, Taste It. Town Ship H+B." The stamp on the broadax made by Gottlieb Sener (pl. 45)—"Extra Refined G. Sener Cast Steel Lancaster"—identified a superior product by a craftsman proud enough to include his name and address for customer convenience. Peter Leisey likewise wove his name and his location directly into one of the coverlets he produced (pl. 72): "Made By Peter Leisey Lancaster County Cocaleco Township Patant." Pennsylvania German country products provided a good reason for Philadelphians to arise very early to purchase their fresh produce at the High Street market, a pattern duplicated in York, Reading, and Lancaster. These weekly markets supplied the urban dwellers, while the large annual and semiannual wingdings, the county fairs (see pl. 53), attracted residents of the entire surrounding countryside. In this society, life and work were one. The marketplace, as the center of Pennsylvania German economics, offered social as well as monetary rewards for work well done.

Penn and Pastorius had made an investment in one another. The most visible and tangible expression of their economic interdependence was the rapid development and growth of iron manufacturing. The English and Welsh investors, familiar with the operations of the Coalbrookdale Furnace in England, and the Germanic workmen from central Europe, where ironmaking skills were centuries old, formed natural combinations. For example, Henry William Stiegel, who traveled to Pennsylvania in 1750 on a ship owned by Charles and John Stedman, Scotsmen in the business of transporting Palatines to Pennsylvania, nurtured his encounter with these men into a partnership in iron and glass making. The Stedmans had some capital; Stiegel had some furnace experience if not expertise. Stiegel's furnace was but one of several[10] that produced large, heavy iron stoves to order (pl. 50, checklist 122, 123, 125), chiefly for Germans but also for many Englishmen. Blacksmiths and hammer-forge operators also drove their wagons to the closest furnace to fetch the raw materials of their crafts, cast-iron pigs. At the forges the pigs were slammed into wrought iron bars that were purchased by nailsmiths, farriers, and blacksmiths, who made tools and hardware (pls. 44–47) as well as some delightful personal possessions such as the weather vane made by Michael Schaeffer for his own farm (pl. 43). Iron was refined almost to the tensile strength of steel by locksmiths like David Rohrer (pl. 47) and gunsmiths like John Schreidt (pl. 57), John Philip Beck (pl. 22), and Jacob Kuntz (pls. 81, 82).

Stiegel's glasshouse at Manheim in Lancaster County produced fine tableware for urban centers like Philadelphia and New York, designed to replace the English imports made unpopular after 1765 by the Nonimportation Agreements. The failure of the Manheim operation did not deter later entrepreneurs like Albert Gallatin from founding the New Geneva Glass Works (pl. 42) in Fayette County to serve the demands of a growing market in the post-Revolutionary development of western Pennsylvania. Unlike the eastern

urban shops, businesses such as that established by Gallatin were not jeopardized by the flood of European imports after 1800.

The other large economic enterprises besides iron manufacturing required special buildings, great supplies of raw materials, and a full-time, skilled labor force. The customers came to them. Both urban and rural joiners probably served their customers at their shops. Items such as a carved dressing table (pl. 65) must have required a special order, and account books like that of Peter Ranck (checklist 217)[11] indicate that first come, first served, was usually the method of operation. The extent of the interaction or sharing of specialized skills like carving among such shops has not yet been determined, although it is known that the craftsmen exchanged some services with one another; for example, joiners John Sener (*see* pl. 65) and Michael Lind, Jr. (pl. 78), inventoried the estate of chairmaker Michael Stoner (checklist 70) after his death in 1810.

Potteries were organized somewhat differently than the joinery shops. Journeymen moved from pottery to pottery, throwing pots and readying ware for kiln firing. Because redware pottery was in daily use and very breakable, the potteries were busy. Yet, except for some large potteries like that of John Leidy (checklist 13, 14), which operated three or more kilns, a pottery was usually a one-man operation whose owner was first a farmer. Additional help was hired as needed. Many more individuals were employed in the potteries than tax records can reveal, because these businesses were part-time and seasonal and because the tax list designation for such workers was simply "labourer." In fact, there were many more "labourers" in all categories of crafts than tax or census lists suggest, for much of the rural economy moved on barter and the exchange of services.

Despite the importance of the crafts and industries, agriculture remained the center of Pennsylvania German life, and during harvest most craftsmen—potters and cabinetmakers, clockmakers and gunsmiths—and all their apprentices were at the service of the farmers for a week or more. This was a time of merriment and delight for the young, and also a time when the coppersmith's chef d'oeuvre, the still (checklist 152), was in full use. An expensive piece of specialized equipment, the still was shared in a community and the end product consumed, traded, or sold locally. John Krauss of Montgomery County made the following notes on his distilling activities: "SEPTEMBER . . . 15 til 21 I been stilling Aple's . . . OCTOBER . . . til 4. I been stilling Liquer 2 recd. for 4 b. ash. 40 2 gall whisky . . . 13 til 18 I stilld apples paid for 4 pigs . . . 25 I & my father in Law squard our account by setlement . . . he paid me for stilling cyder 6."[12]

Craftsmen were not the only workers called upon to perform more than one economic function, for within the rural Pennsylvania German society even the professional often filled more than one role. In some instances the village storekeeper appears to have been the local banker as well, and his store often served as a place at which the services of traveling journeymen could be

secured. The Salfordville Store Ledger contains entries detailing such economic transactions: "Christian Keppler 1767. had journeyman Geo: Martin-pd. By iron potts sold for him £2.10.9. by 1 gun £1.10, By a buckwheat plate £0.6.6, by a Pott sold to St. Geist 1.8.0. . . . Peter Minner carpenter served his time W. D. Welker 1767 Henry Kolp joyner. pd with 1 desk & 1 clockcase & 1 cuttl. Box £8.17. . . . George Derr 1772 to 1 steal plate saw & 1 gimbley to 1 look glass, 1 razor, 1 sickel, 2 qts oil & 1 lamp, 1 song book, 1 pr cotton stockings, powder & shot, to inkpowder & needles. pd. By weaving brot in . . . John Betz 1770 pd by making 1 waggon & screws £7.3.7."[13] The educated farmer likewise applied himself to other professional pursuits. David Hottenstein (pl. 6) studied in Philadelphia to become a doctor and practiced in Berks County. Christian Bucher and his family served Schaefferstown, Lebanon County, as doctors, apothecaries, and merchants (pl. 73).

The economic development and diversity of the Pennsylvania countryside are revealed in a summary of the industry in Northampton County appended to the 1810 population census list. Among the businesses reported, together with their production, were "3 potteries in unknown quantity 45 weavers with 70 looms, 47,000 yds of difft linen & linseys 3 blue dyers—unknown quantity 1 blast furnace 300 tons iron 100 Distilleries 105,170 galls rye & apple whiskey 1 Trip hammer 30 tons iron 6 water pow. carding machines 15,625 lb wool 1 paper mill 1210 rheams 27 saw mills 970,000 feet board & scantling 63 grist mills 6850 Barrles flour 259,000 Bushels grain 1 fulling mill unknown quantity 6 tobacco factories 30 tons tobacco 22 smithies 56½ tons iron 1 printing office 300 rheam paper 6 hatters 1750 wool & 1120 furr hatts 3 sadlers unknown quantity 20 shoemakers 380 pr boots 4400 pr shoes 5 limekilns 12,000 bushels lime."[14] Although the proportion of Germans to English is not indicated, this enumeration provides valuable insight into the variety of rural enterprises that needed workmen. Such variety on an individual level is reflected in the 1809 income accounts of the unusually talented John Krauss, who reported payments for "Surveying . . . Writing . . . Marketing grain etc. . . . Organs & other works . . . machinery . . . carding wool . . . do. cotton . . . cotton & cotton yarns."[15] Thus the records of this one man both exemplify and celebrate the wide range of skills that the Pennsylvania Germans came to supply to marketplaces throughout Pennsylvania and beyond.

1. Quoted in Charles R. Barker, "The 'Old Dutch Church' in Lower Merion (St. Paul's Evangelical Lutheran Church, Ardmore, Pa.)," *The Bulletin of the Historical Society of Montgomery County*, vol. 9, no. 3 (October 1954), p. 200.

2. Quoted in *ibid*.

3. Francis Parkman, *The Journals of Francis Parkman*, ed. Mason Wade (New York, 1947), vol. 1, pp. 299–300.

4. Rudyard Kipling, *Rewards and Fairies* (New York, 1910), p. 167.

5. *See* Samuel Whitaker Pennypacker, *The Settlement of Germantown, Pennsylvania and the Beginning of German Emigration to North America* (Philadelphia, 1899), p. 94.

6. Quoted in *ibid*.

7. Quoted in "A Germantown Chronology," *The American-German Review*, vol. 25, no. 1 (October–November 1958), pp. 13–14.

8. Quoted in Pennypacker, *Settlement of Germantown*, p. 20.

9. *See* Leo A. Bressler, "Agriculture Among the Germans in Pennsylvania During the Eighteenth Century," *Pennsylvania History*, vol. 22, no. 2 (April 1955), pp. 103–33.

10. *See* Henry C. Mercer, *The Bible in Iron: Pictured Stoves and Stoveplates of the Pennsylvania Germans*, ed. Horace M. Mann and Joseph E. Sanford, 3rd ed. (Doylestown, Pa., 1961), pp. 29–33, 40.

11. *See* Alan G. Keyser, Larry M. Neff, and Frederick S. Weiser, eds. and trans., *The Accounts of Two Pennsylvania German Furniture Makers—Abraham Overholt, Bucks County, 1790–1833, and Peter Ranck, Lebanon County, 1794–1817* (Breinigsville, Pa., 1978).

12. "Account Book of John Krauss," *The Perkiomen Region*, vol. 8, no. 2 (April 1930), pp. 50–51.

13. Salfordville [Montgomery County] Store Ledger, 1766–73, G-5, The Historical Society of Montgomery County, Norristown, Pa.

14. United States, Department of the Interior, 1810 Census of Population.

15. Selina Gerhard Schultz, "John Krauss (1770–1819)," *Schwenckfeldiana*, vol. 1, no. 5 (September 1945), p. 28.

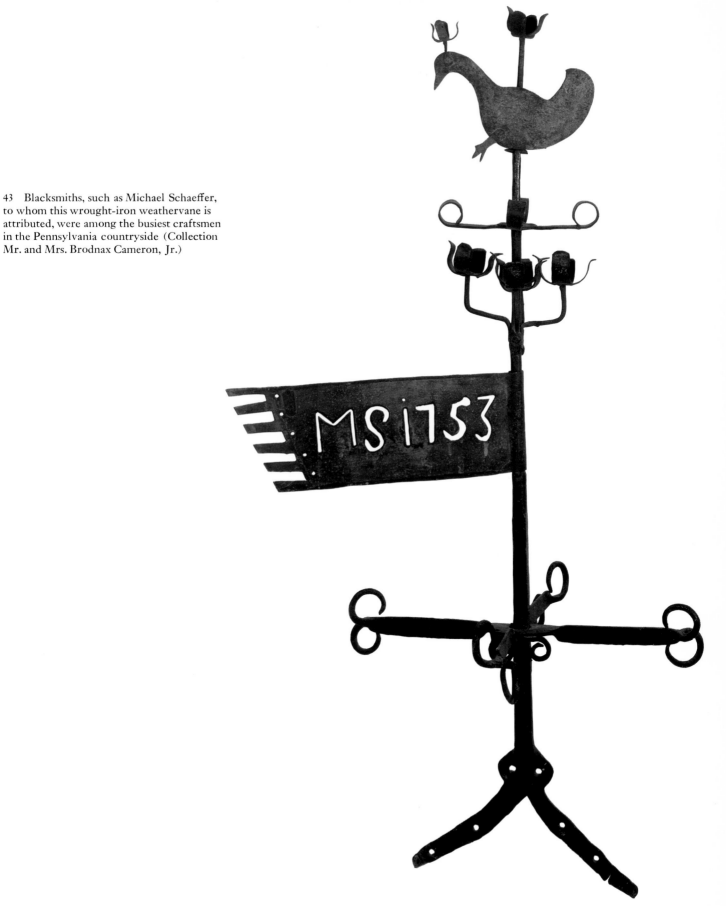

43 Blacksmiths, such as Michael Schaeffer, to whom this wrought-iron weathervane is attributed, were among the busiest craftsmen in the Pennsylvania countryside (Collection Mr. and Mrs. Brodnax Cameron, Jr.)

44

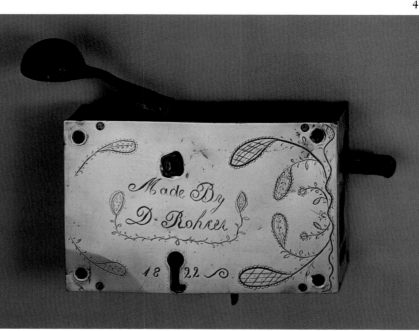

45

44–47 Blacksmiths routinely forged plows, farm tools, such as this broadax (Pennsylvania Historical and Museum Commission), wagon parts, hardware, and hinges (Private Collection and Winterthur Museum). More intricate objects, locks, for example, were produced by specialized smiths (Private Collection)

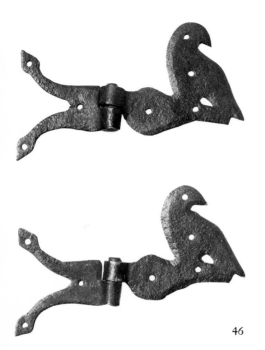

46

47

Made By
D. Rohrer

18 22

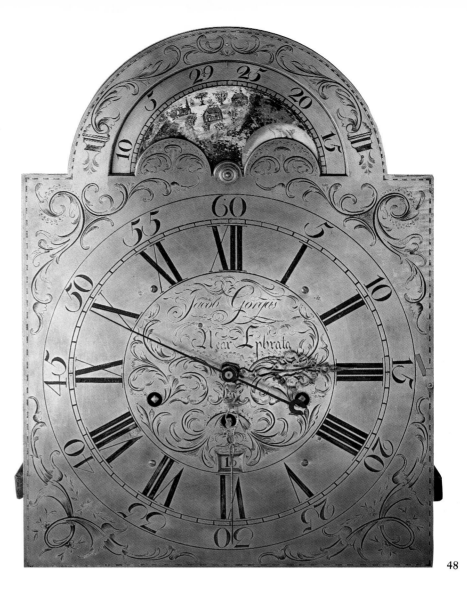

48, 49 Jacob Gorgas probably made these clockmaker's tools (Private Collection) after his apprenticeship and used them to assemble this musical clockworks, which plays five tunes (Philadelphia Museum of Art)

48

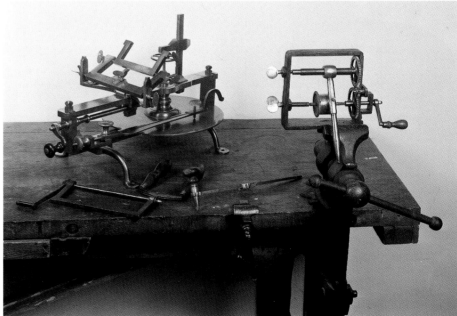

49

In 1801. march 4. the administration of Thomas Jefferson commenced in York the bury the Black Cockade. riband worn on the hat. democratical by George Spangler, Fred Rockey. Conrad welshans. Henry weiser Salmon Myer. michael Edward. at furry's tavern. John Stwed. John Stroman. John weyer.

Mr. Barnhard. A vender give to little Lewis Miller. the first Barlo-Knife as A present. 1799.

Yearly Market, or publick fare.

Held in the Borough of York, June 9th 1801, the had privilege of a Stated yearly market,

In 1816. the prohibited the holding of fairs within the Borough of York, and declared Such holding a common nuisance in Some dispute at Lewis Wampler. tavern— michael Hahn. Stop Robert Dunn. and at the Same time nickolas Scheffer cut Barnhard with a Knife, at Eberhart. tavern,

53

53 The spirited activities of the yearly market in York should not obscure the seriousness of the business transacted there, wherein connections were established, orders placed, and services secured (The Historical Society of York County, York, Pennsylvania

54–56 Butter was a popular market item, often impressed with a butter print (Pennsylvania Historical and Museum Commission), wrapped in cloth, and brought to the market in a butter box (Philadelphia Museum of Art). Some produce came to market in baskets, such as this one of oak splints (Collection Jeannette Lasansky)

54

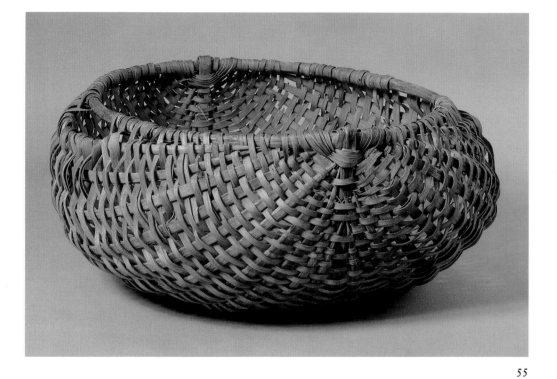

55

56

57 The Kentucky rifle was a gun of American invention and manufacture (Collection Mr. and Mrs. Charles Frederick Beck)

58 The Pennsylvania Germans were expert in processing leather, from tanning to fabrication of fine saddlery, such as this lady's side saddle (Lancaster County Historical Society, Lancaster)

59 Unglazed redware roof tiles were made from the abundant clay deposits found by the earliest German settlers in Pennsylvania; however, this traditional European roofing material was later superseded by wood shakes (Collection John and Rosamond Moxon)

59

57

58

60 Small pottery enterprises supplied local markets with redware objects—jars, dishes, such as this lead-glazed example by Daniel Dry (Pennsylvania Historical and Museum Commission), sieves, and mugs, as well as pipes and whistles.

61 Bottles like this one, free-blown at the New Geneva-Greensboro Glass Works, were used and reused, as fermented liquor was a medium of exchange in western Pennsylvania (Waynesburg College Museum, Waynesburg, Pennsylvania)

62 At his second glasshouse in Manheim, Henry William Stiegel made this sugar bowl, designed to compete with the English imports after which it was modeled (Winterthur Museum)

60

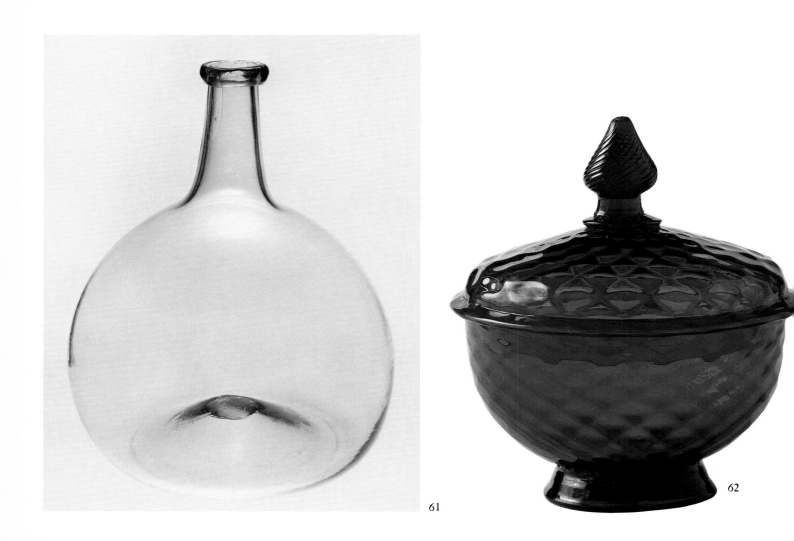

61

62

63, 64 Almanacs and calendars (Winterthur Museum), newspapers and broadsides, pamphlets and certificate blanks, were the daily commerce of the Pennsylvania German printer. Printed certificate blanks were often finished by hand for special occasions, like this one, extensively decorated by Friedrich Krebs as a birth, baptismal, and confirmation record for Abraham Kramer (Franklin and Marshall College, Lancaster)

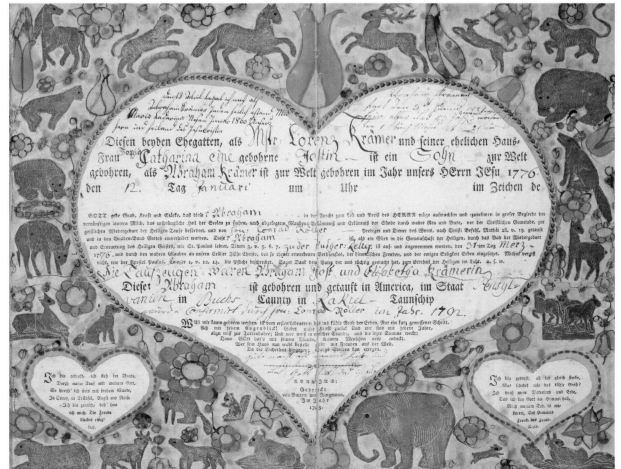

63

64

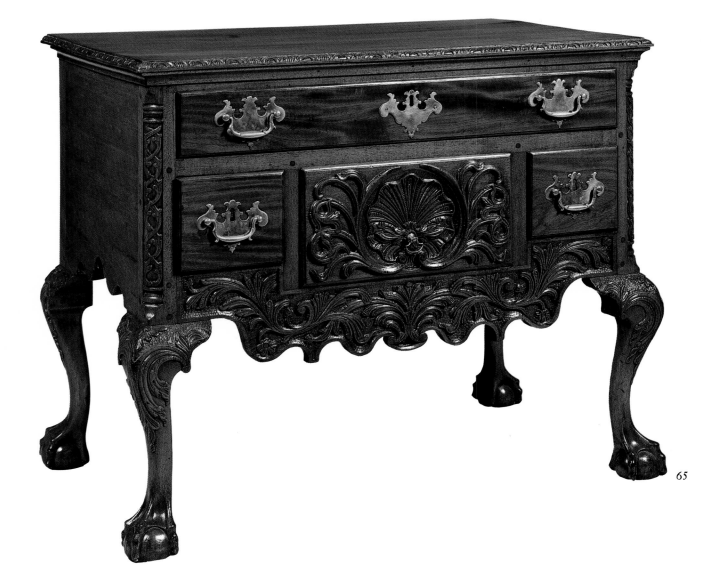

65

65 This dressing table shows the European
heritage of an expert carver (Metropolitan
Museum of Art, New York)

66, 67 The forms of this chest (Winterthur
Museum) and low post bed (Pennsylvania
Historical and Museum Commission) are
typical of the work of Germanic turners and
joiners in Pennsylvania

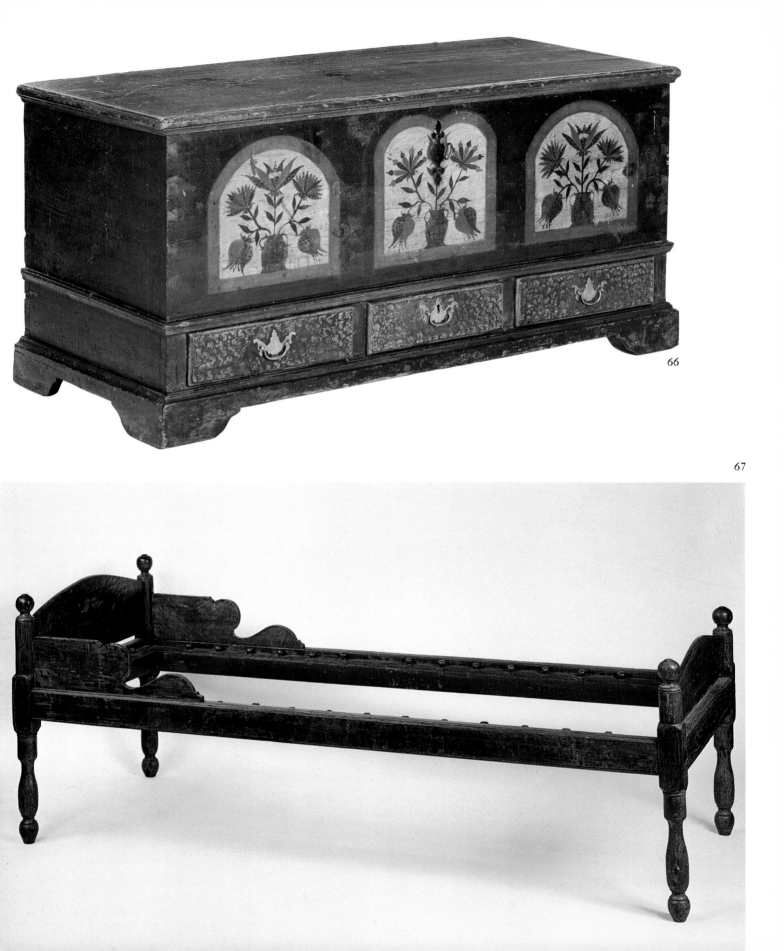

66

67

68

68, 69 Soon after the first Germanic weavers settled in Germantown in 1683, a reputation for the excellence of Pennsylvania German weaving was established. Blue dyers colored threads for checked textiles like this bolster case, and their specialty was patterned resist-dyed, plain woven cloth (both, Collection Dr and Mrs. Donald M. Herr)

69

70

70–72 Traditional patterns were transferred through pattern books (The Free Library of Philadelphia) and weavers "advertised" their products and presented designs through small weaving samples (National Museum of American History, Washington, D.C.). Coverlets woven on Jacquard looms were among the principal wares produced by local weavers (Collection David P. and Susan M. Cunningham)

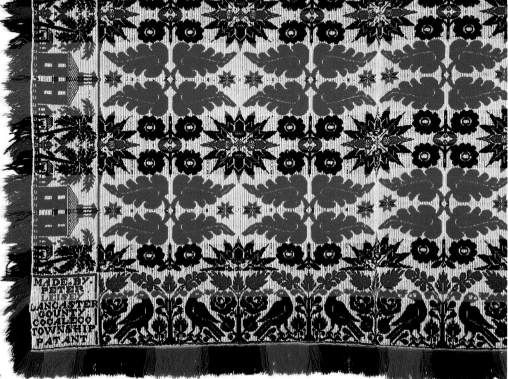

71

72

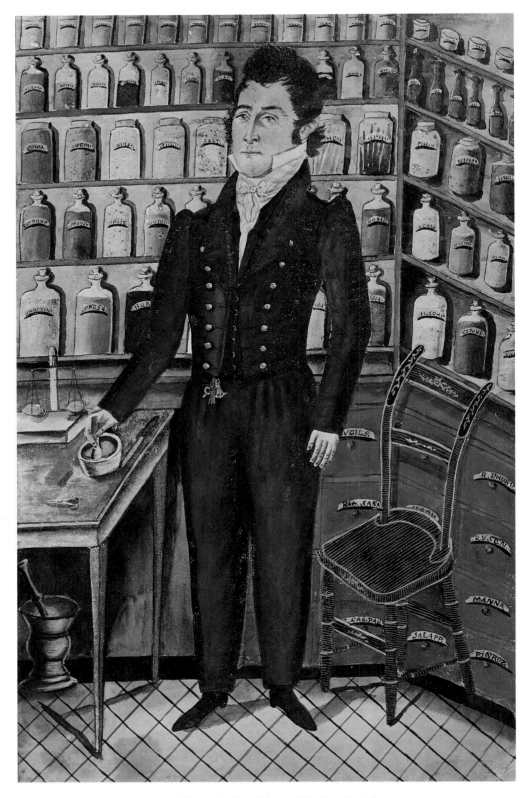

73 The professional doctor, like Dr. Christian
Bucher, was often the local apothecary, shown
here in his Schaefferstown shop (Private
Collection)

Plate 43
WEATHER VANE, 1753
Attributed to Michael Schaeffer
Rockland Township, Berks County
Inscribed: MS 1753
Wrought iron, painted; height 47½" (120.7 cm)
Mr. and Mrs. Brodnax Cameron, Jr.
Checklist 134

Plate 44
CHEST HINGE, 1760–1800
Wrought iron; length 20" (50.8 cm)
Winterthur Museum. G69.2129.1
Checklist 128

Plate 45
BROADAX, 1820–40
Gottlieb Sener (1800–1877)
Lancaster, Lancaster County
Inscribed: EXTRA REFINED G. SENER CAST STEEL LANCASTER
Cast steel, wood; length 23¼" (59.1 cm)
Pennsylvania Farm Museum at Landis Valley: Pennsylvania Historical and Museum Commission. FM24.968
Checklist 126

Plate 46
PAIR OF DOOR HINGES, 1744–80
Attributed to the Hopewell Forge (1744–80)
Union Township, Berks County
Wrought iron; length 11½" (29.2 cm)
Private Collection
Checklist 129

Plate 47
DOOR LOCK, 1822
David Rohrer (1800–1843)
Lebanon, Lebanon County
Inscribed: Made By D. Rohrer 1822
Wrought iron, brass; height 7" (17.8 cm)
Private Collection
Checklist 133

General blacksmiths and those with more precise skills such as axmaker Gottlieb Sener and locksmith David Rohrer were probably the busiest craftsmen in the Pennsylvania German countryside, and those most likely to stay in one place throughout their lifetimes, for local customers came to them for purchases and repairs.*

Inventories often list the iron furnishings of house and farm in some detail and assign them relatively high values. This weather vane, probably made by blacksmith Michael Schaeffer for his own homestead, exhibits the creativity and design sense that Pennsylvania Germans constantly enjoyed and applied to their crafts.

Decorative hinges like these probably were made on special order; the bird motif seen on the door hinge may indicate that it was made under the supervision of William or Mark Bird, who held controlling interests in iron furnaces and forges in Union and Heidelberg townships. The maker of the broadax, Gottlieb Sener, a member of a family of joiners (*see* pl. 65), was classified as a general blacksmith in 1826, but at the time of his death was known as an "ax maker,"† suggesting the development of craft specialization as demand grew.

*See Vernon S. Gunnion and Carroll J. Hopf, eds., *The Blacksmith: Artisan Within the Early Community* (Harrisburg, Pa., 1976), pp. 5–11.
†See Samuel Miller Sener, *The Sehner Ancestry* (Lancaster, Pa., 1896); and Will of Gottlieb Sener, Will Book C, 2, p. 196, Register of Wills, Lancaster County Courthouse, Lancaster, Pa.

Plate 48
MUSICAL CLOCKWORKS, c. 1770
Jacob Gorgas (1728–1798)
Ephrata, Lancaster County
Inscribed: Jacob Gorgas Near Ephrata
Brass, iron, painted; height 19½" (49.5 cm)
Philadelphia Museum of Art. Titus C. Geesey Collection. 54-85-1a,b
Checklist 172

Plate 49
DIVIDING ENGINE, BARREL GROOVER, DIAL SCRIBE, PLANISHER, AND SPRING WINDER,
c. 1760
Attributed to Jacob Gorgas (1728–1798)
Philadelphia or Lancaster County
Iron, brass, wood; barrel groover, height 10½" (26.7 cm)
Private Collection
Checklist 171

Jacob Gorgas, a first cousin of David Rittenhouse (pl. 77), was born in Germantown and may have apprenticed in an English shop in Philadelphia, as his clocks do not have Germanic lantern pinions.* He settled in Ephrata in 1763, where he and his three sons produced clocks with these tools until his death in 1798. This musical movement by Gorgas plays five tunes, including "Now Thank We All Our God," "God Save the King," and "The Doxology"; two have not been identified.

Gorgas may have made these hand-powered tools after his apprenticeship, as was the custom. Each had its separate function within the clockmaking process: the dividing engine cut the required sizes of gear teeth from round, brass blanks; the barrel groover cut the continuous, screwlike grooves around winding barrels, thus forming the guides for the linen cords that held the weights; the dial scribe engraved concentric circles onto the clock's face, in between which numerals were inscribed; the two-handled planisher polished the face; and the spring winder fashioned the tight steel coils used in watches and shelf clocks.

Inventories show that most Pennsylvania German houses had tall case clocks with eight-day movements. Clocks were often the most valuable items in the house, outranking even the bed.† Be-

cause the calendar and almanac (*see* pl. 63) as well as the hours of the day guided the agricultural routine, most clocks owned or made by Pennsylvania Germans were fitted with moon and date dials in addition to minute and hour hands.

*See Beatrice B. Garvan, *The Pennsylvania German Collection: Philadelphia Museum of Art*, Handbooks in American Art, No. 2 (Philadelphia, 1982), pp. 42–43, no. 2, and Biographical Index, "Gorgas, Jacob."

†An inventory of 1778 gives the following comparative valuations: "Books 6 £; Harpsicord 3 £; Walnut Cloath Press 13 £ 10 s; . . . 8 Day Clock & Case 24 £; . . . Joiner tools 3 10s; . . . Old Blue Painted Bedstead 15s." *See* "Inventory of Effects of Christian Weber, Towamencin, 1778," *The Perkiomen Region*, vol. 12, no. 1 (January 1934), p. 22.

Plate 50

SIX-PLATE DRAFT STOVE, c. 1769
Elizabeth Furnace (1757–74), Henry William Stiegel, owner
Elizabeth Township, Lancaster County
Inscribed: H W STIEGEL ELIZABETH FURNACE 1769
Cast iron, wrought iron; height 37″ (94 cm)
Francis G. and William D. Coleman
Checklist 124

The cast-iron stove was the product of the most ambitious and complicated manufacturing process in early America: the mining and refining of iron ore for casting into sand molds for stove plates, large kettles, or pigs. Although the capital for such enterprises was often English and Welsh, the skilled workmen were Alsatian, Swiss, and German, and it was the latter who introduced the fuel-efficient, five-plate jamb stove to Pennsylvania (*see* checklist 122). Benjamin Davies wrote in 1794 that "to lessen the expense of this item [wood] in house-keeping, many of the inhabitants have introduced the use of stoves, a custom borrowed from the Germans, a frugal and industrious people, who compose a numerous class of citizens in Philadelphia."* In letters first settlers had suggested that immigrants bring iron stoves with them, for ceramic models were expensive and not durable in Pennsylvania. Some migrants must have heeded such advice, for one plate from a Zinsweiller five-plate stove made in Alsace was found in the Guth House in Lehigh County, built about 1745.†

The German immigrant Henry William Stiegel made five-, six-, and ten-plate (checklist 125) cast-iron stoves. The six-plate draft stove, like this one, came in three sizes, which sold for two pounds, five shillings; three pounds; and five pounds. Valuable household furnishings, stoves were often bequeathed in wills and usually inventoried.‡

The molds for stove-plate decorations were of carved wood. John Krauss of Montgomery County noted on December 5, 1809, that he had "finished some [stove-plate] patterns . . . [and] brought them to Udris Furnace."§ The designs for this stove, especially the wreathed portrait on the side, presumably of Stiegel, may have been adapted from the English silver half crown of 1696–1700, which showed William III on the obverse, or from the raised decoration on imported cast-bronze cannons.

*Quoted in Theodore W. Bean, ed., *History of Montgomery County, Pennsylvania* (Philadelphia, 1884), p. 765.

†Melville J. Boyer, "Rare Zinsweiller Stove Plate," *Proceedings of the Lehigh County Historical Society*, vol. 15 (August 1946), p. 52, repro. p. 53.

‡*See* "Last Will and Testament of David Longacre," *The Perkiomen Region*, vol. 13, no. 1 (January 1935), p. 43.

§"Account Book of John Krauss," *The Perkiomen Region*, vol. 12, no. 2 (April 1934), p. 82.

Plate 51

TRADE CARD, 1814–37
Attributed to William Heiss, Sr. (c. 1784–1846)
Philadelphia
Inscribed: WILLIAM HEISS. Copper Smith & Plate Maker No. 213 North Second Street Philadelphia. William Heiss Copper Smith No. 213 North Second Street Philadelphia.
Engraving; 5¾ x 4¾″ (14.6 x 12.1 cm)
Rockford-Kauffman Museum, Lancaster, Pennsylvania
Checklist 155

Plate 52

KETTLE, 1814–55
William Heiss, Sr. (c. 1784–1846) or William Heiss, Jr. (c. 1812–1858)
Philadelphia
Inscribed: W. HEISS NO. 213 NORTH 2D. ST. PHILAA.
Copper, tin; height 8⅝″ (21.9 cm)
Rockford-Kauffman Museum, Lancaster, Pennsylvania
Checklist 154

Pennsylvania German craftsmen, particularly specialists like coppersmiths, settled and worked in urban centers side by side with their English neighbors and for the same markets. This interrelationship is reflected in the Heiss trade card with its English-style copperplate script and its elaborate lettering and calligraphic flourishes found in Germanic illuminated manuscripts. The handsome, tin-lined copper kettle by Heiss is exactly like those manufactured by other craftsmen—English and German—for the American market. However, by the early nineteenth century, most metalsmiths, especially copper- and tinsmiths, in the older eastern Pennsylvania settlements were being affected by competition from abroad. The 1820 Census of Manufactures reported a "depression caused by foreign imports & public sales" in Philadelphia. Yet in contrast, P. and S. Mechling, makers of stills, boilers, copper kettles, and tinware in Armstrong County, said their work was "increasing & in a more flourishing condition than heretofore—business just begun, good demand,"* evidence that the newer western communities were able to attract *and* sustain craftsmen at a time when the older eastern areas were facing economic difficulties.

*United States, Department of the Interior, 1820 Census of Manufactures, pp. 583, 120.

Plate 53
YEARLY MARKET IN YORK, after 1816
Lewis Miller (1796–1882)
York, York County
Inscribed: In 1801. march 4. the administration of Thomas
 Jefferson Commenced in York the bury the Black Cock-
 ade. riband worn on the hat. democrationl by George
 Spangler. Freid Rockey. Conrad Welshans. Henry
 Weiser Salmon Myer. michael Edward. at furry's tavern.
 John Sturd. John Stroman. John Weyer . . . Yearly
 Market, or publick fare. Held in the Borough of York,
 June 9th 1801, the had privilege of a Stated yearly
 market. . . .
Ink and watercolor on paper; 9¹³⁄₁₆ x 7⁹⁄₁₆″ (24.9 x 19.2
 cm)
The Historical Society of York County, York, Pennsyl-
 vania. 1-9
Checklist 192

"The Germans in Pennsylvania have a custom amongst them,
which they observe with religious care—this is called a Fair, which
they hold twice a year. . . .

"The first thing I heard in the morning was music in the bar-
room; being informed of the occasion, I stepped to the bar-room
door, and there sat two young men playing on violins, and two or
three young men and women sitting on a long bench and three or
four others dancing. . . .

"While I remained there, the young men and women poured
into the bar-room—the men threw off their cloaks, the ladies . . .
threw off their shawls and bonnets, and to dancing they went.
This was continued till night set in—the bar-room! . . . Nothing,
however, could exceed the grace of the females. The men did not
dance so well, yet they danced well for people who worked, as
doubtless they were all farmers' sons; but the females hopped light
as a feather. . . . They danced two, three, and four couple; the
women, as in olden times, would cut out and fairly dance the men
down. The girls conversed little or none, and were few, I was told,
could speak English—the young men were more gay and lively;
but the room, at length, became so full, that they had scarcely
room for more than one or two to dance at a time.

"Meantime there is market at the market-house, and everything
that can be mentioned, either to eat or to drink, can be found
there; and there the parties hie, and the sweetheart treats his fair
one to the best. . . . Every young lady has the privilege (as in
Christmas and New Year presents) to ask the young man to give
her a 'Fairing,' meaning a present—this is pronounced in the Ger-
man language. The whole is a scene of throng, mirth, and gaiety."*

The Pennsylvania German fair such as that described was much
more than a social event for the young. Important business con-
nections were established, a year's worth of orders for pottery or
furniture was placed, and journeymen's services were procured.
When the three days of business were finished, everyone in at-
tendance feasted and frolicked, as seen in this depiction of the
public fair held on June 9, 1801. At the bottom of this drawing,
the artist Lewis Miller added: "In 1816, the[y] prohibited the
holding of fairs within the Borough of York, and declared Such
holding a common nuisance."

*Quoted in J. Bennett Nolan, *Early Narratives of Berks County*
(Reading, Pa., 1927), pp. 183–85.

Plate 54
BUTTER PRINT, 1800–1850
Lancaster County
Inscribed: ELIZA BETh GOOD FRESh BUTTER, TASTE IT.
 TOWN SHIP H+B
Hardwood, probably walnut; length 9¼″ (23.5 cm)
Pennsylvania Farm Museum at Landis Valley: Pennsyl-
 vania Historical and Museum Commission. F8.415
Checklist 327

Plate 55
FIELD BASKET, 1800–1850
Oak splints; height 13″ (33 cm)
Jeannette Lasansky
Checklist 322

Plate 56
BUTTER BOX, c. 1800
Montgomery County
Inscribed: G. REIFF
Walnut; width 15¼″ (38.7 cm)
Philadelphia Museum of Art. Gift of Mrs. William D.
 Frishmuth. 02-158
Checklist 61

Butter was a popular market item in rural and urban communities,
for not everyone had cows and many relied solely on the weekly
market for their supply. Butter boxes—often made in pairs—were
divided into three sections, with a sliding panel over each. The
butter was wrapped in cloth for further protection, and about
twenty pounds could be carried to market in this box. Some sym-
bols on the prints used to stamp butter may have been supposed to
ward off the evil spirits that could sour butter, but this butter print
is clearly an advertisement for the product of H+B in Elizabeth
Township, Lancaster County.

Most other produce went to market in baskets. This example
made of oak splints in a ribbed structure is designed with hand-
holds below the rim instead of a loop handle to increase the car-
rier's control of a heaping load of apples, potatoes, or beans.

Plate 57
FLINTLOCK RIFLE, 1761
John Schreidt
Reading
Inscribed: John Schreidt 1761
Maple, iron, brass; length 58¾″ (149.2 cm)
Mr. and Mrs. Charles Frederick Beck
Checklist 159

A British soldier fighting in America in 1775 referred to his Penn-
sylvania German opponents as those "shirt-tail men with their
cursed twisted guns . . . —the most fatal widow-orphan-makers in
the world."* The Pennsylvania, or Kentucky, rifle the colonials
carried was a hybrid American invention, which combined the
elaborate carved gunstock and sliding patch-box lid found on the

German jaeger gun with the long and lightweight barrel of the English fowling piece.† In the American model the rifle's caliber was decreased and barrel lengthened. The decorative enrichment of the stock, wrist, and patch box of such guns became highly developed among the Pennsylvania German gunsmiths.‡ This example is the earliest dated Kentucky rifle known. It has a rifled barrel, which had been familiar in the Austrian Tirol long before it was known in the rest of Europe, and the especially early features of engraved chevron grooving, incised stock embellishment, and sliding, wooden patch-box lid. The maker of this rifle, John Schreidt, son of Engelberd and Hannah, arrived in Philadelphia in 1731. In 1758 he owned a town lot in Reading, where he remained until 1777, when he moved to Cocalico Township, Lancaster County.

*Quoted in Russell Wieder Gilbert, *A Picture of the Pennsylvania Germans*, Pennsylvania Historical Studies, no. 1, rev. ed. (Gettysburg, Pa., 1958), p. 27.

†*See* Joe Kindig, Jr., *Thoughts on the Kentucky Rifle in Its Golden Age* (York, Pa., 1960), pp. 25–31.

‡*See* Merrill Lindsay, *The Kentucky Rifle* (New York, 1972), nos. 1–38.

Plate 58
 SIDESADDLE, 1818–42
 Emanuel Schaeffer (1793–1864)
 Lancaster, Lancaster County
 Inscribed: PA [illegible] & SADDLES [EMA]NUEL [SC]HAEFFER SADDLE [illegible] BRIDLE [HAR]NESS & TRUNK [illegible] ACT [illegible] ER [illegible] of KIN[G] & Cen[ter] Square LANCASTE[R] [paper label]
 Leather, iron, woven cinch; height 35″ (88.9 cm)
 Lancaster County Historical Society, Lancaster, Pennsylvania. Gift of Robert E. McMurtrie, 1972. 72.22
 Checklist 328

The Pennsylvania Germans were proficient in the various skills of leather processing, from tanning to the fabrication of fine saddlery like this sidesaddle. For example, one branch of the Leidy family of Montgomery County potters (*see* checklist 13, 14) were tanners as early as 1750, and to the present day continue to work as pork butchers. The growing township of East Penn, Northampton County, was able to support three saddlers, twenty shoemakers, and six hatters by 1810.* In Montgomery County in 1820 there were forty-two men, twenty-four boys and girls, and twenty-six bark mills occupied in tanning.† There were nine saddlers working in the borough of Lancaster in 1830.

Saddles and harnesses were valuable possessions and frequently listed in inventories. However, trunks and other leather items like breeches were rarely itemized, although leatherworkers like Emanuel Schaeffer, whose paper label appears on this saddle, must have had daily commerce in such objects. Apprenticed to his trade at age fifteen, Schaeffer, after working as a journeyman, finally earned his own shop in 1815. He became a prominent Lancaster citizen, serving as president of the city council for thirteen years, and gaining appointment to the Lancaster County Court of Common Pleas in 1842.‡

See United States, Department of the Interior, 1810 Census of Manufactures.

†*See* United States, Department of the Interior, *Fourth Census, 1820*, book 2, *Digest of Accounts of Manufacturing Establishments in the United States and of Their Manufactures* (Washington, D.C., 1823), p. 16.

‡*See* Mrs. James D. Landis, "A Revolutionary Patriot and His Worthy Grandson," *Historical Papers and Addresses of the Lancaster County Historical Society*, vol. 19, no. 7 (1915), pp. 195–99.

Plate 59
 ROOF TILES, 1760–1800
 Berks and Montgomery counties
 Red clay, unglazed; average height 14″ (35.6 cm)
 John and Rosamond Moxon
 Checklist 31

Redware roof tiles were manufactured from the time of the earliest German settlements in Pennsylvania. The thick clay deposits necessary for making tiles were found all over southeastern Pennsylvania under the rich, limestone-based topsoil sought by the Pennsylvania Germans as the best farmland. In 1743 Georg Adam Weidner of Oley, Berks County, advertised in Christopher Saur's Germantown newspaper for a workman for his tile kiln. Johann Grothausz advertised for sale in 1757 "a plantation three miles above Germantown, in Springfield [Montgomery County] whereon there has been a tile kiln for a long time."*

Ceramic roof tiles had been a traditional roofing material in Europe and were a staple of the Pennsylvania German potter's enterprise. Made to order in large batches, some tiles, like these, were specially decorated as presentation pieces or good-luck wishes in the Old World tradition. Unlike Europe, however, Pennsylvania yielded a plentiful supply of wood on each homestead's wood lot, and split wood shakes replaced the heavier ceramic material as roof coverings.

*Quoted in Edward Hocker, "Extracts from German Newspapers," 1935, pp. 1, 66, typescript, Historical Society of Pennsylvania, Philadelphia.

Plate 60
 DISH, c. 1840
 Daniel Dry (1811–1872)
 Dryville, Rockland Township, Berks County
 Inscribed: D. Dry
 Earthenware with slip decoration, clear lead glaze; dia. 10 1/16″ (25.6 cm)
 William Penn Memorial Museum, Harrisburg: Pennsylvania Historical and Museum Commission. 28.8.1
 Checklist 5

The Dry Pottery, in operation by 1804, was a typical regional Pennsylvania German enterprise. John Drey had taken over an existing operation, the Melcher Pottery, and together with his three sons, Daniel, Nathaniel, and Lewis, supplied the area with jars, sieves, bowls, mugs, molds, and baking dishes, as well as whistles (checklist 4) and clay pipes. Such small businesses were managed within the farming schedule, which determined when there was time for the practice of an extra craft.

The 1820 Census of Manufactures reveals that redware potters in eastern Pennsylvania were suffering stiff competition from imported "white Englishware," and potter Adam Gudekunst in Northumberland County reported his trade "30 percent worse than 3 years ago"; further west, however, away from foreign competition, Mercer County potters could say that "demand [was] good."* Yet even in the east the small pottery could survive most economic fluctuations, for its production was relatively small, and much of a kiln load was committed for sale before the firing.

*United States, Department of the Interior, 1820 Census of Manufactures, pp. 566, 994, 421.

Plate 61
BOTTLE, 1798–1813
Attributed to Johann Baltasar Kramer
New Geneva–Greensboro Glass Works
Free-blown nonlead glass; height 10⅞" (26.5 cm)
Waynesburg College Museum, Waynesburg, Pennsylvania
Checklist 46

Plate 62
SUGAR BOWL, 1765–74
Attributed to Henry William Stiegel (1729–1785)
Manheim, Lancaster County
Blown pattern-molded glass; height 5⅛" (13 cm)
Winterthur Museum. 59.3299a,b
Checklist 43

Early glass manufacturing in Pennsylvania was dominated by Germans and Swiss, who were both owners and workers. Essential in architecture and desirable for domestic storage, glass was available in eastern Pennsylvania only by importation until 1739, when Caspar Wistar, from the Heidelberg area of Germany, established the United Glass Company in Salem County, New Jersey.* Until 1763, when Henry William Stiegel began to make glass at his Elizabeth iron furnace, the Wistars supplied many Pennsylvania German buildings with window glass. In 1765, in a response to the Nonimportation Agreements, Stiegel opened his first Manheim glasshouse, and in 1769 his second one, producing table glass, like this sugar bowl, modeled after and designed to compete with English imports (checklist 41, 42, 44). When Stiegel's Manheim factory failed in 1774, a group of his workers, including Johann Baltasar Kramer, went to Maryland and founded another enterprise.† In 1797 Kramer and other former Manheim workers left Maryland to join Albert Gallatin's New Geneva Glass Works in Fayette County (pl. 42). By 1800 Gallatin had pulled out of the business and the remaining partners, including Kramer, moved the factory to Greensboro in Greene County.‡ There the glassworks continued to produce glass for an ever-expanding western population. Bottles like this one were used and reused, for fermented liquor was a medium of exchange in the early nineteenth century in western Pennsylvania.

*See Arlene M. Palmer, *The Wistarburg Glassworks: The Beginning of Jersey Glassmaking* (Alloway, N.J., 1976).

†See Dwight P. Lanmon and Arlene M. Palmer, "John Frederick Amelung and the New Bremen Glassmanufactory," *Journal of Glass Studies*, vol. 18 (1976), pp. 18–19, 39, 41.

‡See Lowell Innes, *Pittsburgh Glass 1797–1891: A History and Guide for Collectors* (Boston, 1976), pp. 12–40.

Plate 63
ALMANAC FOR 1811, 1810
Johann Ritter and Company, publishers
Reading
Inscribed: Der Neue Readinger Calender. 1811. Reading, gedruckt bey Johann Ritter und Comp.
Letterpress and wood engraving; 8½ x 6¾" (21.6 x 17.1 cm) (book)
Winterthur Museum. 69.2203
Checklist 247

Plate 64
BIRTH, BAPTISMAL, AND CONFIRMATION RECORD FOR ABRAHAM KRAMER, 1793
Barton and Jungmann, Reading, printers; decoration attributed to Friedrich Krebs
Probably Bucks County
Inscribed: . . . READING: Gedruckt von Barton und Jungmann, Im Jahr 1793. . . .
Letterpress, with applied paper cutouts, watercolor, and ink; 13⅛ x 16⁄₁₆" (33.3 x 40.8 cm)
Franklin and Marshall College Collections, Lancaster, Pennsylvania. 3110
Checklist 245

Newspapers, almanacs, broadsides, Bibles, hymnals, primers, pamphlets, and religious certificate blanks were the daily commerce of the Pennsylvania German printer. Presses flourished in most Pennsylvania German towns of any size, with centers of intense activity in Germantown (the Saurs), Lancaster County (the Ephrata Brotherhood Press and the Baumanns), Philadelphia (Benjamin Franklin, Michael Billmeyer, and Johannes Henrich Miller), Reading (Johann Ritter), and Carlisle (Moser and Peters).* With the exception of Franklin, who printed in German only as a sideline to fill the early need, the others were primarily German-language printers.

Almanacs were daily reference material that helped determine when to plant, when to sink the fence posts, when to churn the butter. Eclipses, saints' days, zodiac signs, medicinal recipes, and court sittings were combined with moralistic stories and foreign and local news items in these yearly publications.

As one of the most prolific printers in Reading, Johann Ritter, the publisher of this almanac, was influential in the diffusion of ideas and designs across Pennsylvania. Another Reading printing firm, Barton and Jungmann, made the blank for this decorated fraktur to the order of Friedrich Krebs. Krebs is known to have ordered hundreds of blanks which he then decorated and sold, to be filled in after the appropriate ceremonies. Most decorators

simply added freehand drawings around the edges or colored in the printed designs. Krebs, however, gave this fraktur a special touch when he cut out the animal motifs from a piece of embossed Dutch gilded paper and then colored and pasted them onto the printed form.†

*For a list of printers, see Donald A. Shelley, The Fraktur-Writings or Illuminated Manuscripts of the Pennsylvania Germans, Pennsylvania German Folklore Society, vol. 23 (Allentown, Pa., 1961), pp. 182–86.

†For another example, see ibid., pl. 88.

Plate 65
DRESSING TABLE, 1770–80
Lancaster County
Mahogany, tulip; height 29½″ (74.9 cm)
The Metropolitan Museum of Art, New York. John Stewart Kennedy Fund, 1918. 18.110.2
Checklist 98

In the eighteenth century there was probably greater variety available in the furniture market in Lancaster County than there was in Philadelphia. Both Germanic and English joiners worked together in urban shops or singly in more isolated situations to produce traditional Germanic, hybrid German-English, and straight English forms. This dressing table is an English form and is constructed with English techniques. However, the carving, its most distinguishing feature, resembles eighteenth-century work done in Lorraine, France, Hesse, and earlier, around Württemberg.* Circumstantial evidence about the Sener family of joiners suggests that they may have contributed to the development of the Lancaster school of carving. Gottlieb Sener was born in 1721 in Württemberg, where he trained as a house carpenter and joiner, settling in Lancaster in 1749. His five sons became prominent joiners in Lancaster and worked in other shops as well: Gottlieb (born 1751) and Jacob (1757–1798) were in John Baughman's shop (pl. 28) in Conestoga Township in 1775–76.†

Carving similar to that on this table is seen on several wardrobes‡ and on English-style furniture attributed to the Lind family of Lancaster (pl. 78).§ Similar English joinery techniques—unwedged dovetails and drawers nailed at the back—are found on other English-style case pieces from the Lancaster area (see pl. 28), suggesting that both continental decorative carving and English construction methods were standard practices in versatile Lancaster shops.

Other regional carving such as that attributed to Peter Arnd of Jonestown, Lebanon County,** is somewhat crude in comparison, evidence that the demand for and thus the quality of carved decoration did not develop in the Germanic shops outside Lancaster where painting was the more popular embellishment. There does seem to have been at first a direct transfer of a vigorous European carving style to Pennsylvania, concentrating in Lancaster, probably within the Sener family. However, this style lost its distinctive regional identity before 1800, becoming little more than a reflection of English carving as practiced in Philadelphia.

*See Lucile Oliver, Mobilier Lorrain et Ardennais (Paris, n.d.), repro. pp. 18, 31, 51, 53; and Erich Klatt, Die Konstruktion alter Möbel: Form und Technik im Wandel der Stilarten (Stuttgart, 1961), repro. pp. 52, 54, 56, 57.

†See John J. Snyder, Jr., "Chippendale Furniture of Lancaster County, Pennsylvania" (M.A. thesis, University of Delaware, 1976), pp. 16–17.

‡Examples are in the Hershey Museum of American Life, Hershey, Pa.; the Golden Plough Tavern, York, Pa. (Historical Society of York County); and various private collections.

§See John J. Snyder, Jr., "Carved Chippendale Case Furniture from Lancaster, Pennsylvania," Antiques, vol. 107, no. 5 (May 1975), p. 967, figs. 9–12, pp. 972–74.

**Information from Samuel E. Dyke, President, Lancaster County Historical Society, Lancaster, Pa.

Plate 66
CHEST, 1790
John Ranck (1763–1828)
Jonestown, Bethel Township, Lebanon County
Inscribed: Johannes Ranck 1790
Pine, painted; height 25″ (63.5 cm)
Winterthur Museum. 67.783
Checklist 78

Plate 67
BEDSTEAD, 1770–1820
Lancaster County
Pine, poplar, maple, painted; height 28½″ (72.4 cm)
Pennsylvania Farm Museum at Landis Valley: Pennsylvania Historical and Museum Commission. F7.997
Checklist 50

This chest and bedstead are typical products of Pennsylvania German turners and joiners. Account books suggest that the bed was the furnishing in greatest demand. The records of Peter Ranck, who like his brother John, was a joiner in Jonestown, Lebanon County, list the price of a "pitstoot," or bedstead, as between one pound and one pound, five shillings, in 1797.* In 1825 Jacob Landes of Bedminster Township, Bucks County, made beds costing between three dollars and five dollars per pair.†

The smoothly turned, bulbous posts on this bed suggest that it was made by a skilled turner. Most chests, on the other hand, with their plank construction could have been fashioned by householders with general woodworking skills. The encased drawer construction of this chest, however, required the specialized skills of joiner John Ranck.

Although most Pennsylvania German households had one or more chests, the box form made most often by the carpenter-joiner was the coffin. Peter Ranck's "coffinchs" sold for between one pound, twelve shillings, sixpence, and three pounds, seventeen shillings, sixpence; his chests cost from one pound, ten shillings, to two pounds, five shillings. Accounts note the additional cost of fine coffin hardware but rarely itemize the locks and hinges on chests. Most furniture was sold individually, but occasionally several items were ordered at one time; in 1800 John

Leman paid Peter Ranck eight pounds, four shillings, for three bedsteads, three tables, two chests, and a dough trough.‡

Pennsylvania German furniture was often painted and sometimes decorated, probably in the maker's shop. This finish, however, is rarely noted in accounts or inventories beyond designations such as "brown" or "blue." Christian Weber's inventory is typical: "Walnut Cloath Press 13£ 10s; Blue cubberd with glass doors 3£, 10s; . . . Old Blue Painted Bedstead 15s."§

*See Alan G. Keyser, Larry M. Neff, and Frederick S. Weiser, eds. and trans., *The Accounts of Two Pennsylvania German Furniture Makers—Abraham Overholt, Bucks County, 1790–1833, and Peter Ranck, Lebanon County, 1794–1817* (Breinigsville, Pa., 1978), pp. 60–65.
†*See* Account Book of Jacob Landes, 77x374.1, Joseph Downs Manuscript and Microfilm Collection, Winterthur Museum Library.
‡*See* Keyser, Neff, and Weiser, eds. and trans., *Accounts,* p. 90.
§"Inventory of Effects of Christian Weber, Towamencin, 1778," *The Perkiomen Region,* vol. 12, no. 1 (January 1934), p. 22.

Plate 68
CLOTH FRAGMENT, 1780–1850
Southeastern Pennsylvania
Linen, resist dyed; width 19″ (48.3 cm)
Dr. and Mrs. Donald M. Herr
Checklist 269

Plate 69
BOLSTER CASE, 1800–1850
Eastern Lancaster County
Linen, cotton; width 23″ (58.4 cm)
Dr. and Mrs. Donald M. Herr
Checklist 291

Germanic weaving and its reputation for excellence were established in Pennsylvania with the settlement of weavers from Krefeld at Germantown in 1683. After the first season's flax crop, these craftsmen began to supply Philadelphia with basic linens, and, before long, with fine lawns, Hollands, and linen damasks, which had continued to be imported. Pennsylvania German weavers were taxed as professionals. Beginning in 1785 census and tax records show concentrations of weavers in areas where their raw materials grew plentifully. Local households prepared flax or wool through the spinning stage and delivered a predetermined amount of thread to a weaver for fashioning into a finished product, such as this bolster case in a sixteen-shaft point twill,* a traditional weave found in bed casings in Germany and Austria.

Colored textiles were popular among the Pennsylvania Germans. Wool or flax was taken to the "bleu dyer," who dyed the yarn or thread for blue-checked textiles like this bolster cover. His specialty was blue resist-dyeing plain-weave textiles like this fragment, probably a piece of a bed curtain.

*For explanations of this and other weaving terms, *see* Dorothy K. Burnham, *Warp and Weft: A Textile Terminology* (Toronto, 1980).

Plate 70
PAGE OF WEAVER'S PATTERN BOOK, 1816
Peter Leisey (1802–1859)
Cocalico Township, Lancaster County
Inscribed: Peter Leisey 1816 Benedict Bucher
Ink on paper; 3¹³⁄₁₆ x 6½″ (9.7 x 16.5 cm) (book)
The Free Library of Philadelphia. Rare Book Department
Checklist 272

Plate 71
WEAVER'S SAMPLE, after 1809
Attributed to Peter Stauffer (1791–1868)
Isabella, West Nantmeal Township, Chester County
Wool, cotton; width 17¾″ (45.1 cm)
National Museum of American History, Smithsonian Institution, Washington, D.C. Division of Textiles. T.14234 Acc206911
Checklist 276

Plate 72
COVERLET, 1835–50
Peter Leisey (1802–1859)
Cocalico Township, Lancaster County
Inscribed: MADE BY PETER LEISEY LANCASTER COUNTY COCALECO TOWNSHIP PATANT
Wool, cotton; width 78″ (198.1 cm)
David P. and Susan M. Cunningham
Checklist 278

Joseph Leisey was an eighteenth-century German immigrant who was indentured to John Bucher and became a weaver. Leisey's six sons also became weavers. Joseph's pattern book (checklist 271) diagramed point twills, diaper twills, damask diapers, and double weaves, some of which were transcribed into his son Peter's pattern book. Thus were the skills and popular, traditional weaving designs transferred down through generations or carried west in the pockets of migrants. This coverlet woven by Peter Leisey on a Jacquard loom appears in draft in his pattern book; its typical Lancaster County pattern of four ground warps to one tie-down warp produced the ribbed effect of the background.

The weaver's sample piece attributed to Peter Stauffer, who worked in neighboring Chester County, shows one of the Pennsylvania Germans' adaptations of small-scale patterns from Johann Michael Kirschbaum's *Neues Weberbild und Musterbuch* (Heilbronn, 1771). Here Stauffer has altered the point-twill tie-up weave into an expanded twill, sometimes called "multiple-shaft star and diamond" or "Germanic expanded twill." This original technological contribution to weaving traditions in Pennsylvania enlarged designs and created a stronger textile suitable for bedcoverings,* thus enabling the Pennsylvania Germans to hold their markets over time.

*Research and analysis by Janet Gray Crosson, Patricia Herr, and Alan G. Keyser. *See also* Gay McGeary, "Expanded Point Twill," *Interweave,* vol. 4 (Summer 1979), pp. 37–38.

Plate 73

PORTRAIT OF DR. CHRISTIAN BUCHER, 1830–35

Attributed to Jacob Maentel (1763?–1863)

Probably Lebanon County

Watercolor on paper; 16¾ x 10¼" (42.5 x 26 cm)

Private Collection

Checklist 184

Five generations of the Bucher family from the Swiss canton of Bern provided medical services to Lebanon and Lancaster counties, where the professional doctor was also often the local apothecary. Dr. Christian Bucher (1796–1860) was born in Cornwall Township, Lebanon County, and established his office on Main Street in Schaefferstown, where he practiced for many years. He also served as the town's postmaster during the Franklin Pierce administration. He married Mary Valentine (1803–1884), the grandniece of Henry William Stiegel. Their three sons also practiced in Schaefferstown.* Buchers were known as merchants as well as doctor-apothecaries. In this portrait Dr. Christian Bucher's proud stance amid his obviously successful and well-stocked shop illustrates the fact that Pennsylvania Germans turned to local professionals—doctors, lawyers, surveyors—for specialized services.

*See Charles M. Zerbe, *Annals of Schaefferstown, with Some Reference to the Early Jewish Community*, Papers and Addresses of the Lebanon County Historical Society, vol. 4, no. 10 (1907–9), pp. 309–10.

Good Neighbors

IN NO OTHER COLONY and probably in no other state prior to 1850 was there as much potential for conflict between two major cultural groups—English and German—as existed in Pennsylvania. By 1790, the German-Swiss population of Pennsylvania was one-third of the total for the state. In the southeastern region it was as high as forty percent.[1] Benjamin Franklin, probably the first English writer to refer to Germans as Pennsylvania Dutch, summarized Englishmen's concern and resentment in his *Observations Concerning the Increase of Mankind*, written in 1751 but not published until 1755: "Why should the *Palatine Boors* be suffered to swarm into our Settlements and, by herding together, establish their Language and Manners to the Exclusion of ours? Why should *Pennsylvania*, founded by the *English*, become a Colony of *Aliens*, who will shortly be so numerous as to Germanize us instead of our Anglifying them, and will never adopt our Language or Customs any more than they can acquire our Complexion?"[2]

Forgetting for the moment that his English sovereign was of the house of Hanover, however, Franklin did reflect the amazement, frustration, puzzlement, prejudice, and suspicion of both Englishmen and Germans when confronted by differences in language, food preference, religion, dress, as well as other seemingly formidable barriers to understanding. On the German side, diaries and journals repeatedly mention the Pennsylvania Germans' preference for "German" rather than "English" inns. Aside from being more comfortable in every sense of that word, Germans could avoid experiences similar to Pastor Henry Melchior Muhlenberg's in 1742, shortly after his arrival in Pennsylvania: "I had to stop off again at an English inn on account of the horse I had hired. The innkeeper took me into a room where were sitting a number of Englishmen who put on airs of being men of *condition*. As soon as I came in, they asked me whether I was a *Moravian*, a *Lutherien* [sic], a *Calvinist*, or a *Churchman*. I gave them a reprimand and said they must learn better manners and not welcome strangers with such questions. They apologized."[3]

Pastor Muhlenberg constantly referred to Germans who had been "debauched" by English masters or wives. In 1762, he performed a marriage ceremony for John Nicholas Hunter, a widower, and Elizabeth, daughter of Adam Tatz. Hunter had to swear before witnesses that he would send his wife for instruction and confirmation "because she had been in the service of English Quakers, had forgotten the German language, and had not learned anything."[4] A year later, Muhlenberg described the ruination and death of Thomas Meyer, who was born in the Palatinate in 1709 and immigrated in 1732. While his first wife, Catharine Uterich, was alive Meyer was "a well-to-

do man," but his second wife was "an English person." The result: "He was ruined completely, had difficulty in making ends meet," and suffered hunger and privation.[5]

Even facing a common enemy did not always help to allay mistrust between the two groups. During the American Revolution, James McMichael, a Scotch-Irish lieutenant from Lancaster County, encountered German-Americans residing in Northampton and upper Philadelphia counties. McMichael reported that the Germans considered him a "barbarian," and he acknowledged that he returned their opinion in kind.[6]

Even without the necessity for the two societies to coexist on the same turf, the diverse geographical backgrounds and religious beliefs of Germans themselves in Pennsylvania could have provided plenty of sparks to fire conflict. Coming from all over central and western Europe, immigrants had often passed through two or more settlements on the Continent before finally braving the crossing to America. In terms of numbers, Lutherans and German Reformed had the majority of adherents. Minority denominations included Mennonites, Dunkards, Moravians, Schwenkfelders, and Roman Catholics. But differences can be overemphasized; common bonds of language and economic and political goals were strong unifying factors for Germans in Pennsylvania. With the exception of the Roman Catholics, whose numbers were very small, the various German sects shared the basic premises of Protestant theology. As James Lemon notes in *The Best Poor Man's Country*, where interaction among German groups was common, members of various religious sects cooperated and even praised other individuals.[7]

Educated, well-to-do German immigrants in Pennsylvania were usually bilingual even from the earliest settlement in the colony. Those who were involved in crafts and trade learned to speak English. Benjamin Rush, eminent Philadelphia physician, stated in 1789 that while "the intercourse of the Germans with each other, is kept up chiefly in their own language; . . . most of their men who visit the capital, and trading or country towns of the state, speak the English language."[8] At the Hershey Museum of American Life in Pennsylvania is an agreement made in the 1760s between the parents of a German boy and a tailor in nearby Lancaster. The terms of apprenticeship stipulated that the boy was to be educated at the "English schule." It is to be hoped that the lad did not suffer the fate reported by Pastor Muhlenberg of a girl "bound out to English people for a term of six years and seven months": She was to have been instructed in reading and writing but when her term had elapsed, she had received no instruction. Ever dismal on the subject, Muhlenberg stated: "Because I know a little English, I am plagued by poor German folk to do all kinds of writing in addition to my other burdens."[9]

Many German craftsmen and tradesmen did learn to speak, read, and write in English. Abraham Overholt (1765–1834), a Bucks County joiner, kept his records in a hybrid of Pennsylvania Dutch and Pennsylvania High German learned at a Mennonite parochial school. Peter Ranck (1770–1851), a joiner

active about the same time in Lebanon County, kept his accounts in poor English, which was probably no worse than the German of his English counterparts.[10] The gradually increasing use of English by people of all nationalities in the colonies and the predominance of the German dialect spoken in the Palatinate had changed High German drastically by the time of the American Revolution. A Hessian officer wrote home in 1778 that "our loved mother tongue is completely Anglicized in this colony, and will soon be transformed into what may be called 'the Pennsylvania language,' which will be unrecognizable by either Germans or English."[11]

Although surviving records and modern histories often emphasize the tensions between Germans and Englishmen in Pennsylvania, there is much evidence that they accepted each other and were willing to accommodate. In 1763, Pastor Muhlenberg thanked Chief Judge Allen "for his faithfulness and good will toward our German nation." More importantly, he entrusted Allen with the supervision of his three sons on the first leg of their journey to be educated in Germany. In 1779 Muhlenberg's daughter, Maria Swaine, gave birth to her first son and named him George Washington Swaine. In the same year, the English commissary Elisha Davis came to the pastor's home to value his property for taxation. Muhlenberg noted that he was not required to count the money in his possession, merely to swear an oath, which Davis accepted.[12]

The mutual acceptance by Germans and English is often mirrored in the objects made by Pennsylvania Germans. It cannot be assumed that early Pennsylvania furniture that is sophisticated in design and Anglo-American in appearance was made by non-Germans, for detailed examination of construction often reveals that German craftsmen made such pieces. The contribution of Germanic cabinetmaking techniques to the design and appearance of sophisticated Philadelphia furniture has been well documented.[13] Drawings and instructions for making English forms, with which they were not familiar, have been found in the records of Abraham Hoover, Abraham Overholt, and Peter Ranck, working in the late eighteenth and early nineteenth centuries. The objects included here, therefore, provide tangible evidence that Germans in Pennsylvania were, indeed, good neighbors.

1. *See* James T. Lemon, *The Best Poor Man's Country: A Geographical Study of Early Southeastern Pennsylvania* (Baltimore, 1972), pp. 14–15.

2. Benjamin Franklin, *The Writings of Benjamin Franklin*, vol. 3, *1750–1759*, ed. Albert Henry Smyth (New York, 1907), p. 72.

3. Henry Melchior Muhlenberg, *The Notebook of a Colonial Clergyman: Condensed from the Journals of Henry Melchior Muhlenberg*, ed. and trans. Theodore G. Tappert and John W. Doberstein (Philadelphia, 1959), p. 10.

4. *Ibid.*, pp. 57, 117.

5. *Ibid.*, p. 78.

6. *See* William P. McMichael, ed., "Diary of Lieutenant James McMichael, of the Pennsylvania Line, 1776–1778," *The Pennsylvania Magazine of History and Biography*, vol. 16, no. 2 (1892), pp. 145–46.

7. *See* Lemon, *Best Poor Man's Country*, pp. 22–23.

8. Benjamin Rush, *An Account of the Manners of the German Inhabitants of Pennsylvania, Written 1789*, ed. I. Daniel Rupp (Philadelphia, 1875), pp. 54–55.

9. Muhlenberg, *Notebook*, p. 117.

10. *See* Alan G. Keyser, Larry M. Neff, and Frederick S. Weiser, eds. and trans., *The Accounts of Two Pennsylvania German Furniture Makers—Abraham Overholt, Bucks County, 1790–1833, and Peter Ranck, Lebanon County, 1794–1817* (Breinigsville, Pa., 1978), pp. viii, xvii.

11. Quoted in Juliana Roth, "Travel Journals as a Folklife Research Tool: Impressions of the Pennsylvania Germans," *Pennsylvania Folklife*, vol. 21, no. 4 (Summer 1972), p. 37.

12. *See* Muhlenberg, *Notebook*, pp. 79, 212–13.

13. *See* Benno M. Forman, "Delaware Valley 'Crookt Foot' and Slat-Back Chairs: The Fussell-Savery Connection," *Winterthur Portfolio*, vol. 15, no. 1 (Spring 1980), pp. 41–64.

Margret Wistar her work
in the 9 year of her age 1738

74 The Germans and English in Pennsyl-
vania found benefits in accommodating each
other. Margert Wistar's sconce of 1738,
inscribed in English and embroidered in the
fancy needlework taught in English-run
schools, documents a stage of German assimi-
lation into the English society of Pennsylvania
(Wyck Charitable Trust, Philadelphia)

75

75 Illustrated in various English cabinet-makers' design books, breakfast tables were also fashioned by German-American craftsmen, such as Adam Hains of Philadelphia, who may have apprenticed with an English cabinetmaker or joiner (Winterthur Museum)

76 Made by a German craftsman for an Englishwoman living in Chester (Delaware) County, this miniature chest combines English form with Germanic woodworking techniques and decoration (Winterthur Museum)

77 By the time he made this transit telescope in 1769, the renowned German-American scientist and intellectual David Rittenhouse had become a prominent leader within the Anglo-American community (American Philosophical Society, Philadelphia)

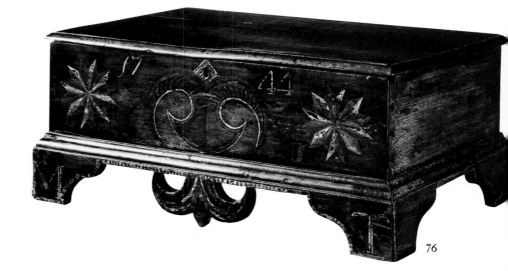

76

80 The Philadelphia silversmith John
Christian Wiltberger had up-to-date English
models to copy for the tea and coffee service
he made and engraved for Bernard and Mary
Raser of Philadelphia (Museum of Fine Arts,
Boston)

81 Philadelphia's celebrated 19th-century gunsmith, Jacob Kuntz, produced this elaborately decorated rifle with swiveling twin barrels, one smoothbored (the English gun of choice) and one rifled (the German preference for accuracy) (Collection David S. Hansen)

82 Jacob Kuntz spelled his name phonetically as KOONS on the barrel and lock plate of this smoothbore flintlock pistol, an English form (Private Collection)

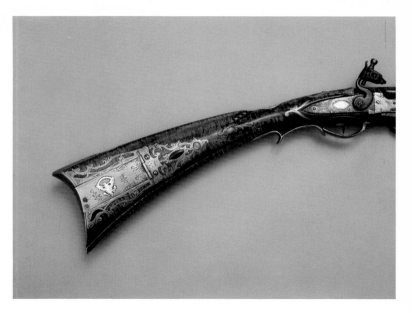

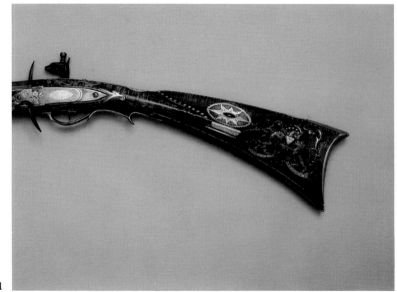

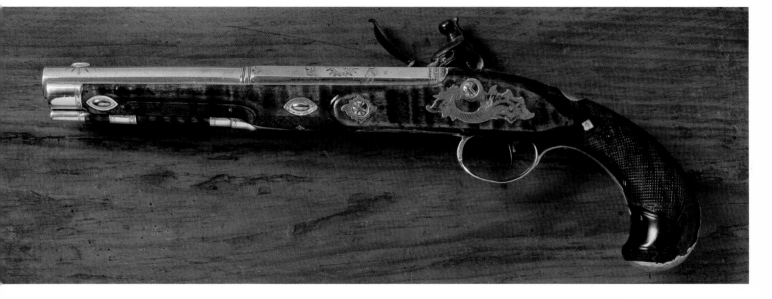

83 Daniel Stalls drew this traditional German token of affection, a lover's knot, for Mary Finkenbiner, but inscribed it in English (Rockford-Kauffman Museum, Lancaster)

Plate 74

EMBROIDERED SCONCE, 1738
Margert Wistar (1728/9-1793)
Philadelphia
Inscribed: Margert Wistar her work in the 9 year of her
 age 1738
Silk satin, silk embroidery; 17 1/16 x 10 1/4" (43.3 x 26 cm)
 (with frame)
Wyck Charitable Trust, Philadelphia
Checklist 309

If not for the fact that nine-year-old Margert Wistar proclaimed her responsibility for this needlework sconce, surely it would have been ascribed to a young English girl in Philadelphia. Judging from the embroidered inscription at the base of the sconce, Margert was able to read and write at least rudimentary English at an early age. She was the second child of Caspar Wistar (1696-1782) and Catherine Jansen Wistar (1703-1786), whose Germantown home was filled with high-style furnishings in the English taste. A financially successful immigrant, Wistar and other well-to-do Germans sent their daughters to learn fine or fancy needlework, wax- and shellwork, watercolor, music, and dancing at English-run young ladies' schools in America. According to an entry made by Reuben Haines in 1805, Margert also made a needlework pocketbook (checklist 310) for her father about 1750.* Fashionable in America, pocketbooks seem to be smaller versions of large English needlework letter cases and are a form unknown in the Germanic areas from which Wistar and his contemporaries emigrated. Both the sconce and the pocketbook provide evidence of early attempts by educated Germans to become assimilated into, or at least accommodated to, the dominant English society of Pennsylvania.

*See Wyck Papers, Ser. 3, Box 88, Folder 31, Wyck Association, Philadelphia.

Plate 75

PEMBROKE OR BREAKFAST TABLE, 1790-1800
Adam Hains (1768-1846)
Philadelphia
Inscribed: A. HAINS PHILA fecit
Mahogany, tulip, white cedar, white oak; height 27 7/8"
 (70.8 cm)
Winterthur Museum. G57.669
Checklist 106

Breakfast tables are invariably considered to be strictly an English or Anglo-American form. Designs for them are illustrated in Thomas Chippendale's *Director* (London, 1762). With the exception of its saltier stretchers and gadrooning, exact specifications for this table are described in the *Cabinet-Makers London Book of Prices* (London, 1788) and in the *Cabinet-Makers' Philadelphia and London Book of Prices* (Philadelphia, 1796), both available to craftsmen in Pennsylvania. Frequently the assumption is made that the maker of this type of table and his clientele were Anglo-American. Yet Adam Hains was a German-American, the son of Heinrich and Anna Catharine Hähns. Like many children of German background born in Philadelphia, he was baptized at Old Saint Michael's and Zion Lutheran Church. He married a German-American woman, Margareta Baisch, daughter of a cordwainer.* From 1803 to 1846, he lived in Berks County, and was buried at the Pricetown Lutheran and Reformed Church in Ruscombmanor

Township in the same county.†
 Adam Hains was probably apprenticed to an English joiner or cabinetmaker, judging from this table, which shows no signs of Germanic woodworking techniques. Like the maker of this table, other Germans in Pennsylvania were adaptable and had a strong preference for this form. Between 1786 and 1850, the account and day books of four German-American craftsmen working in Pennsylvania—John Bachman, Abraham Hoover, Jacob Landes, and Jacob Bachman—record sixty-two tables made for their customers.‡ In these records they were spelled *prakfest Taeble,* and were described in 1784 and 1786 by John Bachman in Pennsylvania German as *ein Düsch brägfast Döbel* ("a table, breakfast table") or *ein zümorganess Disch* ("in the morning eat," or "breakfast table").§

*See Carl M. Williams, "Adam Hains of Philadelphia: Master Cabinetmaker of the Marlborough School," *Antiques,* vol. 51, no. 5 (May 1947), pp. 316-17.
†See Louis Richards, "Early Berks County Tombstone Inscriptions (Conclusion)," *The Pennsylvania-German,* vol. 12, no. 8 (August 1911), p. 494. See also Will Book 9, p. 115, Register of Wills, Berks County Courthouse, Reading, Pa.
‡Account and Day Books of John Bachman, Jacob Landes, and Jacob Bachman, 73x317, 73x374.1-3, M395.1, Joseph Downs Manuscript and Microfilm Collection, Winterthur Museum Library; Account Book of Abraham Hoover, Heritage Center of Lancaster County, Inc., Lancaster, Pa.
§See Benno M. Forman, "German Influences in Pennsylvania Furniture," in Scott T. Swank et al., *Arts of the Pennsylvania Germans at Winterthur,* forthcoming.

Plate 76

MINIATURE CHEST OR BOX, 1744
Chester (Delaware) County
Inscribed: 17 44 MT
Walnut, tulip, painted; height 10" (25.4 cm)
Winterthur Museum. G65.2257
Checklist 53

The form, construction, and decoration of this miniature chest provide abundant evidence of the give-and-take that must have existed in the complex relationships between Englishmen and Germans in the colony of Pennsylvania. Its lid, bracket feet, moldings, and general form are English in origin, as is the use of nails to fasten its bottom board. Wedged dovetails, a common Germanic, not English, woodworking technique, were used to attach the front, sides, and back in strong, tight joints. Twelve-pointed stars and fleurs-de-lis were frequently used to decorate furniture made by Germans in Pennsylvania. Such devices can be seen on furniture made in Alsace, Bavaria, Franconia, and Switzerland. The numeral *1* in the date on its front board resembles the curved letter *j* used by craftsmen in continental Europe to designate that number. There is nothing especially Germanic about the initials MT that are painted on the front bracket feet. In fact, the history of ownership accompanying this chest and its recovery in Downingtown, Chester County, indicate that it was originally made for an Englishwoman, Mary Palmer Trimble, who lived with her husband James on a tract of land purchased in 1744 in Bradford Township, Chester County, which contained a gristmill and sawmill. The latter reference is pertinent because the bottom board of this box is mill-sawn. On August 28, 1744, Mary Trimble gave

birth to a daughter, Sarah, her fifth child,* and perhaps the box was a gift to commemorate that event. There can be no doubt that it was made by a German craftsman residing nearby or indentured to the Trimbles.

*See Lewis Palmer, comp., *A Genealogical Record of the Descendants of John and Mary Palmer of Concord, Chester (now Delaware) Co., Pa.* (Chester, Pa., 1910), pp. 670–77, 685.

Plate 77

TRANSIT TELESCOPE, 1769
David Rittenhouse (1732–1796)
Philadelphia
Brass, iron, glass; frame, height 25" (63.5 cm)
American Philosophical Society, Philadelphia
Checklist 157

The complexity of life in eighteenth-century America is well illustrated by incidents in David Rittenhouse's career. By 1767, when he began to establish a reputation as a clockmaker and scientific-instrument maker of great genius, his assimilation into Anglicized society was virtually complete. His mechanical abilities had also been exhibited by his great-grandfather, Wilhelm Rittinghausen (sometimes spelled Rittinghuysen), born near Mulheim on the Ruhr, who, after immigration to the colonies, established a paper mill in 1690 on Monoshoe Creek near the Wissahickon. David's grandfather, Nicholas (Claus), who was also born in Germany, immigrated to New York, where he married a Dutch woman, and settled in Pennsylvania to help run the paper mill. David Rittenhouse's great-grandfather and grandfather were both Mennonite lay ministers. David Rittenhouse's father, Matthias, was born in Germantown. When he was denied a share of the paper mill, he purchased a farm in Norriton, Montgomery County. Matthias married Elizabeth Williams, an English Quaker, and broke from his Germanic background to move closer to the Anglicized world of his wife. Although he wanted his son to become a farmer, too, a bequest of joiner's tools and arithmetic, geometry, and calculation books from his wife's brother, David Williams, ignited the young man's latent mechanical and mathematical skills. The Reverend Thomas Barton, an Anglican minister and schoolmaster in Norriton, became Rittenhouse's brother-in-law and encouraged him. Another Anglican minister, the Reverend William Smith, provost of the College of Philadelphia, considered himself responsible for discovering Rittenhouse's talents. He sponsored Rittenhouse's election to membership in the American Philosophical Society in 1768 and assisted with his participation in the first important scientific enterprise of the society, the measurement of the transit of the planet Venus across the sun on June 3, 1769. It was for that occasion that Rittenhouse made this transit telescope and other precision instruments. The transit was of international interest because another such opportunity to calculate absolute distances between the known planets of the solar system would not occur until 1877. Rittenhouse's part in these proceedings cemented his reputation for all time. He moved from Norriton to Philadelphia in 1770 and remained quite distant from his German background and relatives.* When he died, he was eulogized by Dr. Benjamin Rush at the First Presbyterian Church.

*See Edward Ford, *David Rittenhouse: Astronomer-Patriot, 1732–1796* (Philadelphia, 1946); Brooke Hindle, *David Rittenhouse* (Princeton, N.J., 1964); and Robert P. Multhauf, comp., *A Catalogue of Instruments and Models in the Possession of the American Philosophical Society* (Philadelphia, 1961).

Plate 78

DESK AND BOOKCASE, 1785–1800
Attributed to Michael Lind (1725–1807) or Michael Lind, Jr. (1763–1840)
Lancaster, Lancaster County
Cherry, tulip; height 103½" (262.9 cm)
Winterthur Museum. G51.56
Checklist 94

Germans living in areas outside Philadelphia also acquired a taste for objects of Anglo-American design. When they were well-to-do, as was Michael Withers (1733–1821), they could afford to order expensive, elaborately carved furniture like this desk and bookcase. Withers lived in Strasburg Township near the town of Lancaster, and described himself as a "yeoman." He was not only a landowner, but also a gunsmith and part owner of iron furnaces and forges. The 1821 inventory of his estate valued this piece of furniture at fifteen dollars.*

Drawings of highly embellished furniture in the Philadelphia Chippendale style can be found in the account and day books of German-American craftsmen who learned to make such forms to fulfill requests of customers with English and German backgrounds. Daniel Arnd's elaborate, rococo-decorated furniture drawings may be seen in the account book of Peter Ranck (checklist 217), who worked in Jonestown, Lebanon County. The account book of Abraham Hoover, a Lancaster County joiner, spans the years 1791 to 1837 and also contains drawings of Anglo-American forms.† Features of this desk and bookcase that are English in origin are melded with carving and construction of Germanic tradition. Aside from the obvious carved pendant tulip on the pediment, the general pattern and manner of this carving have been described as being in the northern European vernacular tradition.‡ Other Germanic woodworking techniques include wooden pegs instead of nails to fasten the drawer bottoms, braces dovetailed into the case behind the rear foot brackets, and wedged rail tenons where they are mortised through the stiles of the bookcase doors.

Reputedly of Swedish origin, Michael Lind arrived in Philadelphia in 1752 in the company of German emigrants. The following year he settled in Lancaster. Judging from this piece of furniture, the Lind family had obviously become familiar with woodworking practices common in Germanic areas of Europe. A high chest of drawers with dovetail construction and carving similar to those of this desk and bookcase is in the collections of the Diplomatic Reception Rooms, Department of State, Washington, D.C. It bears the signature of a member of the Lind family.§

*See John J. Snyder, Jr., "The Bachman Attributions: A Reconsideration," *Antiques*, vol. 105, no. 5 (May 1974), pp. 1056–65, figs. 1, 12, repro. opp. p. 1059. *See also* Will Book 4, p. 40, Lancaster County Courthouse, Lancaster, Pa.; and Michael Withers Inventory, M-1821, Lancaster County Historical Society, Lancaster, Pa.

†Account Book of Abraham Hoover, Heritage Center of Lancaster County, Inc., Lancaster, Pa.

‡See Benno M. Forman, "German Influences in Pennsylvania Furniture," in Scott T. Swank et al., *Arts of the Pennsylvania Germans at Winterthur*, forthcoming.

§See John J. Snyder, Jr., "Carved Chippendale Case Furniture from Lancaster, Pennsylvania," *Antiques*, vol. 107, no. 5 (May 1975), pp. 967, 972–73, figs. 9, 10.

Plate 79

MARRIAGE CERTIFICATE FOR DANIEL BENTZIN-
GER AND MARIA BARBARA BEINMANNIN, 1779
Daniel Schumacher (c. 1729–1787)
Brunswick Township, Berks County
Ink and watercolor on paper; 7¾ x 12¾" (19.7 x 32.4 cm)
Richard S. and Rosemarie B. Machmer
Checklist 198

The Reverend Daniel Schumacher was probably born in Hamburg, Germany, and arrived in Halifax, Nova Scotia, in 1751 with other emigrants from northern Germany. By 1754 he had established himself in Pennsylvania. The fraktur from his hand, including this marriage certificate prepared while he was serving the congregation of Zion Church, Brunswick Township, Berks County, is evidence that he was able to adopt a tradition common to Germanic areas of south central Europe but foreign to northern Germanic regions. Although Schumacher claimed to be a Lutheran clergyman, it was discovered that he lacked university training, had not been a candidate for the ministry in Hamburg, was addicted to alcohol, and had abandoned his wife in Nova Scotia. Despite official rejection by Pastor Henry Melchior Muhlenberg, Daniel Schumacher was accepted by almost twenty congregations between 1754 and 1781. He was able to place his earlier escapades behind him and apparently conducted his ministries with the dignity and skill demanded by his self-appointed office.

The crown of righteousness that appears in this marriage certificate may have sat uncertainly on Schumacher's head, but its very existence indicates that Germans in Pennsylvania with Palatinate traditions could accept someone from northern Germany willing to serve them and accommodate to their needs, among which were religious leadership and recording of significant events in fraktur.*

See Frederick S. Weiser, ed. and trans., "Daniel Schumacher's Baptismal Register," *Publications of the Pennsylvania German Society,* vol. 1 (Allentown, Pa., 1968), pp. 185–208; and Richard and Rosemarie Machmer, "Early Settlers of Drehersville," *Historical Review of Berks County,* vol. 37, no. 3 (Summer 1972), pp. 86–87, 119–20.

Plate 80

TEA AND COFFEE SET, 1793–1805
John Christian Wiltberger (1766–1851)
Philadelphia
Inscribed: C. Wiltberger BMR
Silver, wood; coffeepot, height 14" (35.6 cm)
Museum of Fine Arts, Boston. Gift of John R. Farovid in memory of Bertha Sease Farovid, Mary Vincent Farovid, and Bishop John Heyl Vincent. 61.950
Checklist 150

Neither the maker nor the owner of this handsome and fashionable silver tea and coffee set can be considered representative of the majority of rural Germans living in Pennsylvania prior to 1850. Both lived in a cosmopolitan, populous center. Both were engaged in occupations that kept them in touch with new ideas, changes in fashion, and a broad spectrum of Philadelphia's citizens engaged in commerce. The initials BMR engraved on the silver service are those of Bernard (died 1804) and Mary Raser (1766–1810) of Philadelphia. Not much is known about Raser's background other than his listing in Philadelphia directories as a sea

captain, administration papers filed at the time of his death, and his burial at Saint John's Lutheran Church in that city.* He had acquired enough wealth to own a considerable amount of silver inherited by his wife and, in turn, by their daughter Mary.†

It is possible that Captain Raser's ship carried the silver-plated wares imported by Christian Wiltberger, maker of this service, for sale in his shop. The silversmith had up-to-date English models to copy for the sterling tea and coffee set that he produced for the Rasers. Wiltberger's father was also a craftsman, a hatter, and a member of a Lutheran congregation. But silversmiths occupied a top rung in the craft hierarchy of social prestige, and it is not surprising that Christian Wiltberger, a second-generation German-American, joined the Episcopal church.‡

See Administration No. 143, 1804, Register of Wills, City Hall, Philadelphia; and Burial Book, p. 6, Saint John's Lutheran Church, Philadelphia.
†Will Book, 1804, p. 107, Register of Wills, City Hall, Philadelphia.
‡*See* Ellen Sampson Magoun, comp., "History of the Wiltberger Family," July 15, 1936, Genealogical Society of Pennsylvania Collections, HSP.

Plate 81

SWIVEL BARREL FLINTLOCK RIFLE, 1810–20
Jacob Kuntz (1780–1876)
Philadelphia
Inscribed: Jacob Kuntz Jacob Kuntz Philad D. Hunt
LOEW
Maple, iron, brass, silver, ivory, enamel, glass; length 56½" (143.5 cm)
David S. Hansen
Checklist 166

Plate 82

FLINTLOCK PISTOL, 1810–20
Jacob Kuntz (1780–1876)
Philadelphia
Inscribed: J Koons Philada J. Koons G. Nagle
Maple, iron, brass, silver, mother-of-pearl; length 14½" (36.8 cm)
Private Collection
Checklist 168

Economic reality for German-American craftsmen in Pennsylvania often dictated conscious assimilation into Anglo-American society. The fact is well illustrated in these superb weapons. The rare swivel barrel flintlock rifle bears the name of its original owner, D. Hunt, engraved on an escutcheon. On the cheekplate of the rifle is an American eagle flanked by rampant lions, identified by the gunsmith as *Loew* ("lion"), thus combining American, English, and German components in one decorative element. The surviving twin barrels convey messages both of practicality and divergent strains operating on both the owner and maker. One is smoothbored—the English gun of choice—and the other is rifled—the German preference for accuracy. The owner of the pistol, one of a pair, a German-American named George Nagle of Lehigh Township, Northampton County,* bought from Jacob Kuntz smoothbore weapons patterned after English models.

The gunsmith Kuntz was born in Lehigh Township, Lehigh County, and apparently was apprenticed to a Philadelphia gun-

smith. From about 1799 to 1811 he practiced his "art and mystery" in Lehigh County, but a notice in a Northampton newspaper, *Der Unabhängige Republikaner*, indicates that he returned to Philadelphia in 1812. His ability as a maker of excellent firearms was recognized in 1833, when he received a silver medal from the Franklin Institute.† The phonetic spelling of the craftsman's name as "Koons" on the pistols may be an Anglicizing of Kuntz. The gunsmith's name appears in both versions on weapons that he made in Philadelphia.

See United States, Department of Commerce and Labor, Bureau of the Census, *Heads of Families at the First Census of the United States Taken in the Year 1790: Pennsylvania* (Washington, D.C., 1908), p. 172.

†*See* Charles Rhoads Roberts et al., *History of Lehigh County, Pennsylvania and a Genealogical and Biographical Record of Its Families* (Allentown, Pa., 1914), vol. 2, p. 764. *See also* Merrill Lindsay, *The Kentucky Rifle* (New York, 1972), no. 12.

Plate 83
LOVER'S KNOT FOR MARY FINKENBINER, 1824
Daniel Stalls
Probably Cumberland County
Inscribed: MARY, FINKENBINER HER PICTUR Made By the
 hand of Daniel Stalls Febuary 21st One thousand Eight
 Hundred and Twenty Four
Ink and watercolor on paper; 13⅜ x 8″ (34 x 20.3 cm)
Rockford-Kauffman Museum, Lancaster, Pennsylvania
Checklist 201

The *Liebesbrief,* or "love letter," in several forms was a personal token of love and affection known to Germans in Europe and America.* These private communications were usually kept in closets and boxes, not framed as works of art or public declarations. About 1800–1810 a new type of *Liebesbrief* appeared, using English language and incorporating the older German form of a labyrinth.† In this example, both the maker, Daniel Stalls, and the object of his affections, Mary Finkenbiner, are German-Americans, but the written language on their picture is English. In fact, both may have become so assimilated by 1824 that Daniel Stalls had to identify the picture as "a true lover's knot." An eagle and the Pennsylvania state seal appear above the lover's knot. The name Stalls, Stall, or Stahl occurs in several Pennsylvania counties, and in the United States Census of 1820, several Finkenbiner (or Finkenbinder) families were located in Cumberland County, particularly in Mifflin Township.

See Donald A. Shelley, *The Fraktur-Writings or Illuminated Manuscripts of the Pennsylvania Germans,* Pennsylvania German Folklore Society, vol. 23 (Allentown, Pa., 1961), pp. 52–55.
†*See ibid.,* p. 53.

Liberty and Freedom

THE LOVE OF LIBERTY and the consequences and the rewards of living in a free society were so important to Germans living in Pennsylvania that their art could not help reflecting those concerns. Ceramics, drawings, fraktur, furniture, glassware, domestic metalwork, paintings, and weapons, in profuse numbers, give testimony to the Germans' strong, even passionate, determination to retain and to cherish their freedom and independence.

The extent to which an individual could exercise the rights and privileges of a free man was clearly an attraction to the Germanic people who immigrated to Pennsylvania. A succinct statement on this subject was made by David Seibt, writing to his brother in Silesia from Pennsylvania in 1734: "Liberty of conscience is certainly allowed here, each may do or leave undone as he pleases. It is the chief virtue of this land and on this score I do not repent my immigration. . . . But for this freedom, I think this country would not improve so rapidly. . . ."[1]

In 1688, only five years after settlement of Germantown, German Quakers presented a petition to the monthly Friends meeting in that community protesting the institution of slavery. Their Germantown leader Francis Daniel Pastorius may have been worried about the effect of reports concerning slavery on those Germanic people considering immigration to Pennsylvania, but he, and most Germans in the colony, refused to own slaves on religious and political grounds. They equated liberty of conscience with liberty of the body.[2] A writing specimen in the hand of the Reverend George Geistweit (checklist 225) reflects the same sentiment more than a hundred years after the Germantown protest. One of its details is a man on horseback pursuing a slave. Relating to the latter is one of a series of explanatory remarks: "He who would catch up the blacks [is] so crooked that he leaps like the highwayman upon a village."

There were many issues, of course, between 1683 and 1850 that for Germans in Pennsylvania were threats to liberty and freedom. Their involvement in elections and politics, therefore, was of great importance to them as a means of protecting their rights. The great Lutheran minister Henry Melchior Muhlenberg, respected by English and Germans in Pennsylvania, summarized in 1765 the Germans' strong feelings about participation in the electoral process. He noted that members of his congregation were called together on election day to meet in a large schoolhouse, where they "unanimously" decided that election of several German citizens to the assembly would be "a good thing." Pastor Muhlenberg pointed out that Germans in Pennsylvania "have

to bear taxes and *onera* just as much as the *English* inhabitants, and therefore we have the right and liberty to have one or more German citizens in the Assembly and to learn through them what is going on."[3]

The extent to which Germans participated in elections can be gathered from Muhlenberg's comment that on September 30, 1764, "several hundred German settlers from the country came to the city [Philadelphia] on account of the election of the *assembly*."[4] This election involved not only German political representation but also was another instance in which the great variety in backgrounds of Germans in Pennsylvania led to differing perceptions of which authority—the Penn proprietors or the crown—could best guarantee continued liberty and freedom. In 1764, German Quakers, Moravians, Mennonites, and Schwenkfelders were anti-proprietor, while German Lutherans and German Reformed church members were pro-proprietor.[5]

Sometimes their right to vote had to be exercised by force. In 1750, for example, an election riot between English, Irish, and German settlers broke out in York. When the local sheriff impounded the ballot box, one hundred and fifty Germans surrounded the house where the election was held. Told that they would not be permitted to vote and should disperse, the Germans replied that "they had as good a right to vote as the others that had voted." They made good their threat and cast their ballots.[6]

Pastor Muhlenberg observed in 1748, and again in 1765, that Christopher Sauer, the Germantown newspaper and book publisher, had "prepared and instructed" German inhabitants of Pennsylvania "as to how they should vote and whom they should elect." In Muhlenberg's view, the core of Sauer's repeated message was for Germans to elect those who would not relinquish even a "hairbreadth" of the "privileges, rights, and liberties" granted to William Penn "and through him to the people." The consequences of ignoring Sauer's exhortations would be deprivation of ancient rights and liberties, forced military drill and service, and a forced tithe to the Episcopal church.[7] The practical consequences of loss of liberty were not lost on Germans in Pennsylvania. In September 1765, Muhlenberg noted that he had to prepare about two hundred naturalization certificates in English for members of his Lutheran congregations in Philadelphia and in the countryside. Naturalization papers "may still be obtained for two dollars," he pointed out, "whereas after the Stamp Act goes into effect it will probably cost £9 or £10."[8]

In November 1765, a skull and crossbones appeared in the *Pennsylvanischer Staatsbote* to protest the Stamp Act. This cosmopolitan Philadelphia newspaper, founded in 1762 by Johannes Henrich Miller (1702–1782), circulated throughout Pennsylvania and the other colonies. Miller's newspaper offered an alternative to the pacifist views publisher Christopher Sauer was expressing. The Stamp Act and taxation without representation were bitterly attacked in Miller's paper as violations of individual rights. The Boston Massacre and blockade of Boston were reported and duly castigated as reprehensible acts, as were all similar examples of British policy. In March 1776, Miller appealed

to Germans in Pennsylvania with the poem "Ihr Americaner," which re-called the various acts committed by Great Britain against the colonies. The beginning of each line of the poem exhorted Germans to *Gedenkt* ("remember"). Miller helped to strengthen German support for the patriots' cause in Pennsylvania by reporting the business of the Continental Congress and every scrap of news reflecting German-American support of the struggle for liberty.[9]

Some German Moravians, Mennonites, Schwenkfelders, and even Quakers elected to defend their liberty and freedom during the American Revolution. Unlike the members of Lutheran or German Reformed congregations, whose ministers occasionally served the patriots' cause as army officers, the members of pacifist sects knew that they might forfeit membership in their religious groups as a consequence of their decision to take arms and fight. The seriousness of that risk to their spiritual well-being demonstrates how intense their commitment to the patriots could be.

Because most Germans in Pennsylvania earned their living in agricultural pursuits, many lived in rural areas of the province. John Michael Lindenmuth's early involvement in militia and military affairs was probably typical. His family emigrated from the Neckar River region in 1752, and in their first year in Pennsylvania, Lindenmuth's father purchased 140 acres in Windsor Township, Berks County, where they endured three years of hardship to establish a working farm. In 1756, Indian raids forced the family to leave their home. At the age of nineteen, and with his father's consent, John Michael Lindenmuth enlisted for three years in Captain Morgan's company. From then until 1781 he served various enlistments in local companies and regiments.[10]

By 1775 Pastor Muhlenberg noted, on a trip to Reading, that in "every place through which I passed . . . I found the males under arms." He was informed that the purpose of such military exercises was "to defend the liberty and rights vouchsafed by God and stipulated by earlier governments."[11] Muhlenberg, of course, recorded the enlistment of his son, John Peter Gabriel, in the patriots' cause, and his notes are filled with references to colleagues enlisting as chaplains or to the participation of Germans in the Continental army.[12] A note important to the interpretation of some fraktur is Muhlenberg's statement that in 1777 he prepared several baptismal certificates for parents in his congregation to help prove when their sons were born. These certificates were executed some years after the event to help meet the requirements of a militia act that stipulated that all inhabitants between the ages of eighteen and fifty-three must engage in military exercise.[13]

The passion for liberty became so ingrained in Germans in Pennsylvania that second- and third-generation citizens were astounded by Hessian prisoners in Philadelphia. When a Hessian prisoner was asked why he had come to do violence against his own flesh and blood, he indicated that he had been torn from his family and forced into service. Those born in Pennsylvania replied that this was "the way the farmers in this country treated their horses, oxen,

and cows which they sold to horse copers and butchers."[14]

Following the American Revolution, Germans in Pennsylvania remained active supporters and defenders of liberty and freedom. Their votes were actively sought. Muhlenberg noted in 1783 that English Presbyterian "politico-theologians" had previously "compared us Germans with sauerkraut and foul cheese. Now their taste has changed."[15] John Lewis Krimmel's *Election Scene, State House in Philadelphia*, of 1815, in the Winterthur Museum (checklist 189), reflects the continued, strong interest of Germans in Pennsylvania in exercising their franchise.

German-American votes, crucial in several Pennsylvania elections, finally brought about the election of Lancaster-born Simon Snyder as governor in 1808, 1811, and 1814. The significance of his election to ordinary German-American citizens in Pennsylvania is well illustrated by an entry in the account book of Jacob Bucher, a hatmaker from Lebanon. In settling an account with Jacob Boas, "a framed copperplate of Simon Snyder, Esq.," valued at six dollars, was received by Jacob Bucher.[16] It was no longer necessary to rely only on George Washington and other Anglo-American heroes to symbolize the importance of liberty and freedom to Germans in Pennsylvania. The son of a mechanic who immigrated to Pennsylvania from the Palatinate, Simon Snyder served a four-year apprenticeship as a tanner and currier in York, where he went to school at night. In 1789–90, he served as a member of the state constitutional convention and was elected to the Pennsylvania Assembly from 1797 to 1807.[17] The first representative of the German element in Pennsylvania to be elected to high office, Simon Snyder was their own hero.

1. Quoted in David Schultze, *The Journals and Papers of David Schultze*, vol. 1, *1726–1760*, ed. and trans. Andrew S. Berky (Pennsburg, Pa., 1952), p. 53.

2. *See* Samuel Whitaker Pennypacker, *The Settlement of Germantown, Pennsylvania and the Beginning of German Emigration to North America* (Philadelphia, 1899), pp. 61–62, 145. *See also* Hildegard Binder-Johnson, "The German Protest of 1688 Against Negro Slavery," *The Pennsylvania Magazine of History and Biography*, vol. 65, no. 2 (April 1941), pp. 145–56; and "Negro Slavery and the Pennsylvania Germans," in Preston A. Barba, ed., " 'S Pennsylvaanisch Deitsch Eck," *The Morning Call* (Allentown, Pa.), March 14, 1959.

3. Henry Melchior Muhlenberg, *The Notebook of a Colonial Clergyman: Condensed from the Journals of Henry Melchior Muhlenberg*, ed. and trans. Theodore G. Tappert and John W. Doberstein (Philadelphia, 1959), p. 115.

4. *Ibid.*, p. 110.

5. *See ibid.*, p. 111.

6. *See* "An Early Election Report," in Preston A. Barba, ed., " 'S Pennsylvaanisch Deitsch Eck," *The Morning Call* (Allentown, Pa.), November 13, 1954.

7. Muhlenberg, *Notebook*, pp. 30–31, 114–15.

8. *Ibid.*, p. 119.

9. *See* Alexander Waldenrath, "Johann Heinrich Miller: German-American Patriot," *Der Reggeboge: The Rainbow. Quarterly of the Pennsylvania German Society*, vol. 8, no. 1 (March 1974), pp. 9–11.

10. *See* "The Family Journal of John Michael Lindenmuth," in Preston A. Barba, ed., " 'S Pennsylvaanisch Deitsch Eck," *The Morning Call* (Allentown, Pa.), April 14 and 21, 1951.

11. Muhlenberg, *Notebook*, p. 155.

12. *Ibid.*, pp. 162–63.

13. *See ibid.*, p. 170.

14. *Ibid.*, p. 167.

15. *Ibid.*, p. 227.

16. Account Book of Jacob Bucher, 75x67, Joseph Downs Manuscript and Microfilm Collection, Winterthur Museum Library.

17. *See Dictionary of American Biography*, s.v. "Snyder, Simon."

84 Germans in Pennsylvania were active supporters and defenders of liberty and freedom. Inscribed "liberty or death," this pewter mug was probably presented by Continental soldiers to their captain, Peter Ickes, after the conclusion of the Revolutionary War (Winterthur Museum)

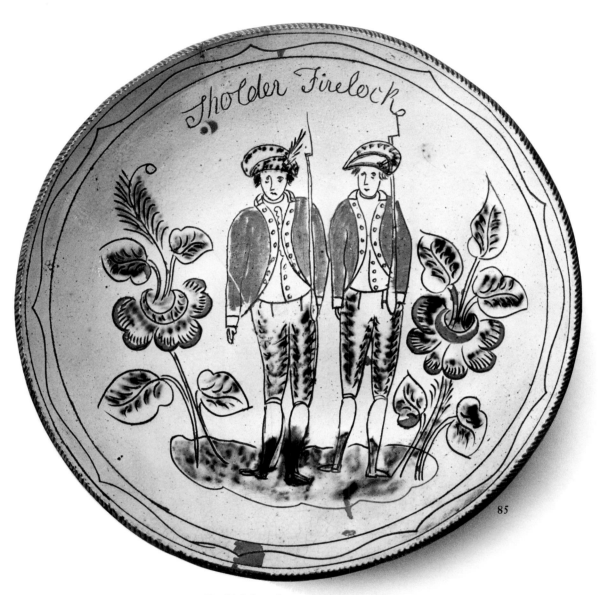

Sholder Firelock

85

85 David Spinner's commemorative dish shows two soldiers with muskets at shoulder arms, probably during a militia drill on Battalion Day (Philadelphia Museum of Art)

86 Peter Angstadt's pipe tomahawk is an ironic combination of the symbols of peace and war (Collection David Currie)

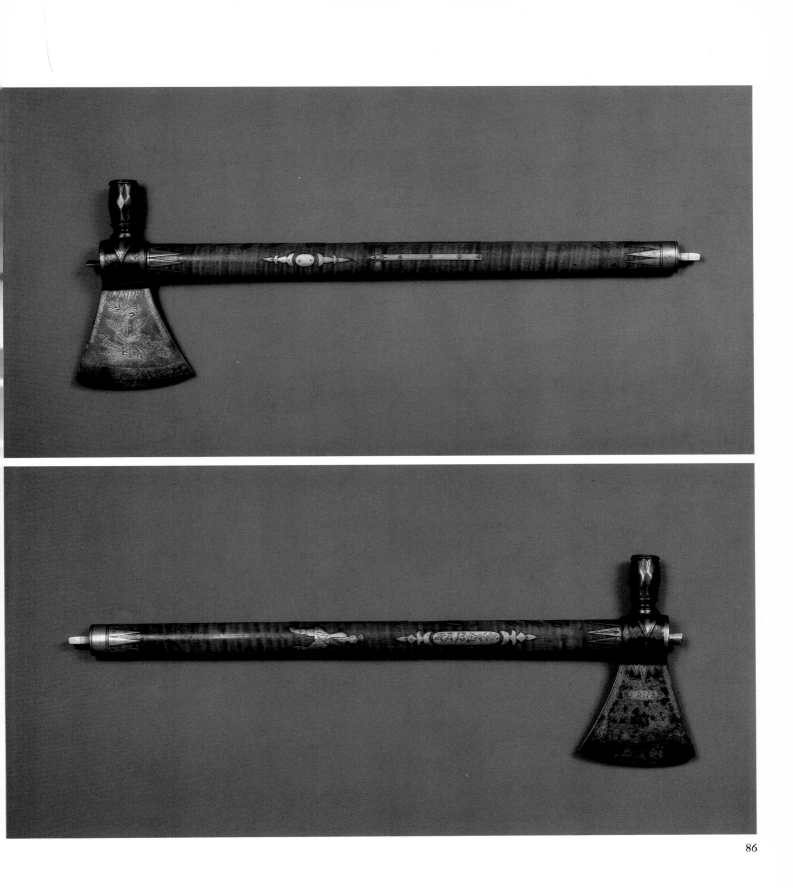

Christian Lehman, Big and large Pumpkin, Grown
in his garden, it was—as large as A barrel and more
in Circumference, round. old Dr. John
Fisher, bought it and send it to Baltimore.
to let them See what old York Can Raise,
and Examin it, no man Could lift it, from
the ground.
1809.

1800.

Thos. McKean Frolick.
York Borough.

Governor McKean
In the State of Pennsylvani

Governor McKean, Elect, James Ross, defeated
in October 1800.
Publick feast on the Common open ground
near george Spanglers lane, you see two
volunteer Company's, Captain, Lewis Wampler.
Lieutenant Bd. Hersh, Cap. William Ross, lieut Jo. Greer.
the red and blue is cap— Ross's company—

The nankin boys and
the Schmirkeß boys—
Huza—for the red and blue.
Michael Grabill's Song, 1809.—And his Small fieldpiece,

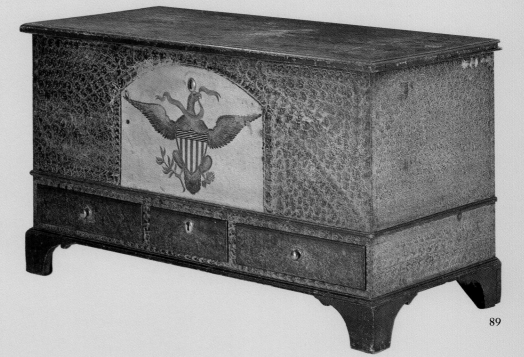

87 Exercising their right to vote was of great importance to Germans in Pennsylvania, shown here rejoicing in York at the election of Thomas McKean as governor in 1800 (The Historical Society of York County, York, Pennsylvania)

88 The numerous eagles and the word "liberty" on the case of this clock were John Paul, Jr.'s personal salute to the precious liberty and freedom retained by the United States after the War of 1812 (Winterthur Museum)

89 After the adoption of the Great Seal of the United States in 1782, the American eagle became a symbol of the rights and privileges guaranteed by the federal government (Winterthur Museum)

88

89

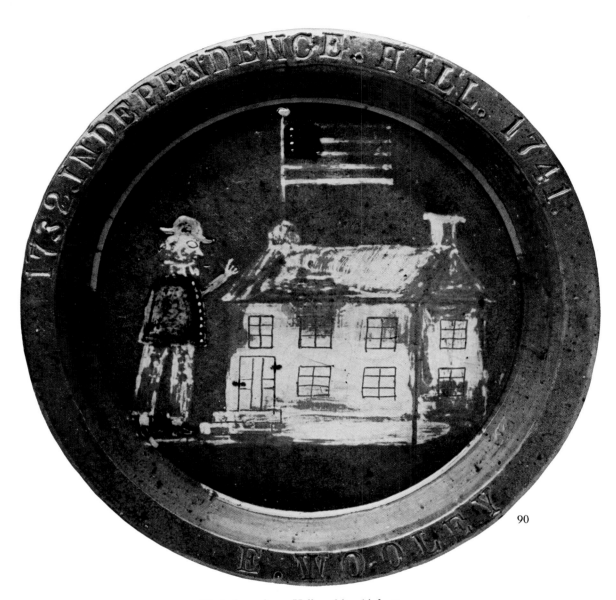

90 Independence Hall, and its chief carpenter, Edmund Wooley, are commemorated on this earthenware dish made by Absalom Bixler (Winterthur Museum)

91 The German inscription above the figure of George Washington translates as "liberty, equality, harmony, and brotherly love" (Philadelphia Museum of Art)

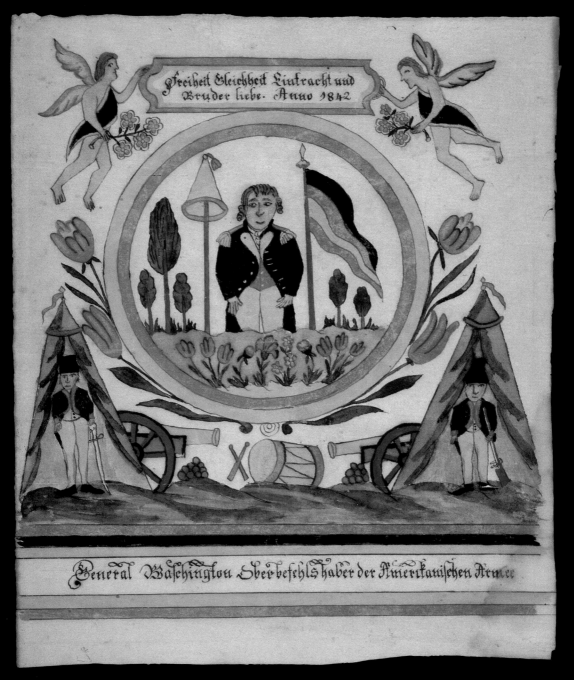

Freiheit Gleichheit Eintracht und Bruder liebe. Anno 1842

General Waschington Oberbefehlshaber der Amerikanischen Armee

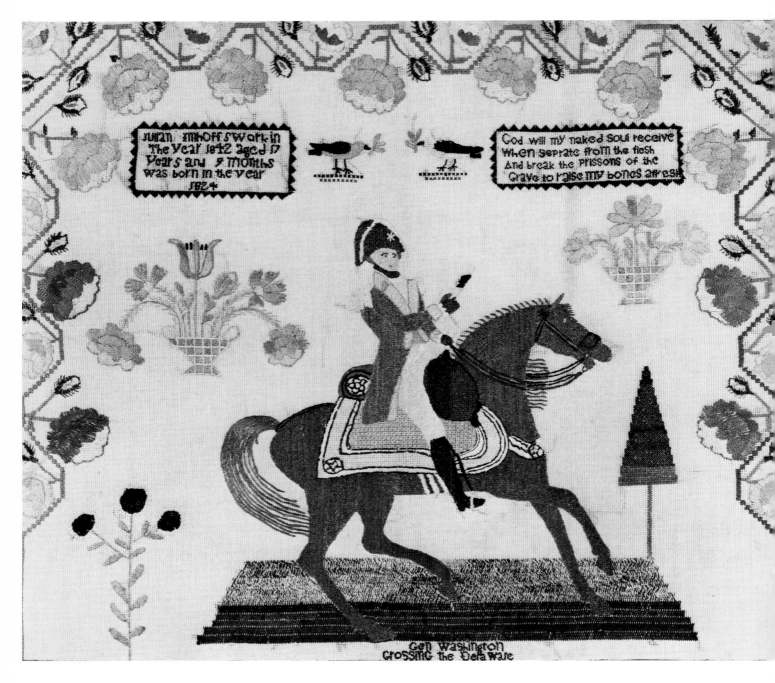

Susan Imhoff's work in
The year 1842 aged 17
years and 5 months
was born in the year
1824

God will my naked soul receive
when seprate from the flesh
And break the prissons of the
Grave to raise my bones afresh

Gen Washington
crossing the Delaware

92 Themes of religious and political salva-
tion are combined in this needlework picture
of George Washington crossing the Delaware
(Collection Gretchen Holderbaum Knothe)

Plate 84

MUG, c. 1784
William Will (1742–1798)
Philadelphia
Inscribed: LIBERTY or DEATH HUZZA for CAPT. ICKES PHILAD
Pewter; height 5¾" (14.6 cm)
Winterthur Museum. G67.1369
Checklist 145

A horse and rider is used as a decorative device on many objects made or owned by Germans in Pennsylvania. The inscription "liberty or death huzza for Capt. Ickes" indicates that Germans in Pennsylvania were aware of Patrick Henry's speech to the Virginia Convention in 1775 and also provides evidence of the strong German-American conviction of the necessity to take up arms in order to preserve liberty and independence. A descendant has noted that the Ickes family settled in Philadelphia (now Montgomery) County as early as 1717 and were founding members of the New Haven Lutheran Church in that county.* Many German-American Lutherans supported the patriots' cause. The subject of the engraved motto, Captain Peter Ickes (1748–1829), is known to have been in the "Flying Camp" by 1776, listed as a captain, Sixth Pennsylvania Battalion, Fifth Company.† Like Patrick Henry, he had a substantial stake in property. In 1773, Peter Ickes had purchased 152 acres in Limerick Township, Montgomery County, for 400 pounds. Between 1789 and 1794, Peter Ickes patented and sold 117 acres in York County. By 1799, he had apparently given up farming, for his name appears on a tax assessment list as a hotelkeeper in Abbottstown, Adams County, Pennsylvania. Officers in the Continental army had to earn the respect of the volunteers they commanded, and this pewter mug was probably a gift from Peter Ickes's company at the war's conclusion. The mug was purchased from a German-American pewterer, William Will, who served as a lieutenant colonel in the Philadelphia militia. The mug was retained by Captain Ickes and his descendants until the 1930s, when it was purchased near Carlisle, Pennsylvania.‡

*Judith B. Baxter to Donald L. Fennimore, October 6, 1977, Object Folder 67.1369, Registrar's Office, Winterthur Museum.

†See George R. Prowell, *History of York County Pennsylvania* (Chicago, 1907), vol. 1, pp. 279, 282.

‡See Charles F. Montgomery, *A History of American Pewter* (New York, 1973), pp. 43, 46, fig. 3-1.

Plate 85

DISH, 1800–1811
Attributed to David Spinner (1758–1811)
Willow Creek, Milford Township, Bucks County
Inscribed: Sholder Firelock
Earthenware with slip coating, clear lead glaze; dia. 11⅝" (29.5 cm)
Philadelphia Museum of Art. Gift of John T. Morris. 00-199
Checklist 22

This commemorative dish, made by potter David Spinner, shows two soldiers with muskets at shoulder arms, probably during a militia drill on Battalion Day, or General Training Day. Such exercises were held in late May or early June, after essential farm activity was completed in the spring. Local militia units met at central locations in company or brigade strength or, if enough volunteers between the ages of eighteen and forty-five were available in a district, in battalion strength. One such unit was re-created from neighbors' memories by Lewis Miller, a York County carpenter, who depicted Col. George Spangler drilling a militia battalion in York in 1801.* On these occasions, officers were elected and inspections, drills, and public parades were held. Militia training days also provided an opportunity for expressions of patriotism and an excuse for drinking, singing, dancing, general carousing, and other forms of celebration, until dawn.†

David Spinner was a second-generation German-American, whose father had emigrated from Zurich, Switzerland, in 1739. The potter could write in both German and English. The use of "Sholder," therefore, is a reflection of inconsistent rules for spelling rather than Spinner's unfamiliarity with the English language.

*See Robert P. Turner, ed., *Lewis Miller: Sketches and Chronicles. The Reflections of a Nineteenth Century Pennsylvania German Folk Artist* (York, Pa., 1966), p. 28.

†See Fredric Klees, *The Pennsylvania Dutch* (New York, 1950), pp. 330–31.

Plate 86

PIPE TOMAHAWK, 1800–1815
Peter Angstadt (1763–1815)
Rockland Township, Berks County
Inscribed: P.C. Angstadt F. Hoff
Maple, iron, steel, German silver, silver, gold; length 23" (58.4 cm)
David Currie
Checklist 169

Tomahawks were a standard weapon of frontiersmen and soldiers from the colonial period through the end of the War of 1812. A resolution of the Continental Congress on July 18, 1775, decreed that among the arms that militiamen must provide was "a cutting sword or tomahawk."* The arsenal at Carlisle Barracks, Pennsylvania, had more than 2,000 of these weapons, and as late as 1819, the arsenal stocked 1,074. Pipe tomahawks were usually the personal property of militiamen.†

This superb example of a pipe tomahawk was made by Peter Angstadt,‡ a member of a family of Berks County gunsmiths, for use by a son or relative of the same name, or for a young militiaman named Frederick Hoff, whose name is engraved on one side of the blade. There were two Peter Angstadts living in Rockland Township, Berks County, according to United States census records for 1790, 1800, and 1810. Both are unlisted in 1820. Harold Peterson refers to Hoff as a blacksmith in Lancaster County, about 1800–1815, in his study *American Indian Tomahawks*, although census records first refer to Frederick Hoff in Hopewell Township, York County, in 1820. The excellent quality of metalwork on the blade handle indicates that it was made by a skilled gunsmith, whose work usually included making edged weapons.

*William H. Guthman, "Frontiersmen's Tomahawks of the Colonial and Federal Periods," *Antiques*, vol. 119, no. 3 (March 1981), p. 663.

†See Harold L. Peterson, *American Indian Tomahawks*, Contributions from the Museum of the American Indian, Heye Foundation, vol. 19 (New York, 1965), pp. 41–42, 139, fig. 303. See also Guthman, "Frontiersmen's Tomahawks," pp. 658–65.

‡See Will of Gunsmith Peter Angstadt, 1815, Will Book D, p. 125, Register of Wills, Berks County Courthouse, Reading, Pa., See also Register, 1738–1903, Christ Lutheran Church (Bieber Creek Church), near Dryville, Rockland Township, Berks County, Pa.

Plate 87

THOMAS McKEAN ELECTION, after 1812

Lewis Miller (1796–1882)

York, York County

Inscribed: . . . Thos McKean Frolick York Borough Governor McKean Elect, James Ross defeated in October 1800 Publick feast on the Common open ground. . .

Ink and watercolor on paper; 9¹⁵⁄₁₆ x 7¹¹⁄₁₆″ (25.2 x 19.5 cm)

The Historical Society of York County, York, Pennsylvania. 1-67-7

Checklist 191

From early childhood to his death, the York carpenter Lewis Miller sketched the life and customs of his community. Miller's father was from Schwäbisch-Hall, Württemberg, and his mother's roots were in Heidelberg, Baden. They immigrated to Pennsylvania in 1771, spent their first years there in Philadelphia, and then moved to York, where Lewis was born and where his father (*see* checklist 261) was schoolmaster of the German Lutheran Parochial School.*

Elections and the exercise of their right to vote were of great importance to German-Americans. Because he was only four years old in 1800, Miller must have been told about the rejoicing in York when the news was confirmed of Thomas McKean's election as governor and James Ross's defeat after a bitter campaign. McKean's early Federalist party activity, strong support for ratification of the Constitution in Pennsylvania, and equally strong animosity toward England when he switched to Jeffersonian Republicanism appealed to Germans in Pennsylvania. Their alliance with Scotch-Irish voters helped to bring about McKean's election. The equation of elections with militia service and protection of liberty is graphically shown in Miller's drawing. Two companies of militia volunteers are on parade, commanded by captains Louis Wampler and William Ross.

**See* Robert P. Turner, ed., *Lewis Miller: Sketches and Chronicles. The Reflections of a Nineteenth Century Pennsylvania German Folk Artist* (York, Pa., 1966), p. xvi.

Plate 88

TALL CASE CLOCK, 1815

Case: John Paul, Jr. (1789–1868)

Lykens Township, Dauphin County

Inscribed: Leichens Taunschip Dauphin County Verfertiget von Johanes Paul 1815 LIBERTY

Curled maple, black walnut, tulip, pine, mahogany, ivory inlay; height 98″ (248.9 cm)

Winterthur Museum. G58.2874

Checklist 114

This clockcase was made by John Paul, Jr., for his personal use, and he took great pains to express both his own love of liberty and freedom and his German-American heritage. Its movement, dial plate, and the overall profile of the case are Anglo-American, but its joined construction and inlaid decoration and letters are of Germanic origin. In 1815, at the age of twenty-six, John Paul, Jr., was obviously delighted that the War of 1812 had confirmed the ability of the United States to ward off English domination. That date is prominently inlaid at the top of the pendulum case door. The word "liberty" is inlaid in ivory at the bottom of the door and numerous eagles inlaid or carved on the case to symbolize his love of country. Loyalty to Pennsylvania is shown by a version of the Pennsylvania state seal inlaid at the center of the door. John

Paul, Jr.'s Germanic heritage was expressed in the form of inlaid tulips, vases, birds, a version of La Fontaine's fable of the fox and the goose, and an inlaid horse and rider. Altogether, the clockcase represents an unabashed, joyous, and proud salute to the maker's European background and allegiance to chosen country and state.

Presumably of French Huguenot descent, John Paul, Jr., was the son of George and Catharina Paul. His baptism is recorded at Saint John's Evangelical Lutheran Church, Mifflin Township, Dauphin County. He was an expert carpenter, cabinetmaker, surveyor, engineer, and a gifted mathematician, and is credited by the Pennsylvania Railroad with laying out the famous Horseshoe Curve near Altoona. His will, written in English, stipulates explicitly, however, that his tombstone be engraved "with German letters in the German Language." John Paul, Jr., died in Elizabethville, Washington Township, not far from the Lykens Township celebrated in inlaid German script on his clockcase.*

**See* Frederick S. Weiser to Nancy G. Evans, May 12, 1976, Object Folder G58.2874, Registrar's Office, Winterthur Museum; Miles Miller, *History of Elizabethville, Dauphin County, Pennsylvania, 1817–1967* (Millersville, Pa., 1967), pp. 135–36; and Will Book, 1868, p. 582, Dauphin County Courthouse, Harrisburg.

Plate 89

CHEST, 1800–1825

Possibly Snydertown, Northumberland County

White pine, painted; height 29⅜″ (74.6 cm)

Winterthur Museum. G57.1105

Checklist 84

Following adoption of the Great Seal of the United States in 1782, most citizens in favor of the Confederation and later, the new federal government, found the eagle to be a handy symbol of the rights and privileges guaranteed by the central government. Monroe Fabian has demonstrated that United States coinage of the late 1790s was the design source for the eagle and shield in the central panel of this chest.* Cut-nail drawer construction signifies that this chest was not made before 1800. However, like the clockcase (pl. 88), the chest may have been decorated to celebrate the end of the War of 1812, or it may have been made as much as ten or fifteen years after that event.

The fact that this example bears no name and exhibits Anglo-German furniture construction techniques may indicate that it was made for a person of non-German background. Wedged tenons mortised through the heavy lid molding and wooden pegs to attach the moldings are its sole Germanic construction features. A desk and bookcase (checklist 95) with blue-and-white painted decoration similar to that on this chest was recovered in Northumberland County. When Henry Francis du Pont acquired this chest in 1937, the dealer who sold it stated that the chest had been purchased in the Mahantango Valley, Snyder County.† Although there is a second Mahantango valley and creek in Snyder County, the residents of the area from which the dealer acquired this chest usually mean Schuylkill and Northumberland counties as the location of the Mahantango Valley, and perhaps the dealer's statement referred to Snydertown, Northumberland County, as the place of origin of this chest.

**See* Monroe H. Fabian, *The Pennsylvania-German Decorated Chest* (New York, 1978), pp. 166–67, figs. 161–62.
†A. J. Pennypacker to Henry Francis du Pont, May 26, 1937, Correspondence Folder, Registrar's Office, Winterthur Museum.

Plate 90

DISH, 1826–41
Absalom Bixler (1802–1884)
Lancaster County
Inscribed: 1732. INDEPENDENCE. HALL. 1741. E. WOOLEY
Earthenware with slip decoration, clear lead glaze; dia.
14⅛″ (35.9 cm)
Winterthur Museum. 67.1662
Checklist 2

Like John Lewis Krimmel, who in 1815 painted an election scene at the State House in Philadelphia (checklist 189), Absalom Bixler—potter, farmer, woodcarver, and justice of the peace—was also fascinated by the symbolism of Independence Hall, the fountainhead of liberty and freedom. Bixler considered it an appropriate subject for a commemorative dish and so stated—in English—by impressing typeface letters into the rim before firing. His estate inventory included a listing for a "printing press & lot of type."* Also honored by Bixler was Edmund Wooley, the chief carpenter of the Independence Hall building project, which began in 1731 and was completed by 1741. Two similar dishes by Bixler, one depicting the Liberty Bell and one celebrating the deeds of Daniel Boone, bear messages in German and are inscribed 1776 and 1787 respectively. The fiftieth anniversary of the Declaration of Independence occurred in 1826. Independence Hall was a hundred years old in 1831 and/or 1841. This dish, therefore, could have been made any time between 1826 and 1841.

Bixler's ancestors came to Philadelphia from Bern, Switzerland, in 1727.† As a fourth-generation descendant of immigrants, his preoccupation with the themes of liberty, freedom, and independence offers strong proof of their continuing significance to Germanic people in Pennsylvania.

*See Will and Inventory of Absalom Bixler, Will Book F2, p. 27, Lancaster County Historical Society, Lancaster, Pa.

†See Washington, D.C., National Gallery of Art, 101 American Primitive Water Colors and Pastels from the Collection of Edgar William and Bernice Chrysler Garbisch (October 8—November 20, 1966), p. 47, pl. 31; and Miriam E. Bixler, "David Bixler, Folk Artist," Journal of the Lancaster County Historical Society, vol. 81, no. 1 (1977), p. 30.

Plate 91

GENERAL WASHINGTON, 1842
Durs Rudy, Jr. (1789–1850)
Lehigh County
Inscribed: Freiheit Gleichheit Eintracht und Bruder liebe. Anno 1842 General Waschington Oberbefehlshaber der Amerikanischen Armee
Ink and watercolor on paper; 12 x 10″ (30.5 x 25.4 cm)
Philadelphia Museum of Art. Titus C. Geesey Collection. 54-85-131
Checklist 197

On April 20, 1788, George Washington, newly inaugurated president of the United States, wrote to the German Lutheran congregation "in and near Philadelphia" to thank them for their address of good wishes.* As "Commander-in-Chief of the American Army"—the role in which Durs Rudy, Jr., chose to commemorate him—or as president of the new republic, George Washington was a hero to most Germans in Pennsylvania. The liberty pole and cap

on Washington's right provide visual punctuation for the German inscription above his head, which translates as "liberty, equality, harmony, and brotherly love."

The depth of feeling expressed by German-Americans for military and political heroes who had helped to guarantee their continued enjoyment of liberty and freedom is humorously expressed in A. R. Horne's Pennsylvania German Manual, in which a likeness of Andrew Jackson is accompanied by this translated Pennsylvania German caption: "Old General Jackson. In Berks County, they say some people still vote for him, but this is not true."† From Rudy's drawing, attributed to his hand on the basis of a signed Metamorphosis (pl. 120), it seems clear that, in 1842, Germans in Pennsylvania were still voting for the ideals and virtues symbolized by General Washington.

*See "George Washington Writes to the German Lutherans," in Preston A. Barba, ed., "'S Pennsylfawnisch Deitsch Eck," The Morning Call (Allentown, Pa.), February 24, 1940, and "Aus Unserm Briefkaschte," in ibid., March 23, 1940.

†A. R. Horne, Horne's Pennsylvania German Manual: How Pennsylvania German Is Spoken and Written—For Pronouncing, Speaking and Writing English, 3rd ed. (Allentown, Pa., 1910), p. 76.

Plate 92

GENERAL WASHINGTON CROSSING THE DELAWARE, 1842
Susan Imhoff (1824–1896)
Somerset, Somerset County
Inscribed: Susan Imhoffs Work in The Year 1842 aged 17 Years and 9 months was born in the year 1824 God will my naked soul receive When seprate from the flesh And break the Prissons of the Grave to raise my bones afresh Gen Washington Crossing the Delaware
Penelope cotton canvas, silk and merino wool embroidery; 18⁹⁄₁₆ x 21½″ (47.1 x 54.6 cm)
Gretchen Holderbaum Knothe
Checklist 314

According to family history inscribed on the back of this needlework picture, Susan Imhoff received embroidery instruction in Somerset from an itinerant German teacher who traveled from Pittsburgh. Germans in western Pennsylvania, like their counterparts in the east, kept up their intense admiration for George Washington. The source for this portrait of the military hero is an 1833 etching published in New York City by Humphrey Phelps, which was used by another Pennsylvanian, Caroline Hite, to complete a similar needlework picture in 1841.* Since 1810, Germans in Pennsylvania, both young and old, had been exposed to a German-language edition of Mason Locke Weems's Life of George Washington, published in Lebanon by I. Schnee for Mathew Carey of Philadelphia.† It is quite likely, therefore, that Emanuel Leutze's Washington Crossing the Delaware represents a culmination of a strain of hero worship connected with their feeling for him as Landes Vater ("Father of Our Country"), which persisted among Germans in Pennsylvania from 1776 onward.

*See Davida Tenenbaum Deutsch and Betty Ring, "Homage to Washington in Needlework and Prints," Antiques, vol. 119, no. 2 (February 1981), p. 419, pl. xv, fig. 25.

†Mason Locke Weems, Das Leben des Georg Waschington, mit Sonderbaren Anecdoten Sowohl ehrenvoll für ihn selbst . . . (Lebanon, Pa., 1810).

For the Home

FROM BIRTH TO DEATH, virtually all of the personal events, milestones, memories, and activities important to Germans in Pennsylvania centered around their homes and churches. Emigration, settlement, earning a living, learning to adjust to a new environment, and protecting individual rights and privileges—all reflected interaction between Pennsylvania Germans and a wider world. Home, on the other hand, represented a private retreat, never completely isolated, of course, but nevertheless a place where basic values, beliefs, customs, traditions, and activities could be practiced and shared in relative peace and safety.

Life for Germans in Pennsylvania was exceedingly complex. The Pennsylvania German home included those of farmers and farmer-craftsmen as well as those of city or town dwellers such as clergymen, craftsmen, storekeepers, merchant-entrepreneurs, servants, and schoolteachers. No single home can be described in detail, and generalizations are necessary to describe the Pennsylvania German house. The time and place of construction of a Pennsylvania German house also had much to do with its appearance and size. In 1742, Pastor Henry Melchior Muhlenberg recorded that many Germans living in the country had houses with only one room.[1] Eighty years later, in 1822, Jonas Heinrich Gudehus described a similar one-room log house near Lancaster occupied by young people with nine children and two beds where he "could not have lodged . . . well." Gudehus also described the home of Heinrich Spang in Berks County and noted that "all of the rooms, even the kitchen, were painted in the most beautiful way and the wooden floors of the house were almost all covered with colorful woolen rugs. Even the steps were not forgotten. In the visitors' room hung paintings of the entire family in life size, all chastely and beautifully appointed."[2]

As early as 1734, David Seibt observed that because houses in Philadelphia and Germantown were built "a-la-mode and handsomely," a thousand dollars would not provide much of a house in the city, but would be sufficient for a good house in the country.[3] In his *Account of the Manners of the German Inhabitants of Pennsylvania*, written in 1789, Benjamin Rush reported a common saying among Pennsylvania Germans that after inheriting property, often containing a small house built of logs, " 'a son should always begin his improvements, where his father left off,' that is, by building a large and convenient stone house."[4]

There was a strong desire among Germans in Pennsylvania to beautify and to embellish their homes, furniture, and furnishings with motifs from "homeland and . . . new land."[5] Frequently, the exteriors of houses built by German

settlers in eastern Pennsylvania were decorated with date stones and house mottoes. Sometimes humorous, sometimes religious, often practical in content, the house motto was a custom carried over from the Palatinate and from the German cantons of Switzerland.[6] A wood house door lintel (checklist 121) from a log or half-timbered house built in 1740 in East Petersburg, Lancaster County, was inscribed with a bit of humorous, practical philosophy to supplement a German couplet. Translated it reads, "Whether I go out or in, Death stands and waits for me. Better a dry morsel to enjoy than a house full of fresh meat and strife." The second sentence of that house motto, identified by Frederick S. Weiser as a variation on Proverbs 17:1, is a reminder that religious beliefs and customs were an integral part of the Pennsylvania German home. Many Germanic residences contained a house blessing (checklist 205), which placed the dwelling and all who were under its roof under the care of God.

The interior arrangement of houses built by Germans in Pennsylvania was different from that of their Anglo-American neighbors, primarily because of the Germans' use of stoves (pl. 50). As early as 1783, a German observer in Pennsylvania, Johann David Schoepf, reported that even at a distance one could always distinguish a house built by Germans. If the house had one chimney in the middle, it was built and occupied by a German. If there were chimneys at each gable end, it was designed and inhabited by a "Scotch, Irish or Englishman,"[7] who used fireplaces throughout and not stoves.

If one generalizes the features of a "typical" Pennsylvania German farmhouse, there were three principal rooms on the first floor, one of which was the *Schtub* ("stove room" or "living room"). The others were the kitchen and *die Kammer* ("bedchamber").[8] Because of the need to have the kitchen fireplace and living room stove linked to the flue of a central chimney, this placement was inflexible and, therefore, invariable. The bedchamber was always entered from the living, or stove, room. Sometimes, however, there was no separate *Kammer* and the first-floor plan followed the European custom of using one end of the *Schtub* as a bedchamber. A traveler in 1794, having "visited several farms in the famous Lancaster County belonging to farmers known to be worth 10 to 15 thousand pounds," stated that their downstairs rooms consisted of "a kitchen and a large room with the farmer's bed and the cradle, where the family stays all the time."[9]

Where a Pennsylvania German home was situated on the basic economic unit of about 150 acres, life consisted of a sunup-to-sundown routine centered about field cultivation and harvest, the house-garden plot and orchards, livestock care, fence maintenance, yarn production, cloth preparation, food preparation and preservation, cooking, eating, sleeping, and procreation. It cannot be stressed enough that all members of the family, including the elderly and the children, contributed to the economic well-being of each farm household. For a doctor and surgeon of German extraction and his English wife seeking advice, Pastor Muhlenberg distinguished between what he called the

"rough country mode of living" and "an English family used to living genteelly, whose members cannot work themselves and must employ servants and day laborers."[10] Benjamin Rush also noted that wives and daughters of German farmers frequently left the dairy and spinning wheel for awhile to "join their husbands and brothers, in the labour of cutting down, collecting, and bringing home, the fruits of the fields and orchards."[11]

Not that some German families in Pennsylvania were loathe to employ servants. Pastor Muhlenberg redeemed a newly arrived German immigrant as a house servant in 1751 for fifteen pounds but had his services for only nine months, for the redemptioner became unruly and demanded freedom. Muhlenberg referred to other German families with servants, and in 1777 he recorded the widespread complaint about the difficulty of finding servants because the war had stopped emigration from Germany and England.[12] A bawdy sentiment in this regard appears on a sgraffito-decorated earthenware dish (checklist 33) dated 1786 depicting two couples dancing. A German inscription around its rim proclaims: "Our maid, the ugly pig, always wanted to be a housewife. O, you ugly slut." It is difficult to know whether the complaint was made about the maid's behavior in trying to land her man at a dance or out of annoyance with the difficulty of replacing a maid if she married and left her master's employ. Perhaps both!

In the kitchen, an almanac (pl. 99) hung on a string near the fireplace provided reminders of the secular and church calendar. Saints' days indicated when certain crops should be planted or harvested. Spring chores would be interrupted by Easter Monday and Whitmonday, secular holidays following the respective Sunday church celebrations. Days when certain work was prohibited, such as Good Friday and Ascension Day, were also listed.[13] Kitchens also contained a dresser or a cupboard, a stretcher table usually with two drawers of unequal width, but sometimes only one, a dough tray, the usual fireplace equipment (excluding andirons), earthenware, pewter, a candlestick, an iron Betty lamp, a tin coffeepot, a coffee mill, and knives, forks, and spoons (pls. 94–98).

In the *Schtub* was, of course, a stove, usually of iron but occasionally of ceramic tile. Benches (pl. 102) were built into the corner of the room directly opposite its entrance door. A sawbuck or other form of dining table was placed in front of the benches and a separate movable bench placed alongside the table. At the end of the table was a back stool, or *Daddi Schtuhl* in Pennsylvania German dialect, reserved for the male head of the household. In this corner would be placed a hanging corner cupboard (pl. 101) or shelves. A wardrobe, or clothespress (pl. 103), filled most of a wall opposite the dining table, and wall cupboards might hang on either side of the stove. Fraktur and samplers (pl. 104) would not be displayed, but would be stored with table and bed linens and personal items in chests or wardrobes. A spinning wheel (pl. 100), tea equipage, and a few chairs would complete the furnishings of this room.

A bedstead, either low or high post, was the main furnishing of the *Kammer*. Bedding for a double bedstead included two feather-filled pillows, a feather or chaff underbed, linen checked cases for the pillows, bolster and feather bed, sheets, and a coverlet (pls. 108–11) or a quilt (pl. 107). If a high-post bedstead was used, bed curtains would also hang on it.[14] A cradle, trundle bed, looking glass (pl. 112), or other furniture for storage, such as a chest, chest of drawers, or wardrobe, completed the furnishings of this room. If a guest occupied the *Kammer*, an unlikely event, a hand towel would be hung on the door. Most of the time, hand towels were displayed outside a second-story guest bedroom.

Clearly the objects specified above do not begin to complete the furnishing of many self-sufficient German homes in Pennsylvania. A book on household economy and arts, published for Pennsylvania Germans in 1819, contains 350 sections providing information about preparation and preservation of food, craft secrets for maintenance of furnishings, home medical remedies, care of livestock, and house repairs.[15] Instructions are given to mark linens or laundry "in the English way," with permanent ink. All of these activities, of course, required equipment that would be found in the home.

Home remedies for medicine and medical care were necessary for households located in rural areas. Pastor Muhlenberg graphically described what must have been a common accident in the home. In 1781 his wife was seated on a bench near a kettle of red beets cooking over a fire. Experiencing a seizure, "she fell into the boiling pot," and suffered horrible burns. The nearest doctor was seven miles away and Muhlenberg was doubly distressed because he had "prescriptions but no ingredients."[16]

Household and work routines did provide time for pleasure, amusement, and celebration throughout the year. As Frederick Weiser and Howell Heaney have noted, Pennsylvania Germans were not dour. They sang, danced (pl. 118), laughed, and pulled pranks. "Alongside the work in a Pennsylvania Dutchman's life, there was the play and glee that only a man at peace with life can relish."[17] Many of the practices and customs followed by modern Americans to celebrate Christmas and Easter are owed to Pennsylvania Germans (pls. 116, 117). But those and other religious holidays were often celebrated over a two-day period in order to separate religious and secular aspects.

Sgraffito- and slip-decorated plates made by Pennsylvania German potters for customers who wished to commemorate special occasions often bear English and German inscriptions that provide insight into both their humor and social relationships within families. Conservative attitudes toward marriage are certainly illustrated by the motto on a plate (checklist 14), which translates: "Rather would I single live than the wife the breeches give." But an instance of female resistance from a bad-tempered cook can be read from another translated inscription: "I cook what I can. If my pig will not eat it, my husband will" (pl. 97).

Those Pennsylvania Germans who lived near a large town or city partici-

pated in the twice-yearly fairs, held in spring and fall (pl. 53). On May 27, 1762, Pastor Muhlenberg noted, "The *fair* was held today, and there was worldly revelry in all parts of the city [Philadelphia]."[18] Earlier, in 1753, Muhlenberg also noted that public auctions of household goods were often occasions when "willful sinners of every religious party and nationality, both young and old, indulge too freely in strong drinks."[19]

Almost nothing that smacked of worldly revelry escaped the attention of Pastor Muhlenberg, including the practice of "shooting in" the new year. The good pastor was instrumental in closing a tavern located opposite a church in New Hanover, Montgomery County, in 1765, because "people who had come from near and far to go to church . . . were lured inside and then came to church half-drunk." He stated that since revelry on Sunday was punishable, "they reveled all the more frivolously on the days after holidays— such as Christmas, Easter, Whitsunday—tippling, fiddling, dancing, and engaging in all the other abominations that go with them, and the poor young people were especially drawn into them."[20]

Many of the attitudes, concerns, needs, hopes, aspirations, and behavior of other groups living in Pennsylvania were also shared by Pennsylvania Germans. Despite some differences in the objects they used and the unusual decorative motifs, the works included here demonstrate that their art, even in domestic things, does give voice to their ideas, beliefs, and values.

1. Henry Melchior Muhlenberg, *The Notebook of a Colonial Clergyman: Condensed from the Journals of Henry Melchior Muhlenberg*, ed. and trans. Theodore G. Tappert and John W. Doberstein (Philadelphia, 1959), p. 11.

2. Quoted in Larry M. Neff, trans., "Jonas Heinrich Gudehus: Journey to America," in Albert F. Buffington et al., *Ebbes fer Alle-Ebber—Ebbes fer Dich: Something for Everyone—Something for You. Essays in Memoriam—Albert Franklin Buffington*, Publications of the Pennsylvania German Society, vol. 14 (Breinigsville, Pa., 1980), pp. 245, 217.

3. Quoted in David Schultze, *The Journals and Papers of David Schultze*, vol. 1, *1726–1760*, ed. and trans. Andrew S. Berky (Pennsburg, Pa., 1952), p. 52.

4. Benjamin Rush, *An Account of the Manners of the German Inhabitants of Pennsylvania, Written 1789*, ed. I. Daniel Rupp (Philadelphia, 1875), pp. 12–13.

5. *See* an excellent summary by Frederick S. Weiser and Howell J. Heaney, comps., *The Pennsylvania German Fraktur of the Free Library of Philadelphia*, Publications of the Pennsylvania German Society, vol. 10 (Breinigsville, Pa., 1976), pp. xiv–xv.

6. *See* John Bear Stoudt, "House Mottoes in Eastern Pennsylvania," *A Collection of Papers Read Before the Bucks County Historical Society*, vol. 6 (1932), pp. 65–75. See also Fredric Klees, *The Pennsylvania Dutch* (New York, 1950), pp. 387–88.

7. *See* Rush, *Account of the Manners*, p. 12, n. 1.

8. *See* Alan G. Keyser, "Beds, Bedding, Bedsteads and Sleep," *Der Reggeboge: The Rainbow. Quarterly of the Pennsylvania German Society*, vol. 12, no. 4 (October 1978), pp. 1–28. See also Robert C. Bucher, "The Continental Log House," *Pennsylvania Folklife*, vol. 12, no. 4 (Summer 1962), pp. 14–19; and G. Edwin Brumbaugh, *Colonial Architecture of the Pennsylvania Germans*, Pennsylvania German Society Proceedings at Harrisburg, Pa., October 17, 1930, and Papers Prepared for the Society, vol. 41 (Lancaster, Pa., 1933).

9. Quoted in Keyser, "Beds, Bedding," p. 4.

10. Muhlenberg, *Notebook*, p. 230.

11. Rush, *Account of the Manners*, p. 25.

12. Muhlenberg, *Notebook*, pp. 41, 43, 81, 173.

13. *See* Weiser and Heaney, comps., *Pennsylvania German Fraktur*, p. xiv.

14. *See* Keyser, "Beds, Bedding," p. 3.

15. Johann Krauss, comp., *Oeconomisches Haus-und Kunst-Buch* . . . (Allentown, Pa., 1819).

16. Muhlenberg, *Notebook*, p. 220.

17. Weiser and Heaney, comps., *Pennsylvania German Fraktur*, p. xv.

18. Muhlenberg, *Notebook*, p. 62.

19. *Ibid.*, p. 53.

20. *Ibid.*, pp. 69, 118.

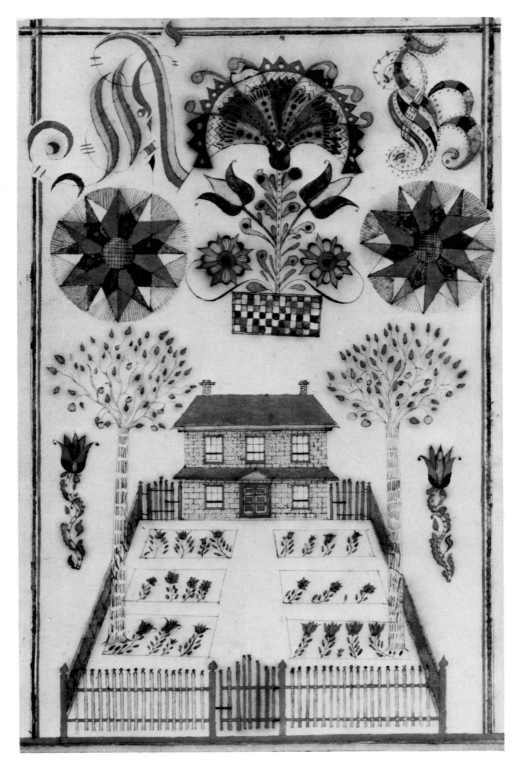

93 The well being and traditional values of
Pennsylvania German life were sustained in
the home. Houses were usually well ordered
and maintained, and set amid neat kitchen
gardens (Schwenkfelder Library, Pennsburg,
Pennsylvania)

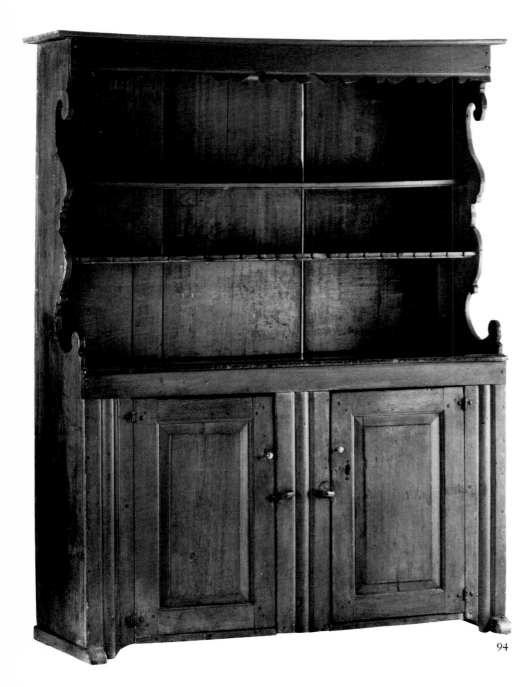

94–96 Kitchen furnishing included a dish cupboard (Winterthur Museum) and work table (Lancaster County Historical Society, Lancaster). A Betty lamp (Private Collection), suspended from a hook and chain, would have been used on a cupboard or mantle, or carried to any part of the house.

94

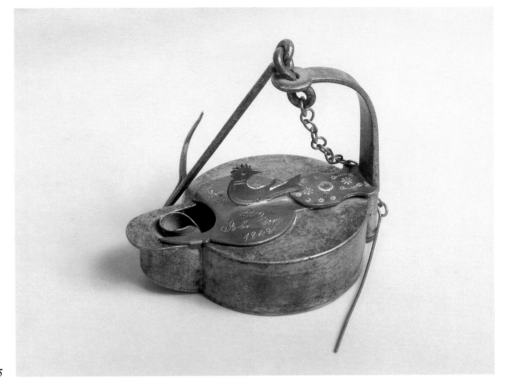

95

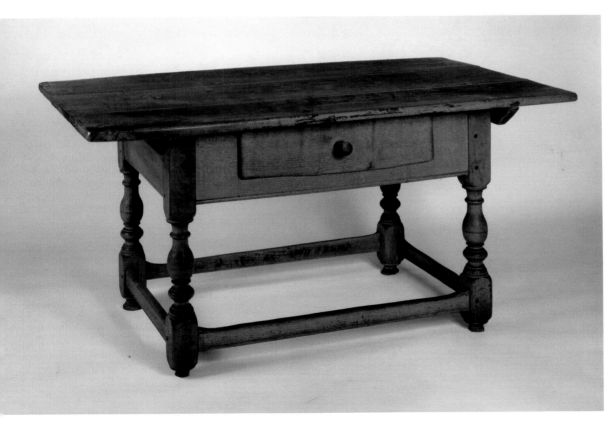

96

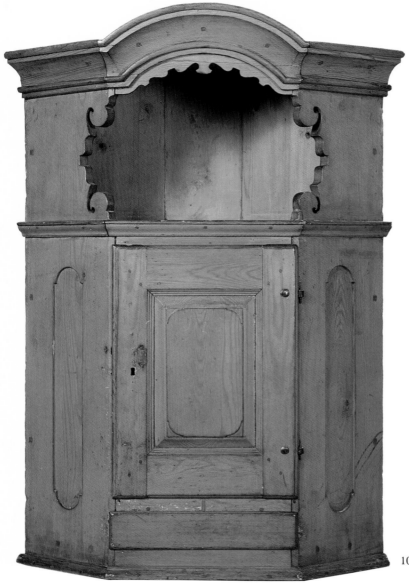

101, 102 Pennsylvania German parlors were customarily furnished with built-ins, such as corner shelves or a hanging corner cupboard (Philadelphia Museum of Art), where a Bible or religious books might be stored, and also with pine benches (Collection Mr. and Mrs. Richard Flanders Smith)

103 A wardrobe, or clothespress, was essential for storing clothing and linens in houses that lacked closets (Winterthur Museum)

101

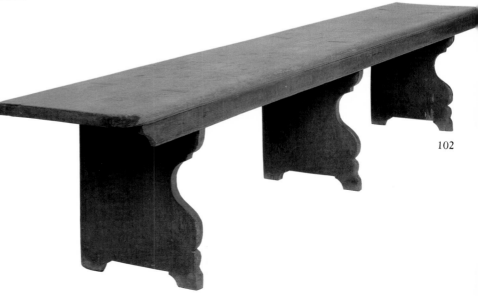

102

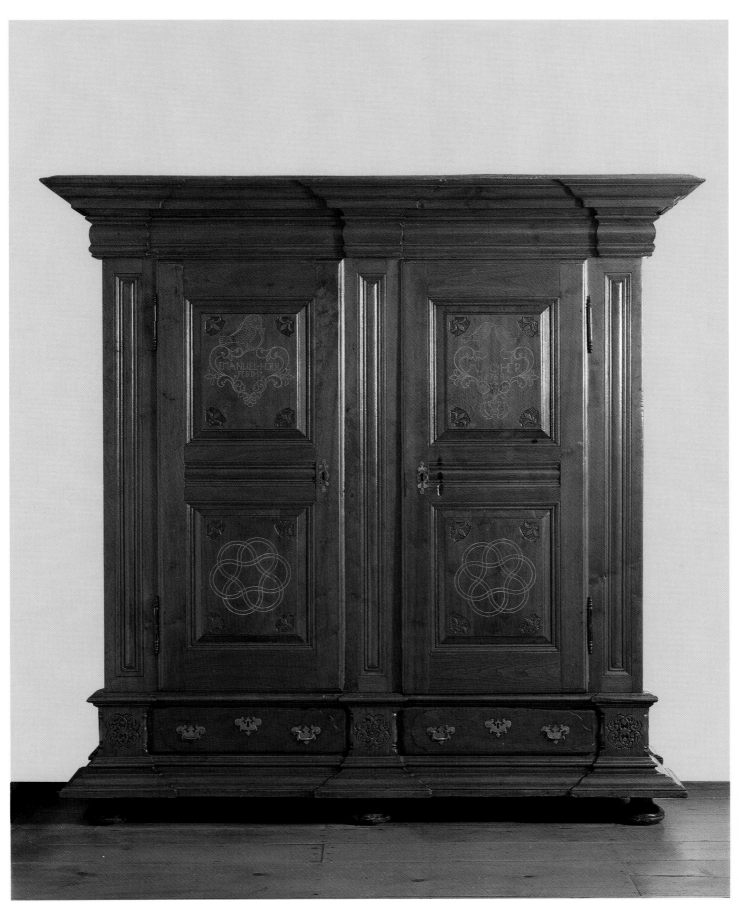

103

104

105

106

104–6 Women learned sewing skills at home
from their mothers or other relatives, trans-
ferring cross-stitch designs from paper
patterns (The Reading Public Museum and
Art Gallery, Reading) to samplers (Winter-
thur Museum), as well as hand towels and
other linens. Sewing baskets, lined with cloth,
held the necessary materials, and some had a
smaller holder for needles and pins (Collec-
tion Dorothy and Eugene Elgin)

107 Feather beds and coverlets were cus-
tomary bedding, and embroidered quilts such
as this one dating from 1830 were rare
(Collection Dr. and Mrs. Donald M. Herr)

107

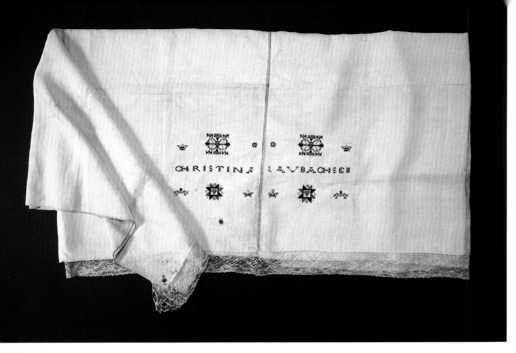

108–11 The bedstead (Winterthur Museum) —its mattress supported by ropes wound around pegs—was furnished with bedding that included linen sheets marked with cross-stitch (Germantown Historical Society, Philadelphia), woven coverlets (Collection Dr. and Mrs. Donald Herr), and linen cases for pillows and bolsters (Collection Mr. and Mrs. Richard Flanders Smith)

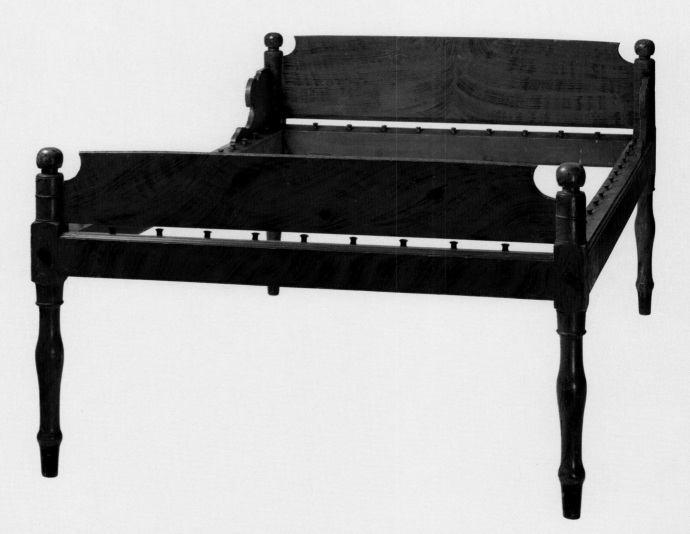

110

111

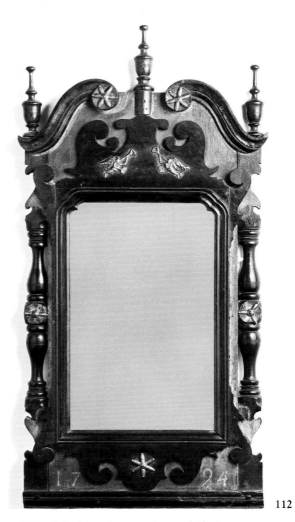

112

112 A looking glass usually would be hung
in the bedchamber, one of three rooms on the
ground floor of a typical Pennsylvania
German farmhouse (Winterthur Museum)

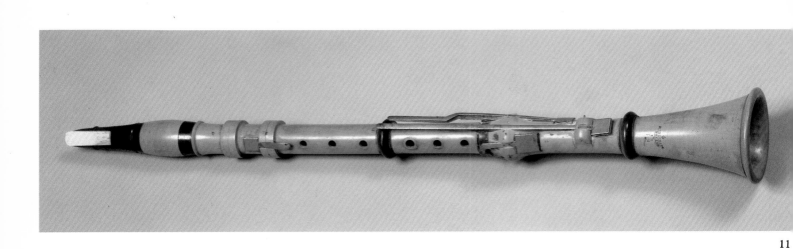

113, 114 Germans brought a strong musical tradition with them to Pennsylvania. Violins, clarinets (both, Moravian Historical Society, Nazareth, Pennsylvania), and zithers were among the instruments commonly played in the home as well as in taverns and churches.

115 Daniel Rose, a clockmaker and purveyor of musical instruments in Reading, is shown here with some of the instruments he played (The Historical Society of Berks County, Reading)

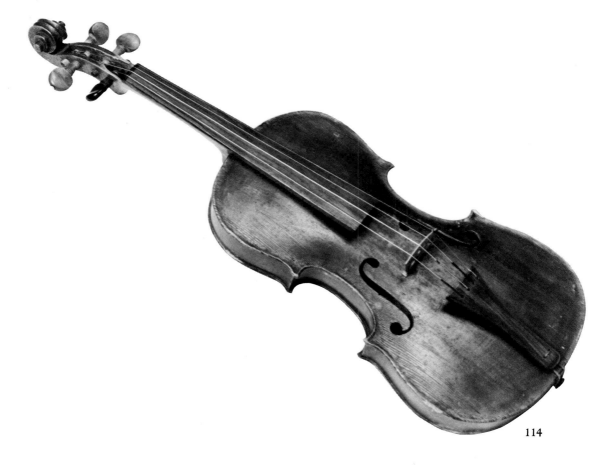

114

116

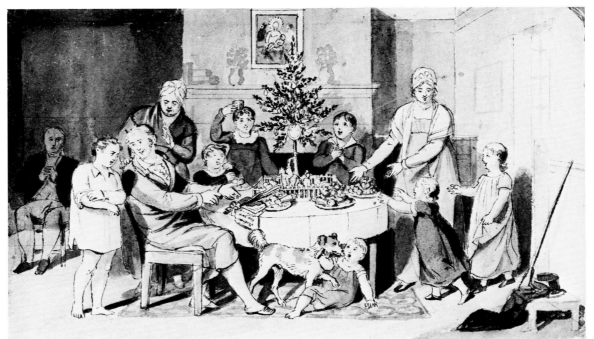

117

Stephan, und Das Hackbret, 1808..
Danceing, at the house of John Glefsner.

Stephan a good violin player and his companien a German playing on the indileimor, or barbiton neut. lyricum, ein hackbret.

Die Posaunen in 1828. The Trumpet players from Litiz, 1828.
november den 9. at the Consecration,
Gehet zu seinen Thoren ein, of the Moravian mit Danken, und zu seinen vorhöfen Church mit loben! at the time of Rev. Kluge.

Ruh sanft Schlaf wohl in deiner gruft, biss dass dein Jesus dich, zu gleicher zeit auch mich, zum leben wieder ruft, nie sanft Schlaf wohl in deiner gruft. Composed by Ludwig miller the Schoolmaster. And this hymn at the time when david Danneberger was buried.

From Litiz.

mr. Hall. he finishes the Organ

David Danneberger, Organ builder and his Journeyman in the old Lutheran Church, 1807. he was from Litiz, and died in York, at the time working at the organ.

118

116, 117 Many of the customs and traditions associated today with Easter and Christmas —from the Easter bunny (Abby Aldrich Rockefeller Folk Art Center, Williamsburg, Virginia) to the Christmas tree and gifts (Winterthur Museum)—originated with the Pennsylvania Germans.

118 Music and dancing were among the pastimes that broke the routine of work and household chores (The Historical Society of York County, York, Pennsylvania)

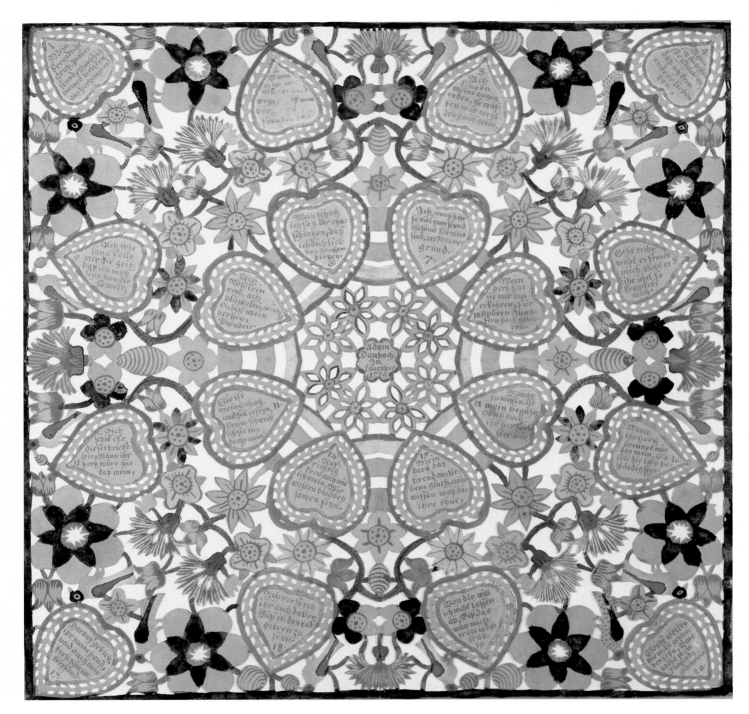

119 Affection and love sometimes were
expressed in the form of painted and inscribed
cutwork love letters (Winterthur Museum)

Plate 93

HOUSE WITH SIX-BED GARDEN, 1818
Attributed to David Huebner
Upper Montgomery County
Inscribed: 1818
Ink and watercolor on paper; 12⁷⁄₁₆ x 7¾" (31.6 x 19.7 cm)
Schwenkfelder Library, Pennsburg, Pennsylvania. 2-34b
Checklist 194

Neat kitchen gardens were the pride of Pennsylvania German women. Gardens were generally rectangular in plan with four or more main beds planted in vegetables. Flowers and herbs grew between perimeter paths and fences. In addition to herbs, these gardens furnished beans, beets, cabbage, corn, cucumbers, onions, peas, squash, and turnips—some produce to be consumed fresh, some to be dried or pickled.* Nearby orchards provided apples, cherries, peaches, and plums. Pastor Muhlenberg noted that Pennsylvania German custom permitted travelers to pick up or knock down as much fruit as could be eaten in an orchard but not carried away;† however, no such custom pertained to the kitchen garden. Ironically, the house in this drawing by David Huebner (Heebner) is of the English type, with a chimney at each end, rather than one central chimney.

*See Alan G. Keyser, "Gardens and Gardening Among the Pennsylvania Germans," *Pennsylvania Folklife*, vol. 20, no. 3 (Spring 1971), pp. 2–15; Fredric Klees, *The Pennsylvania Dutch* (New York, 1950), pp. 396–99; Johann Krauss, comp., *Oeconomisches Haus-und Kunst-Buch* . . . (Allentown, Pa., 1819); and Amos Long, Jr., *The Pennsylvania German Family Farm*, Publications of the Pennsylvania German Society, vol. 6 (Breinigsville, Pa., 1972), pp. 37–56.
†Henry Melchior Muhlenberg, *The Notebook of a Colonial Clergyman: Condensed from the Journals of Henry Melchior Muhlenberg*, ed. and trans. Theodore G. Tappert and John W. Doberstein (Philadelphia, 1959), p. 174.

Plate 94

KITCHEN CUPBOARD OR DRESSER, 1750–75
Probably Lancaster County
Walnut, tulip; height 81¾" (207.6 cm)
Winterthur Museum. G65.2750
Checklist 86

Germans in Pennsylvania listed in household accounts *ein Schüssel Schank* ("dish cupboard") or *ein Küchen Schranck* ("kitchen cupboard") as essential kitchen furnishings. Of fine walnut or plain poplar, they were used to hold dishes, spoons, and forks. From 1749 to 1839, every daughter of the Clemens family in Montgomery County received one from her parents as part of a wedding gift.* As in a drawing by Lewis Miller of a similar cupboard overturned in a York kitchen, cupboards might also hold a fat lamp, candlestick, coffee mill, tin coffeepot, crocks, and jars.† This example is constructed in Germanic woodworking traditions—diagonally placed double-pegged tenons on its doors, backboards fastened solely by wooden pegs, and an overhanging top board with a molding returning across the grain of its side edges. A German tool called the *Grathobel* ("dovetail plane") fashioned the lower molding of the fascia board beneath the top.‡

*See Alan G. Keyser, ed., and Raymond E. Hollenbach, trans., *The Account Book of the Clemens Family of Lower Salford

Township, Montgomery County, Pennsylvania, 1749–1857 (Breinigsville, Pa., 1975), pp. 38–39, 42–43, 46–47, 50–51, 53–55, 64–65, 72–73, 78–79, 92–93, 108–11.
†See Robert P. Turner, ed., *Lewis Miller: Sketches and Chronicles. The Reflections of a Nineteenth Century Pennsylvania German Folk Artist* (York, Pa., 1966), repro. p. 72.
‡See Benno M. Forman, "German Influences in Pennsylvania Furniture," in Scott T. Swank et al., *Arts of the Pennsylvania Germans at Winterthur*, forthcoming.

Plate 95

BETTY LAMP, 1848
John Long (b. c. 1787)
Rapho Township, Lancaster County
Inscribed: Fanny M. Erisman Manufactured By John Long 1848
Wrought iron, brass; height 9¾" (24.8 cm)
Private Collection
Checklist 138

By 1848, when the locksmith John Long made this oil lamp for Fanny M. Erisman (1822–1913), more efficient and brighter-burning lighting devices had been developed. An "iron light or lamp" was, however, a traditional wedding gift to a bride from her parents. In 1773, for example, Jacob Clemens presented his daughter Margreda with one costing two shillings.* This Betty lamp probably marked the occasion of Fanny Erisman's marriage to John Becker.† Suspended from a hook and chain, the lamp could be used on a kitchen cupboard or a fireplace mantle, or taken to any room in the house as a portable light. "Betty" is presumed to be a corruption of *besser* ("better"), but Pennsylvania German accounts and inventories consistently refer to these forms as "iron" or "oil" lamps. John Long, who moved from Manheim to Rapho Township about 1840,‡ and the better-known Johann Peter Derr of New Schaefferstown, Berks County, made many iron lamps.

*See Alan G. Keyser, ed., and Raymond E. Hollenbach, trans., *The Account Book of the Clemens Family of Lower Salford Township, Montgomery County, Pennsylvania, 1749–1857* (Breinigsville, Pa., 1975), pp. 60–61.
†Genealogical Card File, Lancaster Mennonite Historical Society, Lancaster, Pa.
‡See Jeannette Lasansky, *To Draw, Upset, and Weld: The Work of the Pennsylvania Rural Blacksmith, 1742–1935* (Lewisburg, Pa., 1980), p. 49.

Plate 96

KITCHEN OR WORK TABLE, 1750–70
Probably Lancaster County
Walnut; height 29½" (74.9 cm)
Lancaster County Historical Society, Lancaster, Pennsylvania. 50.6
Checklist 104

Pennsylvania German records do not refer to kitchen or work tables, but many walnut tables with rectangular stretcher bases, turned legs, one or two drawers, and removable tops, have sur-

vived. Like this one, they show evidence of Germanic joinery—wedged dovetails, wooden pegs fastening a flat-drawer bottom, and battens dovetailed under the top. Unlike this intact example, most show heavy use—replaced or restored tops and drawers, dry-rotted or broken legs, and missing feet. The top is at a height convenient for kitchen work, and despite an overhang the stretcher prevents sitting at the table. Traditionally, two-drawer versions held bread and linens for meals. Abraham Overholt, a Bucks County joiner, made "a walnut table with 1 drawer" in 1791 for one pound, ten shillings, whereas in 1796 he charged three pounds for one "with two drawers and hardware." Between 1794 and 1813, Peter Ranck (checklist 217) of Lebanon County made at least fourteen tables for the lower price.* Their usefulness in a home is indicated by the gifts of tables to Clemens family daughters in 1763 and 1774.†

*See Alan G. Keyser, Larry M. Neff, and Frederick S. Weiser, eds. and trans., *The Accounts of Two Pennsylvania German Furniture Makers—Abraham Overholt, Bucks County, 1790-1833, and Peter Ranck, Lebanon County, 1794-1817* (Breinigsville, Pa., 1978), pp. 4, 9ff.

†See Alan G. Keyser, ed., and Raymond E. Hollenbach, trans., *The Account Book of the Clemens Family of Lower Salford Township, Montgomery County, Pennsylvania, 1749-1857* (Breinigsville, Pa., 1975), pp. 54-55, 64-65.

Plate 97

DISH, 1847
Attributed to John Nase (b. 1822)
Upper Salford Township, Montgomery County
Inscribed: Ich Koch was ich Kan est mein sau net so est mein man Ao 1847
Earthenware with slip decoration, clear lead glaze; dia. 12¼" (31.1 cm)
Philadelphia Museum of Art. Gift of John T. Morris. 92-50
Checklist 15

More than one early observer of Pennsylvania German families commented on the contribution made by wives and daughters to the general economic well-being and comfort of their homes. Because work on farms was hard and women were observed in harvesting work, it has been thought that they were completely subservient to the male-dominated society. Slip or scratched inscriptions on Pennsylvania German plates and dishes sometimes reinforce this view. But wives did retain their dowry portion and there are dish and plate inscriptions that speak of loving, respectful relationships between husbands and wives (checklist 23). Evidence of female resistance can be deduced from the inscription on this dish, which translates: "I cook what I can. If my pig will not eat it, my husband will." Not exactly a spineless attitude.

John Nase continued his father's pottery business until 1850.* He selected an unusual black slip background rather than the traditional white or yellow for this dish. Its design harks back to eighteenth-century German and Swiss examples.

*See Edwin Atlee Barber, *Tulip Ware of the Pennsylvania-German Potters: An Historical Sketch of the Art of Slip-Decoration in the United States* (Philadelphia, 1903), pp. 147-48.

Plate 98

FORK, SPATULA, AND TASTER, 1832
Northumberland County
Inscribed: HS 1832
Wrought iron, brass; spatula, length 19¼" (48.9 cm)
C. Keyser Stahl (fork and spatula)
Hilda Smith Kline (taster)
Checklist 136

Kitchen utensils, usually in a combination of flesh or meat fork, ladle, and skimmer, were a popular, traditional gift from Pennsylvania German parents to their newly married daughters. These were owned by Johanna Ditzler Smith (1806-1891). Johanna (Hanna) Ditzler married Wilhelm Schmidt in 1832 in the Evangelical Lutheran Church at McEwensville, Northumberland County.* Hence the initials HS and date 1832 inlaid in brass in these examples. Kitchen utensils were included in dowries for daughters, usually in sets of three or four, until well into the nineteenth century. In 1749 and 1751, Anna and Esther Clemens, respectively, received three iron spoons and a flesh fork, and iron and copper spoons and a flesh fork from their father as part of their dowries. In 1755, Maria Clemens was given a skimming ladle, iron ladle, flesh fork, and copper bowl, which together cost eight shillings.†

*Mrs. C. Keyser Stahl to Donald L. Fennimore, August 26, 1981, Winterthur Museum.

†See Alan G. Keyser, ed., and Raymond E. Hollenbach, trans., *The Account Book of the Clemens Family of Lower Salford Township, Montgomery County, Pennsylvania, 1749-1857* (Breinigsville, Pa., 1975), pp. 40-43, 46-47, 50-51, 54-55.

Plate 99

ALMANAC FOR 1792, 1791
Johann Albrecht and Company, publishers
Lancaster, Lancaster County
Inscribed: Neuer Lancasterscher Calender 1792.
Letterpress and woodcut; 8½ x 6⅞" (21.6 x 17.5 cm)
Winterthur Museum. 69.2202
Checklist 244

Wherever printing presses with German typeface existed in Pennsylvania, almanacs were part of their production (checklist 240, 241). Indispensable to Pennsylvania German households, almanacs were hung from a cord—the original is still part of this almanac—on or near the kitchen fireplace. The core of each almanac was a page for each month with days of every week in chart form. Phases of the sun and the moon, the sign under which that heavenly body appeared, and lunar and solar eclipses were featured. Summaries of Christian movable feast days, saints' days, and symbols for days propitious for planting crops, letting blood for good health, cutting wood, harvesting fruit and grains, were also integral.* Home remedies were included because most medical care was furnished at home. Dates of court sessions for state and counties were provided. Profiles of prominent social, religious, political, and military figures rounded out the reading fare offered by the variety of almanacs available to Pennsylvania Germans.

*See Louis Winkler, "Pennsylvania German Astronomy and Astrology: I. Almanacs," *Pennsylvania Folklife*, vol. 21, no. 3 (Spring 1972), pp. 24-31.

Plate 100

SPINNING WHEEL, 1806
Samuel Henry (d. 1816)
Lampeter Township, Lancaster County
Inscribed: s HENRY 1806
Wood, iron; height 44½″ (113 cm)
Lancaster County Historical Society, Lancaster, Pennsylvania
Checklist 265

A major task for Pennsylvania German women until late in the nineteenth century was the countless hours of spinning yarn for household textiles. Dowries frequently included a spinning wheel; from 1749 through 1839, each Clemens family daughter, for example, was given one as part of her parental wedding gift.* This one was made for Fannie Simmons Kessey. A survey of Montgomery County inventories for the year 1810 revealed one spinning wheel for every third person.† Between 1790 and 1794, Abraham Overholt supplied seventy-one spinning wheels to his Bucks County customers, usually at a cost of fifteen shillings.‡

This upright type, referred to as a "German wheel," took up less space in a house and could be transported or stored more easily than a conventional wheel. In 1778 its maker, Samuel Henry, signed an oath of allegiance in Lancaster to become a citizen.§

*See Alan G. Keyser, ed., and Raymond E. Hollenbach, trans., *The Account Book of the Clemens Family of Lower Salford Township, Montgomery County, Pennsylvania, 1749–1857* (Breinigsville, Pa., 1975), pp. 40–119.

†See Rudolf Hommel, "About Spinning Wheels," *The American-German Review*, vol. 9, no. 6 (August 1943), p. 4.

‡See Alan G. Keyser, Larry M. Neff, and Frederick S. Weiser, eds. and trans., *The Accounts of Two Pennsylvania German Furniture Makers—Abraham Overholt, Bucks County, 1790–1833, and Peter Ranck, Lebanon County, 1794–1817* (Breinigsville, Pa., 1978), pp. viii, 3–8.

§Inventory of Samuel Henry, 1816, Lancaster County Historical Society, Lancaster, Pa. (courtesy of John Aungst).

Plate 101

HANGING CORNER CUPBOARD, 1770–1800
Possibly Lebanon County
Yellow pine, originally painted; height 48″ (121.9 cm)
Philadelphia Museum of Art. Gift of J. Stogdell Stokes. 28-10-1
Checklist 90

In German Protestant households, hanging corner cupboards or corner shelves replaced the crucifix usually found in the *Herr Gottswinkel* corner of German Catholic houses.* Although a rare form in Pennsylvania—the less expensive walnut, tulip, or pine corner shelves were more common—hanging corner cupboards were used in the parlor to store a Bible, religious books, a personal hymnal or manuscript choral book, and other items important as religious or moral reminders at family gatherings. Either form, cupboard or shelves, was always located in the parlor corner directly opposite the entrance to the kitchen. In the Germanic woodworking tradition, wooden pegs fasten all members of this cupboard, even its drawer bottom, and diagonally placed pegs

tighten all mortise and tenon joints. A similar hanging corner cupboard from Germany also has paneled sides and a paneled door.†

*See Alexander Schöpp, *Alte deutsche Bauernstuben und Hausrat* (Elberfeld, 1921), pls. 36, 42.

†See Erich Klatt, *Die Konstruktion alter Möbel: Form und Technik im Wandel der Stilarten* (Stuttgart, 1961), pp. 47–49.

Plate 102

BENCH, 1800–1830
Eastern Pennsylvania
White pine, painted; length 96¾″ (245.7 cm)
Mr. and Mrs. Richard Flanders Smith
Checklist 71

The unfinished rear edge and right end of the top of this bench indicate that it butted against a wall in the corner of a room. Such benches were built into a corner of the *Schtub* ("stove room"), or parlor, of a Pennsylvania German house during construction, so chairs did not have to be part of the new furnishings. No Clemens family daughter, for example, received chairs as a wedding gift until 1773, although their dowries were listed from 1749.* This type of bench was not recorded in inventories because it was part of the house structure. But John Bachman, a Lancaster County joiner, referred to *ein Banck* ("bench") costing three shillings in the work order for his laying floors and installing windows and doors for Andreas Fereres in 1783.†

Movable benches with a wide top overhanging front and back are listed in inventories and craftsmen's records. Jacob Landes, a Bucks County cabinetmaker, made a *Banck* in 1825, another in 1839, and two for Abraham Moyers in 1843.‡

*See Alan G. Keyser, ed., and Raymond E. Hollenbach, trans., *The Account Book of the Clemens Family of Lower Salford Township, Montgomery County, Pennsylvania, 1749–1857* (Breinigsville, Pa., 1975), pp. 60–61.

†See Benno M. Forman, "German Influences in Pennsylvania Furniture," in Scott T. Swank et al., *Arts of the Pennsylvania Germans at Winterthur*, forthcoming.

‡Account Book of Jacob Landes, 77x374.1, Joseph Downs Manuscript and Microfilm Collection, Winterthur Museum Library.

Plate 103

WARDROBE OR CLOTHESPRESS, 1768
Manor Township, Lancaster County
Inscribed: EMANUEL HERR FEB.D. 17 MA. HER 1768
Walnut, tulip, sulphur inlay; height 89½″ (227.3 cm)
Winterthur Museum. G65.2262
Checklist 115

In Pennsylvania German records, this form (checklist 116–20) is referred to as *Kleiderschanck, Glederschang*, wardrobe, clothes cupboard, clothespress, or clothes dresser.* By any of these names, it was essential for storing clothing and household textiles in homes that lacked closets. Between 1755 and 1799, Clemens family daughters, never sons, were always given a *Kleiderschank* at their marriages. Theirs ranged in value from two pounds, ten shillings (1755–56), to ten pounds (1799). Two examples similar to this one were made for the Kauffman and Reist families in

1775–76.† They must have come from the same Lancaster County shop that produced this tour de force of Pennsylvania German joinery. Sulphur-inlaid inscriptions and decorations of doves or parrots, lovers' knots, names, dates, and angel head and wings indicate that this wardrobe was made to celebrate the marriage of Emanuel Herr (1745–1828) and Mary Herr. He owned a house in New Millerstown, Manor Township.‡

*See Alan G. Keyser, ed., and Raymond E. Hollenbach, trans., *The Account Book of the Clemens Family of Lower Salford Township, Montgomery County, Pennsylvania, 1749–1857* (Breinigsville, Pa., 1975), pp. 46–47, 64–65, 72–73, 78–79, 145; and Alan G. Keyser, Larry M. Neff, and Frederick S. Weiser, eds. and trans., *The Accounts of Two Pennsylvania German Furniture Makers—Abraham Overholt, Bucks County, 1790–1833, and Peter Ranck, Lebanon County, 1794–1817* (Breinigsville, Pa., 1978), p. 234.

†One, made for I. M. and A. M. Kauffman, March 1, 1776, is in the William Penn Memorial Museum, Harrisburg. The other bears the names of Abraham and Elizabeth Reist and the date March 8, 1775 (Private Collection).

‡See Genealogical Card File, Lancaster Mennonite Historical Society, Lancaster, Pa.; and Theodore W. Herr, *Genealogical Record of Reverend Hans Herr* (Lancaster, Pa., 1980).

Plate 104
SAMPLER, 1817–20
Elisabeth Waner
Lancaster or Lebanon County
Inscribed: [2 alphabets minus js; numerals 1–12] OEHBDDE ELISABETH WANER 1820 1817
Linen, silk and cotton embroidery; 17¼ x 16⅜" (43.8 x 41.6 cm)
Winterthur Museum. 80.60
Checklist 299

Plate 105
SAMPLER PATTERN, 1827
Sara Schultz or her teacher
Eastern Pennsylvania
Inscribed: [alphabet minus y and z; numerals 1–10] SARA. SCHULTZ. 1827
Ink and watercolor on paper; 15½ x 12½" (39.4 x 31.8 cm)
The Reading Public Museum and Art Gallery, Pennsylvania
Checklist 298

Most Pennsylvania German women learned sewing skills at home from mothers or other female relatives. Through Germanic tradition they transferred embroidery designs from printed or hand-lined paper to actual needlework in cross-stitches. The pattern prepared by Sara Schultz or by her teacher could have been taken from one of many books.* Its motifs are typical of those found on Pennsylvania German samplers such as the one made by Elisabeth Waner. She employed ninety cross-stitched designs to be filed for future reference for embroidering more ambitious work such as hand towels. The letters OEHBDDE near the center stand for the German phrase meaning, "Oh, noble heart, ponder

well thy end." This was often, but not exclusively, used by Mennonite women.

*See Carl Friederich Engelmann, *Deutsche & Englische Vorschriften für die Jugend* (Reading, Pa., 1821).

Plate 106
SEWING BASKET, 1800–1850
Eastern Pennsylvania, probably York County
Rye straw coil, oak splints; height 7" (17.8 cm)
Dorothy and Eugene Elgin
Checklist 320

Yarn spun at home was usually given to a professional weaver to prepare cloth. When that cloth was returned, Pennsylvania German women had a chance to display their sewing skills, seaming widths together and then hemming sheets, bed and bolster cases, hand towels, samplers, tablecloths, and so forth. These items and laundry were often identified with initials and numbers in cross-stitches. Such "marking" was considered plain sewing. Sometimes ink was used for marking such items, especially in the nineteenth century. Fancy sewing ability was demonstrated in decorating textiles.* Most sewing baskets† were lined with protective cloth and a few had a small holder attached to the rim for needles and pins, as does this example, which was recovered in Hanover, Pennsylvania. Its original owner must have been as proud of it as she was in showing to visitors and relatives the abundant quantity of textiles carefully stowed in chests or wardrobes. This ritual was common among Pennsylvania German women, as a means of demonstrating tangible evidence of their contribution to the prosperity and well-being of their families.

*See Fredric Klees, *The Pennsylvania Dutch* (New York, 1950), p. 379.
†See Jeannette Lasansky, *Willow, Oak & Rye: Basket Traditions in Pennsylvania* (Lewisburg, Pa., 1978), repro. pp. 38–39.

Plate 107
QUILT, 1830
Eastern Pennsylvania, possibly Northampton County
Inscribed: ES 18 30
Cotton, wool, silk and crewel embroidery; 90 x 90" (228.6 x 228.6 cm)
Dr. and Mrs. Donald M. Herr
Checklist 294

Although they are in the Anglo-American tradition, quilts were made by some Pennsylvania German women both before and after marriage. *The Quilting Frolic*, a painting at Winterthur by John Lewis Krimmel, shows Pennsylvania Germans in 1813 celebrating an early nineteenth-century custom of marking a betrothal in this fashion. This quilt and two others in the exhibition (checklist 293, pl. 20), one dated 1814, are quite rare because few Pennsylvania German quilts can be documented before 1850. With feather beds a normal part of their bedding, Pennsylvania Germans preferred coverlets. The maker of this quilt, whose initials ES appear at its center surrounded by a tulip vine, is unknown. A similar quilt at the Moravian Museum, Bethlehem, Pennsylvania, has identically embroidered border squares and similar netted fringe. Whoever ES was, she spent months of her time preparing this remarkable quilt in expectation of marriage.

Plate 108
BED SHEET, 1750–1825
Christina Laubach
Probably Lehigh or Northampton County
Inscribed: CHRISTINA LAVBACHSEN CL [twice]
Linen, silk embroidery; 76½ x 70" (194.3 x 177.8 cm)
Germantown Historical Society, Philadelphia. 917
Checklist 289

Plate 109
BEDSTEAD, 1810–40
Probably Pottstown, Montgomery County
Tulip, white pine, painted; length 74" (188 cm)
Winterthur Museum. 81.10
Checklist 52

Plate 110
COVERLET, 1844
Eastern Lancaster County
Inscribed: LLF 1844
Cotton, wool, linen; width 78" (198.1 cm)
Dr. and Mrs. Donald Herr
Checklist 275

Plate 111
BED CASE, 1800–1850
Oley Township, Berks County
Inscribed: E A D T
Linen, cotton, wool; length 77" (195.6 cm)
Mr. and Mrs. Richard Flanders Smith
Checklist 292

In Pennsylvania German households sleeping took place in a long narrow first-floor master bedroom entered from the *Schtub*, or parlor. Lacking a partition, the parlor was sometimes furnished as a bedroom at one end. Bedsteads had recessed pegs or holes for a hemp bed rope that supported a bed bag filled with feathers or chaff, a homespun bed sheet, one or two bolsters, feather pillows, a feather bed in place of a blanket, and a coverlet. This was the Germanic tradition, which continued to flourish in Pennsylvania, and to amaze travelers of English background, until the early years of the twentieth century, when this sleeping equipment was replaced by the English style—two sheets, several blankets, and a quilt on top. Characteristic of Germanic bedsteads from Pennsylvania are scrolled panels mortised and tenoned into the headboard and side rails. These pillow panels kept the pillows and bolsters in place. The importance of bedsteads can be inferred from the fact that five Pennsylvania joiners made a total of 433, usually painted brown, blue, red, or green, between 1795 and 1850.* The accounts of the Clemens family show that both daughters and sons received a "marriage bed"—the bedstead with necessary bedding—from their parents when they set up housekeeping.† Women like Christina Laubach, who made the bed sheet, or those in the DeTurk family, who owned the bed linens (pl. 111), would have spun linen and wool fibers at home and then supplied them to weavers for dyeing and production of cloth. When the cloth was returned, sheets and bed cases, bolster and pillow cases, usually matching, were prepared at home and marked with initials.‡

*See Account and Day Books of Jacob Bachman, Abraham Landes, Abraham Overholt, and Peter Ranck, 54.104, 73x315, 77x374. 1-3, 67x23, Joseph Downs Manuscript and Microfilm Collection, Winterthur Museum Library; Account Book of Abraham Hoover, Heritage Center of Lancaster County, Inc., Lancaster, Pa. *See also* Alan G. Keyser, Larry M. Neff, and Frederick S. Weiser, eds. and trans., *The Accounts of Two Pennsylvania German Furniture Makers—Abraham Overholt, Bucks County, 1790–1833, and Peter Ranck, Lebanon County, 1794–1817* (Breinigsville, Pa., 1978), pp. 8–27.

†See Alan G. Keyser, ed., and Raymond E. Hollenbach, trans., *The Account Book of the Clemens Family of Lower Salford Township, Montgomery County, Pennsylvania, 1749–1857* (Breinigsville, Pa., 1975), pp. 39–177.

‡See Alan G. Keyser, "Beds, Bedding, Bedsteads and Sleep," *Der Reggeboge: The Rainbow. Quarterly of the Pennsylvania German Society*, vol. 12, no. 4 (October 1978), pp. 1–28.

Plate 112
LOOKING GLASS, 1794
Bucks, Lehigh, or Northampton County
Inscribed: 17 94
Mahogany, black walnut, red cedar, gilded pewter; height 36" (91.4 cm)
Winterthur Museum. G64.1528
Checklist 99

Despite the mention that in 1819 the traveler Ludwig Gall was shown to a boardinghouse in Philadelphia by "a Philadelphia-German mirror-maker born in Mannheim," few looking glasses were produced by Pennsylvania German craftsmen.* Perhaps they could not compete effectively with those imported from England by vendors such as the Elliotts of Philadelphia, whose labels were often printed in English and German. This mirror is a case in point: A small English mahogany-framed looking glass was attached in 1794 to a large scrolled Chippendale-style black walnut frame. Germanic touches include wooden pegs to fasten all moldings and turnings to the frame, and the addition of trumpeting angels and stars of gilded pewter. A luxury, the looking glass was most likely to be found in the *Kammer*, or first-floor bedchamber. Only two Clemens family daughters received mirrors.† Another looking glass in this exhibition (checklist 100) may have been a twentieth birthday gift for Caterina German.

*See Frederic Trautmann, "Pennsylvania Through a German's Eyes: The Travels of Ludwig Gall, 1819–1820," *The Pennsylvania Magazine of History and Biography*, vol. 105, no. 1 (January 1981), pp. 37–39.

†See Alan G. Keyser, ed., and Raymond E. Hollenbach, trans., *The Account Book of the Clemens Family of Lower Salford Township, Montgomery County, Pennsylvania, 1749–1857* (Breinigsville, Pa., 1975), pp. 74–77.

Plate 113
CLARINET IN E-FLAT, 1820–47
Heinrich Gottlob Gütter (1797–1847)
Bethlehem
Inscribed: GÜTTER BETHLEHEM PENN GÜTTER BETHLEHEM
Boxwood, ebony, brass, leather; length 24¼" (61.6 cm)
Moravian Historical Society, Nazareth, Pennsylvania
Checklist 332

Born in Neukirchen, Voigtland, Germany, Heinrich Gütter* was already an instrument maker when he arrived in Bethlehem in

1817. A number of woodwind instruments, including clarinets and a wood serpent covered in leather, are stamped with his name (later changed to Henry G. Guetter) and an American place of manufacture. The music accounts of the Moravian church in Bethlehem contain a number of references to violin, cello, and bass strings supplied by Gütter.†

*See Joseph Mortimer Levering, A History of Bethlehem, Pennsylvania, 1741–1892: With Some Account of Its Founders and Their Early Activity in America (Bethlehem, Pa., 1903), pp. 634, 645, 701.
†Music Accounts, Archives, Moravian Church, Bethlehem, Pa.

Plate 114
VIOLIN, 1758
Johannes Antes (1740–1811)
Bethlehem
Inscribed: Johannes Antes in Bethlehem 1758 [paper label]
Pine, maple, walnut, ebony; length 25½" (64.8 cm)
Moravian Historical Society, Nazareth, Pennsylvania
Checklist 333

Johannes Antes is credited with making a full range of stringed instruments including violins, violoncellos, and violas between 1758 and 1764. This 1758 example is one of the first violins made in this country. The son of Rhenish Palatinate immigrants, Antes was born in Frederick Township, Montgomery County. His father had been a member of the Reformed church but then joined the Moravian congregation of Bethlehem. Johannes Antes was baptized there in 1746 and joined the Moravian church in 1760. Some of the most sophisticated music played and heard in Pennsylvania was performed in the Moravian communities. Bach, Beethoven, Boccherini, Chopin, Donizetti, Handel, Haydn, and Mozart were among the composers whose works were performed. Haydn's Creation was first performed in America in Bethlehem (1811). Johannes Antes also composed thirteen choral tunes, twenty-five voice compositions, and, in keeping with his work as an instrument maker, several pieces of instrumental music for strings. In 1765 Antes left Pennsylvania for Herrnhut and never returned to these shores.*

*See Richard D. Claypool, "Mr. John Antes: Instrumentmaker," Moravian Music Foundation Bulletin, vol. 23, no. 2 (Fall–Winter 1978), pp. 10–13; John Antes, "The Personalia of John Antes," c. 1810, Archives, Moravian Church, Bethlehem, Pa.; and Donald M. McCorkle, "John Antes, 'American Dilettant,'" The Moravian Contribution to American Music, Moravian Music Foundation Publications, no. 1 (Winston-Salem, N.C., 1956).

Plate 115
PORTRAIT OF DANIEL ROSE, 1795–1800
Attributed to William Witman (active 1794–1802)
Reading
Inscribed: Witman Pinxit
Oil on canvas; 64 x 40½" (162.6 x 102.9 cm)
The Historical Society of Berks County, Reading, Pennsylvania. ACP92
Checklist 179

A strong tradition of written and oral music, to be enjoyed in churches, homes, and taverns, came to Pennsylvania with the Germans. Daniel Rose, an affluent purveyor of clocks and musical instruments, played nine instruments, some of which are illustrated in this painting from Reading. An 1827 inventory of his estate recorded that his home contained two organs and a piano, clarinet, flute, bassoon, hautboy, and French horn.* Immigrant craftsmen like Johannes Klemm, David Tannenberg, John Philip Bachman, Conrad Doll, and the Diffenbach and Drauss families in Berks County, all made organs. Pianos were crafted by Charles Albrecht (checklist 331) and Jacob Till. Stringed instruments were made by Johannes Antes (pl. 114) and Azariah Smith (Schmidt), and woodwinds by Heinrich Gütter (pl. 113) and Joel Krauss. Brass instruments, especially important to the Moravians, were imported from Germany. Although more sophisticated instruments were used in towns or cities, country folk played zithers, violins, and simple instruments like the recorder, or shepherd's pipe.†

*See Inventory of the Estate of Daniel Rose, October 3, 1827, Register of Wills, Berks County Courthouse, Reading, Pa.
†See Mary P. Dives, "Daniel Rose Comes Home," Historical Review of Berks County, vol. 47, no. 1 (Winter 1981–82), pp. 7–9, 33–35; Fredric Klees, The Pennsylvania Dutch (New York, 1950), pp. 359–71; and Albert F. Buffington, Pennsylvania German Secular Folksongs, Publications of the Pennsylvania German Society, vol. 8 (Breinigsville, Pa., 1974).

Plate 116
EASTER RABBIT, before 1812
Attributed to Conrad Gilbert (1734–1812)
Probably Brunswick Township, Berks County
Inscribed: Belongs to Johannes Bolich in Braunschweig Township, Bercks Caunti
Ink and watercolor on paper; 3 3/16 x 3 13/16" (8.1 x 9.7 cm)
Abby Aldrich Rockefeller Folk Art Center, Williamsburg, Virginia. 59.305.3
Checklist 193

For Germans in Pennsylvania, Good Friday and Easter Sunday were important religious holidays. As with the celebration of Christmas, secular customs were brought to Pennsylvania along with religious observances. For Easter, flowers and pots of spring bulbs filled the churches, while at home there was another, older symbol of regeneration each spring—Easter eggs brought by the Easter rabbit, which filled the children's baskets, caps, or hats.* Early Christian priests in Germany had encountered an old Teutonic legend in which rabbits laid eggs each spring on the feast of the goddess Ostara in gratitude for her fulfillment of their request to be transformed from birds to animals.

To obtain the favored red, chestnutlike color, the hard-boiled eggs (checklist 329) were colored in boiling solutions of onion-skins and water. An inscription on the reverse of this colorful drawing indicates its ownership by Johannes Bolich of Braunschweig (Brunswick) Township, Berks County. That township became part of Schuylkill County in 1811, thus dating this drawing before 1812 and making it the earliest American depiction of an Easter rabbit.† A correspondent to the Allentown Republikaner on April 23, 1829, wrote, "Easter Sunday! . . . everywhere however colored eggs that the rabbit had laid! The little ones were picking eggs; the old folks were scratching tulips on the eggs."‡

*See Fredric Klees, The Pennsylvania Dutch (New York, 1950), pp. 345–46.

†*See* Frederick S. Weiser, "About the Cover," *Der Reggeboge: The Rainbow. Quarterly of the Pennsylvania German Society*, vol. 5, no. 1 (March 1971), p. 2.

‡Quoted in Alfred L. Shoemaker, *Eastertide in Pennsylvania: A Folk Cultural Study* (Kutztown, Pa., 1960), p. 32.

Plate 117

FAMILY CHRISTMAS CELEBRATION, 1810–17
John Lewis Krimmel (1787–1821)
Philadelphia
Pencil and ink wash on paper; 3 13/16 x 6 5/16" (9.7 x 16 cm)
Winterthur Museum. Joseph Downs Manuscript Collection. 59x5.7
Checklist 190

The religious and secular natures of Christmas celebrations among Pennsylvania Germans are captured by this sketch, one of two by John Lewis Krimmel that depicts this holiday. The Christmas customs practiced by many Americans originated in the Rhineland areas from which most Lutherans and German Reformed came to Pennsylvania. A framed picture of the Virgin Mary and Christ Child, prominent over the mantle, emphasizes the religious nature of Christmas, when virtually all members of a Pennsylvania German family attended church services. But there is also a Christmas tree decorated with apples and cookies, a barnyard scene of a toy man on horseback and toy animals enclosed by a fence, as well as cookies, nuts, and candy as gifts to children, and a switch, perhaps left by Belznickel as a reminder to the children that he would pay a visit to punish the naughty and to reward the nice. Rye baskets, used for bread raising and other purposes, were lined with clean white linen and left out on Christmas Eve for the visit of *Christkindel* (Kriss Kringle), the little Christ Child. The gifts of sweets were proof of his visit. It was the most important holiday of the Pennsylvania Germans, often celebrated over two days, with great joy.*

*See Fredric Klees, *The Pennsylvania Dutch* (New York, 1950), pp. 347–55; Alfred L. Shoemaker, *Christmas in Pennsylvania: A Folk-Cultural Study* (Kutztown, Pa., 1959); Martha S. Best, "Christmas Customs in the Lehigh Valley," *Pennsylvania Folklife*, vol. 22, no. 2 (Winter 1972–73), pp. 15–24; and Isaac Clarence Kulp, Jr., "Christmas Customs of the Goschenhoppen Region," *The Goschenhoppen Region*, vol. 1, no. 2 (1968), pp. 4–11.

Plate 118

DANCING AT THE HOUSE OF JOHN GLESSNER, TRUMPET PLAYERS, AND DAVID DANNEN-BERGER, ORGAN BUILDER, 1814–30
Lewis Miller (1796–1882)
York, York County
Ink and watercolor on paper; 9 7/8 x 7 5/8" (25.1 x 19.4 cm)
The Historical Society of York County, York, Pennsylvania. 1,48
Checklist 262

Judging from this view of a well-dressed group dancing to the music of a violin and a dulcimer, depictions of dancing on ceramics (checklist 33), and contemporary accounts, Pennsyl-

vania Germans loved dancing. Pastor Muhlenberg complained constantly about dancing and revelry.* Perhaps only dancing in someone's home was ever controlled and sedate. The Reverend William A. Helffrich described a dance that he attended at an inn in the winter of 1841 as a youth of fourteen. Music was supplied by a fiddler and the dances were reels, "*schticks,*" or a "degenerated German folk dance," during which "ten or more couples . . . jumped and leaped around in the circle as though out of their minds."† In 1810, Margaret Van Horn Dwight was in a tavern two miles from Bethlehem, where, she said, "Dutchmen" were singing and caught "up a fiddle & I expect soon to be pulled up to dance."‡ The Lititz trumpet players in this watercolor illustrate the importance of brass instruments to Moravians, who also used them on numerous religious occasions. The organ builder David Tannenberg (Dannenberger) learned how to build organs from Johannes Gottlob Klemm and opened a shop in Lititz in 1765. He was one of the most important organ builders in America and his organs were installed in churches from Albany, New York, to Winston-Salem, North Carolina.§

*Henry Melchior Muhlenberg, *The Notebook of a Colonial Clergyman: Condensed from the Journals of Henry Melchior Muhlenberg*, ed. and trans. Theodore G. Tappert and John W. Doberstein (Philadelphia, 1959), p. 118.

†Quoted in David B. Kaufman, "A Minister's Son Attends a Frolic," in Preston A. Barba, ed., " 'S Pennsylvaanisch Deitsch Eck," *The Morning Call* (Allentown, Pa.), March 2, 1968.

‡Margaret Van Horn Dwight, *A Journey to Ohio in 1810. As Recorded in the Journal of Margaret Van Horn Dwight* (New Haven, 1912), p. 15.

§*See* William H. Armstrong, *Organs for America: The Life and Work of David Tannenberg* (Philadelphia, 1967).

Plate 119

LOVE LETTER FROM ADAM DAMBACH, 1779
Lancaster, Lancaster County
Inscribed: Adam Dambach, In Lancaster 1779.
Ink, watercolor, and cut paper; 12 3/8 x 12 5/8" (31.4 x 32.1 cm)
Winterthur Museum. 65.1339
Checklist 202

Interpreters of Pennsylvania German symbolism often think hearts burn only with religious fervor, but Adam Dambach of Lancaster could confess to purely secular fires: "My heart which burns out of love's passion, would like to know what hers does." Feelings of affection, love, and passion were expressed in the form of inscriptions on special ceramics (checklist 23), true lovers' knots (pl. 83), and cutwork love letters, or *Liebesbriefe.** According to English custom, valentines were sent only on February 14, but Adam Dambach and some of his contemporaries sent them throughout the year. Many cutwork love letters were folded in a complex fashion, to be read section by section. This example was folded in quarters. They were not meant for public or family display and were never framed and hung in the home.

See Donald A. Shelley, *The Fraktur-Writings or Illuminated Manuscripts of the Pennsylvania Germans*, The Pennsylvania German Folklore Society, vol. 23 (Allentown, Pa., 1961), pp. 52–53.

Religion and Education

FOR MANY PENNSYLVANIA GERMANS before 1850, religion was a constant, daily part of their lives and not just a series of formal practices observed only on Sundays and religious holidays. The centrality of religion, ingrained through formal and informal educational processes, was clear to at least one late eighteenth-century Anglo-American observer, Benjamin Rush. An admirer of, but not an apologist for, Pennsylvania Germans, he stated in 1789: " 'To fear God, and to love work,' are the first lessons they teach their children. They prefer industrious habits to money itself."[1] The wealth of objects in this exhibition is evidence, however, that Pennsylvania Germans had no objection to acquiring material goods. Much of the decoration of these goods ultimately stems from learned, written sources, but so reduced and changed when transformed into art that the sources are difficult to identify, and the visual has gained ascendancy over the literary.

For many Americans, trying to focus on religions of the Pennsylvania Germans is like a first attempt to perceive and to comprehend the various, complex patterns and colors of an Oriental rug. The variety of sects among Pennsylvania Germans can be bewildering, and their differences are often stressed in articles and books. This attitude may very well stem from observations recorded by the earliest non-German visitors and travelers in Pennsylvania. "If it's different, it must be noteworthy and should be seen" is a posture noted by Juliana Roth in her study of travelers' impressions of the Pennsylvania Germans: "Visitors and American travelers . . . were particularly interested in the various community experiments in Pennsylvania such as Ephrata, the Moravian communities of Bethlehem and Nazareth, and the communities of George Rapp at Harmony and Economy."[2]

The common traits, taken for granted by the contemporary travelers, might be reviewed for the modern observer. If, as Fredric Klees has maintained, religion determined the paths, or cultural patterns, for Pennsylvania Germans—"As a man worshipped in colonial Pennsylvania, so he lived"—it is important to understand that the German population of Pennsylvania between 1683 and 1850 was overwhelmingly Protestant. Further, the mainstream of Pennsylvania German culture, including much of its art, was formed by only two churches—Lutheran and Reformed.[3] Almost ninety percent of the Germans living in Pennsylvania were affiliated, or in sympathy, with these two groups. The other ten percent were divided among Mennonites, Amish, Moravians, Schwenkfelders, the religious communities at Ephrata, Harmony, and Economy, and Roman Catholics. For Pennsylvania Germans the differences between the Lutheran and Reformed religious groups were insignificant. Fre-

quently—especially in rural areas or towns—the two congregations shared a church building and schoolhouse, thus forming a union church. Each congregation had its own pastor, funds, and affiliation with a central administration.

Because many of the German princes were Lutherans, members of that church were spared religious persecution in Germany. But German Reformed church members were not tolerated there, and, like the minority religious groups, were motivated to come to Pennsylvania for religious liberty and freedom. Before 1755, the Reformed church was stronger in Pennsylvania, but after that date the majority were Lutherans. It is significant that most Lutherans came to Pennsylvania not for religious reasons, but to better themselves economically. Both groups, therefore, found conditions to their liking in Pennsylvania, were comfortable there, and throve. They and their descendants produced decorated useful objects that survive in far greater numbers than is true of the Germanic areas of Europe from which so many emigrated. The Pennsylvania German customs in celebrating Christmas and Easter (pls. 116, 117) adopted by many Americans in the late nineteenth century largely derive from Lutheran and Reformed practices.

The domination of Lutheran and Reformed congregations in Pennsylvania had important ramifications for the education of Germans living there. Contrary to misconceptions about their education, Benjamin Rush observed shortly after the American Revolution that most German men could read and write and women could read, but that many wives and daughters of German farmers could not write.[4] Lutheran and Reformed church members insisted on a well-educated clergy. A pastor with learning was honored and esteemed and his position in a community was assured. For young members of every Pennsylvania German sect, learning took place in church schools, at home, and as part of an apprenticeship. For some young women, education was obtained in special academies or schools for young girls and ladies.

Between 1742 and 1751, Pastor Henry Melchior Muhlenberg spent a great deal of his time improving the quality of instruction in Lutheran parochial schools. Soon after his arrival in Pennsylvania, he noted that "lazy and drunken schoolmasters" had been ordained and placed in vacancies. As a result of such neglect, "children seventeen, eighteen, nineteen, and twenty years old come with their A-B-C books." But well-educated Lutheran and Reformed clergy were able to check the qualifications of schoolmasters and weed out those who were inept. Recognizing the problem of Germans obtaining a sound education for professional training in Pennsylvania, Pastor Muhlenberg sent his three sons to Germany in 1763 for schooling.[5]

In the absence of a public school system, most Germans in Pennsylvania, especially those in rural areas, were educated in church-directed schools. These schools had three primary goals. One was to provide children with basic skills in reading, writing, and arithmetic. Such instruction was to equip them to function in a farm, small craft shop, and small business economy. Pastor Muhlenberg observed the necessity for country people to barter or sell

their produce in Philadelphia[6] and other towns. A certain level of education was helpful for success in these dealings. A second goal of the parochial schools was to inculcate piety in children and to familiarize students with tenets of their church. This was undoubtedly their most important function. A child's mind was filled with texts of scripture and hymns learned from reading and memorizing. Rules for governing the church school established at Tulpehocken, Berks County, in 1743–44 are typical of those adopted at other Lutheran and Reformed church schools. The Small Catechism of Luther, "to be made plain by the teacher," was used for instruction. Scripture texts and hymns were to be memorized. The language textbooks used were the primer and reader issued by the University of Jena. Advanced readers used the Bible. Pupils were to be taught to write, read, and do "as much arithmetic as is needed by a Plantage man [farmer]." If the congregation had its own pastor, he was to be the chief supervisor of the school.[7] Pastor Muhlenberg's description of his visit in 1763 to a school where thirty students were enrolled detailed their recitation of one such religious portion of its curriculum. He was so pleased with their industry that he promised each student the gift of a book.[8] Significantly, most imprints from Pennsylvania German presses in the eighteenth century were religious in nature, and books mentioned in inventories of estates of Pennsylvania Germans are usually religious in content.

Most Germans who came to America brought with them the Protestant church tradition of hymn singing. Schools, therefore, were to teach hymn singing, not too difficult an assignment because frequently the schoolteacher was also the local church organist. In 1823, Jonas Heinrich Gudehus described an evening visit to Saint James Lutheran Church in Gettysburg. He found the pastor, John Herbst, "conducting an English singing class with the schoolteacher." The instructors sat in the middle of the church: "They and almost every other person present had a chorale book in addition to the hymnal lying before him, every two persons had a wax or tallow candle and sang in four parts, so beautifully and harmonically, that it makes me happy yet today whenever I think of this singing."[9] Gudehus's reference to a singing class conducted in English is significant. When he questioned Pastor Herbst about this, he was informed that the English language prospered in Gettysburg to the extent that "instruction in the German language would not be thought of ever again." That experience was being repeated in Lehigh County at the same time, where, from earliest settlement to 1775, about twenty-two church schools were established. Between 1775 and 1840, only three additional schools were established, despite a population increase of almost two hundred percent. In the same period, almost ninety neighborhood schools were established and in slightly more than one-third of these, English alone or English and German combined were taught.[10]

The pressures to accommodate to their English neighbors threatened the Pennsylvania German church schools. In 1834 the Pennsylvania legislature adopted a measure to create free public, or "common," schools, partially to

deal with the problem of educating poor children whose parents could not afford tuition for attendance at church or neighborhood schools. Pennsylvania Germans sensed that this would weaken their culture. They were also aware that through their efforts they had established an extensive network of church and neighborhood schools throughout the Commonwealth of Pennsylvania. Pennsylvania Germans, for example, supported almost one hundred and fifteen schools in Lehigh County alone. The 1834 law was responsible for a change in the way many Pennsylvania Germans were educated. Only the Amish were able to resist its full effect into the twentieth century.

Not explicit in the rules governing church schools, but implicit in the conduct of the schools, was the fact that for many Pennsylvania German children the pastor or teacher who served as schoolmaster was their main font of artistic expression. Music, poetry, and drawing flowed from this source. As Frederick S. Weiser and Howell J. Heaney have demonstrated, schoolteachers were the greatest practitioners of fraktur.[11] They were the chief makers of *Vorschrift* ("writing examples"), title pages to copybooks and manuscript chorale books, rewards for merit, and bookplates in hymnals, testaments, and related volumes. If the pastor was also the schoolteacher, he might issue decorated baptismal and marriage certificates.[12]

One of the earliest treatises on education in America was written by Christopher Dock, a pioneer schoolmaster in Germantown and lower Montgomery County Mennonite schools. Published in 1770 by Christopher Sauer, its title translates as "A Simple and Thoroughly Prepared Plan for School Management." It advocated use of a monitor system not unlike the Lancaster method used for many years in one-room schoolhouses. Dock stated that when a child learned his ABC's, his parents owed the child a penny and two fried eggs for his industry. When the same child began to read, the schoolmaster owed the child a certificate. When no volunteers (monitors) were available to teach, Dock indicated, "I ask who will teach the child for a certain time for a motto (Vorschrift) or a bird." To the child who received the most chalk marks for good daily work and who pointed out the greatest number of letters, "I owe something, perhaps a flower drawn on paper or a bird."[13]

The number of examples of the various types of fraktur that are extant is proof enough that Pennsylvania Germans enjoyed visual depictions of the religious and moral precepts taught in their churches and schools and practiced at home. They could "read" a depiction of Adam and Eve drawn on a chest or printed on a broadside (pls. 122, 123). They understood the significance of the "dance of death" cast into the plates of a stove (checklist 122), even if they could not express it in writing as could their minister or teacher. The objects displayed in this exhibition are visual representations of some of the ideas, beliefs, and customs that concerned Germans in Pennsylvania between 1683 and 1850. Their survival provides a voice that speaks for those now silent people.

1. Benjamin Rush, *An Account of the Manners of the German Inhabitants of Pennsylvania, Written 1789*, ed. I. Daniel Rupp (Philadelphia, 1875), p. 29.

2. Juliana Roth, "Travel Journals as a Folklife Research Tool: Impressions of the Pennsylvania Germans," *Pennsylvania Folklife*, vol. 21, no. 4 (Summer 1972), p. 34.

3. The best concise summaries of Pennsylvania German religious groups are found in Fredric Klees, *The Pennsylvania Dutch* (New York, 1950), pp. 13–133; and Frederick S. Weiser and Howell J. Heaney, comps., *The Pennsylvania German Fraktur of the Free Library of Philadelphia*, Publications of the Pennsylvania German Society, vol. 10 (Breinigsville, Pa., 1976), vol. 1, pp. xv–xvii.

4. Rush, *Account of the Manners*, p. 55.

5. Henry Melchior Muhlenberg, *The Notebook of a Colonial Clergyman: Condensed from the Journals of Henry Melchior Muhlenberg*, ed. and trans. Theodore G. Tappert and John W. Doberstein (Philadelphia, 1959), pp. 11, 14, 40, 79 n.1.

6. *Ibid.*, pp. 12–13.

7. Quoted in "A Pennsylvania German School Code of 200 Years Ago," in Preston A. Barba, ed., " 'S Pennsylfawnisch Deitsch Eck," *The Morning Call* (Allentown, Pa.), October 31, 1942.

8. Muhlenberg, *Notebook*, pp. 71–72.

9. Quoted in Larry M. Neff, trans., "Jonas Heinrich Gudehus: Journey to America," in Albert F. Buffington et al., *Ebbes fer Alle-Ebber—Ebbes fer Dich: Something for Everyone—Something for You. Essays in Memoriam —Albert Franklin Buffington*, Publications of the Pennsylvania German Society, vol. 14 (Breinigsville, Pa., 1980), p. 239.

10. *See* Carl F. Hensinger, "The Transition to Public Education Among the Pennsylvania Germans in Lehigh County, 1734–1870," in Preston A. Barba, ed., " 'S Pennsylfawnisch Deitsch Eck," *The Morning Call* (Allentown, Pa.), March 30, 1940.

11. *See* Weiser and Heaney, comps., *Pennsylvania German Fraktur.*

12. *See* Frederick S. Weiser, "The Concept of Baptism Among Colonial German Lutheran and Reformed Church People," *Essays and Reports: The Lutheran Historical Conference*, vol. 4 (1970), pp. 1–45.

13. Quoted in Weiser and Heaney, comps., *Pennsylvania German Fraktur*, vol. 1, p. xix.

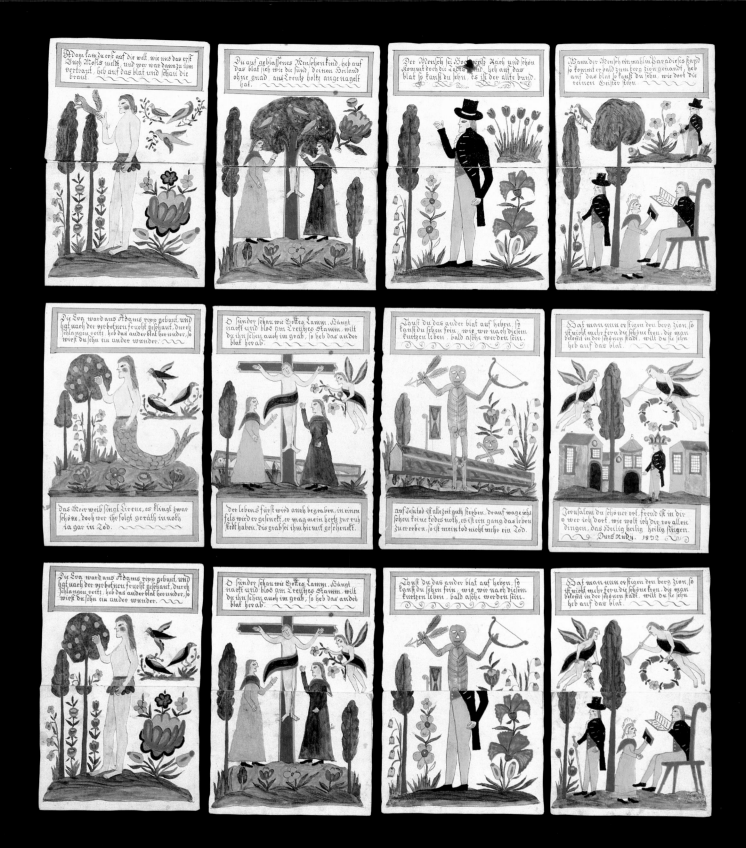

120 Religion was a constant and daily part of most Pennsylvania Germans' lives, stressed through formal and informal educational tools, such as this puzzle book, by which a young reader learned religious and moral truths as he turned half pages up or down (The Lehigh County Historical Society, Allentown, Pennsylvania)

131, 132 Most German children in Pennsyl-
vania were educated in church-directed
schools, and passages from hymns or scrip-
ture were usually chosen for writing exercises
(Schwenkfelder Library, Pennsburg,
Pennsylvania)

133 Susan Killefer embroidered the date of
her first communion in the German Reformed
Church in Millerstown in 1846 on this hand
towel (Collection Harold H. Royer)

131

132

133

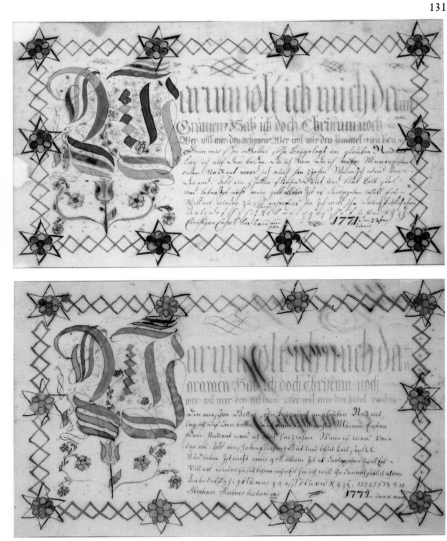

Plate 120

METAMORPHOSIS, 1832
Durs Rudy, Jr. (1789–1850)
Lehigh County
Inscribed: Durs Rudy 1832
Ink and watercolor on paper; 6⅚6 x 3 ¹⁵⁄₁₆″ (16 x 10 cm)
 (closed)
The Lehigh County Historical Society, Allentown, Pennsylvania
Checklist 196

Versions of puzzle books printed in England, Germany, and America were advertised as "turn-ups" in early nineteenth-century American newspapers. By reading rhymed text, in German in this example, and turning pages up or down in sequence, a young reader received instruction in religious and moral truths as he pursued his natural curiosity. When a "puffed-up fellow" did as instructed in the text and lifted the first page of this manuscript, he encountered a series of depictions of the Crucifixion of Christ, Adam's temptation by Eve, the inevitability of death, and salvation in Christ.*

Of Swiss origin, Durs Rudy, Jr., sailed from Amsterdam with his parents in 1803. Fraktur dated 1806 and 1809 suggest that he may have lived in Skippack, Montgomery County. Rudy served as an organist at the union church in Neff, Lehigh County,† which may have provided the inspiration for the concluding line of this metamorphosis, which translates: "In preference to all else would I sing. Holy, Holy, Holy, to Thy Name."

*See Melville J. Boyer, "Specimens of Sacred Pictorial Poetry," Proceedings of the Lehigh County Historical Society, vol. 14 (July 1944), pp. 44–53.
†See Richard Warren Mottern, The Rudy Family Tree of Montour County, Pennsylvania (Glendale, Calif., 1938), pp. 1–6.

Plate 121

TITLE PAGE OF "DER BLUTIGE SCHAU-PLATZ
 ODER MARTYRER SPIEGEL," 1748–49
Ephrata Brotherhood Press (Kloster Press), publishers
Ephrata, Lancaster County
Letterpress; 14¹⁵⁄₁₆″ x 10⅟₁₆″ (37.9 x 25.6 cm) (book)
Winterthur Museum Library, RBR. BV4503/B81/F
Checklist 239

Mennonites were the earliest of the German religious groups to settle in Pennsylvania, particularly in Germantown and in Lancaster County. As they were persecuted in Europe for their strong belief in adult baptism, it is not surprising that for their members the story of their ancestors' struggles, first published in Holland (1660), should be second only to the Bible.* Mennonites contracted with the brotherhood at Ephrata to translate The Martyr's Mirror from Dutch to German.† Peter Müller, translator, editor, and corrector, supervised fifteen men at the cloister over a period of three years in the production of this monumental two-volume, 1,512-page book. In an edition of 1,300 copies costing one pound per copy, this publication was the largest undertaking in colonial printing.‡ Unlike this example, some copies lack the engraved frontispiece depicting the army of martyrs being led to heaven.

*See Fredric Klees, The Pennsylvania Dutch (New York, 1950), pp. 13–30.

†Title page of vol. 1: "Der Blutige Schau-Platz oder Märtyrer Spiegel der Tauffs-Gesinnten oder Wehrlosen-Christen, . . . von T.J.V. Braght . . . Ephrata in Pensylvanien, Drucks und Verlags der Brüderschafft. Anno MDCCXLVIII."
‡See James E. Ernst, Ephrata: A History, ed. John Joseph Stoudt, The Pennsylvania German Folklore Society, vol. 25 (Allentown, Pa., 1963), pp. 293–94.

Plate 122

CHEST, 1800–1825
Berks or Northumberland County
White pine, painted; height 24¾″ (62.9 cm)
Winterthur Museum. 57.99.4
Checklist 83

Plate 123

BROADSIDE: ADAM AND EVE IN PARADISE,
 1800–1830
Eastern Pennsylvania
Inscribed: Adam und Eva in Paradies Adam war altgeworden, Neun-hundere'und Dreÿssig jahre und starb
Ink and watercolor on paper; 12¾ x 7¾″ (32.4 x 19.7 cm)
The Dietrich Brothers Americana Corporation, Philadelphia
Checklist 230

Much of the decoration found on Pennsylvania German objects, even design with a strong religious connotation, is from inherited and remembered tradition.* Adam and Eve were depicted in a number of broadsides from German presses in Ephrata, Harrisburg, Lancaster, Orwigsburg, Philadelphia, and Reading.† The first couple was a very popular decorative motif used by Germanic artists and craftsmen, which probably indicates that Adam and Eve reminded Pennsylvania Germans of the sanctity of marriage and of original sin.‡ In the early nineteenth century, Heinrich B. Sage, of Reading, produced a printed broadside virtually identical to this manuscript example.

Broadsides were undoubtedly the source of decoration for this chest. Berks County chests were often decorated with columns and pilasters similar to those seen on this example. Eight-petaled floral rosettes like those decorating this chest are commonly found on furniture made in the Schwaben Creek Valley.§

*See Frederick S. Weiser, "The Concept of Baptism Among Colonial Pennsylvania German Lutheran and Reformed Church People," Essays and Reports: The Lutheran Historical Conference, vol. 4 (1970), pp. 10–11.
†See Alfred L. Shoemaker, "Engravings: Adam and Eve Broadsides," The Pennsylvania Dutchman, vol. 4, no. 6 (October 1952), pp. 4–5.
‡See Lutz Röhrich, Adam und Eva, Das erste Menschenpaar in Volkskunst und Volksdichtung (Stuttgart, 1978).
§See Monroe H. Fabian, The Pennsylvania-German Decorated Chest (New York, 1978), figs. 156, 167; and Frederick S. Weiser and Mary Hammond Sullivan, "Decorated Furniture of the Schwaben Creek Valley," in Albert F. Buffington et al., Ebbes fer Alle-Ebber—Ebbes fer Dich: Something for Everyone—Something for You. Essays in Memoriam—Albert Franklin Buffington, Publications of the Pennsylvania German Society, vol. 14 (Breinigsville, Pa., 1980), pp. 344–45, figs. 16–17, 34, 41, 44–45, 47, 52, 55–62.

Plate 124

CHALICE, c. 1795
William Will (1742–1798)
Philadelphia
Inscribed: Zur ehre Gottes Gestifftet von Catharina Elisa-
 betha Morrin
Pewter; height 7⅞" (20 cm)
Winterthur Museum. 58.24
Checklist 146

Plate 125

FLAGON, c. 1795
William Will (1742–1798)
Philadelphia
Inscribed: Zur ehre Gottes gestifftet Von Andreas Morr in
 die Evangelisch Lutherische Zion Kirche, in Penns-
 township Northumberland County Den 29ten july Anno
 dom. 1795
Pewter; height 13¾" (34.9 cm)
Charles V. Swain
Checklist 146

About 1836, when Lewis Miller drew the altar of the Lutheran
Church in York, recording gifts of silver, pewter, and altar cloths
made by members of the congregation to help celebrate baptism
and communion, he included on the altar a chalice and a flagon.*
This chalice and its attendant flagon, central to the celebration of
communion, were made by the Pennsylvania German pewterer
William Will about 1795. Purchased by Andrew (1727–1801) and
Elizabeth (1732–1795) Morr, these vessels were given to the Evan-
gelical Lutheran Zion Church, Penns Township, Northumberland
County. The presentation inscriptions are engraved within flaming
hearts, the Christian symbol of religious fervor.† The Morrs ar-
rived in Philadelphia in 1749 or 1751.‡ They settled in Freeburg
and were original members of the church founded there in 1774.§

*See Robert P. Turner, ed., Lewis Miller: Sketches and Chronicles.
The Reflections of a Nineteenth Century Pennsylvania German
Folk Artist (York, Pa., 1966), repro. p. 15.
†See George Ferguson, Signs & Symbols in Christian Art (New
York, 1954), p. 67.
‡See "Morr Family of Freeburg," Heber G. Gearhart Collection,
Genealogical Society of Pennsylvania Collections, HSP; and Ralph
Beaver Strassburger, Pennsylvania German Pioneers, ed. William
John Hinke, vol. 1, 1727–1775, Proceedings of the Pennsylvania
German Society, vol. 42 (Norristown, Pa., 1934), pp. 423, 464.
§See Charles H. Glatfelter, Pastors and People: German Lutheran
and Reformed Churches in the Pennsylvania Field, 1717–1793, vol.
1, Pastors and Congregations, Publications of the Pennsylvania
German Society, vol. 13 (Breinigsville, Pa., 1980), p. 453.

Plate 126

THE GERMAN LUTHERAN CHURCH IN YORK,
 1814–30
Lewis Miller (1796–1882)

York, York County
Inscribed: Die Deutsche Lutherische Kirche in York, pa.
 1799 . . .
Ink and watercolor on paper; 12¼ x 18⁵⁄₁₆" (31.1 x 46.5
 cm) (framed)
William H. Kain III and Carol Kain Woodbury
Checklist 263

Sometime after 1811, Lewis Miller twice drew from memory the
interior of "Die Deutsche Lutherische Kirche in York, pa. 1799,
biss 1811." Another version of this scene, owned by the Historical
Society of York County, was drawn from a different perspective.*
Even without the artist's inscription, the large full-length portrait
of Martin Luther hanging under a balcony, the singing choir, and
the huge iron stove provide clues that a German Lutheran congre-
gation is depicted. On the balcony panels are portraits of Luke,
Paul, Peter, Samuel, Joshua, Solomon, David, and Saul, followed
by Old Testament scenes of Adam and Eve and Abraham's sacri-
fice. An organ built and installed by David Tannenberg (see pl.
118) at a cost of 355 pounds in 1804 is also given prominence by
the artist. The organ was played for the first time at Tannenberg's
funeral service.† Among the congregants named by Miller was
"Old John Hay," the great-great-great-grandfather of the present
owners of this drawing.

*See Robert P. Turner, ed., Lewis Miller: Sketches and Chronicles.
The Reflections of a Nineteenth Century Pennsylvania German
Folk Artist (York, Pa., 1966), repro. p. 13.
†See William H. Armstrong, Organs for America: The Life and
Work of David Tannenberg (Philadelphia, 1967), p. 110.

Plate 127

PAGE OF "PARADISISCHES WUNDER-SPIEL,"
 1754
Johann Conrad Beissel (1690–1768), compiler and editor
Ephrata, Lancaster County
Letterpress; 13⅛ x 8½" (33.3 x 21.6 cm) (book)
The Free Library of Philadelphia. Rare Book Department.
 FLP1151
Checklist 257

The cloister at Ephrata was an important printing center and
many volumes of printed as well as manuscript text illuminated
with fraktur by its residents have survived. An economic success
in its own time, with branch "monasteries" at Germantown and
Snow Hill in Franklin County, the Ephrata Cloister was, neverthe-
less, a religious oddity among Pennsylvania Germans. At its peak,
a total of only eighty industrious "brethren and sisters" accom-
plished near-miracles, but by 1785 their number had dwindled to
sixteen.* This community, like the Paradisisches Wunder-Spiel,
was largely the creation of Johann Conrad Beissel. Born in Eber-
bach, Germany, in 1690, Beissel immigrated to Pennsylvania in
1720. He worked as a weaver in Germantown, withdrew to the
woods near Conestoga to live an ascetic life, and founded his com-
munity at Ephrata in 1732.† Self-taught, Beissel is credited with
composing over one thousand hymns. His system divided the
music into measures accented for words rather than musical
rhythm. The hymns were scored for from four to seven voices
singing four-part harmony.‡ Illuminations in books such as this in-
cluded floral decoration and geometric designs, similar to weaving
patterns. Sister Barbara Snowberger, whose name is inscribed on

the hymnal, was a resident of the nunnery at Snow Hill, where the Ephrata singing tradition survived into the nineteenth century.

*See Fredric Klees, *The Pennsylvania Dutch* (New York, 1950), pp. 127–28.

†See Walter C. Klein, *Johann Conrad Beissel: Mystic and Martinet, 1690–1768* (Philadelphia, 1942).

‡See Julius Friedrich Sachse, *The Music of the Ephrata Cloister* . . . (Lancaster, Pa., 1903), pp. 27–31.

Plate 128

BOOKPLATE AND FRONT PAGE OF SONGBOOK, 1797
John Christian Strenge (1758–1828)
Hempfield Township, Lancaster County
Watercolor and ink on paper; 3⅞ x 6⅝" (9.8 x 16.8 cm) (book)
Pennsylvania Farm Museum at Landis Valley: Pennsylvania Historical and Museum Commission. F5.96
Checklist 254

One purpose of the parochial school system in Pennsylvania was to reinforce the Protestant hymn-singing traditions of German immigrants. John Christian Strenge, a former Hessian soldier who remained in America, worked in Hempfield Township from 1794 to 1804, probably at a union school.* He and other schoolmasters produced songbooks and bookplates (pl. 10) as awards for diligent students. The bookplate in this songbook indicates that it belonged to "the industrious student Maria Schwar." Songbooks generally provided melodies but not full texts of hymns. Chorale books, therefore, were used as supplements to printed hymnals. This one begins with Psalm 100, "All People That on Earth Do Dwell."

*See David R. Johnson, "Christian Strenge, Fraktur Artist," *Der Reggeboge: The Rainbow. Quarterly of the Pennsylvania German Society*, vol. 13, no. 3 (July 1979), pp. 1–24.

Plate 129

FOOTED CUP, 1812–18
Anthony Rasch (1778–1858) and Company
Philadelphia
Inscribed: A. RASCH & CO. PHILADELPHIA Unitas Fratrum
Silver; height 4¹⁄₁₆" (10.3 cm)
Moravian Historical Society, Nazareth, Pennsylvania
Checklist 151

The Moravian church flourished in the fifteenth and sixteenth centuries in Bohemia and Moravia, regions north of Vienna. Persecuted in the seventeenth century, Moravians went into exile in Silesia, Hungary, Holland, and England. Provided refuge in 1722 by Count Zinzendorf, they built the village of Herrnhut on his estate in Saxony. Faced with banishment in 1736, they founded a settlement in Georgia, but left that colony for Pennsylvania in 1740 at the invitation of George Whitefield.* Their principal settlements there were in Bethlehem, Nazareth, and Lititz. In 1742 a church was begun in Philadelphia, which was later replaced by a new building at the southeast corner of Moravian Alley and Race Street. This communion cup was probably made for use in that church.† Anthony Rasch, owner of the firm that made this silver cup, was born in Passau, Bavaria, and came to Philadelphia in 1804.‡ A skilled, fashion-conscious silversmith, he decorated this cup with neoclassical motifs in the Anglo-American taste, perhaps not a coincidence in light of the decision by this Philadelphia church at that time to use only the English language for its services. The Latin name of the Moravian church, "Unitas Fratrum," is engraved on the cup.

*See Fredric Klees, *The Pennsylvania Dutch* (New York, 1950), pp. 91–121.

†See Abraham Ritter, *History of the Moravian Church in Philadelphia, from Its Foundation in 1742 to the Present Time* (Philadelphia, 1857), pp. 41, 170.

‡See Philadelphia, Philadelphia Museum of Art, *Philadelphia: Three Centuries of American Art* (April 11–October 10, 1976), p. 213.

Plate 130

PAIR OF CANDLESTICKS, 1754–81
Johann Christoph Heyne (1715–1781)
Lancaster, Lancaster County
Inscribed: LANCASTER ICH IHS
Pewter, tinned sheet iron; height 21¾" (55.2 cm)
Winterthur Museum. G65.1602.1,.2
Checklist 144

The religious conviction of the vast majority of Germans in Pennsylvania was Protestant, and despite the relative religious freedom in Pennsylvania, Roman Catholicism was not encouraged. Jesuits established a church at Conewago about 1721 and a second, the Church of the Most Blessed Sacrament, at Goschenhoppen (now Bally), Berks County, in 1743.* These altar candlesticks, from the latter church, are cast with symbols of the Passion: Christ's monogram, cross, hammer, scourge, crown of thorns, spear, and vinegar-soaked sponge. The first pastor of the Goschenhoppen church, Father Theodore Schneider, had been *rector magnificus* of the University of Heidelberg. Before he arrived, Mennonites and Moravians had already settled in Goschenhoppen. Johann Christoph Heyne, the pewterer who made these candlesticks, was a Moravian and had lived for a time in Tulpehocken, Berks County. Much of Heyne's surviving pewter consists of vessels or objects made for churches in Pennsylvania.†

*See Fredric Klees, *The Pennsylvania Dutch* (New York, 1950), pp. 84–85.

†See Eric de Jonge, "Johann Christoph Heyne: Pewterer, Minister, Teacher," *Winterthur Portfolio*, vol. 4 (1968), pp. 168–84.

Plate 131

WRITING EXERCISE, 1771
Christian Cassel
Montgomery County
Inscribed: Christian Cassel his hand and pen 1771 . . .
Ink and watercolor on paper; 7¾ x 13" (19.7 x 33 cm)
Schwenkfelder Library, Pennsburg, Pennsylvania. 2-12a
Checklist 223

Plate 132

WRITING EXERCISE, 1772
Abraham Heebner
Montgomery County
Inscribed: Abraham Heebner his hand and pen 1772 . . .
Ink and watercolor on paper; 7 11/$_{16}$ x 12^{7}/$_{8}$" (19.5 x 32.7
 cm)
Schwenkfelder Library, Pennsburg, Pennsylvania. 2-12b
Checklist 224

These writing specimens were produced at a church school at-
tended by children of Schwenkfelder families. The children
copied from an original prepared by a teacher in a tradition sim-
ilar to that of the classic *Vorschrift* ("writing example"), which
usually represented a going-away gift from teacher to pupil at the
end of a school term. They consisted of two or three sizes of
letters beginning with one large and ornate example. Passages from
scripture or a hymn usually provided the text. That section was
followed by German cursive script with the text, perhaps, of an-
other hymn. Upper- and lowercase letters of the alphabet and
numerals completed the document.* It seems clear from the word-
ing of their signatures that the two children who prepared these
copies had learned some English. Observers and participants in
these schools indicate that a good portion of what was learned
depended on rote and copy work.

See Frederick S. Weiser and Howell J. Heaney, comps., *The
Pennsylvania German Fraktur of the Free Library of Philadelphia*,
Publications of the Pennsylvania German Society, vol. 10 (Breinigs-
ville, Pa., 1976), vol. 1, p. xvii.

Plate 133

HAND TOWEL, 1846–47
Susan C. Killefer (b. 1829)
Millersville, Manor Township, Lancaster County
Inscribed: sk 1847 [twice] Susan C Killefer is my name I
 was born the 30 day of SePtember in the Year of our
 lord 1829 I Was receved into the communion of the
 German reformed Church on the 21 day of february in
 the Year of our lord 1846 Susan Killefer 1847
Linen, merino wool embroidery; length 54^{1}/$_{8}$" (137.5 cm)
Harold H. Royer
Checklist 308

A rite of passage of great importance to young people is to take
one's place among the adult members of a community. Susan
Killefer marked such a joyous occasion by embroidering on this
towel the date of her first communion in the local German Re-
formed church, the Zion United Church of Christ, in 1846. Just
before her seventeenth birthday she had completed her catechism
classes, passed public examination (confirmation), and partaken of
communion for the first time. She became in the truest sense a
member of the Reformed church.* The making and preservation
of this hand towel provide evidence that among surviving hand
towels some were made to commemorate a special occasion and
were used sparingly, if at all, in Pennsylvania German homes.

*Record Book, 1845–73, German Reformed Congregation at Mil-
lerstown (Millersville), Philip Schaff Library, Lancaster Theologi-
cal Seminary, Lancaster, Pa.

Checklist of the Exhibition

CERAMICS AND GLASS

1 *WATCH HOLDER*, 1850
Anthony Baecher (1824–1889)
Mount Pleasant Township, Adams
County
Earthenware, manganese lead glaze;
H 9⅜″ (23.8 cm), W 6⅞″ (17.5 cm),
D 3⅞″ (9.8 cm)
Philadelphia Museum of Art. Gift of
Joseph H. Himes in memory of his
wife, Mrs. Eilleen C. Himes. 54-62-39

2 *DISH*, 1826–41
Absalom Bixler (1802–1884)
Lancaster County
Earthenware with slip decoration,
clear lead glaze; H 1⅞″ (4.8 cm),
dia. 14⅛″ (35.9 cm)
Winterthur Museum. 67.1662
Plate 90

3 *DISH*, 1792
John Rudolph Drach (b. 1759)
Tohickon Creek, Bedminster Town-
ship, Bucks County
Earthenware with slip coating, clear
lead glaze; H 1⅞″ (4.8 cm), dia.
11⁵⁄₁₆″ (28.7 cm)
The Art Institute of Chicago. 1907.122

4 *WHISTLE*, 1809
Attributed to John Drey (1785–1870)
Dryville, Rockland Township, Berks
County
Earthenware, clear lead glaze colored
with manganese; H 3⅜″ (8.6 cm),
L 3½″ (8.9 cm)
Winterthur Museum. 62.658

5 *DISH*, c. 1840
Daniel Dry (1811–1872)
Dryville, Rockland Township, Berks
County
Earthenware with slip decoration,
clear lead glaze; H 2¼″ (5.7 cm),
dia. 10¹⁄₁₆″ (25.6 cm)
William Penn Memorial Museum,
Harrisburg: Pennsylvania Historical
and Museum Commission. 28.8.1
Plate 60

6 *FIGURE OF A HORSEMAN*, 1809
Attributed to Jacob Fretz
Southeastern Pennsylvania
Earthenware, clear lead glaze; H 7½″
(19.1 cm), L 9½″ (24.1 cm)

Philadelphia Museum of Art. Titus C.
Geesey Collection. 55-94-17a,b

7 *MILK PAN*, 1800–1815
Harmony Society
Harmony, Butler County
Earthenware, clear lead glaze; H 4¾″
(12.1 cm), W 16½″ (41.9 cm)
Old Economy Village: Pennsylvania
Historical and Museum Commission.
06.71.16.1

8 *FLOWER HOLDER*, 1849
Charles Headman (1826–1909)
Richland and Rockhill townships,
Bucks County
Earthenware with slip decoration,
clear lead glaze; H 10⅞″ (27.6 cm),
dia. 9⅞″ (25.1 cm)
Philadelphia Museum of Art. Gift of
John T. Morris. 92-88

9 *DISH*, 1786
George Huebner (1757–1828)
Upper Hanover Township, Mont-
gomery County
Earthenware with slip coating, clear
lead glaze; H 2⅛″ (5.4 cm), dia.
12½″ (31.8 cm)
Philadelphia Museum of Art. Gift of
John T. Morris. 00-21
Plate 2

10 *STOVE TILES*, 1743–63
Attributed to John Ludwig Huebner
(1717–1796)
Northampton County
Earthenware, manganese lead glaze;
H 6⁹⁄₁₆″ (16.7 cm), W 8½″ (21.6 cm)
Moravian Museums of Bethlehem,
Pennsylvania. 1123-1,2

11 *PUZZLE JUG*, 1809
Phillip Kline
Nockamixon Township, Bucks County
Earthenware, clear lead glaze; H 9″
(22.9 cm), W 9⅜″ (23.8 cm)
Philadelphia Museum of Art. Gift of
John T. Morris. 92-59
Shown only in Philadelphia

12 *JAR*, c. 1790
Attributed to Christian Klinker
Nockamixon Township, Bucks County
Earthenware, clear lead glaze; H 10¼″
(26 cm), dia. 11″ (27.9)

Philadelphia Museum of Art. Pur-
chased: Baugh-Barber Fund. 73-212-1

13 *DISH*, 1796
John Leidy (1764–1846)
Near Souderton, Franconia Township,
Montgomery County
Earthenware with slip coating, clear
lead glaze; H 2⅝″ (6.7 cm), dia.
14″ (35.6 cm)
Philadelphia Museum of Art. Gift of
John T. Morris. 92-43
Shown only in Philadelphia

14 *DISH*, 1797
John Leidy (1764–1846)
Near Souderton, Franconia Township,
Montgomery County
Earthenware with slip decoration,
clear lead glaze; H 2⅛″ (5.4 cm),
dia. 14″ (35.6 cm)
Philadelphia Museum of Art. Gift of
A. C. Harrison. 95-78

15 *DISH*, 1847
Attributed to John Nase (b. 1822)
Upper Salford Township, Mont-
gomery County
Earthenware with slip decoration,
clear lead glaze; H 2⅝″ (6.7 cm),
dia. 12¼″ (31.1 cm)
Philadelphia Museum of Art. Gift of
John T. Morris. 92-50
Plate 97

16 *DISH*, 1800–1825
Attributed to Johannes Neesz (1775–
1867)
Tylersport, Upper Salford Township,
Montgomery County
Earthenware with slip coating, clear
lead glaze; H 1⁹⁄₁₆″ (4 cm), dia.
12¾″ (32.4 cm)
Winterthur Museum. 60.660

17 *DISH*, 1838
Conrad Kolb Ranninger (1809–1869)
Montgomery County
Earthenware with slip coating, clear
lead glaze; H 1⅞″ (4.8 cm), dia.
9¹¹⁄₁₆″ (24.6 cm)
Winterthur Museum. 67.1612

18 *PITCHER*, 1838
Attributed to Henry Remmey, Jr.
(1794–1878)
Philadelphia

Salt-glazed stoneware; H 8½" (21.6 cm), dia. 5¾" (14.6 cm)
National Museum of American History, Smithsonian Institution, Washington, D.C. Gift of Mrs. Arnold Miles. 196486
Shown only in Philadelphia

19 *COVERED JAR*, c. 1830
Jacob Scholl (1781–1851)
Tylersport, Upper Salford Township, Montgomery County
Earthenware with slip coating, clear lead glaze; H 9⅛" (23.2 cm), dia. 6⅞" (17.5 cm)
Philadelphia Museum of Art. Purchased: Baugh-Barber Fund. 22-4-7a,b

20 *DISH*, 1800–1811
David Spinner (1758–1811)
Willow Creek, Milford Township, Bucks County
Earthenware with slip decoration, clear lead glaze; H 2⅜" (6.7 cm), dia. 12⅝" (32.1 cm)
Philadelphia Museum of Art. Gift of John T. Morris. 06-297

21 *DISHES*, 1800–1811
David Spinner (1758–1811)
Willow Creek, Milford Township, Bucks County
Earthenware with slip coating, clear lead glaze; H 2¼" (5.7 cm), dia. 11⅝" (29.5 cm)
Philadelphia Museum of Art. Gift of John T. Morris. 00-74, 76

22 *DISH*, 1800–1811
Attributed to David Spinner (1758–1811)
Willow Creek, Milford Township, Bucks County
Earthenware with slip coating, clear lead glaze; H 2" (5.1 cm), dia. 11⅝" (29.5 cm)
Philadelphia Museum of Art. Gift of John T. Morris. 00-199
Plate 85

23 *DISH*, 1800–1811
Attributed to David Spinner (1758–1811)
Willow Creek, Milford Township, Bucks County
Earthenware with slip coating, clear lead glaze; H 2¼" (5.7 cm), dia. 11⅝" (29.5 cm)
Philadelphia Museum of Art. Gift of John T. Morris. 00-75

24 *DISH*, 1800–1811
Attributed to David Spinner

(1758–1811)
Willow Creek, Milford Township, Bucks County
Earthenware with slip coating, clear lead glaze; H 1⅜" (3.5 cm), dia. 12" (30.5 cm)
Winterthur Museum. 60.652

25 *DISH*, 1762
John Jacob Stoudt (1710–1779)
Rockhill Township, Bucks County
Earthenware with slip coating, clear lead glaze; H 2⅞" (7.3 cm), dia. 15⅛" (38.4 cm)
Philadelphia Museum of Art. Purchased: Baugh-Barber Fund. 58-124-1
Shown only in Philadelphia

26 *DISH*, 1765–74
John Jacob Stoudt (1710–1779)
Rockhill Township, Bucks County
Earthenware with slip coating, clear lead glaze; H 2¼" (5.7 cm), dia. 12⁵⁄₁₆" (31.3 cm)
Philadelphia Museum of Art. Purchased: Baugh-Barber Fund. 1980-91-1
Plate 7

27 *JAR*, 1788
Philip Sussholtz (d. c. 1826)
Berks County
Earthenware with slip coating, clear lead glaze; H 9⅛" (23.2 cm), dia. 6⅞" (17.5 cm)
Winterthur Museum. 65.2706
Plate 34

28 *DISH*, 1833
Samuel Troxel (c. 1803–1870)
Upper Hanover Township, Montgomery County
Earthenware with slip coating, clear lead glaze; H 2" (5.1 cm), dia. 11⅞" (30.2 cm)
Philadelphia Museum of Art. Purchased: Baugh-Barber Fund. 60-120-1

29 *FLOWERPOT*, c. 1838
Samuel Troxel (c. 1803–1870)
Upper Hanover Township, Montgomery County
Earthenware with slip coating, clear lead glaze; H 11⅝" (29.5 cm), dia. 13¾" (34.9 cm)
Philadelphia Museum of Art. Gift of John T. Morris. 00-22

30 *DISH*, 1846
Samuel Troxel (c. 1803–1870)
Upper Hanover Township, Montgomery County

Earthenware with slip coating, clear lead glaze; H 1⁹⁄₁₆" (4 cm), dia. 9⅜" (23.8 cm)
Winterthur Museum. 60.626

31 *ROOF TILES*, 1760–1800
Berks and Montgomery counties
Red clay, unglazed; a: H 14⅛" (35.9 cm), w 6¾" (17.1 cm); b: H 14¾" (37.5 cm), w 7" (17.8 cm); c: H 13⅞" (35.2 cm), w 6¾" (17.1 cm); d: H 14" (35.6 cm), w 6¾" (17.1 cm)
John and Rosamond Moxon
Plate 59

32 *TEAPOT*, 1750–1825
Salt-glazed stoneware with cobalt decoration; H 7¹⁵⁄₁₆" (20.2 cm) w 8¼" (21 cm)
Winterthur Museum. 59.1765a,b

33 *DISH*, 1786
Attributed to Johannes Neis (1754–1826)
Upper Salford Township, Montgomery County
Earthenware with slip coating, clear lead glaze; H 1⅞" (4.8 cm), dia. 11¾" (29.8 cm)
Philadelphia Museum of Art. Gift of John T. Morris. 00-20

34 *DISH*, 1788
Southeastern Pennsylvania
Earthenware with slip coating, clear lead glaze; H 1⅞" (4.8 cm), dia. 11½" (29.2 cm)
Winterthur Museum. 60.651

35 *BOWL, COLANDER, AND PITCHER*, 1800–1850
Earthenware, clear lead glaze; bowl: H 3³⁄₁₆" (8.1 cm), dia. 6⅛" (15.6 cm); colander: H 5½" (14 cm), dia. 12" (30.5 cm); pitcher: H 3⅞" (9.8 cm), dia. 4⅝" (11.7 cm)
Winterthur Museum. 60.542, 60.109, 66.722

36 *DISH*, 1802
Southeastern Pennsylvania
Earthenware with slip coating, clear lead glaze; H 2" (5.1 cm), dia. 11" (27.9 cm)
Philadelphia Museum of Art. Gift of John T. Morris. 04-16

37 *FOOD MOLD*, 1825–50
Earthenware with manganese sponging, clear lead glaze; H 5¼" (13.3 cm), dia. 8¾" (22.2 cm)
Winterthur Museum. 78.56

38 *MUG*, c. 1830
Earthenware with slip decoration,
 clear lead glaze; H 5⅜" (13.7 cm),
 w 4⅞" (12.4 cm)
Winterthur Museum. 67.1584

39 *LAMPSTAND*, 1830–50
Earthenware, clear lead glaze; H 7"
 (17.8 cm)
Richard S. and Rosemarie B. Machmer

40 *COOKING POT*, 1837
Earthenware with slip decoration,
 clear lead glaze; H 5⅝" (14.3 cm),
 w 7½" (19.1 cm)
Winterthur Museum. 60.617

41 *GOBLET*, c. 1773
Henry William Stiegel (1729–1785)
Manheim, Lancaster County
Blown and engraved lead glass; H 6¾"
 (17.1 cm), dia. 3½" (8.9 cm)
Mr. and Mrs. Roland C. Luther and
 their daughter Ann Luther Dexter

42 *FLASK*, 1765–74
Henry William Stiegel (1729–1785)
Manheim, Lancaster County
Blown pattern-molded glass; H 4⅞"
 (12.4 cm)
Winterthur Museum. 59.3082

43 *SUGAR BOWL*, 1765–74
Attributed to Henry William Stiegel
 (1729–1785)
Manheim, Lancaster County
Blown pattern-molded glass; H 5⅛"
 (13 cm), dia. 4⅜" (11.1 cm)
Winterthur Museum. 59.3299a,b
Plate 62

44 *TUMBLER*, 1765–74
Attributed to Henry William Stiegel
 (1729–1785)
Manheim, Lancaster County
Blown pattern-molded glass; H 3" (7.6
 cm)
The Baltimore Museum of Art. Be-
 quest of Jane James Cook. 1944.216

45 *GOBLET*, 1798–1800
New Geneva Glass Works
New Geneva, Fayette County
Free-blown glass; H 9⅛" (23.2 cm),
 dia. 5³⁄₁₆" (13.2 cm)
The Corning Museum of Glass,
 Corning, New York. 79.4.329
Shown only in Philadelphia
Plate 42

46 *BOTTLE*, 1798–1813
Attributed to Johann Baltasar Kramer
New Geneva—Greensboro Glass
 Works

Free-blown nonlead glass; H 10⁷⁄₁₆"
 (26.5 cm), dia. 7¹⁵⁄₁₆" (20.2 cm)
Waynesburg College Museum,
 Waynesburg, Pennsylvania
Plate 61

47 *FLASK*, 1824–40
Friedrich Rudolf Joachim Lorenz
 (1794–1854)
Pittsburgh
Blown-molded nonlead glass; H 6¾"
 (17.1 cm)
The Historical Society of Western
 Pennsylvania, Pittsburgh
Shown only in Philadelphia

48 *JAR*, 1824–40
Friedrich Rudolf Joachim Lorenz
 (1794–1854)
Pittsburgh
Blown-molded nonlead glass; H 7¹⁵⁄₁₆"
 (20.2 cm), dia. 3¹⁵⁄₁₆" (10 cm)
Oglebay Institute—Mansion Museum,
 Wheeling, West Virginia

FURNITURE

49 *CRADLE*, 1760–90
Lancaster County
Walnut; H 23½" (59.7 cm), L 43"
 (109.2 cm), w 30½" (77.5 cm)
Mr. and Mrs. Richard Flanders Smith
Shown only in Philadelphia

50 *BEDSTEAD*, 1770–1820
Lancaster County
Pine, poplar, maple, painted; H 28½"
 (72.4 cm), L 70½" (179.1 cm), w
 32½" (82.6 cm)
Pennsylvania Farm Museum at Landis
 Valley: Pennsylvania Historical and
 Museum Commission. F7.997
Plate 67

51 *BEDSTEAD FOOTBOARD*, 1789
Cumberland or Lebanon County
Tulip, painted; H 25¾" (65.4 cm),
 L 49¼" (125.1 cm), D 3¾" (9.5 cm)
Private Collection
Shown only in Philadelphia

52 *BEDSTEAD*, 1810–40
Probably Pottstown, Montgomery
 County
Tulip, white pine, painted; H 35¹⁄₁₆"
 (89.1 cm), L 74" (188 cm), w 49¾"
 (126.4 cm)
Winterthur Museum. 81.10
Plate 109

53 *MINIATURE CHEST OR BOX*,
 1744
Chester (Delaware) County
Walnut, tulip, painted; H 10" (25.4
 cm), L 23⅜" (59.4 cm), D 15⅛"
 (38.4 cm)
Winterthur Museum. G65.2257
Plate 76

54 *WATCH BOX*, 1760–1800
Eastern Pennsylvania
Walnut, glass; H 8¼" (21 cm), w 5⅝"
 (14.3 cm), D 2⅜" (6 cm)
Winterthur Museum. G59.639

55 *MINIATURE CHEST OR BOX*,
 1769
Possibly Lancaster or Berks County
Walnut, tulip; H 11" (27.9 cm), L 26½"
 (67.3 cm), D 12½" (31.8 cm)
Philadelphia Museum of Art. Titus C.
 Geesey Collection. 53-125-4
Shown only in Philadelphia

56 *MINIATURE CHEST OR BOX*,
 1770–1800
Probably Berks or Northampton
 County
White pine; H 9³⁄₁₆" (23.3 cm), L
 15¹¹⁄₁₆" (39.8 cm), D 8½" (21.6 cm)
Winterthur Museum. G59.2805

57 *MINIATURE CHEST OR BOX*,
 1785
Bern Township, Berks County
Pine, painted; H 9¹⁄₁₆" (23 cm),
 L 16¾" (42.5 cm), D 10⅜" (26.4 cm)
Winterthur Museum. 59.2806

58 *BOX WITH SLIDING LID*, 1796
Attributed to John Drissell (active
 1790–1817)
Milford Township, Bucks County
White or yellow cedar, painted;
 H 1⅝" (4.1 cm), L 8⅞" (22.5 cm),
 D 4¹⁵⁄₁₆" (12.5 cm)
Winterthur Museum. 65.2259

59 *SALT BOX*, 1797
John Drissell (active 1790–1817)
Milford Township, Bucks County
White pine, painted; H 11" (27.9 cm),
 w 7¼" (18.4 cm), D 8½" (21.6 cm)
Winterthur Museum. 58.17.1
Plate 33

60 *SALT OR SPICE BOX*, c. 1800
Possibly Lebanon County
Walnut, poplar, pine, maple inlay;
 H 16⅛" (41 cm), w 13½" (34.3 cm),
 D 7¾" (19.7 cm)
Philadelphia Museum of Art. Gift of
 J. Stogdell Stokes. 28-10-59

61 *BUTTER BOX*, c. 1800
Montgomery County
Walnut; H 5½″ (14 cm), L 16½″ (41.9
cm), w 15¼″ (38.7 cm)
Philadelphia Museum of Art. Gift of
Mrs. William D. Frishmuth. 02-158
Plate 56

62 *COVERED OVAL SPLINT BOX*,
1800–1850
Possibly Lancaster County
White or yellow cedar, painted;
H 4⅜″ (11.1 cm), L 11⅞″ (30.2
cm), D 7³⁄₁₆″ (18.3 cm)
Winterthur Museum. 64.1581

63 *DOME-TOP BOX*, 1814
Lancaster, Lancaster County
Poplar, tinned sheet iron, painted;
H 7⅞″ (20 cm), w 10¾″ (27.3 cm),
D 10⅞″ (27.6 cm)
Winterthur Museum. 65.1981

64 *TAPE LOOM*, 1795
John Drissell (active 1790–1817)
Milford Township, Bucks County
Pine, red oak, painted; H 17½″ (44.5
cm), L 17½″ (44.5 cm), w 11⅞″
(30.2 cm)
Winterthur Museum. 59.2812

65 *SIDE CHAIR*, 1730–40
Germantown
Walnut; H 43¾″ (111.1 cm), w 18½″
(47 cm), D 15½″ (39.4 cm)
Winterthur Museum. 66.698
Plate 16

66 *SLAT-BACK ARMCHAIR*, 1750–75
Possibly York County
Maple, hickory, splint seat, painted;
H 44½″ (113 cm), w 23¼″ (59.1
cm), D 18″ (45.7 cm)
The Historical Society of York
County, York, Pennsylvania. Gift
of York Society of Farm Women.
65-250

67 *PLANK-SEAT CHAIR*, 1750–80
Bethlehem
Pine, chestnut, oak; H 33″ (83.8 cm),
w 18″ (45.7 cm), D 15½″ (39.4 cm)
Private Collection
Plate 17

68 *EASY CHAIR*, 1752–70
Lancaster County
Walnut, pine, cowhide; H 47″ (119.4
cm), w 22⅛″ (56.2 cm), D 18¼″
(46.4 cm)
Winterthur Museum. M58.65

69 *SIDE CHAIR*, 1770
Eastern Pennsylvania

Black walnut, white oak; H 31¼″
(79.4 cm), w 16¼″ (41.3 cm),
D 14⅜″ (36.5 cm)
Winterthur Museum. G63.827

70 *SIDE CHAIR*, 1780–1800
Michael Stoner (1764–1810)
Lancaster County
Poplar, maple, hickory; H 36″ (91.4
cm), w 19½″ (49.5 cm), D 18½″
(47 cm)
Winterthur Museum. 78.211

71 *BENCH*, 1800–1830
Eastern Pennsylvania
White pine, painted; H 18″ (45.7 cm),
L 96¾″ (245.7 cm), D 13¾″ (34.9
cm)
Mr. and Mrs. Richard Flanders Smith
Plate 102

72 *CHILD'S SIDE CHAIR*, 1750–75
Possibly Northampton County
White pine; H 20¹⁵⁄₁₆″ (53.2 cm),
w 12¾″ (32.4 cm), D 12¾″ (32.4
cm)
Winterthur Museum. G67.1163

73 *CHEST*, 1780
Heidelberg Township, Northampton
(Lehigh) County
Pine, painted; H 21¾″ (55.2 cm), L 49″
(124.5 cm), D 23¼″ (59.1 cm)
Richard S. and Rosemarie B. Machmer
Plate 35

74 *CHEST*, 1781
Lancaster County
Sycamore, maple and sulphur inlay,
tulip; H 27¾″ (70.5 cm), L 54¼″
(137.8 cm), D 24″ (61 cm)
Mr. and Mrs. Richard Flanders Smith
Shown only in Philadelphia

75 *CHEST*, 1784
Bern Township, Berks County
Pine, painted; H 21⅝″ (54.9 cm),
L 50⅝″ (128.6 cm), D 22⅞″ (58.1
cm)
The Reading Public Museum and Art
Gallery, Pennsylvania. 44-132-1
Plate 11

76 *CHEST*, 1788
Lehigh County
Pine, tulip, painted; H 30½″ (77.5 cm),
L 51″ (129.5 cm), D 33½″ (85.1 cm)
Philadelphia Museum of Art. Titus C.
Geesey Collection. 58-110-2

77 *CHEST*, 1788
Probably Berks, Bucks, or
Northampton County
Tulip, painted; H 28⅜″ (72.1 cm),

L 50″ (127 cm), D 24″ (61 cm)
Winterthur Museum. G59.2804

78 *CHEST*, 1790
John Ranck (1763–1828)
Jonestown, Bethel Township, Lebanon
County
Pine, painted; H 25″ (63.5 cm), L 51½″
(130.8 cm), D 22″ (55.9 cm)
Winterthur Museum. 67.783
Plate 66

79 *CHEST*, 1791
Attributed to John Flory (1754–
c. 1824)
Rapho Township, Lancaster County
Walnut; H 27⅞″ (70.2 cm), L 56″
(142.2 cm), D 26″ (66 cm)
Private Collection

80 *CHEST*, 1791
Attributed to John Flory (1754–
c. 1824)
Rapho Township, Lancaster County
Tulip, white pine, painted; H 25½″
(64.8 cm), L 50″ (127 cm), D 24″
(61 cm)
Philadelphia Museum of Art. Titus C.
Geesey Collection. 58-110-1

81 *CHEST*, 1796
Christian Seltzer (1749–1831)
Bethel Township, Lebanon County
Pine, painted; H 23⅜″ (60 cm), L 52⅛″
(132.4 cm), D 22⅛″ (56.2 cm)
Winterthur Museum. G59.2803

82 *CHEST OF DRAWERS*, 1800–1820
Possibly Berks County
Cherry, tulip; H 63″ (160 cm), w 43″
(109.2 cm), D 28″ (71.1 cm)
Annie S. Kemerer Museum,
Bethlehem, Pennsylvania. 61-K-295

83 *CHEST*, 1800–1825
Berks or Northumberland County
White pine, painted; H 24¾″ (62.9
cm), L 50″ (127 cm), D 21½″ (54.6
cm)
Winterthur Museum. 57.99.4
Plate 122

84 *CHEST*, 1800–1825
Possibly Snydertown, Northumberland
County
White pine, painted; H 29⅜″ (74.6
cm), L 51″ (129.5 cm), D 23″ (58.4
cm)
Winterthur Museum. G57.1105
Plate 89

85 *CHEST*, 1803
Upper Bern Township, Berks County
Tulip, painted, pine; H 31″ (78.7 cm),

L 51½″ (130.8 cm), D 21½″ (54.6 cm)
Philadelphia Museum of Art. Gift of Arthur Sussel. 45-12-1
Plate 38

86 *KITCHEN CUPBOARD OR DRESSER*, 1750-75
Probably Lancaster County
Walnut, tulip; H 81¾″ (207.6 cm), w 63″ (160 cm), D 21⅜″ (54.3 cm)
Winterthur Museum. G65.2750
Plate 94

87 *HANGING WALL CUPBOARD*, 1750-60
Ephrata, Lancaster County
Poplar, pine, walnut; H 25³⁄₁₆″ (64 cm), w 19¹⁄₁₆″ (48.4 cm), D 9″ (22.9 cm)
Philadelphia Museum of Art. Gift of J. Stogdell Stokes. 28-10-97
Plate 18

88 *WALL CUPBOARD*, 1752
Millbach, Lebanon County
Walnut; H 43⅞″ (111.4 cm), w 31⅛″ (79.1 cm), D 11¾″ (29.8 cm)
Philadelphia Museum of Art. Gift of Mr. and Mrs. Pierre du Pont and Mr. and Mrs. Lammot du Pont. 26-74-1

89 *HANGING WALL CUPBOARD*, 1770-1800
Possibly Berks County
White pine, tulip, painted; H 36⁵⁄₁₆″ (92.2 cm), w 38¹³⁄₁₆″ (98.6 cm), D 18¹⁄₁₆″ (45.9 cm)
Winterthur Museum. 64.1591

90 *HANGING CORNER CUPBOARD*, 1770-1800
Possibly Lebanon County
Yellow pine, originally painted; H 48″ (121.9 cm), w 36″ (91.4 cm), D 18⅛″ (46 cm)
Philadelphia Museum of Art. Gift of J. Stogdell Stokes. 28-10-1
Plate 101

91 *HANGING CORNER SHELVES*, 1770-1800
Eastern Pennsylvania
Walnut, originally painted or stained; H 56½″ (143.5 cm), w 19½″ (49.5 cm), D 15″ (38.1 cm)
Philadelphia Museum of Art. Titus C. Geesey Collection. 53-125-17

92 *KITCHEN CUPBOARD OR DRESSER*, 1780-1800
York County
Walnut, cherry, tulip; H 85¾″ (217.8 cm), w 58¼″ (148 cm), D 19″

(48.3 cm)
Mr. and Mrs. Richard Flanders Smith
Shown only in Philadelphia

93 *CUPBOARD OVER DRAWERS*, 1780-1800
Berks County
Walnut, white and yellow pine, tulip; H 65⅜″ (166.1 cm), w 35½″ (90.2 cm), D 17¾″ (45.1 cm)
Mr. and Mrs. Robert L. Raley
Plate 37

94 *DESK AND BOOKCASE*, 1785-1800
Attributed to Michael Lind (1725-1807) or Michael Lind, Jr. (1763-1840)
Lancaster, Lancaster County
Cherry, tulip; H 103½″ (262.9 cm), w 45″ (114.3 cm), D 23⅜″ (60 cm)
Winterthur Museum. G51.56
Plate 78

95 *DESK AND BOOKCASE*, 1790-1820
Northumberland County
White pine; H 100⅛″ (254.3 cm), w 40¾″ (103.5 cm), D 23⅜″ (60 cm)
Winterthur Museum. 57.502

96 *DESK AND BOOKCASE*, 1826
Henry Shellenberger (active 1814-35)
Bullskin Township, Fayette County
Walnut, cherry, butternut, maple, poplar, pine; H 86½″ (219.7 cm), w 39″ (99.1 cm), D 20½″ (52.1 cm)
Museum of Art, Carnegie Institute, Pittsburgh. Promised gift of Mr. and Mrs. James A. Drain, 1981
Plate 39

97 *DESK*, 1834
Schwaben Creek Valley, Northumberland County
Poplar, painted, pine; H 49⅛″ (124.8 cm), w 39″ (99.1 cm), D 19¾″ (50.2 cm)
Winterthur Museum. 64.1518
Plate 36

98 *DRESSING TABLE*, 1770-80
Lancaster County
Mahogany, tulip; H 29½″ (74.9 cm), w 35¼″ (89.5 cm), D 21¼″ (54 cm)
The Metropolitan Museum of Art, New York. John Stewart Kennedy Fund, 1918. 18.110.2
Plate 65

99 *LOOKING GLASS*, 1794
Bucks, Lehigh, or Northampton County
Mahogany, black walnut, red cedar, gilded pewter; H 36″ (91.4 cm), w 17¾″ (45.1 cm)

Winterthur Museum. G64.1528
Plate 112

100 *LOOKING GLASS*, 1846
Lehigh County
Tulip, painted; H 11¹⁵⁄₁₆″ (30.3 cm), w 13⅞″ (35.2 cm)
Philadelphia Museum of Art. Gift of Frances Lichten. 58-89-1
Shown only in Philadelphia

101 *SIDE TABLE*, 1740-60
Nazareth or Bethlehem, Northampton County
Walnut, tulip, ash or oak; H 28½″ (72.4 cm), w 36¹⁄₁₆″ (91.6 cm), D 23″ (58.4 cm)
The Moravian Archives, Bethlehem, Pennsylvania
Plate 19

102 *GATELEG TABLE*, 1740-60
Probably Germantown
Walnut, poplar; H 29⅜″ (75.2 cm), w 58⅞″ (149.5 cm), D 46⅜″ (117.8 cm)
Private Collection
Shown only in Philadelphia

103 *TABLE*, 1750-70
Ephrata, Lancaster County
Poplar, walnut; H 28¾″ (73 cm), w 54¼″ (137.8 cm), D 23⁵⁄₁₆″ (59.2 cm)
Ephrata Cloister: Pennsylvania Historical and Museum Commission. 14.65.668

104 *KITCHEN OR WORK TABLE*, 1750-70
Probably Lancaster County
Walnut; H 29½″ (74.9 cm), w 56½″ (143.5 cm), D 32½″ (82.6 cm)
Lancaster County Historical Society, Lancaster, Pennsylvania. 50.6
Plate 96

105 *SAWBUCK OR TRESTLE TABLE*, 1770-1800
Eastern Pennsylvania
Black walnut, white oak; H 30″ (76.2 cm), L 110⅛″ (279.7 cm), D 29″ (73.7 cm)
Winterthur Museum. G65.2263

106 *PEMBROKE OR BREAKFAST TABLE*, 1790-1800
Adam Hains (1768-1846)
Philadelphia
Mahogany, tulip, white cedar, white oak; H 27⅞″ (70.8 cm), w 40⅜″ (102.6 cm), D 29¾″ (75.6 cm)
Winterthur Museum. G57.669
Plate 75

107 *TALL CASE CLOCK*, 1760–70
Augustin Neisser, Jr. (1717–1780)
Germantown
Walnut, poplar, brass, iron; H 99″
(251.5 cm), W 18¼″ (46.4 cm),
D 10″ (25.4 cm)
Hope Lodge, Whitemarsh: Pennsyl-
vania Historical and Museum
Commission. HL76.2.1

108 *TALL CASE CLOCK*, 1770–80
John George Hoff (1733–1816)
Lancaster, Lancaster County
Walnut, pine, iron, pewter; H 81¼″
(206.4 cm), W 22½″ (57.2 cm),
D 12″ (30.5 cm)
Pennsylvania Farm Museum at Landis
Valley: Pennsylvania Historical
and Museum Commission. F70.20.1
Shown only in Philadelphia

109 *TALL CASE CLOCK*, 1775
Jacob Godshalk (c. 1735–1781)
Philadelphia
Walnut, maple inlay, brass, pewter,
iron; H 90″ (228.6 cm), W 15½″
(39.4 cm), D 9¾″ (24.8 cm)
Hope Lodge, Whitemarsh: Pennsyl-
vania Historical and Museum
Commission. HL76.2.2
Plate 5

110 *TALL CASE CLOCK*, c. 1789
Jacob Herwick (active 1779–90)
Carlisle, Cumberland County
Walnut, cherry, pine, iron, brass,
silver plate; H 103⁵⁄₁₆″ (262.4 cm),
W 22⅛″ (56.2 cm), D 10¾″ (27.3
cm)
The Historical Society of York
County, York, Pennsylvania
Shown only in Philadelphia

111 *TALL CASE CLOCK*, 1800–1810
Movement: Jacob Diehl (1777–1858)
Reading
Walnut, pine, iron, brass, enamel;
H 96½″ (245.1 cm), W 21½″ (54.6
cm), D 12½″ (31.8 cm)
The Metropolitan Museum of Art,
New York. Purchase, Douglas and
Priscilla deForest Williams, Mr. and
Mrs. Eric W. Wunsch, and The
Sack Foundation Gifts, 1976.
1976.279

112 *TALL CASE CLOCK*, 1790
John Fisher (1736–1808)
York, York County
Black walnut, tulip, brass, blued steel;
H 100¾″ (255.9 cm), W 24⅞″ (63.2
cm), D 11¾″ (29.9 cm)
Yale University Art Gallery, New
Haven. The Mabel Brady Garvan

Collection. 1936.307
Plate 26

113 *TALL CASE CLOCK*, 1800–1815
Movement: Daniel Oyster (1766–1845)
Reading
Walnut, white pine, enameled iron,
brass; H 97⅜″ (248 cm), W 21⅜″
(54.9 cm), D 10⅞″ (27.6 cm)
Winterthur Museum. G59.2807

114 *TALL CASE CLOCK*, 1815
Case: John Paul, Jr. (1789–1868)
Lykens Township, Dauphin County
Curled maple, black walnut, tulip,
pine, mahogany, ivory inlay, iron,
brass, enamel; H 98″ (248.9 cm),
W 20¾″ (52.7 cm), D 10¼″ (26 cm)
Winterthur Museum. G58.2874
Plate 88

115 *WARDROBE OR CLOTHESPRESS*,
1768
Manor Township, Lancaster County
Walnut, tulip, sulphur inlay; H 89½″
(227.3 cm), W 85¾″ (217.8 cm),
D 30⅜″ (77.8 cm)
Winterthur Museum. G65.2262
Plate 103

116 *WARDROBE*, 1776
Springfield Township, Montgomery
County
Walnut, tulip; H 85¼″ (216.5 cm),
W 65⁹⁄₁₆″ (166.5 cm), D 24⅞″ (63.2
cm)
Germantown Historical Society,
Philadelphia. 2288

117 *WARDROBE*, 1781
Maxatawny Township, Berks County
Black walnut, white pine, wood inlay,
possibly maple, inlaid filler, probably
sawdust with lead paint binder;
H 101″ (256.5 cm), W 86½″ (219.7
cm), D 25½″ (64.8 cm)
Winterthur Museum. 58.17.6
Plate 6

118 *WARDROBE*, 1779
Attributed to Peter Holl III (d. 1825)
and Christian Huber (1758–1820)
Manheim and Warwick townships,
Lancaster County
Black walnut, sulphur inlay, poplar,
pine, oak; H 88″ (223.5 cm), W 78″
(198.1 cm), D 27½″ (69.9 cm)
Philadelphia Museum of Art. Pur-
chased. 57-30-1
Plate 1

119 *WARDROBE*, 1790–1800
John Baughman (1746–1829)
Conestoga Township, Lancaster

County
Walnut, poplar; H 82″ (208.3 cm),
W 86″ (218.4 cm), D 30⅜″ (77.2 cm)
Dr. and Mrs. Donald M. Herr
Plate 28

120 *WARDROBE*, 1792
Attributed to John Bieber (1768–1825)
Northampton (Lehigh) or Berks
County
Tulip, painted, white pine; H 87½″
(222.3 cm), W 52¾″ (134 cm), D 26″
(66 cm)
Private Collection
Plate 27

121 *DOOR LINTEL*, 1740
East Petersburg, Lancaster County
Tulip; H 9¾″ (24.8 cm), L 41½″
(105.4 cm), D 5½″ (14 cm)
Pennsylvania Farm Museum at Landis
Valley: Pennsylvania Historical and
Museum Commission. F24.817

METALWORK

122 *JAMB STOVE*, c. 1749
Attributed to the Durham Furnace
(1727–89)
Durham Township, Bucks County
Cast iron, wrought iron; H 22″ (55.9
cm), W 19½″ (49.5 cm), D 23″
(58.4 cm)
Philadelphia Museum of Art. Pur-
chased: Joseph E. Temple Fund.
14-216

123 *CANNON STOVE*, c. 1763
Elizabeth Furnace (1757–74), Henry
William Stiegel, owner
Elizabeth Township, Lancaster
County
Cast iron, wrought iron; H 55½″ (141
cm), dia. 18″ (45.7 cm)
The Historical Society of Mont-
gomery County, Norristown,
Pennsylvania
Shown only in Philadelphia

124 *SIX-PLATE DRAFT STOVE*,
c. 1769
Elizabeth Furnace (1757–74), Henry
William Stiegel, owner
Elizabeth Township, Lancaster
County
Cast iron, wrought iron; H 37″ (94
cm), W 18½″ (47 cm), D 39½″
(100.3 cm)
Francis G. and William D. Coleman
Shown only in Philadelphia
Plate 50

125 *TEN-PLATE DRAFT STOVE,*
c. 1769
Elizabeth Furnace (1757–74), Henry
William Stiegel, owner
Elizabeth Township, Lancaster
County
Cast iron, wrought iron; H 37½" (95.3
cm), W 17½" (44.5 cm), D 45½"
(115.6 cm)
Hershey Museum of American Life,
Hershey, Pennsylvania

126 *BROADAX,* 1820–40
Gottlieb Sener (1800–1877)
Lancaster, Lancaster County
Cast steel, wood; L 23¼" (59.1 cm),
W 7" (17.8 cm), D 2" (5.1 cm)
Pennsylvania Farm Museum at Landis
Valley: Pennsylvania Historical and
Museum Commission. FM24.968
Plate 45

127 *CHEST LOCK,* 1730–1800
Joseph Stumb
Wrought iron; H 7¼" (18.4 cm),
W 4½" (11.4 cm), D 2½" (6.4 cm)
Private Collection

128 *PAIR OF CHEST HINGES,* 1760–
1800
Wrought iron; L 20" (50.8 cm),
W 6¼" (15.9 cm)
Winterthur Museum. G69.2129.1,.2
Plate 44

129 *PAIR OF DOOR HINGES,* 1744–80
Attributed to the Hopewell Forge
(1744–80)
Union Township, Berks County
Wrought iron; L 11½" (29.2 cm),
W 9½" (24.1 cm)
Private Collection
Plate 46

130 *DOOR DOGS,* 1791–c. 1860
Colebrook Furnace (1791–c. 1860)
South Londonderry Township,
Lebanon County
Wrought iron; H 12" (30.5 cm), W 4"
(10.2 cm), D 10" (25.4 cm)
Richard S. and Rosemarie B. Machmer

131 *DOOR LATCH,* 1793
G. Fry
Wrought iron; H 24" (61 cm), W 8½"
(21.6 cm)
Winterthur Museum. G69.2136

132 *DOORS WITH LOCK,* 1803
John Rohrer
Lebanon, Lebanon County
Wrought iron, wood, painted; lock:
H 8" (20.3 cm), W 9" (22.9 cm),
D 5¾" (14.6 cm); doors: H 90"

(228.6 cm), W 46½" (118.1 cm)
Bindnagle Lutheran Church, Palmyra,
Pennsylvania
Shown only in Philadelphia

133 *DOOR LOCK,* 1822
David Rohrer (1800–1843)
Lebanon, Lebanon County
Wrought iron, brass; H 7" (17.8 cm),
W 9½" (24.1 cm), D 1½" (3.8 cm)
Private Collection
Plate 47

134 *WEATHER VANE,* 1753
Attributed to Michael Schaeffer
Rockland Township, Berks County
Wrought iron, painted; H 47½"
(120.7 cm), W 23½" (59.7 cm)
Mr. and Mrs. Brodnax Cameron, Jr.
Plate 43

135 *KITCHEN UTENSIL,* 1785
J. Werman
Wrought iron; L 21⅛" (53 cm),
W 3⅛" (7.9 cm)
Mr. and Mrs. Richard Flanders Smith

136 *FORK, SPATULA, AND TASTER,*
1832
Northumberland County
Wrought iron, brass; fork: L 18¾"
(47.6 cm), W 1⅞" (4.8 cm); spatula:
L 19¼" (48.9 cm), W 2⅝" (6.7 cm);
taster: L 14" (35.6 cm), W 2" (5.1
cm)
C. Keyser Stahl (fork and spatula)
and Hilda Smith Kline (taster)
Plate 98

137 *SPIDER,* 1810–40
Gustav William Ibach (b. 1791)
Probably Birdsboro, Berks County
Wrought iron; H 10½" (26.7 cm),
L 17⅜" (44.1 cm), D 6⅝" (16.8 cm)
Rockford-Kauffman Museum,
Lancaster, Pennsylvania

138 *BETTY LAMP,* 1848
John Long (b. c. 1787)
Rapho Township, Lancaster County
Wrought iron, brass; H 9¾" (24.8
cm), W 5" (12.7 cm), D 2⅜" (6.7
cm)
Private Collection
Plate 95

139 *PLOW,* 1750–1800
Wood, wrought iron; H 34¾" (88.3
cm), L 91" (231.1 cm), W 26" (66
cm)
Pennsylvania Farm Museum at Landis
Valley: Pennsylvania Historical and
Museum Commission. FM29.955
Shown only in Philadelphia

140 *CONESTOGA WAGON BOX,*
1853–98
Henry S. Hersh (1833–1917)
New Danville, Pequea Township,
Lancaster County
Wood, painted, wrought iron; H 18"
(45.7 cm), L 20¾" (52.7 cm), D 8½"
(21.6 cm)
Pennsylvania Farm Museum at Landis
Valley: Pennsylvania Historical and
Museum Commission. FM24.377

141 *PAIR OF COFFEEPOTS,* 1845
Willoughby Shade (b. 1820)
Marlboro Township, Montgomery
County
Tinned sheet iron, brass; H 11" (27.9
cm), W 10⅛" (25.7 cm)
Mr. and Mrs. Richard Flanders Smith

142 *COFFEEPOT,* c. 1850
Tinned sheet iron, painted; H 10½"
(26.7 cm), W 9¾" (24.8 cm)
Greenfield Village and Henry Ford
Museum, The Edison Institute,
Dearborn, Michigan

143 *COMMUNION SET,* 1754–81
Johann Christoph Heyne (1715–1781)
Lancaster, Lancaster County
Pewter; flagon: H 11⅜" (28.9 cm),
W 7½" (19.1 cm); flagon: H 11¼"
(28.6 cm), W 7½" (19.1 cm);
covered chalice: H 11¼" (28.6 cm),
dia. 4½" (11.4 cm); ciborium:
H 5¾" (14.6 cm), dia. 4½" (11.4
cm); paten: dia. 7¾" (19.7 cm)
Hill Evangelical Lutheran Church,
Cleona, Pennsylvania
Shown only in Philadelphia

144 *PAIR OF CANDLESTICKS,* 1754–81
Johann Christoph Heyne (1715–1781)
Lancaster, Lancaster County
Pewter, tinned sheet iron; H 21¾"
(55.2 cm), W 8" (20.3 cm)
Winterthur Museum. G65.1602.1,.2
Plate 130

145 *MUG,* c. 1784
William Will (1742–1798)
Philadelphia
Pewter; H 5¾" (14.6 cm), W 6⅜"
(16.2 cm)
Winterthur Museum. G67.1369
Plate 84

146 *FLAGON AND CHALICE,* c. 1795
William Will (1742–1798)
Philadelphia
Pewter; flagon: H 13¾" (34.9 cm),
W 7¼" (18.4 cm); chalice: H 7⅞"
(20 cm), W 4⅜" (11.1 cm)
Charles V. Swain (flagon) and

Winterthur Museum. 58.24 (chalice)
Plates 124, 125

147 *SWAGE*, 1781–1800
Philadelphia or Lancaster, Lancaster
County
Cast iron; H 4½″ (11.4 cm), W 2⅜″
(6 cm)
S. Alexander Haverstick and John M.
Haverstick

148 *TEASPOON*, 1781–1800
William Haverstick, Sr. (1756–1823)
Philadelphia or Lancaster, Lancaster
County
Silver; L 5⅜″ (13.7 cm)
Winterthur Museum. 62.240.313

149 *TUREEN*, c. 1790
Peter Getz (1764–1809)
Lancaster, Lancaster County
Silver; H 8⅜″ (21.3 cm), W 7″ (17.8
cm)
Wadsworth Atheneum, Hartford.
The Philip H. Hammerslough
Collection
Plate 23

150 *TEA AND COFFEE SET*, 1793–1805
John Christian Wiltberger (1766–1851)
Philadelphia
Silver, wood; coffeepot: H 14″ (35.6
cm), W 10½″ (26.7 cm); teapot:
H 11¼″ (28.6 cm), W 9½″ (24.1
cm); sugar bowl: H 10⅜″ (26.4 cm),
W 3½″ (8.9 cm); slop bowl: H 5″
(12.7 cm), W 6⅞″ (17.5 cm); cream
pot: H 7¼″ (18.4 cm), W 4½″ (11.4
cm)
Museum of Fine Arts, Boston. Gift of
John R. Farovid in memory of
Bertha Sease Farovid, Mary Vincent
Farovid, and Bishop John Heyl
Vincent. 61.950
Plate 80

151 *FOOTED CUP*, 1812–18
Anthony Rasch (1778–1858) and
Company
Philadelphia
Silver; H 4¹⁄₁₆″ (10.3 cm), W 4″
(10.2 cm)
Moravian Historical Society,
Nazareth, Pennsylvania
Plate 129

152 *STILL*, after 1800
Andrew Eisenhut (1746–1814),
Andrew Eisenhut, Jr. (1791–1816),
or John Eisenhut
Philadelphia
Copper; H 34⅜″ (87.9 cm), W 40⅛″
(101.9 cm), D 26⅜″ (67 cm)
National Museum of American His-

tory, Smithsonian Institution,
Washington, D.C. John Paul
Remensnyder Collection

153 *SAUCEPAN*, c. 1791–1844
John Lay (1771–1844)
York, York County
Copper, tin; H 11″ (27.9 cm), W 14½″
(36.8 cm)
Rockford-Kauffman Museum,
Lancaster, Pennsylvania

154 *KETTLE*, 1814–55
William Heiss, Sr. (c. 1784–1846) or
William Heiss, Jr. (c. 1812–1858)
Philadelphia
Copper, tin; H 8⅜″ (21.9 cm), W 9″
(22.9 cm)
Rockford-Kauffman Museum,
Lancaster, Pennsylvania
Plate 52

155 *TRADE CARD*, 1814–37
Attributed to William Heiss, Sr.
(c. 1784–1846)
Philadelphia
Engraving; H 5¾″ (14.6 cm), W 4¾″
(12.1 cm)
Rockford-Kauffman Museum,
Lancaster, Pennsylvania
Plate 51

156 *BAPTISMAL BASIN AND EWER*,
1831–55
Ernst Ludwig Lehman (1806–1857)
Bethlehem
Gilded copper; basin: H 19″ (48.3 cm),
W 14¼″ (36.2 cm), D 3¼″ (8.3 cm);
ewer: H 9¾″ (24.8 cm), W 4¾″
(12.1 cm), D 2¾″ (7 cm)
Central Moravian Church, Bethlehem,
Pennsylvania
Shown only in Philadelphia

157 *TRANSIT TELESCOPE*, 1769
David Rittenhouse (1732–1796)
Philadelphia
Brass, iron, glass; tube: L 33″ (83.8
cm); frame: H 25″ (63.5 cm), W 20″
(50.8 cm)
American Philosophical Society,
Philadelphia
Shown only in Philadelphia
Plate 77

158 *SEAL*, 1851
John Matthew Miksch (1798–1882)
Bethlehem
Brass; H 11⁄16″ (1.7 cm), W 1 13⁄16″
(4.6 cm)
Moravian Museums of Bethlehem,
Pennsylvania

159 *FLINTLOCK RIFLE*, 1761
John Schreidt

Reading
Maple, iron, brass; L 58¾″ (149.2 cm)
Mr. and Mrs. Charles Frederick Beck
Plate 57

160 *PAIR OF FLINTLOCK PISTOLS*,
1765–80
Frederick Zorger and John Fisher
(1736–1808)
York, York County
Walnut, iron, silver; L 14½″ (36.8 cm)
Winterthur Museum. G61.857.1,.2

161 *FLINTLOCK RIFLE*, 1770–90
Joel Ferree (1731–1801) or Jacob
Ferree (1750–1807)
Leacock or Strasburg Township,
Lancaster County
Maple, iron, brass; L 55″ (139.7 cm)
Rockford-Kauffman Museum,
Lancaster, Pennsylvania
Plate 9

162 *DOUBLE BARREL FLINTLOCK
RIFLE*, 1780–1810
Christian Beck
Bethel Township, Lebanon County, or
Chambersburg area, Franklin
County
Maple, brass, iron; L 51½″ (130.8 cm)
Private Collection

163 *FLINTLOCK RIFLE*, 1780–1811
John Philip Beck (1752–1811)
Lebanon, Lebanon County
Maple, iron, brass, silver; L 60½″
(153.7 cm)
Private Collection
Plate 22

164 *FLINTLOCK RIFLE*, 1780–1815
Nicholas Beyer
Annville Township, Lebanon County
Maple, iron, brass, silver; L 59½″
(151.1 cm)
Private Collection

165 *FLINTLOCK RIFLE*, 1800–1830
John Henry Albright (1772–1845)
Shippensburg Township, Cumberland
County; Warwick Township,
Lancaster County; or Nazareth,
Northampton County
Walnut, iron, brass, silver; L 63″
(160 cm)
Private Collection

166 *SWIVEL BARREL FLINTLOCK
RIFLE*, 1810–20
Jacob Kuntz (1780–1876)
Philadelphia
Maple, iron, brass, silver, ivory,
enamel, glass; L 56½″ (143.5 cm)
David S. Hansen
Plate 81

167 *FLINTLOCK RIFLE*, 1810–20
Jacob Kuntz (1780–1876)
Philadelphia
Maple, iron, brass, silver, ivory, glass;
L 59¼″ (150.5 cm)
The Metropolitan Museum of Art,
New York. Rogers Fund, 1942. 42.22

168 *PAIR OF FLINTLOCK PISTOLS*,
1810–20
Jacob Kuntz (1780–1876)
Philadelphia
Maple, iron, brass, silver, mother-of-
pearl; L 14½″ (36.8 cm)
Private Collection
Plate 82

169 *PIPE TOMAHAWK*, 1800–1815
Peter Angstadt (1763–1815)
Rockland Township, Berks County
Maple, iron, steel, German silver,
silver, gold; L 23″ (58.4 cm), w 7¾″
(19.7 cm)
David Currie
Plate 86

170 *TALL CASE CLOCK*, c. 1735–50
Jacob Graff (d. 1778)
Lebanon, Lebanon County
Walnut, brass, iron, pewter; works
(excluding weights and pendulum):
H 16¾″ (42.5 cm), w 12″ (30.5 cm),
D 6½″ (16.5 cm); case: H 98″ (248.9
cm), w 24½″ (62.2 cm), D 12⁹⁄₁₆″
(31.9 cm)
Winterthur Museum. G65.2261
Plate 25

171 *DIVIDING ENGINE, BARREL
GROOVER, DIAL SCRIBE,
PLANISHER, AND SPRING
WINDER*, c. 1760
Attributed to Jacob Gorgas (1728–
1798)
Philadelphia or Lancaster County
Iron, brass, wood; dividing engine:
H 11¾″ (29.8 cm); barrel groover:
H 10½″ (26.7 cm); dial scribe: L 13″
(33 cm); spring winder: L 10¼″
(26 cm); planisher: L 4⅞″ (12.4 cm)
Private Collection
Plate 49

172 *MUSICAL CLOCKWORKS*, c. 1770
Jacob Gorgas (1728–1798)
Ephrata, Lancaster County
Brass, iron, painted; H 19½″ (49.5 cm),
w 14¼″ (36.2 cm), D 6½″ (16.5 cm)
(excluding weights and pendulum)
Philadelphia Museum of Art. Titus C.
Geesey Collection. 54-85-1a,b
Plate 48

173 *BRACKET CLOCK*, c. 1775
John George Hoff (1733–1816)
Lancaster, Lancaster County
Brass, iron, painted, gilded pewter;
H 11¾″ (29.8 cm), w 8⅝″ (21.9
cm), D 4¾″ (12.1 cm)
On loan to the Heritage Center of
Lancaster County, Inc., Lancaster,
Pennsylvania
Shown only in Philadelphia

PAINTINGS, FRAKTUR, DRAWINGS, AND IMPRINTS

174 *PORTRAIT OF JOHN JACOB
SCHMICK, SR.*, c. 1754
John Valentine Haidt (1700–1780)
Bethlehem
Oil on canvas; H 26⅜″ (67 cm),
w 20½″ (52.1 cm)
Moravian Historical Society,
Nazareth, Pennsylvania
Plate 3

175 *PORTRAIT OF JOHANNA
INGERHEIDT SCHMICK*, c. 1754
John Valentine Haidt (1700–1780)
Bethlehem
Oil on canvas; H 26³⁄₁₆″ (66.5 cm),
w 20½″ (52.1 cm)
Moravian Historical Society,
Nazareth, Pennsylvania
Plate 4

176 *PORTRAIT OF A YOUNG
MORAVIAN GIRL*, 1754–79
John Valentine Haidt (1700–1780)
Bethlehem
Oil on canvas; H 30″ (76.2 cm), w 25″
(63.5 cm)
Private Collection
Shown only in Philadelphia

177 *THE CRUCIFIXION*, 1754–79
John Valentine Haidt (1700–1780)
Bethlehem
Oil on canvas; H 40″ (101.6 cm),
w 51³⁄₁₆″ (130 cm)
Moravian Historical Society,
Nazareth, Pennsylvania

178 *SELF-PORTRAIT*, 1750–54
John Meng (1734–c. 1754)
Germantown
Oil on canvas; H 43¼″ (109.9 cm),
w 32½″ (82.6 cm)
The Historical Society of Pennsyl-
vania, Philadelphia

179 *PORTRAIT OF DANIEL ROSE*,
1795–1800
Attributed to William Witman (active
1794–1802)

Reading
Oil on canvas; H 64″ (162.6 cm),
w 40½″ (102.9 cm)
The Historical Society of Berks
County, Reading, Pennsylvania.
ACP92
Plate 115

180 *SELF-PORTRAIT*, 1825
Jacob Eichholtz (1776–1842)
Philadelphia or Lancaster County
Oil on canvas; H 29½″ (74.9 cm),
w 24½″ (62.2 cm)
Lancaster County Historical Society,
Lancaster, Pennsylvania. Henry
Alfred Dubbs Collection

181 *SHOP SIGN*, 1808–20
Jacob Eichholtz (1776–1842)
Lancaster, Lancaster County
Tin, painted, gilded letters; H 6″
(15.2 cm), w 13″ (33 cm)
Lancaster County Historical Society,
Lancaster, Pennsylvania

182 *PORTRAIT OF THE REVEREND
GOTTHILF HENRY ERNST
MUHLENBERG*, 1811
Jacob Eichholtz (1776–1842)
Lancaster, Lancaster County
Oil on canvas; H 30″ (76.2 cm), w 24″
(61 cm)
Franklin and Marshall College Collec-
tions, Lancaster, Pennsylvania. 1984

183 *CONESTOGA CREEK AND
LANCASTER*, 1833
Jacob Eichholtz (1776–1842)
Lancaster, Lancaster County
Oil on canvas; H 18″ (45.7 cm), w 30″
(76.2 cm)
The Pennsylvania Academy of the
Fine Arts, Philadelphia. Presented
by Mrs. James H. Beal. 1961.8.10
Plate 12

184 *PORTRAIT OF DR. CHRISTIAN
BUCHER*, 1830–35
Attributed to Jacob Maentel
(1763?–1863)
Probably Lebanon County
Watercolor on paper; H 16¾″ (42.5
cm), w 10¼″ (26 cm)
Private Collection
Plate 73

185 *PORTRAIT OF MARY VALEN-
TINE BUCHER*, c. 1830–35
Attributed to Jacob Maentel
(1763?–1863)
Probably Lebanon County
Watercolor on paper; H 16¾″ (42.5
cm), w 10¼″ (26 cm)
Private Collection

186 *PORTRAIT OF COLONEL ISAAC
 S. HOTTENSTEIN*, c. 1845
 The Reading Artist
 Possibly Reading or Kutztown
 Ink and watercolor on paper; H 20½"
 (52.1 cm), w 16⅜₆" (41.1 cm)
 (sight)
 Private Collection

187 *VIEW OF THE GEISSINGER
 FARM, THE LEHIGH RIVER,
 AND THE CANAL NEAR
 BETHLEHEM*, 1836–66
 Gustavus Grünewald (1805–1878)
 Bethlehem
 Oil on panel; H 28⅜" (72.1 cm),
 w 38" (96.5 cm)
 Private Collection

188 *VIEW OF HAMBURG, PENNSYL-
 VANIA*, c. 1840
 Augustus Koellner (1813–1906)
 Hamburg, Windsor Township, Berks
 County
 Watercolor on paper; H 6⅝" (16.8
 cm), w 11" (27.9 cm)
 Richard S. and Rosemarie B. Machmer
 Plate 13

189 *ELECTION SCENE, STATE
 HOUSE IN PHILADELPHIA*,
 1815
 John Lewis Krimmel (1787–1821)
 Philadelphia
 Oil on canvas; H 16⅞" (42.9 cm),
 w 22⅜" (56.8 cm)
 Winterthur Museum. G59.131

190 *FAMILY CHRISTMAS CELE-
 BRATION*, 1810–17
 John Lewis Krimmel (1787–1821)
 Philadelphia
 Pencil and ink wash on paper; H 3¹³⁄₁₆"
 (9.7 cm), w 6⁵⁄₁₆" (16 cm)
 Winterthur Museum. Joseph Downs
 Manuscript Collection. 59x5.7
 Plate 117

191 *THOMAS McKEAN ELECTION*,
 after 1812
 Lewis Miller (1796–1882)
 York, York County
 Ink and watercolor on paper; H 9¹⁵⁄₁₆"
 (25.2 cm), w 7¹¹⁄₁₆" (19.5 cm)
 The Historical Society of York
 County, York, Pennsylvania. 1-67-7
 Plate 87

192 *YEARLY MARKET IN YORK*,
 after 1816
 Lewis Miller (1796–1882)
 York, York County
 Ink and watercolor on paper; H 9¹³⁄₁₆"
 (24.9 cm), w 7⁹⁄₁₆" (19.2 cm)
 The Historical Society of York

County, York, Pennsylvania. 1-9
Plate 53

193 *EASTER RABBIT*, before 1812
 Attributed to Conrad Gilbert (1734–
 1812)
 Probably Brunswick Township, Berks
 County
 Ink and watercolor on paper; H 3³⁄₁₆"
 (8.1 cm), w 3¹³⁄₁₆" (9.7 cm)
 Abby Aldrich Rockefeller Folk Art
 Center, Williamsburg, Virginia.
 59.305.3
 Plate 116

194 *HOUSE WITH SIX-BED
 GARDEN*, 1818
 Attributed to David Huebner
 Upper Montgomery County
 Ink and watercolor on paper; H 12⁷⁄₁₆"
 (31.6 cm), w 7¾" (19.7 cm)
 Schwenkfelder Library, Pennsburg,
 Pennsylvania. 2-34b
 Plate 93

195 *SOLDIERS AND LADIES*, 1790–1820
 Attributed to John Adam Eÿer (1755–
 1837)
 Bucks County
 Ink and watercolor on paper; H 12⁵⁄₁₆"
 (31.3 cm), w 15⁷⁄₁₆" (39.2 cm)
 Winterthur Museum. 61.1124

196 *METAMORPHOSIS*, 1832
 Durs Rudy, Jr. (1789–1850)
 Lehigh County
 Ink and watercolor on paper; H 6⁵⁄₁₆"
 (16 cm), w 3¹⁵⁄₁₆" (10 cm) (closed)
 The Lehigh County Historical
 Society, Allentown, Pennsylvania
 Plate 120

197 *GENERAL WASHINGTON*, 1842
 Durs Rudy, Jr. (1789–1850)
 Lehigh County
 Ink and watercolor on paper; H 12"
 (30.5 cm), w 10" (25.4 cm)
 Philadelphia Museum of Art. Titus C.
 Geesey Collection. 54-85-131
 Plate 91

198 *MARRIAGE CERTIFICATE FOR
 DANIEL BENTZINGER AND
 MARIA BARBARA
 BEINMANNIN*, 1779
 Daniel Schumacher (c. 1729–1787)
 Brunswick Township, Berks County
 Ink and watercolor on paper; H 7¾"
 (19.7 cm), w 12¾" (32.4 cm)
 Richard S. and Rosemarie B. Machmer
 Plate 79

199 *WEDDING WISH*, c. 1790
 Andreas Kolb (1749–1811)

Probably Bucks or Montgomery
County
Ink and watercolor on paper; H 9⅜"
(23.8 cm), w 7⅞" (20 cm)
Schwenkfelder Library, Pennsburg,
Pennsylvania. 5-32
Shown only in Philadelphia

200 *LOVER'S KNOT FOR ELISABETH
 FRY*, c. 1800
 Buffalo Township, Northumberland
 (Union) County
 Ink and watercolor on paper; H 15¾"
 (40 cm), w 15¾" (40 cm)
 Annie S. Kemerer Museum, Bethle-
 hem, Pennsylvania. 61-K-366
 Shown only in Philadelphia

201 *LOVER'S KNOT FOR MARY
 FINKENBINER*, 1824
 Daniel Stalls
 Probably Cumberland County
 Ink and watercolor on paper; H 13⅜"
 (34 cm), w 8" (20.3 cm)
 Rockford-Kauffman Museum,
 Lancaster, Pennsylvania
 Plate 83

202 *LOVE LETTER FROM ADAM
 DAMBACH*, 1779
 Lancaster, Lancaster County
 Ink, watercolor, and cut paper;
 H 12⅜" (31.4 cm), w 12⅜" (32.1
 cm)
 Winterthur Museum. 65.1339
 Plate 119

203 *LETTER FOR JOHANNES AND
 MARGARET LEIN*, 1799
 Hans Jacob Brubaker (d. 1802)
 Lancaster County
 Ink and watercolor on paper; H 12¾"
 (32.4 cm), w 15⅝" (39.7 cm)
 Private Collection
 Shown only in Philadelphia

204 *NEW YEAR'S WISH*, 1751
 Hans Jacob Brubaker (d. 1802)
 Lancaster County
 Ink and watercolor on paper; H 7⅞"
 (20 cm), w 12⁹⁄₁₆" (31.9 cm)
 Winterthur Museum. 52.102

205 *HOUSE BLESSING*, 1803
 Probably eastern Pennsylvania
 Ink and watercolor on paper; H 12½"
 (31.8 cm), w 15⅜" (39.1 cm)
 Winterthur Museum. 57.1190

206 *FAMILY RECORD OF DANIEL
 AND MARIA ALTLAND
 PETERMAN*, 1834
 Daniel Peterman (1797–1871)
 Probably Manheim Township, York

County
Ink, pencil, and watercolor on paper;
H 12″ (30.5 cm), w 14″ (35.6 cm)
Private Collection

207 *BAPTISMAL WISH FOR STOVEL
 EMRICH*, 1771–80
 The Sussel-Washington Artist
 Bethel Township, Berks County
 Ink and watercolor on paper; H 10⅜″
 (27 cm), w 12¹/₁₆″ (30.6 cm) (sight)
 Winterthur Museum. 58.120.15
 Plate 21

208 *BIRTH AND BAPTISMAL
 RECORD FOR SABINA HEIGES*,
 after 1776
 Attributed to Arnold Hoevelmann
 (1749–1804)
 Monahan Township, York County
 Ink and watercolor on paper; H 13⅜″
 (34 cm), w 16¼″ (41.3 cm)
 Philadelphia Museum of Art. Gift of
 J. Stogdell Stokes. 28-10-73

209 *BAPTISMAL CERTIFICATE FOR
 GEORGE WILD*, 1784
 Henry Dutye
 Berks County
 Ink and watercolor on paper; H 12⁹/₁₆″
 (31.9 cm), w 15¹⁵/₁₆″ (40.5 cm)
 Winterthur Museum. 62.185

210 *BIRTH AND BAPTISMAL CER-
 TIFICATE FOR JACOB KUNTZ*,
 1789
 Carl Scheibeler (active 1789–1846)
 Hempfield Township, Westmoreland
 County
 Ink and watercolor on paper; H 16³/₁₆″
 (41.1 cm), w 12¾″ (32.4 cm)
 The Westmoreland County Museum
 of Art, Greensburg, Pennsylvania.
 Gift of the Woods-Marchand
 Collection. 60.533
 Plate 40

211 *BIRTH AND BAPTISMAL CER-
 TIFICATE FOR ELISABETH
 ROSSLI*, after 1789–91
 Johannes Ernst Spangenberg (before
 1755–1814)
 Lower Saucon Township, North-
 ampton County
 Ink and watercolor on paper; H 16½″
 (41.9 cm), w 21″ (53.3 cm)
 Pennsylvania Farm Museum at Landis
 Valley: Pennsylvania Historical and
 Museum Commission. FM80.6

212 *BAPTISMAL RECORD FOR
 JOHANN MARTIN EYER*, 1795
 John Adam Eÿer (1755–1837)
 Bucks County

Ink and watercolor on paper; H 10″
(25.4 cm), w 7⅝″ (19.4 cm)
Private Collection

213 *BIRTH, BAPTISMAL, AND CON-
 FIRMATION CERTIFICATE
 FOR MARGARETA MUNCH*,
 probably 1826
 Charles Edward Münch (1769–1833)
 Northumberland County
 Ink and watercolor on paper; H 9¾″
 (24.8 cm), w 15″ (38.1 cm)
 National Gallery of Art, Washington,
 D.C. Gift of Edgar William and
 Bernice Chrysler Garbisch. B25,177
 Shown only in Philadelphia

214 *BIRTH RECORD FOR JOHANNES
 ZARTMANN*, 1828
 Jacob Maentel (1763?–1863)
 Probably Lebanon County
 Ink and watercolor on paper; H 9¹⁵/₁₆″
 (25.2 cm), w 8⅛″ (20.6 cm)
 Philadelphia Museum of Art. Gift of
 Edgar William and Bernice
 Chrysler Garbisch. 67-268-15

215 *BIRTH AND BAPTISMAL
 RECORD FOR ELISA ADAM*,
 1833
 The Mount Pleasant Artist
 Lancaster County
 Ink and watercolor on paper; H 9¼″
 (23.5 cm), w 7¼″ (18.4 cm)
 Franklin and Marshall College
 Collections, Lancaster, Pennsylvania
 Plate 24

216 *BIRTH AND BAPTISMAL CER-
 TIFICATE FOR MARGARET
 ELLEN YOUNG*, 1840
 Henry Christian Andrew Harmon
 Young (1792–1861)
 Probably Centre County
 Ink and watercolor on paper; H 12¾″
 (32.4 cm), w 7⅞″ (20 cm)
 Abby Aldrich Rockefeller Folk Art
 Center, Williamsburg, Virginia.
 78.305.1

217 *ACCOUNT BOOK OF PETER
 RANCK*, 1794–1813
 Drawings by Daniel Arnd
 Jonestown, Bethel Township, Lebanon
 County
 Book: ink and pencil on paper; H
 10¾″ (27.3 cm), w 8½″ (21.6 cm)
 Winterthur Museum. Joseph Downs
 Manuscript Collection. 67x23

218 *ECONOMY HOTEL*, 1834
 Attributed to Frederick Reichert
 Old Economy, Beaver County
 Ink and watercolor wash on paper;

H 16¾″ (42.5 cm), w 22¼″ (56.5
cm)
Old Economy Village: Pennsylvania
Historical and Museum Commission.
OE72.17.83
Plate 41

219 *MAP OF GERMANTOWN*, 1688
 Probably Germantown
 Ink on paper; H 15⅝″ (39.7 cm),
 w 10″ (25.4 cm)
 Private Collection

220 *COPYBOOK TITLE PAGE FOR
 ABRAHAM LANDES*, 1780
 John Adam Eÿer (1755–1837)
 Bucks County
 Ink and watercolor on paper; H 8⅜″
 (21.3 cm), w 6⁷/₁₆″ (16.4 cm)
 The Free Library of Philadelphia.
 Rare Book Department. FLP716
 Shown only in Philadelphia

221 *BOOKPLATE FOR SAMUEL
 MARTIN*, 1797
 The Earl Township Artist
 Lancaster County
 Ink and watercolor on paper; H 5⁵/₁₆″
 (13.5 cm), w 6⅜″ (16.2 cm)
 Philadelphia Museum of Art. Titus C.
 Geesey Collection. 58.110.35
 Shown only in Philadelphia

222 *BOOKMARK*, 1790–1825
 Ink and watercolor on paper; H 4″
 (10.2 cm), w 2¾″ (7 cm)
 Winterthur Museum. 57.1236

223 *WRITING EXERCISE*, 1771
 Christian Cassel
 Montgomery County
 Ink and watercolor on paper; H 7¾″
 (19.7 cm), w 13″ (33 cm)
 Schwenkfelder Library, Pennsburg,
 Pennsylvania. 2-12a
 Plate 131

224 *WRITING EXERCISE*, 1772
 Abraham Heebner
 Montgomery County
 Ink and watercolor on paper; H 7¹¹/₁₆″
 (19.5 cm), w 12⅞″ (32.7 cm)
 Schwenkfelder Library, Pennsburg,
 Pennsylvania. 2-12b
 Plate 132

225 *WRITING SPECIMEN*, 1801
 Attributed to Rev. George Geistweit
 (active 1794–1804)
 Wolf's Chapel School, eastern Centre
 County
 Ink and watercolor on paper; H 12½″
 (31.8 cm), w 15″ (38.1 cm)
 Philadelphia Museum of Art. Titus C.
 Geesey Collection. 54-85-7

226 *WRITING SPECIMEN*, 1808
Eastern Pennsylvania
Ink and watercolor on paper; H 14⅝"
(37.1 cm), w 25⅜" (64.5 cm)
Winterthur Museum. 57.1213

227 *SCHOOL EXERCISE FOR
ELISABETH LANDIS*, 1826
Attributed to John Landis
Lancaster County
Ink and watercolor on paper; H 7⅝"
(19.4 cm), w 12¹¹⁄₁₆" (32.2 cm)
Franklin and Marshall College
Collections, Lancaster, Pennsylvania.
369
Shown only in Philadelphia

228 *BROADSIDE FEATURING THE
GREAT COMET*, after 1769
Possibly Susanna Huebner
Probably Montgomery County
Ink and watercolor on paper; H 12⅜"
(31.4 cm), w 15⅛" (38.4 cm)
Philadelphia Museum of Art. Gift of
J. Stogdell Stokes. 28-83-1

229 *BROADSIDE: SEVEN RULES OF
WISDOM*, 1784
Baltzer Heydrich (1765–1846)
Montgomery County
Ink and watercolor on paper; H 12³⁄₁₆"
(31 cm), w 15" (38.1 cm)
Schwenkfelder Library, Pennsburg,
Pennsylvania. 2-1

230 *BROADSIDE: ADAM AND EVE
IN PARADISE*, 1800–1830
Eastern Pennsylvania
Ink and watercolor on paper; H 12¾"
(32.4 cm), w 7¾" (19.7 cm)
The Dietrich Brothers Americana
Corporation, Philadelphia
Plate 123

231 *RELIGIOUS TEXT*, 1817
Probably Bucks County
Ink and watercolor on paper; H 15⅞"
(40.3 cm), w 13¹⁄₁₆" (33.2 cm)
The Free Library of Philadelphia.
Rare Book Department. FLP714
Shown only in Philadelphia

232 *BROADSIDE: THE SPIRITUAL
CLOCKWORK*, 1832
Andreas B. Bauer
Probably Montgomery County
Ink and watercolor on paper; H 12⅝"
(32.1 cm), w 7¾" (19.7 cm)
Schwenkfelder Library, Pennsburg,
Pennsylvania. 4-88
Shown only in Philadelphia

233 *RELIGIOUS TEXT*, 1835–45
Attributed to Martin Gottshall

(d. 1857)
Franconia or Salford Township,
Montgomery County
Ink and watercolor on paper; H 12"
(30.5 cm), w 7¾" (19.7 cm)
Private Collection
Plate 32

234 *BROADSIDE: THE CRUCIFIXION*,
c. 1840
Arnold Puwelle (b. 1809)
Probably Berks County
Ink and watercolor on paper;
H 12¹³⁄₁₆" (32.5 cm), w 9¹³⁄₁₆" (24.9
cm)
The Free Library of Philadelphia.
Rare Book Department. FLP310
Shown only in Philadelphia

235 *BOOKPLATE*, c. 1800
John Christian Strenge (1758–1828)
Lancaster County
Ink and watercolor on paper; H 6¾"
(17.1 cm), w 4⁵⁄₁₆" (11 cm)
American Antiquarian Society,
Worcester, Massachusetts
Shown only in Philadelphia
Plate 10

236 *DER HOCH-DEUTSCH
PENNSYLVANISCHE
GESCHICHT-SCHREIBER*, 1739
Christopher Saur (1694–1758),
publisher
Germantown
Newspaper: letterpress; H 7½" (19.1
cm), w 6⁵⁄₁₆" (16 cm)
Juniata College, Huntingdon,
Pennsylvania. IM27

237 *ZIONITISCHER WEYRAUCHS-
HUGEL*, 1739
Christopher Saur (1694–1758),
publisher
Germantown
Book: letterpress; H 4¼" (10.8 cm),
w 6½" (16.5 cm)
Don Yoder Collection
Plate 14

238 *BIBLIA, DAS IST: DIE HEILIGE
SCHRIFT ALTES UND NEUES
TESTAMENTS*, 1743
Christopher Saur (1694–1758),
publisher
Germantown
Book: letterpress, bound in leather
with hubbed spine and brass
closures; H 9¹⁵⁄₁₆" (25.2 cm), w 8"
(20.3 cm)
Juniata College, Huntingdon,
Pennsylvania
Plate 15

239 *DER BLUTIGE SCHAU-PLATZ
ODER MARTYRER SPIEGEL*,
1748–49
Ephrata Brotherhood Press (Kloster
Press), publishers
Ephrata, Lancaster County
Book: letterpress, etching, and
engraving, bound in calf with
hubbed spine and brass corners and
closures; H 14¹⁵⁄₁₆" (37.9 cm),
w 10¹⁄₁₆" (25.6 cm)
Winterthur Museum Library, RBR.
BV4503/B81/F
Plate 121

240 *ALMANAC FOR 1755*, 1754
Christopher Saur (1694–1758),
publisher
Germantown
Letterpress and woodcut; H 8¹⁄₁₆"
(20.5 cm), w 6½" (16.5 cm)
Juniata College, Huntingdon,
Pennsylvania. 051A4

241 *ALMANAC FOR 1772*, 1771
Christopher Sauer (1721–1784),
publisher
Germantown
Letterpress and woodcut; H 8¼" (21
cm), w 6¾" (17.1 cm)
Winterthur Museum. 69.2201

242 *PENNSYLVANISCHER
STAATSBOTE*, 1776
Johannes Henrich Miller (1702–1782),
publisher
Philadelphia
Newspaper: letterpress (bound);
H 14⁵⁄₁₆" (36.4 cm), w 9⅛" (23.2
cm)
The Historical Society of Pennsyl-
vania, Philadelphia
Shown only in Philadelphia

243 *BROADSIDE: SPIRITUAL
GARDEN MAZE*, c. 1784
Johann Henrich Otto
Near Ephrata, Lancaster County
Letterpress, with ink and watercolor;
H 20⅞" (53 cm), w 16½" (41.9 cm)
Winterthur Museum. 58.120.13

244 *ALMANAC FOR 1792*, 1791
Johann Albrecht and Company,
publishers
Lancaster, Lancaster County
Letterpress and woodcut; H 8½" (21.6
cm), w 6⅞" (17.5 cm)
Winterthur Museum. 69.2202
Plate 99

245 *BIRTH, BAPTISMAL, AND CON-
FIRMATION RECORD FOR
ABRAHAM KRAMER*, 1793

Barton and Jungmann, Reading,
printers; decoration attributed to
Friedrich Krebs
Probably Bucks County
Letterpress, with applied paper cut-
outs, watercolor, and ink; H 13⅛″
(33.3 cm), w 16 1/16″ (40.8 cm)
Franklin and Marshall College
Collections, Lancaster, Pennsylvania.
3110
Shown only in Philadelphia
Plate 64

246 *DAS GUTE KIND VOR UND
NACH DER SCHULE*, 1796
Melchior Steiner and Heinrich
Kämmerer, publishers
Philadelphia
Book: letterpress and woodcut;
H 4 11/16″ (11.9 cm), w 3 1/16″ (7.8 cm)
The Free Library of Philadelphia.
Rare Book Department. Rosenbach
Collection. 211

247 *ALMANAC FOR 1811*, 1810
Johann Ritter and Company,
publishers
Reading
Letterpress and wood engraving;
H 8½″ (21.6 cm), w 6¾″ (17.1 cm)
Winterthur Museum. 69.2203
Plate 63

248 *BIRTH, BAPTISMAL, AND CON-
FIRMATION RECORD FOR
MARIA ROTHERMEL*, probably
1816
Johann Herschberger, Chambersburg,
Franklin County, printer
Probably completed in Maidencreek
Township, Berks County
Letterpress and woodcut, with ink;
H 12 5/16″ (31.3 cm), w 14¾″ (37.5
cm)
Winterthur Museum. 61.1145

249 *DEUTSCHE & ENGLISCHE
VORSCHRIFTEN FUR DIE
JUGEND*, 1821
Carl Friederich Egelmann (1782–
1860), engraver and publisher
Reading
Book: engraving; H 6 7/16″ (16.4 cm),
w 7⅞″ (20 cm)
The Free Library of Philadelphia.
Rare Book Department
Shown only in Philadelphia

250 *BROADSIDE: JOSEPH AND HIS
BROTHERS*, 1829
Gustav S. Peters (1793–1847), printer
Harrisburg
Letterpress and woodcut, with
stenciled colors; H 20⅛″ (51.1 cm),

w 16¾″ (42.5 cm)
The Free Library of Philadelphia.
Rare Book Department. FLP-X-108b

251 *METAMORPHOSIS*, possibly before
1831
Gustav S. Peters (1793–1847), printer
Harrisburg
Letterpress and wood engraving;
H 6 11/16″ (17 cm), w 3¾″ (9.5 cm)
Pennsylvania Farm Museum at Landis
Valley: Pennsylvania Historical and
Museum Commission. FM18.328.1-4

252 *ALMANAC*, 1836
George W. Menz and Son, publishers;
John Spittall, engraver (b. 1811)
Philadelphia
Wood engraving; H 7¾″ (19.7 cm),
w 6⅝″ (16.8 cm)
Winterthur Museum. 69.1711

253 *CHORALE BOOK*, 1793
Christophel (Christopher) Kriebel
(1779–1822)
Montgomery County
Book: watercolor and ink on paper;
H 3⅞″ (9.8 cm), w 7 11/16″ (19.5 cm)
Schwenkfelder Library, Pennsburg,
Pennsylvania. VD1-33

254 *SONGBOOK*, 1797
John Christian Strenge (1758–1828)
Hempfield Township, Lancaster
County
Book: watercolor and ink on paper;
H 3⅞″ (9.8 cm), w 6⅝″ (16.8 cm)
Pennsylvania Farm Museum at Landis
Valley: Pennsylvania Historical and
Museum Commission. F5.96
Plate 128

255 *MUSIC BOOK*, c. 1780–1825
Possibly Lancaster County
Book: watercolor and ink on paper;
H 5″ (12.7 cm), w 9″ (22.9 cm)
Moravian Historical Society,
Nazareth, Pennsylvania

256 *MUSIC BOOK*, 1830–40
Snow Hill, Franklin County
Book: letterpress, with hand drawing
and coloring; H 8⅞″ (22.5 cm),
w 7¼″ (18.4 cm)
The Free Library of Philadelphia.
Rare Book Department

257 *PARADISISCHES WUNDER-
SPIEL*, 1754
Johann Conrad Beissel (1690–1768),
compiler and editor
Ephrata, Lancaster County
Book: letterpress, with hand coloring,

bound in paper with calf spine;
H 13⅛″ (33.3 cm), w 8½″ (21.6 cm)
The Free Library of Philadelphia.
Rare Book Department. FLP1151
Plate 127

258 *ERBAULICHE LIEDER*, 1829
Michael Billmeyer (active 1784–1829),
publisher
Germantown
Book: letterpress, bound in leather
with metal clasps; H 7¼″ (18.4 cm),
w 4¼″ (10.8 cm)
Hershey Museum of American Life,
Hershey, Pennsylvania

259 *BROADSIDE: THE MOURNFUL
BALLAD OF SUSANNA COX*,
1840–50
Probably Reading
Letterpress; H 15⅛″ (38.4 cm), w 9⅝″
(24.4 cm)
The Free Library of Philadelphia.
Rare Book Department. 156.2

260 *BIRTHDAY WISH*, 1795
Bethlehem
Watercolor on paper; H 12″ (30.5
cm), w 10″ (25.4 cm) (framed)
Moravian Historical Society,
Nazareth, Pennsylvania

261 *LUDWIG MILLER, 1805*, 1814–30
Lewis Miller (1796–1882)
York, York County
Ink and watercolor on paper; H 9⅞″
(25.1 cm), w 7⅝″ (19.4 cm)
The Historical Society of York
County, York, Pennsylvania. 1,82

262 *DANCING AT THE HOUSE OF
JOHN GLESSNER, TRUMPET
PLAYERS, AND DAVID
DANNENBERGER, ORGAN
BUILDER*, 1814–30
Lewis Miller (1796–1882)
York, York County
Ink and watercolor on paper; H 9⅞″
(25.1 cm), w 7⅝″ (19.4 cm)
The Historical Society of York
County, York, Pennsylvania. 1,48
Plate 118

263 *THE GERMAN LUTHERAN
CHURCH IN YORK*, 1814–30
Lewis Miller (1796–1882)
York, York County
Ink and watercolor on paper; H 12¼″
(31.1 cm), w 18 5/16″ (46.5 cm)
(framed)
William H. Kain III and Carol Kain
Woodbury
Plate 126

TEXTILES

264 *HATCHEL*, 1815
S. T. Ulrich
White oak, iron, tin; H 4″ (10.2 cm),
L 12¼″ (31.1 cm)
Heritage Center of Lancaster County,
Inc., Lancaster, Pennsylvania. 81.10

265 *SPINNING WHEEL*, 1806
Samuel Henry (d. 1816)
Lampeter Township, Lancaster
County
Wood, iron; H 44½″ (113 cm)
Lancaster County Historical Society,
Lancaster, Pennsylvania
Plate 100

266 *SPINNING WHEEL*, 1839–50
James Fox (c. 1785–c. 1862)
Tulpehocken Township, Berks County
Wood, iron; H 46¾″ (118.7 cm)
Chester County Historical Society,
West Chester, Pennsylvania.
00172TT/59

267 *GRAIN BAG*, 1828
Lancaster or Lebanon County
3/1 twill weave, unbleached tow, 3
ply cotton tie; w 19″ (48.3 cm),
L 60″ (152.4 cm)
Dr. and Mrs. Donald M. Herr

268 *TEXTILE PRINTING BLOCK*,
1750–1830
Southeastern Pennsylvania
Wood; H 7½″ (19.1 cm), w 11½″
(29.2 cm), D 1″ (2.5 cm)
Pennsylvania Farm Museum at Landis
Valley: Pennsylvania Historical and
Museum Commission. F11.476

269 *CLOTH FRAGMENT*, 1780–1850
Southeastern Pennsylvania
Plain weave linen, resist dyed; w 19″
(48.3 cm), L 44″ (111.8 cm)
Dr. and Mrs. Donald M. Herr
Plate 68

270 *COVERLET*, c. 1840
Attributed to Regina Whitner Rarig
(1819–1902)
Roaring Creek Township, Columbia
County
Plain weave wool; w 72″ (182.9 cm),
L 87″ (221 cm)
Mr. and Mrs. Paul N. Wagner

271 *WEAVER'S PATTERN BOOK*,
1783
Joseph Leisey (1754–1826)
Cocalico Township, Lancaster County
Book: watercolor and ink on paper,
87 double leaves; H 3⅞″ (9.8 cm),

w 6½″ (16.5 cm)
Private Collection
Shown only in Philadelphia

272 *WEAVER'S PATTERN BOOK*,
1816
Peter Leisey (1802–1859)
Cocalico Township, Lancaster County
Book: ink on paper, 46 double leaves;
H 3¹³⁄₁₆″ (9.7 cm), w 6½″ (16.5 cm)
The Free Library of Philadelphia.
Rare Book Department
Plate 70

273 *COVERLET*, 1799
Southeastern Pennsylvania
16 shaft double weave, warp: wool
and cotton, weft: wool and cotton,
top binding: wool twill tape; w 75″
(190.5 cm), L 84″ (213.4 cm)
Dr. and Mrs. Donald M. Herr

274 *COVERLET*, 1800–1850
Lancaster County
12 shaft controlled *beiderwand* weave,
tie down proportion 4:1, wool
pattern weft on cotton foundation;
w 84″ (213.4 cm), L 97″ (246.4 cm)
Heritage Center of Lancaster County,
Inc., Lancaster, Pennsylvania. P.78-80

275 *COVERLET*, 1844
Eastern Lancaster County
20 shaft point twill weave, warp:
cotton, weft: wool and cotton,
outer selvages: linen, top binding:
printed plain weave cotton; w 78″
(198.1 cm), L 96½″ (245.1 cm)
Dr. and Mrs. Donald M. Herr
Plate 110

276 *WEAVER'S SAMPLE*, after 1809
Attributed to Peter Stauffer (1791–
1868)
Isabella, West Nantmeal Township,
Chester County
18 shaft Germanic expanded twill,
expanded point twill or multiple-
shaft star and diamond, wool pattern
weft on cotton foundation; w 17¾″
(45.1 cm), L 24″ (61 cm); applied
fringe: 4½″ (11.4 cm)
National Museum of American
History, Smithsonian Institution,
Washington, D.C. Division of
Textiles. T.14234Acc206911
Plate 71

277 *COVERLET*, after 1809
Attributed to Peter Stauffer (1791–
1868)
Isabella, West Nantmeal Township,
Chester County
18 shaft Germanic expanded twill,

expanded point twill or multiple-
shaft star and diamond, wool pattern
weft on cotton foundation; w 84″
(213.4 cm), L 92″ (233.7 cm)
National Museum of American
History, Smithsonian Institution,
Washington, D.C. Division of
Textiles. T.14230Acc206911
Shown only in Philadelphia

278 *COVERLET*, 1835–50
Peter Leisey (1802–1859)
Cocalico Township, Lancaster County
Jacquard patterned compound weave
with supplementary weft, tie down
proportion 4:1, wool pattern weft
on cotton foundation; w 78″ (198.1
cm), L 93″ (236.2 cm)
David P. and Susan M. Cunningham
Plate 72

279 *COVERLET*, 1838
John Schwartz (c. 1811–1892)
York, York County
Jacquard patterned with plain weave
foundation, supplementary weft
bound in two twill patterns, wool
pattern weft on cotton foundation;
w 78″ (198.1 cm), L 98″ (248.9 cm)
Ms. Dotty Lewis

280 *CHILD'S COVERLET*, 1839
Aaron Zelner (1812–1893)
Plumstead Township, Bucks County
Jacquard patterned compound weave
with supplementary weft, tie down
proportion 2:1, wool pattern weft
on cotton foundation; w 34″ (86.4
cm), L 40¼″ (102.2 cm)
Mr. and Mrs. Paul R. Flack
Plate 29

281 *COVERLET*, 1830–50
David Steiner
Brecknock Township, Lancaster
County
Jacquard patterned compound weave
with supplementary weft, tie down
proportion 2:1, wool pattern weft
on cotton foundation; w 84″ (213.4
cm), L 88″ (223.5 cm)
David P. and Susan M. Cunningham

282 *COVERLET*, 1843
Martin Hoke (c. 1803–1881)
York, York County
Jacquard patterned compound weave
with supplementary weft, tie down
proportion 2:1, wool pattern weft
on cotton foundation; w 87″ (221
cm), L 98″ (248.9 cm)
Dr. and Mrs. Donald M. Herr
Plate 8

283 *COVERLET*, 1846
Jacob Hausman, Sr. (1788–1863) or
 Jacob Hausman, Jr. (1815–1891)
Lobachsville, Pike Township, Berks
 County
Jacquard patterned compound weave
 with supplementary weft, tie down
 proportion 3:1, wool pattern weft
 on cotton foundation; w 75″ (190.5
 cm), L 102″ (259.1 cm)
The Historical Society of Berks
 County, Reading, Pennsylvania.
 67-24-2

284 *COVERLET*, 1848
Jacob Lutz (c. 1806–c. 1861)
East Hempfield Township, Lancaster
 County
Jacquard patterned compound weave
 with supplementary weft, tie down
 proportion 4:1, wool pattern weft
 on cotton foundation; w 70½″
 (179.1 cm), L 87″ (221 cm)
Peto Collection

285 *COVERLET*, 1848
Adam Hoerr (b. c. 1812)
Harmony, Butler County
Jacquard patterned compound weave
 with supplementary weft, tie down
 proportion 4:1, wool pattern weft
 on cotton foundation; w 76″ (193
 cm), L 92″ (233.7 cm)
Old Economy Village: Pennsylvania
 Historical and Museum Commission.
 OE65.6.1
Plate 30

286 *TABLECLOTH*, 1824
Plain weave linen ground, cotton
 embroidery in cross-stitch, drawn-
 work center panel; w 41¾″ (106
 cm), L 70¼″ (178.4 cm) (with
 fringe)
Winterthur Museum. M60.355

287 *TABLECLOTH*, 1800–1870
Southern Lancaster County
12 shaft twill diaper, warp: cotton,
 weft: linen; w 53″ (134.6 cm), L 88″
 (223.5 cm)
Ms. Dotty Lewis

288 *TABLECLOTH*, 1841
Christian Yordy (b. 1811)
Willow Street, West Lampeter
 Township, Lancaster County
Jacquard patterned compound weave
 with supplementary weft, tie down
 proportion 2:1, linen pattern weft
 on cotton foundation; w 45″ (114.3
 cm), L 45″ (114.3 cm)
Dr. and Mrs. Donald M. Herr

289 *BED SHEET*, 1750–1825
Christina Laubach
Probably Lehigh or Northampton
 County
Plain weave linen ground and lace,
 silk embroidery; w 76½″ (194.3
 cm), L 70″ (177.8 cm)
Germantown Historical Society,
 Philadelphia. 917
Plate 108

290 *PILLOWCASE*, 1826
Maria Herr
Probably Lancaster County
Plain weave linen ground, cotton and
 silk embroidery in whip, chain, and
 cross-stitches; w 17″ (43.2 cm),
 L 23¾″ (60.3 cm)
Mr. and Mrs. Carroll Hopf

291 *BOLSTER CASE*, 1800–1850
Eastern Lancaster County
16 shaft point twill weave, warp: linen,
 weft: cotton, tape: plain weave
 cotton; w 23″ (58.4 cm), L 49″
 (124.5 cm)
Dr. and Mrs. Donald M. Herr
Plate 69

292 *BED LINENS: BED CASE,*
 BOLSTER CASE, PILLOW-
 CASES, 1800–1850
Oley Township, Berks County
Checked plain weave linen body, plain
 weave cotton inset, plain weave
 linen and wool tape, warp: linen
 and wool, weft: linen; bed case:
 w 60″ (152.4 cm), L 77″ (195.6 cm);
 bolster case: w 20″ (50.8 cm), L
 58½″ (148.6 cm); pillowcases: w 20″
 (50.8 cm), L 30″ (76.2 cm)
Mr. and Mrs. Richard Flanders Smith
Plate 111

293 *QUILT*, 1814
Barbara Schenk
Probably Lancaster County
Plain weave cotton and linen ground,
 silk and wool embroidery in cross-
 stitch; w 94″ (238.8 cm), L 94″
 (238.8 cm)
Dr. and Mrs. Donald M. Herr

294 *QUILT*, 1830
Eastern Pennsylvania, possibly
 Northampton County
Plain weave cotton ground, pieced
 areas: twill weave wool and plain
 weave wool, embroidery: silk and
 crewel, fringe: crewel; w 90″ (228.6
 cm), L 90″ (228.6 cm)
Dr. and Mrs. Donald M. Herr
Plate 107

295 *QUILT*, 1848
Frances Wenger
Lancaster County
Plain weave cotton; w 89″ (226.1 cm),
 L 92″ (233.7 cm)
Private Collection
Plate 20

296 *MAN'S SHIRT*, 1800–1850
Heidelberg Township, Northampton
 (Lehigh) County
Plain weave linen, cotton embroidery;
 w 60″ (152.4 cm), L 42″ (106.7 cm)
Mr. and Mrs. Paul R. Flack

297 *HANDKERCHIEF*, 1787
Probably Lancaster County
Plain weave linen, silk embroidery in
 cross-stitch; w 21″ (53.3 cm),
 L 20½″ (52.1 cm)
Hershey Museum of American Life,
 Hershey, Pennsylvania. 78.005.01

298 *SAMPLER PATTERN*, 1827
Sara Schultz or her teacher
Eastern Pennsylvania
Ink and watercolor on paper; H 15½″
 (39.4 cm), w 12½″ (31.8 cm)
The Reading Public Museum and Art
 Gallery, Pennsylvania
Shown only in Philadelphia
Plate 105

299 *SAMPLER*, 1817–20
Elisabeth Waner
Lancaster or Lebanon County
Plain weave linen ground, silk and
 cotton embroidery in cross-stitch
 with herringbone border; H 17¼″
 (43.8 cm), w 16⅜″ (41.6 cm)
Winterthur Museum. 80.60
Plate 104

300 *SAMPLER*, 1830–40
Magdalena Kurtz (1824–1897)
Ephrata, Lancaster County
Plain weave linen ground with every
 10th horizontal thread 2 ply, silk
 and merino wool embroidery;
 H 19⅜″ (49.2 cm), w 17³⁄₁₆″ (43.7
 cm)
Dr. and Mrs. Donald M. Herr

301 *HAND TOWEL*, 1846
Lydia Kurtz
Ephrata, Lancaster County
Plain weave linen ground, merino
 wool embroidery in cross-stitch,
 white cotton fringe and weaving
 stitch embroidery on drawn linen
 ground; w 16″ (40.6 cm), L 62″
 (157.5 cm)
Dr. and Mrs. Donald M. Herr

302 *COPYBOOK*, 1840
Lydia Kurtz
Ephrata, Lancaster County
Book: paper; H 12¼″ (31.1 cm), w
7¾″ (19.7 cm)
Dr. and Mrs. Donald M. Herr

303 *SAMPLER*, 1836
Fanny Nisley (1821–1888)
Rapho Township, Lancaster County
Plain weave linen ground, cotton
embroidery in cross-stitch; H 24⅝″
(62.5 cm), w 22″ (55.9 cm) (with
frame)
Mr. and Mrs. Richard Flanders Smith

304 *HAND TOWEL*, 1841
Mary Nissly (b. 1824)
Rapho Township, Lancaster County
Plain weave linen ground, cotton
embroidery, silk embroidery in
cross-stitch; w 15½″ (39.4 cm),
L 59½″ (151.1 cm)
Mary Ann McIlnay

305 *MINIATURE HAND TOWEL*,
1815
Christina Hess (née Hackman)
(married 1815)
Probably Millersville, Manor Town-
ship, Lancaster County
Plain weave linen ground, silk and
cotton embroidery in whip, cross-,
weaving, satin, and seed stitches;
w 8¾″ (22.2 cm), L 23½″ (59.7 cm)
Winterthur Museum. 67.1266

306 *HAND TOWEL*, 1839
Meri Weinholt (1804–1880)
Northern Lancaster County
Plain weave linen ground, cotton
embroidery; w 18½″ (47 cm), L 60″
(152.4 cm)
Dr. and Mrs. Donald M. Herr
Plate 31

307 *HAND TOWEL*, 1840–50
Sarah Kriebel (1828–1908)
Montgomery County
Cotton ground, fringe, and embroi-
dery; w 16″ (40.6 cm), L 38½″ (97.8
cm)
Ellen J. Gehret

308 *HAND TOWEL*, 1846–47
Susan C. Killefer (b. 1829)
Millersville, Manor Township, Lan-
caster County
Plain weave linen ground, merino
wool embroidery; w 14¼″ (36.2
cm), L 54⅛″ (137.5 cm)
Harold H. Royer
Plate 133

309 *EMBROIDERED SCONCE*, 1738
Margert Wistar (1728/9–1793)
Philadelphia
Silk satin ground, silk embroidery in
satin, surface satin, bullion, French
knots, and whip stitches, twill weave
linen tape, wood frame; H 17¹⁄₁₆″
(43.3 cm), w 10¼″ (26 cm) (with
frame)
Wyck Charitable Trust, Philadelphia
Shown only in Philadelphia
Plate 74

310 *POCKETBOOK*, c. 1750
Attributed to Margert Wistar
(1728/9–1793)
Philadelphia
Linen canvas ground, crewel and silk
embroidery in tent and cross-
stitches, French knots, plain weave
silk lining, plain weave wool tape;
H 4¾″ (12.1 cm), w 7″ (17.8 cm)
Wyck Charitable Trust, Philadelphia

311 *SKETCHBOOK*, 1791–1804
Sally (Salome) Fetter
Lititz, Lancaster County
Book: watercolor on paper; H 7¹⁵⁄₁₆″
(20.2 cm), w 13½″ (34.3 cm)
(open)
Moravian Museums of Bethlehem,
Pennsylvania. A876-1

312 *MOURNING PICTURE*, 1810–13
Elizabeth (Eliza) Boller (1799–1891)
Philadelphia or Bethlehem
Silk satin ground, painted, embroidery
in satin, surface satin, and whip
stitches, and French knots, metallic
spangles, painted and gilded glass,
gilded gesso frame; H 29¼″ (74.3
cm), w 24″ (61 cm) (with frame)
Allentown Art Museum, Pennsylvania.
79.80.63
Shown only in Philadelphia

313 *SAMPLER*, 1803
Elisabeth Sensinich (1789–1804)
Lancaster, Lancaster County
Linen ground, silk embroidery in
cross-, herringbone, seed, whip,
chain, queen's, and satin stitches;
H 13″ (33 cm), w 12¾″ (32.4 cm)
Philadelphia Museum of Art.
Whitman Sampler Collection. Gift
of Pet Incorporated. 69-288-290

314 *GENERAL WASHINGTON
CROSSING THE DELAWARE*,
1842
Susan Imhoff (1824–1896)
Somerset, Somerset County
Penelope cotton canvas ground, silk
and merino wool embroidery in tent,

cross-, double cross-, chain, whip,
herringbone, and satin stitches;
H 18⁹⁄₁₆″ (47.1 cm), w 21½″ (54.6
cm) (sight)
Gretchen Holderbaum Knothe
Plate 92

315 *WOMAN'S BONNET*, 1838–44
Harmony Society
Economy, Beaver County
Silk body, satin weave foundation
with extra patterned wefts, two
widths of plain weave ribbon, silk
ribbon with horizontal stripes,
brim lining of cotton twill and
plain weave cotton with polka dots;
H 6¾″ (17.1 cm), w 8″ (20.3 cm)
Old Economy Village: Pennsylvania
Historical and Museum Commis-
sion. OE80.19.76

316 *WOMAN'S CAPE*, 1838–44
Harmony Society
Economy, Beaver County
Silk satin foundation with cut velvet
nap, extra weft threads, silk fringe,
silk lining of plain weave heavy
weft yarns and fine warp yarns;
L 17″ (43.2 cm) (without fringe)
Old Economy Village: Pennsylvania
Historical and Museum Commis-
sion. OE78.3.122

317 *MAN'S STRAW HAT*, 1835–50
Harmony Society
Economy, Beaver County
Straw, silk ribbon, plain weave cotton,
leather sweat band; H 5½″ (14 cm),
dia. 7⅞″ (20 cm)
Old Economy Village: Pennsylvania
Historical and Museum Commis-
sion. OE68.9.10

MISCELLANEOUS

318 *BASKET*, 1800–1850
Rye straw coil, white oak splints;
H 4½″ (11.4 cm), dia. 12″ (30.5 cm)
Philadelphia Museum of Art. Gift of
Mrs. William D. Frishmuth. 02-544

319 *COVERED BASKET OR HAMPER*,
1800–1850
Possibly York County
Rye straw coil, oak splints; H 22″
(55.9 cm), dia. 25″ (63.5 cm)
The Historical Society of York
County, York, Pennsylvania. 64.198

320 *SEWING BASKET*, 1800–1850
Eastern Pennsylvania, probably York
County
Rye straw coil, oak splints; H 7″ (17.8

cm), w 13″ (33 cm), D 8″ (20.3 cm)
Dorothy and Eugene Elgin
Plate 106

321 *BEE SKEP*, 1850–1900
Rye straw coil, oak rim, white oak
splints; H 12⅛″ (32.1 cm), dia. 14⅜″
(36.5 cm)
Mr. and Mrs. Lester P. Breininger

322 *FIELD BASKET*, 1800–1850
Oak splints; H 13″ (33 cm), L 30″
(76.2 cm), w 24″ (61 cm)
Jeannette Lasansky
Plate 55

323 *CABBAGE PLANE*, 1820
Possibly Berks County
Walnut, iron; L 20½″ (52.1 cm),
w 7½″ (19.1 cm), D 1¾″ (4.4 cm)
Mr. and Mrs. Eugene A. Charles

324 *GRAIN LEVELER*, 1836
Probably Lancaster County
Walnut; H 3⅜″ (9.2 cm), L 21⅛″
(53.7 cm), D ⅝″ (1.6 cm)
Mr. and Mrs. Eugene A. Charles

325 *BAG STAMP*, 1779
Lancaster or Berks County
Poplar; H 6⁵⁄₁₆″ (16 cm), w 17⅛″
(43.5 cm), D ¾″ (1.9 cm)
Richard S. and Rosemarie B. Machmer

326 *BUTTER PRINT*, 1793
Poplar; H 4½″ (11.4 cm), dia. 4⅞″
(12.4 cm)
The Metropolitan Museum of Art,
New York. Gift of Mrs. Robert W.
deForest, 1933. 34.100.58

327 *BUTTER PRINT*, 1800–1850
Lancaster County
Hardwood, probably walnut; H ⅞″
(2.2 cm), L 9¼″ (23.5 cm), D 4⅛″
(10.5 cm)
Pennsylvania Farm Museum at Landis
Valley: Pennsylvania Historical and
Museum Commission. F8.415
Plate 54

328 *SIDESADDLE*, 1818–42
Emanuel Schaeffer (1793–1864)
Lancaster, Lancaster County
Leather, iron, woven cinch; H 35″
(88.9 cm)
Lancaster County Historical Society,
Lancaster, Pennsylvania. Gift of
Robert E. McMurtrie, 1972. 72.22
Plate 58

329 *DECORATED EGG*, 1841
Egg, natural dyes; H 3⅛″ (7.9 cm)
Philadelphia Museum of Art. Titus C.
Geesey Collection. 58-110-25

330 *ZITHER*, 1800–1850
Probably Philadelphia

Oak, pine, iron; L 35¾″ (90.8 cm),
w 3½″ (8.9 cm), D 2¾″ (7 cm)
Germantown Historical Society,
Philadelphia. 459

331 *SQUARE PIANO*, 1789
Charles Albrecht (c. 1760–1848)
Philadelphia
Mahogany, satinwood veneer, ebony
inlay, pine, ivory, ebony; H 31½″
(80 cm), L 61¾″ (156.8 cm), D 21½″
(54.6 cm)
The Historical Society of Pennsyl-
vania, Philadelphia. X-37
Shown only in Philadelphia

332 *CLARINET IN E-FLAT*, 1820–47
Heinrich Gottlob Gütter (1797–1847)
Bethlehem
Boxwood, ebony, brass, leather;
L 24¼″ (61.6 cm), dia. 3¹⁄₁₆″ (7.8
cm)
Moravian Historical Society,
Nazareth, Pennsylvania
Plate 113

333 *VIOLIN*, 1758
Johannes Antes (1740–1811)
Bethlehem
Pine, maple, walnut, ebony; L 25½″
(64.8 cm), w 9¼″ (23.5 cm),
D 4½″ (11.4 cm)
Moravian Historical Society,
Nazareth, Pennsylvania
Plate 114

Bibliography

ARMSTRONG, WILLIAM H. *Organs for America: The Life and Work of David Tannenberg.* Philadelphia, 1967.

BARBER, EDWIN ATLEE. *Tulip Ware of the Pennsylvania-German Potters: An Historical Sketch of the Art of Slip-Decoration in the United States.* Philadelphia, 1903.

BATTISON, EDWIN A., AND KANE, PATRICIA E. *The American Clock, 1725–1865. The Mabel Brady Garvan and Other Collections at Yale University.* Greenwich, Conn., 1973.

BEAL, REBECCA J. *Jacob Eichholtz, 1776–1842: Portrait Painter of Pennsylvania.* Philadelphia, 1969.

BRUMBAUGH, G. EDWIN. *Colonial Architecture of the Pennsylvania Germans.* Pennsylvania German Society Proceedings at Harrisburg, Pa., October 17, 1930, and Papers Prepared for the Society, vol. 41. Lancaster, Pa., 1933.

BUFFINGTON, ALBERT F. *Pennsylvania German Secular Folksongs.* Publications of the Pennsylvania German Society, vol. 8. Breinigsville, Pa., 1974.

CLARKE, JOHN M. *The Swiss Influence on the Early Pennsylvania Slip Decorated Majolica.* Albany, N.Y., 1908.

CREUX, RENE, et al. *Volkskunst in der Schweiz.* Paudex, Switz., 1976.

CROSSON, JANET GRAY. *Let's Get Technical—An Overview of Handwoven Pennsylvania Jacquard Coverlets: 1830–1860.* Lancaster, Pa., 1978.

DUSS, JOHN S. *The Harmonists: A Personal History.* Harrisburg, Pa., 1943.

ECKHARDT, GEORGE H. *Pennsylvania Clocks and Clockmakers: An Epic of Early American Science, Industry, and Craftsmanship.* New York, 1955.

ERNST, JAMES E. *Ephrata: A History.* Edited by John Joseph Stoudt. The Pennsylvania German Folklore Society, vol. 25. Allentown, Pa., 1963.

FABIAN, MONROE H. *The Pennsylvania-German Decorated Chest.* New York, 1978.

FORMAN, BENNO M. "German Influences in Pennsylvania Furniture." In Scott T. Swank et al., *Arts of the Pennsylvania Germans at Winterthur,* forthcoming.

GARVAN, BEATRICE B. *The Pennsylvania German Collection: Philadelphia Museum of Art.* Handbooks in American Art, No. 2. Philadelphia, 1982.

GEHRET, ELLEN J., AND KEYSER, ALAN G. *The Homespun Textile Tradition of the Pennsylvania Germans.* Harrisburg, Pa., 1976.

GERSTELL, VIVIAN S. *Silversmiths of Lancaster, Pennsylvania 1730–1850.* Lancaster, Pa., 1972.

GLATFELTER, CHARLES H. *Pastors and People: German Lutheran and Reformed Churches in the Pennsylvania Field, 1717–1793.* Vol. 1. *Pastors and Congregations.* Publications of the Pennsylvania German Society, vol. 13. Breinigsville, Pa., 1980.

GUNNION, VERNON S., AND HOPF, CARROLL J., eds. *The Blacksmith: Artisan Within the Early Community.* Harrisburg, Pa., 1976.

HAMILTON, KENNETH G., ed. and trans. *The Bethlehem Diary.* Vol. 1. *1742–1744.* Bethlehem, Pa., 1971.

HINDLE, BROOKE. *David Rittenhouse.* Princeton, N.J., 1964.

HUNTER, FREDERICK WILLIAM. *Stiegel Glass.* 1914. Reprint. New York, 1950.

INNES, LOWELL. *Pittsburgh Glass 1797–1891: A History and Guide for Collectors.* Boston, 1976.

KEYSER, ALAN G., ed., and HOLLENBACH, RAYMOND E., trans. *The Account Book of the Clemens Family of Lower Salford Township, Montgomery County, Pennsylvania, 1749–1857.* Sources and Documents of the Pennsylvania Germans, vol. 1. Breinigsville, Pa., 1975.

KEYSER, ALAN G.; NEFF, LARRY M.; AND WEISER, FREDERICK S.; eds. and trans. *The Accounts of Two Pennsylvania German Furniture Makers—Abraham Overholt, Bucks County, 1790–1833, and Peter Ranck, Lebanon County, 1794–1817.* Sources and Documents of the Pennsylvania Germans, vol. 3. Breinigsville, Pa., 1978.

KINDIG, JOE, JR. *Thoughts on the Kentucky Rifle in Its Golden Age.* York, Pa., 1960.

KLATT, ERICH. *Die Konstruktion alter Möbel: Form und Technik im Wandel der Stilarten.* Stuttgart, 1961.

KLEES, FREDRIC. *The Pennsylvania Dutch.* New York, 1950.

LASANSKY, JEANNETTE. *Central Pennsylvania Redware Pottery: 1780–1904.* Lewisburg, Pa., 1979.

LASANSKY, JEANNETTE. *To Draw, Upset, and Weld: The Work of the Pennsylvania Rural Blacksmith, 1742–1935.* Lewisburg, Pa., 1980.

LASANSKY, JEANNETTE. *Willow, Oak & Rye: Basket Traditions in Pennsylvania.* Lewisburg, Pa., 1978.

LAUGHLIN, LEDLIE IRWIN. *Pewter in America: Its Makers and Their Marks.* 3 vols. Barre, Mass., 1969–71.

LICHTEN, FRANCES. *Folk Art of Rural Pennsylvania.* New York, 1946.

MERCER, HENRY C. *The Bible in Iron: Pictured Stoves and Stoveplates of the Pennsylvania Germans.* Edited by Horace M. Mann and Joseph E. Sanford. 3rd ed. Doylestown, Pa., 1961.

MITTELBERGER, GOTTLIEB. *Journey to Pennsylvania in the Year 1750 and Return to Germany in the Year 1754* Translated by Carl Theo. Eben. Philadelphia, 1898.

MUHLENBERG, HENRY MELCHIOR. *The Notebook of a Colonial Clergyman: Condensed from the Journals of Henry Mel-*

chior Muhlenberg. Edited and translated by Theodore G. Tappert and John W. Doberstein. Philadelphia, 1959.

NEFF, LARRY M., trans. "Jonas Heinrich Gudehus: Journey to America." In Albert F. Buffington et al., *Ebbes fer Alle-Ebber—Ebbes fer Dich: Something for Everyone—Something for You. Essays in Memoriam—Albert Franklin Buffington,* pp. 183–329. Publications of the Pennsylvania German Society, vol. 14. Breinigsville, Pa., 1980.

NELSON, VERNON. *John Valentine Haidt.* Williamsburg, Va., 1966.

NEWALL, VENETIA. *An Egg at Easter: A Folklore Study.* London, 1971.

PENNYPACKER, SAMUEL WHITAKER. *The Settlement of Germantown, Pennsylvania and the Beginning of German Emigration to North America.* Philadelphia, 1899.

PHILADELPHIA, PHILADELPHIA MUSEUM OF ART, AND WINTERTHUR, THE HENRY FRANCIS DU PONT WINTERTHUR MUSEUM. *Pennsylvania German Art, 1683–1850.* Microfiche ed. Chicago, forthcoming.

ROSENBERGER, HOMER T. "Migrations of the Pennsylvania Germans to Western Pennsylvania." *The Western Pennsylvania Historical Magazine,* pt. 1, vol. 53, no. 4 (October 1970), pp. 319–35; pt. 2, vol. 54, no. 1 (January 1971), pp. 58–76.

ROTH, JULIANA. "Travel Journals as a Folklife Research Tool: Impressions of the Pennsylvania Germans." *Pennsylvania Folklife,* vol. 21, no. 4 (Summer 1972), pp. 28–38.

RUSH, BENJAMIN. *An Account of the Manners of the German Inhabitants of Pennsylvania. Written 1789.* Edited by I. Daniel Rupp. Philadelphia, 1875.

SEIDENSTICKER, OSWALD. *The First Century of German Printing in America, 1720–1830.* Philadelphia, 1893.

SHELLEY, DONALD A. *The Fraktur-Writings or Illuminated Manuscripts of the Pennsylvania Germans.* The Pennsylvania German Folklore Society, vol. 23. Allentown, Pa., 1961.

SHOEMAKER, ALFRED L. *Christmas in Pennsylvania: A Folk-Cultural Study.* Kutztown, Pa., 1959.

SHOEMAKER, ALFRED L. *Eastertide in Pennsylvania: A Folk Cultural Study.* Kutztown, Pa., 1960.

SMITH, RICHARD FLANDERS. *Pennsylvania Butter Prints.* Ephrata, Pa., 1970.

SNYDER, JOHN J., JR. "Carved Chippendale Case Furniture from Lancaster, Pennsylvania." *Antiques,* vol. 107, no. 5 (May 1975), pp. 964–75.

SNYDER, JOHN J., JR. "The Bachman Attributions: A Reconsideration." *Antiques,* vol. 105, no. 5 (May 1974), pp. 1056–65.

SONN, ALBERT H. *Early American Wrought Iron.* 3 vols. New York, 1928.

STOUDT, JOHN JOSEPH. *Early Pennsylvania Arts and Crafts.* New York, 1964.

STOUDT, JOHN JOSEPH. *Pennsylvania German Folk Art: An Interpretation.* Allentown, Pa., 1966.

TURNER, ROBERT P., ed. *Lewis Miller: Sketches and Chronicles. The Reflections of a Nineteenth Century Pennsylvania German Folk Artist.* York, Pa., 1966.

VON SALDERN, AXEL. "Baron Stiegel and Eighteenth-Century Enameled Glass." *Antiques,* vol. 80, no. 3 (September 1961), pp. 232–35.

WEISER, FREDERICK S. "Piety and Protocol in Folk Art: Pennsylvania German Fraktur Birth and Baptismal Certificates." *Winterthur Portfolio,* vol. 8 (1973), pp. 19–43.

WEISER, FREDERICK S., AND HEANEY, HOWELL J., comps. *The Pennsylvania German Fraktur of the Free Library of Pennsylvania.* 2 vols. Publications of the Pennsylvania German Society, vol. 10. Breinigsville, Pa., 1976.

WEISER, FREDERICK S., AND SULLIVAN, MARY HAMMOND. "Decorated Furniture of the Schwaben Creek Valley." In Albert F. Buffington et al., *Ebbes fer Alle-Ebber—Ebbes fer Dich: Something for Everyone—Something for You. Essays in Memoriam—Albert Franklin Buffington,* pp. 331–94. Publications of the Pennsylvania German Society, vol. 14. Breinigsville, Pa., 1980.

YODER, DON, ed. *Pennsylvania German Immigrants, 1709–1786: Lists Consolidated from Yearbooks of the Pennsylvania German Folklore Society.* Baltimore, 1980.

Acknowledgments

ONE OF THE MANY joys of planning and implementing an exhibition is confirmation of the generosity of individuals and institutions. On that score alone, the curators responsible for this exhibition have been blessed many times over. Active encouragement and support came from Jean Sutherland Boggs, former Director, Anne d'Harnoncourt, Director, and Robert Montgomery Scott, President, of the Philadelphia Museum of Art, and James Morton Smith, Director of Winterthur. A large debt of gratitude for their strong support of and belief in this project is owed to John A. Herdeg, President of Winterthur's Board of Trustees, and to Scott Swank, Deputy Director for Interpretation, Winterthur.

Not to be overlooked are contributions to this project made by Helen Cain, full-time volunteer research assistant, and Vicky Titcomb Uminowicz, project research assistant. Field trips, indexing of records, genealogical research, and just about any other assignment related to this exhibition were accepted with enthusiasm and completed without complaint. Kathryn Plummer, Exhibition Assistant, and Wendy Christie, Research Secretary, Department of American Art, Philadelphia Museum of Art, and Justine Mataleno, Administrative Assistant, Department for Collections, Winterthur Museum and Gardens, helped in numerous, indispensable ways to keep the organizers of this exhibition "organized."

Staff of both institutions not only worked well within each museum, but cooperated with their counterparts in each organization. We are especially grateful for assistance rendered far beyond the narrow constraints of a job description from individuals in the following departments and offices in both institutions: Assistant Director for Operations (PMA)—Lawrence H. Snyder; Special Exhibitions: Planning (PMA)—Suzanne Wells; Exhibition Design (PMA)—Tara Robinson; Department of American Art (PMA)—Deborah Ducoff-Barone, Miriam Mucha; Curatorial Division (WM)—James Albanese, Phillip H. Curtis, Donald L. Fennimore, E. McSherry Fowble, Alberta Melloy, James Paterson, Valerie Rabian, Nancy E. Richards, Cathy Stetler, Susan B. Swan, and Guest Curators Vernon S. Gunnion and Patricia T. Herr; Conservation (PMA)—Marigene Butler, Nancy Hughes, Andrew Lins, Tom Robinson, Denise Thomas; Conservation (WM)—Mary Cash, Margaret Lowe Craft, Margaret Fikioris, Don Heller, Michael Heslip, Jane Klinger, John Krill, Gregory Landrey, Ruth Lee, John Melody, Mervin Richard, Dora Shotzberger, Joyce Hill Stoner; Development (PMA)—Maria Giliotti, Daphne Smith, Susan Stuchlak; Development (WM)—William Ayres, Robert Safrin; Education (PMA)—Elizabeth Anderson, Margaret Burchenal, Marla Shoemaker, Marjorie Sieger; Education (WM)—the late Benno Forman, Peter Hammell; Exhibition Graphics (PMA)—Laurence Channing, Jennifer McChesney, Susan Weinstein; Gardens and Grounds (WM)—Walter Petroll; Installations and Construction (PMA)—Harold Bennett, Hardy Bragg, John Burke, Frank Downing, Rondal Drayton, Michael Elinsky, Joseph Forte, Dan Gorley, Robert Gorley, Warren Henderson, Gary Hiatt, Wayne Johnson, John McGowan, Barney McNellis, Daniel Magill, Jesse Moore, Raymond Orsini, Mickey Provience, Lee Savary, Pat Sirianni, Francis Tucker; Library (PMA)—Carol Homan, Barbara Sevy; Library (WM)—Bert Denker, Barbara Hearn, Karen Hill, Kathryn McKenney, Edward McKinstry, Mary Piendak, Frank Sommer, Beatrice Taylor, Eleanor Thompson; Membership (PMA)—Bonnie Coulter; Membership (WM)—Roberta O'Sullivan; Operations (WM)—Stephen Weldon; Packing (PMA)—T. S. Blues Farley, Hal Jones; Photography (PMA)—Will Brown, Conna Clark, Rick Echelmeyer, Lois Fad, Eric Mitchell; Photography (WM)—Alberta Brandt, Herbert Crossan III, George Fistrovich, Wayne Gibson; Prints, Drawings, and Photographs (PMA)—Suzanne Wheeling; Public Relations (PMA)—Laura Gross, Sandra Horrocks; Public Relations (WM)—Janice Roosevelt, Catherine Wheeler; Registrar's Office (PMA)—Judy Brodie, Clarisse Carnell, Fernande Ross, Irene Taurins; and Registrar's Office (WM)—Barbara Bell, Nancy Evans, and Karol Schmiegel.

This catalogue could not have been produced without the hard work and thoughtful editorial guidance of the Philadelphia Museum of Art Department of Publications. George Marcus, Jane Watkins, Sherry Babbitt, Leslie March, Susan Soltys, Melanie Bartlett, and Bernice Connolly all helped to make the publication a reality. Joanna Hynes supervised the production of much of the ephemeral material related to the exhibition. The Department was aided by Alice Lefton in library research, Susan B. Wolf in preliminary editing, and Joseph B. Del Valle, who designed the catalogue, assisted by Laurie Rippon and Naomi Suess.

Several individuals were willing to give their time and expertise in constructive criticism of the selection of objects, organization, and manuscripts. Their experience, knowledge, willingness to help, and wise counsel were invaluable resources. A very special thank you, therefore, to Vincent Ciulla, Alan Keyser, Larry Neff, Harry Rinker, Donald Shelley, Richard Smith, John Snyder, Jr., Frederick Weiser, Stacy Wood, and Don Yoder. Their insights and generous sharing of information were vital to the focus of this exhibition. In this group were also representatives from host institutions for the travel portion of this exhibition. Suggestions and advice received from Milo Naeve, The Art Institute of Chicago; David Warren, The Museum of Fine Arts, Houston; and Leah Miller and Donald Stover, M. H. de Young Memorial Museum, San Francisco, were most helpful.

In their generous assistance in arranging for exhibition staff to examine objects and check documents and records, the sponsors of this exhibition are grateful to the following insti-

tutions, organizations, and their staffs: Abby Aldrich Rocke-
feller Folk Art Center, Williamsburg, Virginia, Beatrix Rum-
ford, Anne Watkins, Carolyn Weekley; Allentown Art
Museum, Pennsylvania, Peter Blume; American Antiquarian
Society, Worcester, Massachusetts, Georgia Bumgardner;
American Philosophical Society, Philadelphia, Whitfield Bell,
Edgar Richardson; Annie S. Kemerer Museum, Bethlehem,
Pennsylvania, Deborah Evans; Chester County Historical
Society, West Chester, Pennsylvania, Ruth Hagy; Cooper-
Hewitt Museum, New York, Milton Sonday; Cooperstown
Graduate Programs, Cooperstown, New York, Christopher
Tahk; The Dietrich Brothers Americana Corporation, Phila-
delphia, Richard Dietrich, Alexandra Rollins; Embassy of
the Federal Republic of Germany, Washington, D.C., Heide
Russell; Ephrata Cloister, Ephrata, Pennsylvania, John Kraft;
The Free Library of Philadelphia, Frank Halpern, Howell
Heaney; German Consulate General, New York, Heiner
Horsten; Germantown Historical Society, Philadelphia, Mark
Lloyd; Greenfield Village and Henry Ford Museum, Dear-
born, Michigan, Christina Nelson; Heritage Center of Lan-
caster County, Inc., Lancaster, Pennsylvania, George Scott,
Bruce Shoemaker; Hershey Museum of American Life, Her-
shey, Pennsylvania, Eliza Harrison; Historical Society of
Berks County, Reading, Pennsylvania, Barbara Gill, Harold
Yoder, Jr.; The Historical Society of Montgomery County,
Norristown, Pennsylvania, Alice G. Smith; The Historical So-
ciety of Pennsylvania, Philadelphia, James Mooney, William
Oedel, Peter Parker, John Platt, Linda Stanley, and staff of
the Reading and Manuscript rooms; The Historical Society
of Western Pennsylvania, Pittsburgh, John Labanish, Ruth
Reid, Helen Wilson; The Historical Society of York County,
York, Pennsylvania, Douglas Dolan, Landon Reisinger,
Patricia Tomes; Juniata College Library, Huntingdon, Penn-
sylvania, David Eyman, Mrs. Donald Rockwell; Lancaster
County Courthouse, Archives Department, Lancaster, Penn-
sylvania, Kitty Barback; Lancaster County Historical So-
ciety, Lancaster, Pennsylvania, John Aungst, Samuel Dyke,
Salinda Matt; Lancaster Mennonite Historical Society Li-
brary, Lancaster, Pennsylvania, Lois Mast, David Smucker;
The Lehigh County Historical Society, Allentown, Pennsyl-
vania, Mrs. A. Newton Bugbee; Mennonite Heritage Center,
Souderton, Pennsylvania, Mary Hershey; Mercer Museum of
The Bucks County Historical Society, Doylestown, Pennsyl-
vania, Terry McNealy, Lynne Poirier; The Metropolitan
Museum of Art, New York, Alice Frelinghuysen, Morrison
Heckscher, Laurence Liben; The Moravian Archives, Beth-
lehem, Pennsylvania, Luther Madeheim, Vernon Nelson;

Moravian Historical Society, Nazareth, Pennsylvania, E. B.
Clewell, Charles Peischl; Moravian Museums of Bethlehem,
Bethlehem, Pennsylvania, Mrs. Charles Zug, Jr.; The Mora-
vian Music Foundation, Bethlehem, Pennsylvania, Richard
Claypool, Robert Steelman; Museum of Fine Arts, Boston,
Wendy Cooper; The North Museum of Franklin and Mar-
shall College, Lancaster, Pennsylvania, John Andrew; Old
Economy Village, Ambridge, Pennsylvania, Rachel Maines,
Daniel Reibel; William Penn Memorial Museum, Harrisburg,
Pennsylvania, Bruce Bazelon, Gail Getz, Cathryn McElroy;
Pennsylvania Farm Museum at Landis Valley, Lancaster,
Pennsylvania, Robert Sieber, Nadine Steinmetz; Pennsylvania
Historical and Museum Commission, Harrisburg, Pennsyl-
vania, Michael Ripton, Larry Tise, Peter Welsh; The Read-
ing Public Museum and Art Gallery, Reading, Pennsylvania,
Bruce Dietrich, Jefferson Gore; Philip Schaff Library and
Evangelical and Reformed Historical Society, Lancaster
Theological Seminary, Lancaster, Pennsylvania, staff of the
archives and manuscript collections; Schwenkfelder Museum,
Pennsburg, Pennsylvania, Claire Conway, Dennis Moyer;
Sleepy Hollow Restorations, Inc., Tarrytown, New York,
Kate Johnson; Smithsonian Institution, Washington, D.C.,
Rita Adrosko, Susan Myers; and Wyck Charitable Trust,
Philadelphia, Sandra Lloyd.

The cooperation of county officials enabled access to
records at courthouses in the counties of Berks, Bucks,
Dauphin, Lancaster, Montgomery, and Philadelphia.

Individuals who generously provided information about
collectors and collections, gave access to research materials,
and aided the exhibition staff in so many ways include Harry
Berry, Lester Breininger, Gladys Breuer, Clem Caldwell, Rob-
ert Carroll, Kathleen Catalano, Edward Cooke, Jr., Jonathan
Cox, Janet Crosson, William Esborn, Mrs. Silas Eshleman,
Jr., Mr. and Mrs. Austin Fine, Hilda Fisher, Ellen Gehret,
Mr. and Mrs. Richard Gerstell, William Guthman, Donald
Herr, Byron Horne, William Hosley, Jr., Henry Kauffman,
Mr. and Mrs. George Keehn, Guy Kemmer, Joe Kindig III,
Edward LaFond, Jr., Jeannette Lasansky, John Loose, Mr.
and Mrs. Richard Machmer, Don Newcomer, Mary Redus,
Henry Shallenberger, R. M. Shank, Walter Simmons II,
Sandra Walker, Carol Warner, Polly Williams, and Mari-
anne Wokeck. Special thanks to Edith Buxbaum for coaxing
Beatrice Garvan through basic German.

We wish to thank Marlene Hummel and Anthony N. B.
Garvan for their patience, affection, and unflagging support
throughout this project.

B.B.G. and C.F.H.

Photographs courtesy of the lenders, except the following plates:
Will Brown 1–4, 8, 9, 11, 13–15, 17, 19, 20, 22, 24, 27–32, 41, 45–47,
49–61, 64, 67–70, 72–74, 77, 79, 81, 83, 86, 87, 93, 95, 96, 100–102,
105–8, 110, 111, 113–15, 118, 120, 123, 125, 127, 128, 131–33;
Rick Echelmeyer 12; Hollinger 5; Eric Mitchell 7, 18, 38, 48, 85, 91, 97;
Richard A. Stoner 40; Winterthur Museum Library 63, 99